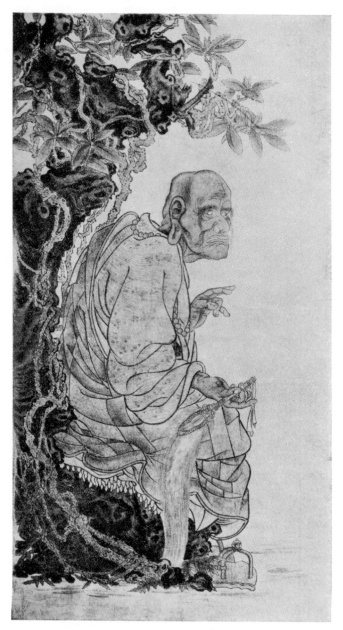

RAKAN HOLDING WAND.
By the priest Zengetsu Daishi (Kuan Hsiu).
At Kodaiji.

EPOCHS *of* CHINESE
& JAPANESE ART

AN OUTLINE HISTORY OF
EAST ASIATIC DESIGN

By

ERNEST F. FENOLLOSA

*Formerly Professor of Philosophy in the Imperial University
of Tokio, Commissioner of Fine Arts to the Japanese
Government, Etc.*

NEW AND REVISED EDITION,
WITH COPIOUS NOTES BY PROFESSOR PETRUCCI

VOLUME I

DOVER PUBLICATIONS, INC.
NEW YORK

This new Dover edition, first published in 1963, is an unabridged republication of the second (1913) edition of the work first published by Frederick A. Stokes Company and William Heinemann in 1912.

The illustrations in Volume One facing pages 43, 90, 156 and 174 were reproduced in color in the 1913 edition.

Standard Book Number: 486-20364-6
Library of Congress Catalog Card Number: 63-5655

Manufactured in the United States of America
Dover Publications, Inc.
180 Varick Street
New York, N. Y. 10014

FOREWORD.

By the EDITOR.

*T*HE Foreword to the original edition of 1912 opened with the following paragraph :—

"*WITH* the publication of this book three years of continuous work upon a most complicated and difficult manuscript comes to an end. I have had assistance from scholars all over the world. Many months have been spent in *Japan*, where invaluable aid was given by artists and scholars who had been associated, several of them since the year 1880, with the archæological researches and the study of Chinese and *Japanese* Art to which, shortly after his arrival in *Japan*, Ernest Fenollosa determined to devote his life. The original manuscript of this book, left as it was in hasty pencil writing, was little more than a rough draft of the finished work he intended to make of it. Many historical dates, the names of temples, Sanskrit and Chinese names, and even the full names of artists were often left a blank. Especially in the choice of illustrations has the work seemed, at times, beyond the grasp of any intelligence less than his. A full list of these was made out, but often the description consisted of a single word of identification known only to the writer. From the beginning I knew that there were certain omissions which could never be filled, and certain mistakes which inevitably I must make. Yet it was the writer's personal charge to me to bring out his book in the best way I could, and this represents my best. All deficiencies and errors must be charged to me alone."

Now, in this second edition, I am glad to be able to state that of the omissions previously mentioned two only remain, the illustration of the Shang bronze on page 156 of Volume II., and the photograph of Chinese porcelains called for on the following page.

In order to meet certain criticisms the publishers, before issuing the new edition, secured the services of Professor R. Petrucci, of the Sociological Institute in Brussels, to make a careful revision of the entire work. This he has done with masterly and painstaking precision.

It is perhaps to be regretted that all of Professor Petrucci's corrections cannot be incorporated. He advises, for instance, the entire abolishing of all *Japanese* pronunciation of the old Chinese names,

replacing them by the Chinese now in use. Such artists as Godoshi, Ririomin, and Mokkei, though collected, studied, and venerated in Japan under these names for centuries, he would have appear always as Wu Tao-tzü, Li Lung-mien, and Mu Ch'i. He questions Professor Fenollosa's statement in his introduction that the Japanese pronunciation has either authenticity or merit, and would have gone so far as to strike out from the introduction those paragraphs explaining and defending them.

Apart from my personal opposition to a change so drastic, the wholesale adoption of purely Chinese names would have necessitated an entire re-setting of type, and have delayed this second edition for many months.

Since the writer's death in 1908 there has been, it seems, a congress of Oriental scholars from all parts of the world, and a system for the Romanized spelling of all Oriental names, not only of artists but of localities, religions, deities, and personal names has been fixed upon. The Chinese epoch, for instance, called in this book " Tang," is now always " T'ang." Ghandara should be Ghandāra, and Yuen, Yuän. These are but a few out of hundreds.

Even in Japanese spelling, where the writer was most at home, Professor Petrucci suggests many changes, chiefly in the lengthening or shortening of vowel sounds. The words Yodo, Wado, Hogen, Jingoji, Kioto, Kobo, Shinto, Shomu, and countless others should now have the long " o "—that is, " ō."

In closing I must repeat, and with a deepened sense of gratitude for more recent assistance, my thanks to Mr. Charles L. Freer, of Detroit; Professor Ariga Nagao and the artist Kano Tomonobu, of Japan; Mr. Laurence Binyon, of the British Museum ; Professor Arthur W. Dow, of Columbia University, New York ; Dr. Stein, of the Indian Archæological Survey, and also to the Secretary of State for India for permission to reproduce four of the illustrations that appeared in " Ancient Khotan."

A special word of thanks must be given to those kind friends as well as publishers, Mr. William Heinemann, of London, and Mr. Frederick A. Stokes, of New York City.

 MARY FENOLLOSA.

PREFACE

IN the earlier years of our marriage, during our residence in Tokio, ERNEST FENOLLOSA would, from time to time, fall into a mood not unfamiliar to any of us as we grow older, that of finding a certain delicate pleasure in speaking of his early childhood. His parentage was unusual ; his whole intellectual and temperamental child-life, so to speak, just a little above the normal. His first memory (and he must have been little more than an infant at the time) was of lying in the sun on a floor near a window, and hearing his parents, his mother at the piano, his father with a violin, playing what he afterwards learned to recognize as Beethoven's *Sonata Appassionata.* His father was a professional musician in Salem, and all the early years of his son's life seem to have been involved and interwoven with strains and themes from the great composers.

Once, in Tokio, during such a mood of reminiscence, I suggested that he let me get a note-book and pencil and take the impressions down in order. He agreed, and in a few moments more I was ready, and had inscribed a new note-book with the words, " Notes on Ernest's Childhood." The following pages are those written at his dictation.

" My father's full baptismal name was Manuel Francisco Ciriaco Fenollosa del Pino del Gil del Alvarez, the names Francisco and Ciriaco standing for the two patron saints, according to Spanish custom. Pino was the family name of his mother and Gil and Alvarez of his two grandmothers. The Alvarez he supposed to be a modified form of the family name Alvarado, so famous in Spanish History, not impossibly the direct descendants of Alvarado, the Lieutenant of Cortez in Mexico, who married the daughter of the King of the Tlascalans. His descendants by her are said to have founded families in Spain. The name Fenollosa is also an historic one, and is doubtless the same as that of the Penalosa, another companion of Cortez, who made the first exploring expedition up through Texas, New Mexico and Colorado. The ' F ' and ' ll ' of the name as pronounced in Spanish can be given many kinds of English spelling. Thus, hardened, the ' F '

would become a 'P'; softened, it would become an 'H.' The
liquid sound of the 'll' may easily be transformed into the sound
of the English 'Y,' or even 'J.' Thus actually rose a great many
ways of spelling the name, and I recall seeing in my youth an old
Spanish illumination belonging to my father's sister, Mrs. Emilio, in
which the name was written 'Hinajosa.' The Fenollosa family was
from ancient days settled in the old Roman city of Valencia. I knew
from my father this one fact only, and that his father, also Manuel
Fenollosa, was born there. But from a Spanish sculptor in New York,
Fernando Miranda, I learned that several branches of the family were
still living in Valencia, that there is a street named after the family,
and that one Fenollosa is a priest in the cathedral of Santes Juanes.
At my request Mr. Miranda wrote to this priest and got a most
courteous reply, saying that he would gladly look up anything for me
in Valencia if I would tell him what was desired. Unfortunately
I have never yet taken advantage of this opportunity.

"I remember also hearing my father say that he had two cousins,
unmarried ladies, living in Madrid, but that was about 1870. My
grandfather, Manuel Fenollosa, must have been born somewhere about
1785 or 1790, and left Valencia as a young man to join in the wars
which troubled Spain in the early part of the nineteenth century,
presumably the wars with Napoleon. He was a musician by profession,
but I did not know whether he entered the army as a member of a
military band, or as an ordinary soldier. After leaving the army he
settled down as a musician in Malaga, where he married Ysobel del
Pino of the neighbouring town, Canillas de Aceytuno. My father was
born on one of the last few days of December in 1818 or 1819.

"He used to tell me many stories of his life as a boy. There was
a great rocky height on which the Moors, driven from Granada, had
their last fortress and palace in Spain. About its ruins he used to
love to clamber, and once fell down a steep part of the slope, cutting
his forehead deeply. The scar of this was large, and was visible to
the day of his death. He was a musical prodigy, and remembered
that, at the age of five or six years, he was made to stand on a table
in the midst of a crowded hall and sing, in a child's soprano voice,
leading arias from Italian operas. By this time also he was quite
proficient on the piano and on the violin, and by the age of ten was
playing in public. He took great delight in being leader of the boys'

choir in the cathedral of Malaga, and used to laugh with joy as he told of the pranks that he and a comrade used to play in that ancient edifice, climbing up under the tower, exploring long-forgotten lofts, and once lying in hiding so that they might break the rules against staying in the church all night. He had love affairs, too, in his boyish days, and used to speak of a little black-eyed aristocrat for singing serenades under whose balcony he was punished by his father. He had no brothers, and but one sister, Ysobel, who was born in 1820, and of whom he was very fond. When he was about fourteen, some war, one of the Carlists', I believe, broke out in Spain, and there was fear that all the young men might be drafted into the army. The war was very unpopular in Malaga, certainly among my father's friends and associates, for the songs of this period that he sometimes would sing me were all about constitutions, liberty and denunciation of tyranny. A man some years older than he, Don Manuel Emilio, also a musician, was engaged to marry his sister Ysobel, and at this time was leader of a celebrated military band. At this moment there happened to be a frigate of the U.S. Navy in the port of Malaga, and its commander made a proposition to take this band to America as the naval band of the ship. The fear of having him drafted into the army prompted Manuel's parents and Mr. Emilio to try to get him a chance to escape to America with this band. It was found that there was but one vacancy, that of the French horn, an instrument which he had never touched. The ship was to sail next morning, and Mr. Emilio said, 'Manuel, if you will spend the whole night practising the French horn it may be possible for you to pass the examination in the morning. At any rate, I will announce you now, publicly, as a candidate.' The night was so passed, the examination successful, and he went off on the ship that day. Before reaching America the frigate was to touch at the Balearic Isles, whither she was conveying an old gentleman, the new Spanish Governor of the Isles. This old Don, as it chanced, became interested in and really attached to the boy Manuel. When they arrived at Majorca there was already great excitement about the war; the rules were imperative that no one should leave Spain without a passport. It had been too late to procure one at Malaga, and the authorities were about to refuse to let young Fenollosa proceed. At this crisis the Governor was appealed to, and through his influence he was allowed to continue his voyage.

"The Spanish band was soon discharged from the frigate, but for several years held together as an American organization. Railroads were almost non-existent in those days and the great cities along the Atlantic coast much more isolated. But there was already a growing love for music, and this band every winter had immense success, giving series of concerts and travelling overland in coaches and by boat from Washington to Portland, Maine. Mr. Emilio was always the leader. He was a great performer on the violin. In a musical criticism or, rather, reminiscence in a New York paper as late as 1892, I read a notice of these concerts, in which the writer spoke of the modern virtuosi who have come from Europe to America during the last fifty years, but that to one who had heard Emilio play in the Spanish band in the eighteen thirties all later performances seemed to lack heart and genius. I have heard my father often refer to these journeys and tell how, as a boy still in his teens, he played sometimes the violin, sometimes a wind-instrument—often in solos. He was always placed at the very front of the stage, and was the pet of the band. In all cities where they visited the musicians were royally entertained. The sort of music they played was the best Italian, generally from operas, but they also introduced something of the new German school, Mozart, Beethoven, Meyerbeer, etc., etc.

"At last the band broke up, and its members settled down as professional musicians in one or another city. Salem, Massachusetts, had been one of the leading centres of refinement and of love for music. The commerce of its merchants extended to all parts of the earth, and its aristocratic families were the rivals of Boston in wealth, education and the advantages of foreign travel. Among such wealthy patrons of culture there was one especially, Mr. George Peabody, who was a fine amateur painter as well as musician. He had a collection of old European masterpieces both of paintings and of musical instruments, such as violins, lutes, etc. He was himself an excellent performer on the 'cello. He had often entertained the Spanish band at his house, perhaps the finest of the old colonial mansions in Salem. When the band broke up it was to his urgent solicitations especially that Mr. Emilio and my father yielded in deciding to make Salem their future home. In those days the two Spaniards spent most of their evenings and many afternoons playing with Mr. Peabody in his studio. The latter outlived them both, not dying until 1890, or thereabouts, at a very advanced age.

"Before long my father's sister, Ysobel, came over from Spain to be married to Mr. Emilio, and my father took up his residence with them. My father is said to have been a great social favourite, and as music teacher visited at most of the leading houses. He also played in orchestras at Boston. In the early days of the railroad between Salem and Boston there were few evening trains, and he used to relate to me with pride how many and many a time he had walked back from Boston to Salem, sixteen miles through the snow, his violin slung across his back, reaching home in time for breakfast. He must, in these days, have possessed a very strong constitution, but an accident, that of losing his foothold upon one of the bridges and falling through into icy water, checked for ever all such adventures, and brought on a temporary hæmorrhage of the lungs.

"The family kept up constant communication with the old people in Malaga, and somewhere about 1845 they induced the old Manuel and Ysobel Fenollosa to come over and live with them in Salem. The old man was not at all contented. He could not appreciate the advance of science, free thought and republican institutions, for all of which Salem was a leading centre, and the young Spaniards leading advocates. In less than a year old Manuel returned to Spain alone, where he died not long after. My grandmother remained with her children for nearly three years, but she, too, was discontented, especially with the changes in religious matters. The children had, of course, in Spain been baptized Roman Catholics, but had already become Episcopalian Protestants. The mother resented this apostasy, and for herself, though most assiduous in her devotions at the cathedral in Salem, could not feel at home with alien priests, and a congregation composed, for the most part, of immigrant Irish. So before 1850 she too had returned to Malaga, and there lived in religious retirement until her death. Communication with her in Malaga was of course kept up, but at longer and longer intervals. I remember as a child having casks of wine and boxes of raisins sent to our home directly from Malaga.

"Among my father's pupils in Salem were many aristocratic young ladies, among whom my mother was one of his favourite pupils on the piano. I must now go back and say something of her family. My mother's name was Mary Silsbee, and she was the daughter of William Silsbee and Mary Hodges, both descendants of old Salem families whose ancestors had migrated from England in the early days of the Salem

colony. The Hodges family had always been known in Salem, but the
Silsbee family was somewhat obscure before the rise to wealth of the three
brothers, of whom my grandfather was one. These brothers, Nathaniel,
Zachary and William, were, in the years succeeding the Revolution,
among that considerable number of Salem ship-owners and ship-captains
who made the commerce of the Atlantic colonies and the coasts of India,
Java, the Straits and the Philippines. I think they operated in partner-
ship. They sent out cargoes in their strong, New England-built barks,
and these, after a two years' voyage, would return bringing the treasures
of the East up to the Derby Street wharves. The brothers were all
highly educated men, graduates of Harvard. Of them, Zachary was the
most devoted to commerce, but Nathaniel became United States senator
from Massachusetts during Washington's and other early Administrations.
William, who was my grandfather, was the most scholarly and
philosophical. It is said that many unpublished letters of him to his
brother, the senator, still exist, and that these show a profound and
original grasp of the political problems then agitating the young states.
He was a tall, thin, dark-eyed man of aristocratic presence.

" My grandmother, Mary Hodges, was a very beautiful woman, with
light hair and blue eyes, and an expression of great benevolence and
sweetness. It was remarked as strange that such a handsome couple
should have a lot of comparatively homely children. These children,
of whom my mother was one, numbered seven. All but one lived to
a somewhat advanced age. My mother was born at Salem in the
year, I think, of 1816. Although still a child when she died, I can
remember hearing some of her impressions of her early youth from
her own lips. She lived in the big colonial house still standing on
the lower part of Essex Street. It is but a stone's throw from
Hawthorne's house on Union Street, and hardly more than that from
Hawthorne's Custom House. The long slope of hill on the water-
side, now completely built up, was in her childhood one great,
beautiful, old-fashioned garden, full of hedges, arbors, fruit trees, box-
bordered paths, and wide flower beds. It reached quite down to
Derby Street, on the opposite side of which were the wharves; and
my mother remembered hearing the gun fired which announced the
return, after long voyaging, of one of her father's ships ; and watching
from the house windows the unlading of the wharves below and
the long lines of men bringing up precious burdens of tea, silks,

porcelains, lacquer and Polynesian curiosities, through the garden paths. From the front windows of their home the children could look down upon Essex Street, then the chief thoroughfare, and listen to their mother tell how she, in her childhood, had watched through half-closed blinds the British red-coats as they marched up the street.

"The three brothers had all married, and each had a group of children living within a stone's throw of one another. Of these, the boys, as they came of age, went to Harvard, as their fathers had done before them. The girls were educated at a fashionable private school in Salem amid a crowd of brilliant and beautiful belles who, at that time, attracted the attention of all the Boston youth. In fact, it was said to be the choicest delight of the Bostonian to be invited down at the height of the Salem season to spend several days as guest at one of her many high-ceiled mansions. On Saturday nights the boys brought down their friends from Cambridge, and there were few parties in Boston as gay as the Salem assemblies. At this period the wealth and shipping of Salem exceeded those of Boston."

At this point the dictation stops and, because of a multitude of newer interests, was never resumed.

His childhood was spent among these young cousins, and should have been a happy one ; but apparently this was not the case. He was, by nature, a shrinking and sensitive child, easily rebuffed, and imagining slights where none were intended. The death of his mother when he was about eleven years of age threw over him a still deeper cast of melancholy. He attended the Hacker Grammar School in Salem, and was fitted at the High School of that city for Harvard, entering the school in the year 1866, with the rank of number one in the preliminary examinations. At college he soon became known as a student of unusual qualities, but socially he still remained sensitive and reserved, and did not make friends easily. He was a member of the College Glee Club, and sang in the chorus of the Handel and Haydn Society. Intellectually his deepest interest was soon fixed upon philosophy, and the influence of Hegel especially remained with him a vital and constructive factor throughout his life. Just at the beginning he was greatly influenced by the writings of Herbert Spencer, and was active in forming the Herbert Spencer Club, to which Mr. Louis Dyer, Mr. Samuel Clarke and a few other devotees belonged.

From time to time he had contributed verses, some of them farcical, to the College periodicals, but the real quality of his poetic gift was not suspected until his reading of the "class poem" in 1874. In this, his graduate year, also he took the first prize in the University Boylston Competition for Elocution. He graduated first in a class of one hundred and fifty men, with a senior year average of ninety-nine per cent., and received "Higher Honours" in philosophy. He had won the "Parker Fellowship," but instead of going abroad decided to take the residence course for a degree in philosophy. The problems of religion and philosophy were, at this time of life, of primary importance. He entered the Divinity School at Cambridge, but did not remain long, being attracted to the new "Art Movement" awakening under the auspices of the Art School at the Boston Museum. Here, under Professor Grundmann, he began a course in drawing and painting.

In 1878, through the influence of Professor Morse, of Salem, he was called to the University of Tokio, then just opening its doors to foreign instruction. He was appointed Professor of Political Economy and Philosophy. Thus he entered a veritable wonderland of new thought, new influences and new inspiration. From the first moment he felt himself at one with the Japanese spirit. Many of his students were men older than he. In his great earnestness, when striving to demonstrate some difficult point of logic, he would step down from the platform, and go among his "boys," as he affectionately called them, putting an arm about their shoulders, and by the power of sheer magnetism and intellect enforce his meaning. I, who never knew him in those early days, have loved to talk with those who did. Among his first graduate class rank many of the leading statesmen of modern Japan, and because of this fact, a beautiful title is often attached to his name. He is spoken of, even now, as "Daijin Sensei," or "The Teacher of Great Men." From 1878 until 1886 he was, every recurrent two years, re-appointed to his Chair in the University. "Professor of Logic," and, later on, "Professor of Æsthetics," were added to his official titles. From the first year he had become deeply interested in an art new to him, the art of Old Japan, and, it must be added, of Old China, too, for in Japan the one cannot be studied without the other.

Just at this moment the Japanese themselves were turning from all their old traditions and indulging in an orgy of foreignism. Italian

sculptors and painters were imported. Foreign teachers, missionaries and adventurers flocked in from all parts of the world. European costumes and customs began to be adopted. In the break-up of the feudal system many of the proudest old Lords or " Daimyo " had been reduced to poverty. Their retainers suffered a similar fate. Collections of paintings, porcelains, lacquers, bronzes and prints were scattered, and treasures that are now almost priceless could at that time be bought for a few yen. It is even said that among the extreme foreignists some of these collections were burned as rubbish. The abolition of Buddhism as a national religion, so to speak, came with the downfall of feudalism, and, as a consequence, the treasures of the temples fared only a little less badly than those of private homes and castles.

It is a strange thing that at such a crisis it should have been the keen eye and prophetic mind of a young American who first realized the threatened tragedy, and that to his energy and effort, more than to any other cause, was due a swift reaction. This statement which, at first reading, may sound a little boastful and exaggerated, will be verified by every Japanese who is familiar with the history of those turbulent days ; and is further borne out by the diplomas given, at successive intervals, by the Japanese Emperor when bestowing some new order or decoration upon the zealous worker for the preservation of Japanese Art.

At first it was only during the summer months of vacation that he really studied the art, or could find time to travel to the more remote provinces, and visit temples where certain treasures of sculpture or painting were said to exist. The government became more and more generous in giving him authority during such expeditions, finally incurring all expenses, and furnishing him with able secretaries and interpreters. It was during these temple sojourns that his interest in Buddhism, both as a religion and a constructive philosophy, was aroused. Mediæval art in Japan and China is as much involved with Buddhism as is Mediæval European Art with Christianity.

In 1881 he established a little artists' club called "Kangwa-kwai," renting a hall for a meeting place and afterwards for exhibitions, taking upon himself all incidental expenses, and presiding at all gatherings. In this effort his chief inspirer and fellow-worker was the artist Kano Hogai, already well into middle age, a splendid and rebellious spirit, and the last of the really great artists of old Japan. This man, proud of his name and traditions, for he was a direct descendant of the long line of Kano painters,

had been one of the very few to hold scornfully aloof from the invasion of foreign ideas. But in spite of this, the genius, earnestness and purpose of the young American finally won him over, and they became not only colleagues, but the closest of personal friends, each believing in and supplementing the other, and each working with heart and soul to save Japanese Art to Japan.

Already, by the next year, 1882, there had begun a sort of reaction among the nobles, and Ernest Fenollosa was asked to assist in organizing the "Bijitsu-kwai" or "Art Club of Nobles." At the first meeting, largely attended, for by this time his name was spoken everywhere, he opened proceedings with a fearless and inflammatory speech denouncing a race who would see their greatest birthright slipping through their fingers and make no effort to retain it. He deplored the then prevailing system of teaching American-style pencil drawing in the public schools, and of studying oil-painting and modern marble sculpture under Italian instructors. From out of the great gasp that followed the end of this speech—so more than one Japanese has told me—came the rebirth of national pride and interest in Japanese Art. No wonder they call him the "Boddhisattva of Art."

In this same year a minor study, of which something must be said later on, was taken up. This was of the sacred drama called "No," sometimes spelled in France and England "Nōh." He found in it most interesting analogies with early morality plays of Europe, and especially with earliest forms of Greek drama. His teacher was Umewaka Minoru, who, before the great break-up of 1868, was court actor to the Shogun.

By the year 1883 the Artists' Club, Kangwa-kwai, was on a self-supporting basis, and dear old Kano Hogai getting more commissions than he could fulfil. Of him, writing elsewhere, Ernest Fenollosa has said, " Kano Hogai, the great central genius of Meiji, may be regarded as clearly striking a last note on the great instrument which Godoshi first sounded." The name next in importance to that of Hogai, was that of Hashimoto Gaho, also one of the original founders of the Kangwa-kwai, and a fine artist. He died but a few years ago. The Japanese prize his work very highly.

In 1885, a special Art Commission, after five months' sitting, reported favourably upon Professor Fenollosa's recommendation that purely Japanese art, with the use of Japanese ink, brush and paper, should be re-introduced into all schools. A preliminary office of a new central Art School, with leading artists from the Kangwa-kwai as instructors, under the supervision of Professor Fenollosa, was instituted, and plans for a

national Art Museum begun. In the next year the Kangwa-kwai held a public exhibition of all its best work done since 1881. To the Tokio public, and to the Government, this proved a revelation of creative power.

In June, 1886, he was, for the fifth time, reappointed to the Chair of Philosophy in the University, but in the very next month, July, was transferred from the University to a Commissionership of Fine Arts, to be held under the joint authority of the Educational Department (for schools) and the Imperial Household Department (for museums). This included the offices and titles "Manager of the Fine Arts Academy," "Manager of the Art Department of the Imperial Museum," and "Professor of Æsthetics and the History of Art in the Fine Arts Academy." Later in the year he was sent abroad, with two Japanese colleagues, as a special Commissioner to report on European methods of Art Administration and Education. This Commission visited all the great centres in Europe, and purchased, for use in Japan, large quantities of photographs and books.

In the next year, 1887, the Commission returned, and the Normal Art School of Tokio was formally opened. Professor Fenollosa was now given, as assistants, nine Japanese experts in archæology and art ; and was entrusted with the task of registering all the art treasures of the country, particularly those of temples. This work included the drawing up of laws concerning repairs, subsidies, export, etc., etc. These years, from 1886 to 1889, may justly be considered as marking the height and climax of his personal influence in Japan. He had been already thrice decorated by the Emperor, held a definite rank at Court, and was the recipient of countless social and official honours. But by this time, some of the Japanese with whom he had been working, and whom he had inspired, began to take a more individual interest in this great national movement, for such it had become. During his absence in Europe, these active spirits had, of necessity, greater control, and Professor Fenollosa found, upon his return, that no longer would his be the single mind to direct affairs of art. It was characteristic of him that no bitterness or resentment came with this realization. Other foreigners placed, on a very much smaller scale, in similar positions, have written whole books to denounce the Japanese as a nation of ingrates, of treacherous underminers, that sapped knowledge and experience from their foreign teachers, and then threw the husk aside. But Professor Fenollosa had no such conception of the situation. Rather he rejoiced

in the courage and intelligence of the Japanese spirit that could so quickly adapt and assimilate new thoughts, and begin weaving them into the very fibres of a new national growth. Honours were still piled thickly enough upon him. He held his various offices and titles undisturbed, but he felt, intuitively, that the time had come when the Japanese had better manage their own art affairs.

A few years before, in 1886, he had sold his collection of Japanese paintings to Dr. G. C. Weld of Boston, under the conditions that it was to remain permanently in the Boston Museum of Fine Arts, and have the name Fenollosa attached to it. In 1890 he received a proposition from this Museum to become Curator of the newly-established Department of Oriental Art; and decided at once to accept. On the eve of his departure from Japan the Emperor granted a personal audience, bestowing with his own hand a fourth decoration. This was called "The Order of the Sacred Mirror," and, up to the time of its presentment, I have been told, no such exalted order had been given to a foreigner. Its special significance is that the recipient has given personal service to the Emperor.

It must have been a wonderful sight, the Court in full regalia, grave Japanese nobles and statesmen standing silently about, all eyes directed to the one foreigner in the great hall, an American, still young, kneeling to receive the highest personal order yet bestowed, and to hear words spoken by the Emperor's own lips, "You have taught my people to know their own art; in going back to your great country, I charge you, teach them also."

For five years he remained in Boston, re-arranging the treasures so many of which had once been his; cataloguing by number the whole collection, and writing special catalogues for the various exhibitions. Some of these were loan exhibits, brought over directly from Japan, others were made from portions of the great collection now housed within the Museum walls. But this alone was not enough to fill the brilliant and ever-reaching mind of such a man. He began to take deep interest in "Problems of Art Education in America." His recent experiences in Japan, supplemented by European research, could not fail to give him a new and vital point of view. One fundamental thought, which has since been widely quoted, is as follows:—The tentative effort of art-expression in childhood and in primitive races has been, in all ages and in all lands, practically the same, and its keynote is "*spacing*."

The hard pencil drawing, copying of shaded cubes, pyramids and balls, still in use in most public schools, were, in his opinion, fatal to real development. Scarcely less pernicious was the enforced drawing from plaster casts—"tracing the shadow of a shadow," he called it. Life, motion, colour, impression, composition, spacing—above all, spacing,—these formed, in his creed, the only true lines of growth.

In this book of his, "Epochs of Chinese and Japanese Art," representing his latest and most mature thought, it will be seen that he continues to place the quality of spacing, as the key not only of design, but of all the visual arts. It must be kept in mind that at the time of his bold arraignment against drawing from the cast, the thought was a new and revolutionary one. He was attacked on all sides.

While in the first enthusiastic stages of his work for a better system of Art Education in America, a new and very precious friendship was formed. This was with Mr. Arthur Wesley Dow, of Ipswich, Massachusetts, a young artist who had just returned from Paris. Literally from the first moment in which he met Professor Fenollosa and was shown some of the great examples of Japanese Art, these two influences became clear factors in his life. On the other hand Professor Fenollosa found in this ardent and receptive young spirit the inspiration and encouragement for which he had been longing. The two friends worked together, sometimes in the same school, as at Pratt Institute at Brooklyn, sometimes at great distances, but always in perfect sympathy, in the years that were to follow. And if the name, the methods and the vital truths imparted to American Art by Professor Fenollosa are to persist in the consciousness of the American people, it will be due chiefly to the untiring efforts and splendid loyalty of Professor Dow.

Another phase of intellectual activity found outlet on the lecture platform. In 1892 he gave his first series of public lectures. These were given in Boston, with the title "Chinese and Japanese History, Literature and Arts." He was asked to speak before many clubs and private gatherings, on the same topics; and at Cambridge delivered the Phi Beta Kappa poem "East and West." In 1893, at the time of the great Columbian Fair at Chicago, he was appointed member of the Fine Arts Jury, especially to represent Japan, since Japan here, for the first time, exhibited her Art classified among the "Fine Arts," and not among "Industries." From this time onward he began to lecture in all the larger cities of this country, and the demand for his

courses grew at such a rate that it was found necessary to employ an assistant curator in the Oriental Department of the Boston Museum. This post was offered to and accepted by Mr. Dow. But in the following year, 1895, Mr. Dow's services were acquired by Mr. Frederick W. Pratt, of the Pratt Institute, as instructor in Art, and with the privilege of establishing a new system based upon the universal principles set forth by Professor Fenollosa during the year 1884 and put into practice by the Japanese Art Academy. His partial services as lecturer and art critic were also secured by Mr. Pratt, and thus was taken the first definite, revolutionary step toward establishing, in America, the new art education.

By this time the work of arranging and cataloguing the Oriental treasures of the Boston Art Museum was practically complete. Professor Fenollosa saw no future there except as a sort of showman and personal demonstrator, and as writer of sporadic catalogues. More serious writing and lecturing appeared now to be the best means of carrying forward his teaching and his thoughts. Above all, he felt the need of travel, to get into touch once more with the art centres of Europe, and to visit, after several years' absence, the ever-changing Japan. He sailed for Europe in the spring of 1896, spent several months there in study, and continued around by the Eastern route to Japan. Late summer there and early autumn were spent in a Japanese villa beside the river Kamo which flows through the sacred capital of Kyoto. Life was carried on in purely a Japanese way. There were no other foreigners except Mrs. Fenollosa (myself), and the *ménage* consisted of two Japanese servants, a student-interpreter, and one of the Professors of Chinese Poetry from the University of Tokio. Japanese artists, priests and poets began to frequent the place. There were many visits, on our part, to the homes of these, and also to temples, chiefly to the patriarch Chiman Ajari, a great teacher, now passed into the Beyond, and, over the shoulder of one of the great Kyoto boundary hills to Miidera, on the shores of Omi (called by foreigners Lake Biwa). It was at this temple, the great stronghold of the leading esoteric sect, that Professor Fenollosa first seriously studied Buddhism. The Archbishop was then Sakurai Ajari, who had since died. Under his successor, Keiyen Ajari, we both now studied.

All the depth, the wonder and the romance of Japanese thought seemed to return to Ernest Fenollosa in an overwhelming wave.

There was no other course for him than to go back to America, settle his affairs as best he could, and return for an indefinite stay in Japan. This was done, and in the years following, from 1897 to 1900, he lived in Tokio, though travelling often to Kyoto, Nara, Nikko and places less well known. Always he was studying, acquiring, reaching forward. Now it was not alone art that he pursued, but religion, sociology, the Nō drama, and Chinese and Japanese poetry. He delivered many lectures in the various Tokio schools, and before art clubs and institutions, wrote articles for Japanese, English and American publications, and began a clear mapping out of this work, "Epochs of Chinese and Japanese Art."

But in 1900 the demand for American lectures had become so insistent that he decided to return for at least a season. He began on the Pacific coast, lecturing before Universities, Art Clubs and Women's Clubs in San Francisco and other large cities, travelled slowly eastward, stopping at the larger cities on the way, and finally reached New York, which he decided to make his headquarters. Mr. Dow's appointment in 1904 as Professor of Art in Teacher's College, Columbia, he had welcomed as a great triumph.

During this year, too, he was deeply stirred by the splendid struggle of Japan in her war with Russia. Ten years before, at the close of the Japan-China war, when the just rewards of victory were withheld by the so-called Triple Alliance, he had said publicly, and had written, in printed articles, these words, "Japan will yet hold Port Arthur, but she will reach it through seas of blood."

The years 1905-6-7-8 brought him ever wider and more appreciative audiences. There is no need to dwell upon the many courses of lectures given, or to enumerate the various universities, art museums, clubs, private schools and drawing-rooms in which they were delivered. It is enough to state that these were years of increasing triumphs. Professor Dow at Columbia was carrying forward the work of Art Education with splendid effect. Already the classes which had graduated at Pratt Institute under the Fenollosa-Dow system, as it is often called, were applying its principles in smaller towns all over the Union. There could be no doubt, now, of success. But the most vital and important happening of these years occurred in the summer of 1906, when Professor Fenollosa, deliberately cancelling a series of Chatauquan lecture engagements, remained in his

New York apartments, and in one magnificent effort completed, in three months, a rough pencil draft of this book, "Epochs of Chinese and Japanese Art."

After the month of October, 1906, it was never touched. November brought new lecture courses, and during the summer of 1907, a long Western lecture tour was made. At times, when I urged him to take up the work on the manuscript, he would say, "I cannot finish it until another visit to Japan. I must see Mr. Ariga, and old Kano Tomonobu, and some of the others who have worked with me for Japanese art. There are corrections to be made, dates to be filled in, certain historical facts to be verified, and all these can be done in Japan only."

He died, quite suddenly, in London, just on the eve of sailing for home after a summer spent in study abroad, on September 21st, 1908. In the spring of 1910, after having completed the long and difficult task of putting into type-written form the scattered, pencilled pages, I took the original and the typed manuscripts to Japan. For two months Mr. Ariga and old Kano Tomonobu worked with me upon it. There were others also who gave assistance, but to these two is chiefly due the fact that practically all omissions were filled, all dates verified. Mr. Ariga (Dr. Ariga Nagao, to give his full name) is a noted scholar in Chinese and Japanese history, and in Chinese poetry, as well as a great statesman and diplomat. Without his personal interest and co-operation this book could never have been brought to light.

His, too, was a moving spirit in the unique and beautiful tribute paid to Professor Fenollosa by the Japanese Government in the removal of his ashes from Highgate, London, to a permanent home in the temple grounds of Miidera, overlooking Omi. This was Professor Fenollosa's own desire, and a more fitting resting-place was never given.

His ashes lie at Miidera, but his far-reaching thoughts and the ideals which he kindled cannot die. They will, it is my belief, continue to burn for many years, and, brightest of all, in the pages of this book.

The Introduction which opens this book has been put together by me from notes left by Ernest Fenollosa.

MARY FENOLLOSA.

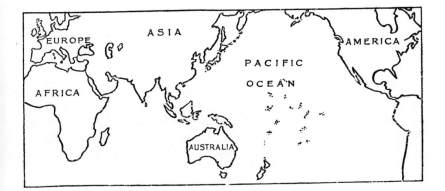

INTRODUCTION

THE purpose of this book is to contribute first-hand material toward a real history of East Asiatic Art, yet in an interesting way that may appeal, not only to scholars, but to art collectors, general readers on Oriental topics, and travellers in Asia. Its treatment of the subject is novel in several respects. Heretofore most books on Japanese Art have dealt rather with the technique of industries than with the æsthetic motive in schools of design, thus producing a false classification by materials instead of by creative periods. This book conceives of the art of each epoch as a peculiar beauty of line, spacing, and colour which could have been produced at no other time, and which permeates all the industries of its day. Thus painting and sculpture, instead of being relegated to separate subordinate chapters, along with "ceramics," "textiles," "metal work," "lacquer," "sword guards," etc., etc., are shown to have created at each epoch a great national school of design that underlay the whole round of the industrial arts.

Again, what has hitherto been written of Chinese Art is rather a study of literary sources than of art itself. It is a "history of the history," but hardly an effort to classify creative works by their æsthetic qualities. The writer wishes to break down the old fallacy of regarding Chinese civilisation as standing for thousands of years at a dead level, by openly exhibiting the special environing culture and the special structural beauties which have rendered the art of each period unique.

The treatment of Chinese and Japanese Art together, as of a single æsthetic movement, is a third innovation. It is shown that not only were they, as wholes, almost as closely inter-related as Greek Art and Roman, but that the ever-varying phases interlock into a sort of mosaic pattern, or, rather, unfold in a single dramatic movement.

We are approaching the time when the art work of all the world of man may be looked upon as one, as infinite variations in a single kind of mental and social effort. Formerly, and even recently, artists and writers seem to have taken their point of view through partisanship. Classicists and Goths flew at each other's throats. We hold to the shibboleth of a "style." So Oriental Art has been excluded from most serious art history because of the supposition that its law and form were incommensurate with established European classes. But if we come to see that classification is only a convenience, valuable chiefly for chronological grouping, and that the real variations are as infinite as the human spirit, though educed by social and spiritual changes, we come to grasp the real and larger unity of effort that underlies the vast number of technical varieties. A universal scheme or logic of art unfolds, which as easily subsumes all forms of Asiatic and of savage art and the efforts of children as it does accepted European schools. We find that all art is harmonious spacing, under special technical conditions that vary. The spaces must have bounds, hence the union of harmonious shape with proportion. The eye follows the bounds, and the hand executes them; hence *line*, which thus becomes the primary medium for representation. The relative quantities of light which they reflect to the eye become another differentiation in the spaces, and the harmonious arrangement of these values involves a new kind of beauty (*notan*) and a new faculty to create ideas in term of it. Lastly comes quality of light or colour, which, at the hands of one born with the faculty, is capable of

endless differentiation and creative grouping. So much all the visual arts may and do possess and work out through varied material, but all pictorial art and representative design come to use their elements with a vaster wealth of combination and suggestion due to subject. Delineation and its possible instruments re-establish wide ranges of quality; the significance of *notan* for modelling, for rendering planes of distance, and for local tone, is as vital as its decorative beauty; colour also may relate to hosts of physical facts. There are millions of ways of combining these many kinds of beauty and these many species of suggestion; the history of art records the ways heretofore tried. But in all these efforts we find some sort of order, due to the similarity of effort in the human spirit and in the incidence of the social environment. So Gothic passes out of Classic and into it again, and Greek methods are carried across Asia also. In this book, too, the similarity of the great Chinese methods of delineation with the brush to our methods of drawing and etching is first perceived. Also the relation of Oriental *notan* on the one hand to Greek *notan*, then to Venetian *notan*, then to the *notan* of Rembrandt and Velasquez, lastly to the *notan* of modern French movements, is a conspicuous fact. There are great points of resemblance in mediæval colour, too, in both hemispheres. The chief differences lie in methods of representation, and this resemblance seems to increase as we approach the present day. In the main there is a sort of convergence of the two separate continental lines of advance in art. Since 1853 the two have been partially intermingled, and from now on this must be more and more the case. Whistler is in some sense the common nodule. It is thus of vital, practical concern that the points of unity should be emphasized, and a history of Oriental Art written from a universal point of view.

The English writers, such as Dr. Anderson, have almost invariably criticised Chinese and Japanese art from the point of view of what they call realism. Thus, to their eyes, all Chinese art is distortion and affectation. Japanese art culminates with Okio and Hokusai because these artists seem nearer to the European. The French have a truer view, yet even they would like to maintain a barrier between pictorial and decorative art, and relegate Oriental to the latter category. The present volume is written from the point of view of principles of criticism which could be applied to the history of European art as well. Qualities of line, *notan*,

and colour, and the use of these in expressing great ideas, are made the basis of classification and of appreciation.

As far as I know this is the first time that a treatment of so vast a subject as a whole has been attempted. However partial the result such treatment must give an impression of social forces caught together in a splendid single sweep. And though the character, the individuality, so to speak, of the different epochs may seem unlike, the parts belong together, and will interlock. In the minds of present writers, Japanese and Chinese civilizations are too often opposed, or else the Japanese is regarded as a mere copy of the Chinese culture. Neither of these views is correct. It is one great working of the human mind under wide variations, like that of early classic art in Europe, Asia and Africa, when the three came closest at the eastern end of the Mediterranean Sea.

If this book is to have permanent value one phase, perhaps the most important, must lie in its unity and brevity. It is, indeed, a single personal life-impression, and I desire to have this thought of it, in the minds of readers, an ever-present one. Being such, it needs to aim at no encyclopædic completeness, and I shall at my own discretion subordinate small facts to large. Some readers will surely complain that too much is left out. To these I would suggest that the omissions are, themselves, of great significance. My constant effort must be to keep the parts in just proportion, and to do this nothing but my own sense of proportion can be consulted.

Nor do I attempt to treat all forms and phases of Art, but only imaginative or creative Art. Art may be looked upon as a continuous effort, a solid material manufacture that persists through the ages, and that never languishes; but this sort of Art is, for the most part, classical and uncreative, and will be found to borrow all its motives and its forms from rare creative epochs. My intention, and one which I believe will render an important historical service, is to treat the creative periods only. In this way we see the separate shining planes of movement of the human spirit. With this thought it seems to me neither unjust nor improper to ignore all minor movements. It becomes a study of relative importances. It may be called, by others, a mere personal appreciation, but has there ever been, or can there be, a synthesis that is not personal?

Most writers upon Oriental Art have, as I said, preferred to classify by the technique of industries. Separate chapters or whole books deal

with the material arts ; but while this may be satisfactory for technique or for material, it is, if the subject be indeed Art, a false classification, full of repetitions, cross lines, and anachronisms. Art is the power of the imagination to transform materials—to transfigure them—and the history of Art should be the history of this power rather than the history of the materials through which it works. At creative periods all forms of Art will be found to interact. From the building of a great temple to the outline of a bowl which the potter turns upon his wheel, all effort is transfused with a single style. Thus classification should be epochal, and in attempting thus to treat it for the first time it becomes possible partially to trace style back to its social and spiritual roots. The former method may be called that of the curio-collector, the latter, of the student of sociology.

With another class of writers who treat of Art its history becomes a history of documents, or, as I have already called it, a " history of a history." This is specially true of Oriental Art. No one denies the importance of documents, but, on the other hand, no one can assert that documents are Art. Documents may sometimes be falsified ; Art, in a certain sense, cannot. Art should be judged by universal standards, and in Oriental criticism waves of opinion, often contradictory, may be traced. Chinese Art is far from being a single manifestation. It is formed of many, with many battling moods ; and often the conservative Chinese scholars have misunderstood and belittled the really creative movements. Also, they have failed at times to realize that it is a dangerous tendency to mistake interest in inscriptions for interest in significant Art qualities. Here the antiquarian and the critic must necessarily diverge. Indeed so entirely does the critic rely on his intuitive and, so to speak, creative faculties, that " scholarship " in art seems almost a contradiction.

Let me say at once that I make no claim to being a scholar. Chiefly because of this I have hesitated, for many years, to attempt this volume. I cannot pretend to original philologic research in Chinese and Japanese documents, so scholars might well counsel me to keep silent. But the fact of my having had unique opportunities for the study of Far Eastern Art cannot be gainsaid. For many years now my friends have been urging me to put a part, at least, of these experiences into permanent form. If I now yield it is because I believe that I have something to say that is worth saying, and feel moved to do it before I die. My special opportunities for the study of Art in Japan came in a most interesting transitional

period. The strongholds of the great feudal lords, or "Daimyo," were being broken up and their ancestral treasures scattered. In Boston I had studied Art as a philosopher, and had also attempted the practice of it. Here, in Japan, I became regarded as an antiquarian, an authority, and before many years was appointed a Japanese commissioner for research, administration, and Art education.

In the performance of these duties I was thrown with all the well-known connoisseurs, visited all important temples, knew the remaining artists, and was in touch with all public and private collections. Besides this, I became personally acquainted with all dealers in Art, and knew their stocks. But specially I became the personal pupil in criticism of the remaining Kano and Tosa artists, and, a little later, of the Shijo in Kyoto. I studied intimately their great collections of copies, and was taught their traditions. Probably because in many cases I have chosen to adhere to these inherited traditions the modern school of young Japanese critics, which prides itself upon being radical, is inclined to call me over-conservative. There is no doubt that future study, if seriously carried forward, will change many estimates, but if we waited for this nothing would ever be written. Later generations must build on the earlier, and I believe that my unified impressions, even if defective, must have a value.

The question of the Roman-letter spelling of the Chinese and Japanese names and of their pronunciation may lead to some confusion. This is especially true of the Chinese. By most European scholars these are written in modern Mandarin. This is, necessarily, a purely modern pronunciation. The Japanese way of pronouncing the names of old Chinese artists is based upon the older Chinese speech, preserved intact by the phonetic nature of the Japanese syllabary. It is thus inevitably much nearer to the old Chinese. This may be further proved by the translations, into the Japanese syllabary, of old East Indian names, which, in their own land, have to-day an unchanged pronunciation, and by rhymes in old Chinese poetry, which is as well known to all educated Japanese as are Homer and Virgil to the English undergraduate. It is perhaps natural that our European and American Sinologues, who have won their mastery of modern Chinese sounds by hard study, should not wish to give them up. But it is also natural that Japanese students, and foreigners who have studied Art in Japan, feeling that they possess the truer sound, and having

done a large amount of critical work, and made strong efforts to assist in the preservation of Chinese Art, should hold to theirs. Chinese Art of most periods is still to be studied in Japan, and the Japanese themselves feel that it is their privilege to interpret Chinese Art to the world. Therefore I shall follow, in the main, the use of the Japanese sound of old Chinese, referring in brackets and in the Index to the Mandarin pronunciation. It is no slight matter, too, that the Japanese sound is less harsh and forbidding than the Mandarin, and stays the more easily on the tongue.

The theory here propounded of elements of change and growth in Chinese culture may seem to some readers quite rash, and perhaps insufficiently substantiated. I plead guilty to the charge of being dogmatic. This fact of change and of individual force at all points is so universal a background or medium, like the air we breathe, that I have to assume it without waiting for proof. It is, after all, a much more natural presupposition than the one so generally and so lightly taken, that China has remained at a dead level for hundreds of years. To stop in the course of my impressions and attempt to enforce each minor point that might possibly arouse opposition, would result only in confusion. After all, I am not necessarily writing this book for scholars, but for those who would try to form a clear conception of the essential humanity of these peoples. The idea may be a grand hypothesis; it surely would never be promulgated by the scholars, but I believe it to be necessary that someone should attempt it. Once granting this point of view it revivifies for us all Chinese institutions, philosophy, art, prose-literature, and poetry. It is sound evolutionary doctrine. I fully confess that my personal contribution to the evidence is a digest of the art itself, the primary document. Art is a sensitive barometer to measure the buoyancy of spirit.

Beyond this I must rest on the scholarship of my Japanese colleagues. For nearly thirty years I have had the constant and minute assistance, by way of teaching, interpretation and translation, of such men as Dr. Ariga Nagao, Baron Hamao, Viscount Kaneko, Professor Inouyè, Mr. Hirai, Mr. Tatsumi, Professor Nemoto (the greatest living authority on the Y-King), and last, but not least, Mori Kainen (the powerful Professor of Chinese Poetry in the Imperial University). Other scholars to whom I owe tribute might be enumerated by the dozens. Marco Polo is surely worth something.

In bringing this Introduction to a close I must give one word of warning that may be needed by even an indulgent reader. In attempting to make this a work of social forces as well as of Art it may happen that the social and artistic periods are not quite synchronous with the political names and dates, since the causes group themselves with slightly different incidence. Thus the Tosa movement already begins in late Fujiwara, before the Kamakura Shogunate is established. On the other hand, the Ashikaga form of Chinese Art does not come in strongly until some time after the founding of the dynasty. Moreover, if we are careful, we should see that all these movements overlap, and frequently run parallel. Thus the Zen movement has already begun at Kioto and Kamakura long before its flowering in Ashikaga, and side by side with Tosa genre. Also in Tokugawa, many waves, large and small, over- and inter-lap. So that chronology alone is not the key to classification. It is, of course, the inner flow of real causes that we follow. It will not be found necessary to dwell upon the persistence of old schools through the days of their successors. Even Kosè has come down to our day with Shoseki. It is not names but powers that we deal with. Our plan is to take the most creative and dominant work of a period and describe it as the chief affair.

After all, all classification must be false. History is an individual series of complex manifestations. To label parts of these under universal categories is deceptive. Yet we have to proceed by noting broad differences, and we must not confuse the effect by taking too much time to correct the error by overlaying the broad with a host of minor considerations. It is all a question of proportioning, like Art itself, and I have to decide upon how to produce what I deem just effects.

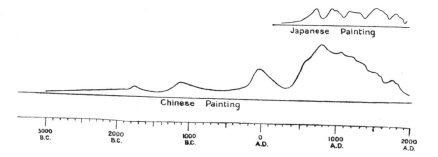

CONTENTS

VOLUME I.

LIST OF ILLUSTRATIONS

VOLUME I.

LIST OF ILLUSTRATIONS.

XXXV

LIST OF ILLUSTRATIONS.

PRIMITIVE CHINESE ART.

Pacific Influence.—3000 B.C. *to* 250 B.C.

NO national or racial art is quite an isolated phenomenon. It is like a great river, the distant rills from which it derives its waters being hidden. The origins of all civilizations are swallowed up in mystery. We do not know the early migrations or human beings upon this globe, nor can we even conjecture what causes, operating in remote millenia, have divided them into such markedly contrasted races. We can only penetrate a short distance backward from the fringe of the known into the thick darkness of the unknown.

One added difficulty in such research is our proneness to adopt and follow easy lines of classification. As if universals were anything more than convenient names for prevalent tendencies ! Forces of upheaval and change always precede the calm that lends itself to generalization ; and it is these transition periods which give the lie to popularly accepted history.

In the true scientific study of ancient Art this same obstacle of accepted categories lies across our path. The very specialization of archæological study leads us to consider types as things hard and fixed. Where Greek art merges off into something else, we do not like to follow it. We boast of "pure Greek art" as if it were the outcome of a law prescribed by heaven. We do not like to admit that the generation which precedes—say Phidias or Michael Angelo—stores and handles the supreme force which the new-comers, perhaps, waste. It is a paradox, but true, that the culmination comes just before the culmination ; just as it is true that the alien influence lies at the very core of the national.

A very real addition to our resources in these difficult lines lies in the "document" of Art itself. Epigraphy records facts *about* Art, but only Art records *Art*. Thus, a careful following of the movements of

art forms, through even the most unpromising channels, often opens
up paths about which history is silent. Man is a very pungent, pene-
trating essence, which, in the course of a hundred thousand years or so,
has diffused itself into every geographical cranny, and, despite lack of
resources, has opened primitive lines of commerce throughout the globe.
British tin is used for the making of bronze by prehistoric races on
the Black Sea. Sea-shells from the Gulf of Mexico are ground into
the pottery of Minnesota savages.

All this is borne strongly upon the mind which takes up the subject
of a real history of East Asiatic art—not a curio-collector's compendium,
mind you, but a tracing of unique lines of cause. "China is China,"
that is enough for the professed sinologue. To find evidence regarding
it outside of its own forbidding records, is what they cannot conceive.
How China became China is what they never ask. "East is East and
West is West, and never the two shall meet," so runs Kipling's specious
dictum ; and American orators use it to-day to affect our treaty legisla-
tion. But the truth is that they have met, and they are meeting again
now ; and history is a thousand times richer for the contact. They have
contributed a great deal to each other, and must contribute still more ;
they interchange views from the basis of a common humanity ; and
humanity is thus enabled to perceive what is stupid in its insularity.
I say firmly, that in Art, as in civilization generally, the best in both
East and West is that which is common to the two, and eloquent
of universal social construction. Translate China into terms of man's
experience, and it becomes only an extension of the *Iliad*.

There is an *Odyssey*, too, in Chinese art and life, an unwritten
Odyssey of the Pacific, where, for five thousand years or more, upon
those vast silent waters the carved canoes of maritime races have cut
lines of commerce from island to island, and from continent to continent.
The bulging broken contours of East Asia could not avoid the currents
of waters and of men, whose relics are strewn, like wreckage, half
around the globe, from the Fuegian coast of South America to the
Aleutian Archipelago, and from Khamskatcha southward to Tasmania.

It must always be considered, of course, in how far primitive men
evolved similar forms through the very poverty of their resources. This
must be specially true of methods :—materials to carve on, and metals,
stone or shell to carve with ; but not so clearly true of art forms.
That all men should conventionalize in adapting pattern to domestic

industries is intelligible; but not that they should reach identical patterns, and with the same æsthetic key to the spacing. Art, after all, in its largest sense, lies in a peculiar, harmonious use of spacing, in which value consists not in laws or classifications, but in uniqueness of effect. We may allow much to concomitant evolution; but not everything, especially when lines of traffic are more or less obvious.

Taking a Mercator projection map of the world, with its centre in the Eastern part of the Eastern hemisphere, bounded on the west by Europe and Africa and (as Asiatic appendages) extended on the east over Australasia and the Pacific Isles until the very western shores of America are included, we can get a bird's-eye view over about all the geographical formations of human art. Only the Atlantic and the eastern half of America is alien to the grouping, a sort of barren region that would separate the outer edge of our map if it were wrapped about a cylinder. Looking down now into the fertile regions of man's work, where continental pathways and Mediterranean proximity of shores have invited access, we are enabled to make a large but sufficiently accurate identification of the most active centres of art-dispersion within this large field, which indeed we are ordinarily accustomed to conceive as one. Making a very broad generalization, it may be said that these centres have been two:—one belonging to the somewhat contracted regions about the east end of the Mediterranean, where the continents of Europe, Asia and Africa come to a common corner, as it were, and where boundary stakes are necessary. The other belongs to some point of the many less defined Mediterraneans enclosed by the large islands of the western half of the Pacific Ocean. Whether it lie in the long strip of sea which separates the semi-continent of Australia from New Zealand, New Guinea and Borneo, or in the warm expanse that stretches between Borneo, the Philippines, Cochin China and Formosa, or in the colder currents that skirt North China, Corea, and Japan, or yet in the frozen seas off the Amoor's mouth, and bounded by Behring's Strait and the Aleutians, we cannot surely determine, but that in one of these it must have originated seems by far the most rational hypothesis. Wherever its origin, it had northern drives, and southern drives, and eastern drives from island to island across the ocean, until it reached American shores. The hypothesis here adopted, but for which there is no opportunity for me to present all the evidence, is of the existence of a substantial unity of art forms, caused by actual dispersion and contact

throughout the vast basin of the Pacific, and includes the arts of Peru, Central America, Mexico and Alaska, as well as those of Hawaii, Micronesia, Macronesia, and the early inhabitants of Formosa, China, and Japan. I thus believe that there exists what we may fairly call a "Pacific School of Art," and that it is quite sharply differentiated from the schools of all other parts of the world, never penetrating far to the west of a longitudinal line drawn from Central China to Borneo. So much for the Eastern centre of dispersion.

To go back now to the Western centre, we seem justified in speaking of it also, in a sense, as one, since the mutual influences of its adjacent parts have so clearly acted and interacted as to make a sharper pointing unintelligible. The three main areas of this centre are the Mesopotamian plain, the Northern Nile Valley, and the Greek Mediterranean ; the influences between which, throughout long periods of time, have been mutual and multiple. We see their interaction specially formulated in Cyprian art. Alexander's conquest, 300 years B.C. almost merged them into a common sea of forms.

If it be objected to this theory of world distribution that it leaves India out of account, the answer is that Indian Art, in all of its high reaches, at least, is dependent upon Mesopotamian : first Babylonian, then Persian, then Greek, Greco-Baktrian, and Greek again. Whatever native motives may have filtered into India's prehistoric industries are only like tiny rills flowing to feed the main Western current.

Such feeding rills are to be traced, too, over the outskirts of established European and African arts. Greek art did not stand alone, but leaned upon early barbarous motives that flowed down from the Tartaric centre of its continent, possibly from Scandinavia also, the lake-dwellers, and even the remote cave-carvers on bones of the hairy mastodon. So Egyptian Art must have received ancient infusions of motive from the same far African sources that yield us to-day the spirited drawings of the Bushmen and Benin bronzes. The Eastern Mediterranean was thus a primitive centre of confluence long before its creative efforts had made it also a centre of dispersion. All later European art grows up, by cuttings as it were, from this concentred stem ; and so also the beginnings of creation in modern America draw from the same life.

The special value to us of this theory of two centres lies in the striking fact that Chinese art is the only large form of world art

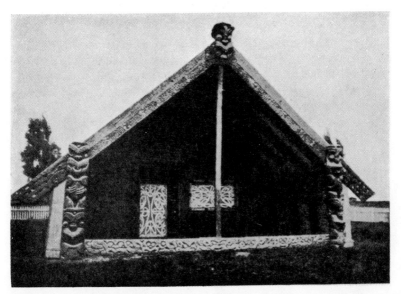

New Zealand House, showing Totem Poles.

Ancient Chinese Bronze showing Slanting Eyes, Chow Dynasty.

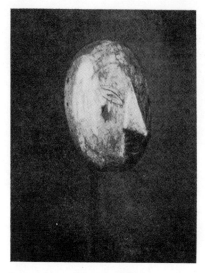

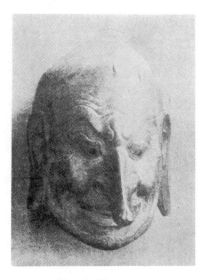

LONG-NOSED WOODEN MASK
FROM THE PHILIPPINES.

ANCIENT SHINTO MASK WITH
LONG NOSE.

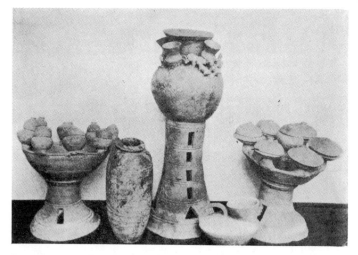

CLAY CHAFING DISHES FROM SHELL MOUNDS.

that has combined in itself creative impulses from both. The key to early Chinese art is as follows :—its earliest motives were influenced by Pacific art, and these were later overlaid by forms of the Greco-Persian. Of course this is quite consistent with the fact that Chinese art, like all great schools, still later must have experienced ferments and achieved powerful reaches of advance from causes operating within.

I have prepared for use throughout this book a chart, graphic and chronological, of Chinese Art as a whole for five thousand years, showing its ups and downs, its periods of creative vitality, its central supreme culmination, and its slow final fall. This is probably one of the first comprehensive views that has ever been given of Chinese culture as a growing and a vulnerable essence,—as contrasted with our ordinary false conception of its dead-level uniformity. We shall see in these pages how Chinese art came to make and unmake itself.

Looking carefully at the chart it will be seen that the art takes its obscure rise somewhere in the earlier part of the third millennium before Christ, rises to its first faint wave of force with the Shang Dynasty about 1800 B.C.; to its second with the Chow Dynasty about 1100 B.C.; to its third and stronger creative effort with the Han Dynasty in the second century before Christ; then, after an interval ascends slowly and firmly to its highest apex under the Tang Dynasty in the eighth century, and again to a second hardly lesser culmination under the Sung Dynasty in the eleventh and twelfth centuries; at last to fall from that point slowly and doggedly, and almost without break, to its present low level of weakness and degeneration. Such is the amazing outline—like a great ground-swell of human power, almost as slow-moving and irresistible as the storm-waves in the earth's crust that have lifted and depressed continents. It will be noted how late in time the culminations appear, contemporary, in fact, with the efforts of Charlemagne to re-collect the shattered forces of Rome.

The smaller line traced above the main one is the similar graphic curve of Japanese art reckoned upon the same time-scale, but on a smaller scale of elevation. This Japanese art, while it also appears late in time, is evidently not centred into a single overmastering wave, like the Chinese, but appears dispersed into five successive and distinct ones, of almost equal creative vitality. The relations between

these and the corresponding periods of Chinese work form the very ground-plan of this present effort to write their common history. The chart should be referred to at every phase of the unfolding story.

Turning now to a special map of the Pacific Ocean, with its island chains like stepping stones in half a hundred directions, let us trace briefly a few of the salient features of Pacific design, and show how closely they seem to be imitated by the earliest Chinese art.

The history of Pacific life and art in remote times is not directly known to us, on account of the perishable nature of the materials used ; but it is a fair presupposition that the primitive forms used to-day by these simple Polynesian races do not greatly differ from their lost predecessors. Most of these Pacific arts are fixed and traditional. But it is of the utmost importance to find that the very oldest forms of Chinese design, preserved to us in bronze, are in the majority of cases nearly identical with the bulk of the island decorations. Now here we have a fairly definite date to which we can carry back the use of Pacific forms upon this globe, namely the beginnings of Chinese history, somewhere between 3000 and 2000 B.C., probably nearer the former ; and while one cannot say that the Chinese species give us the oldest and most original forms of this genus, we can safely conclude that we have a clear term of five thousand years at least in which to account for the slow dispersion of such forms from one or more centres throughout the Pacific half of the globe. Between New Zealand and Hawaii curves a long stretch of sea ; yet at a remote time its dangers were mastered by some dusky Ulysses in Greek-shaped helmet of cocoanut, who has left the kinship of his language to add to the proof of racial descent. Of course, I am far from claiming that blood descent has always or generally accompanied the enormously wide transmission of art forms. I am not required to prove that the peoples of Peru, Alaska, China, and New Guinea were genetically related. It is enough for my purpose to assert that, at least, they communicated, and left behind the evidence of borrowed arts.

So again we can trace but clumsily a few of the probable lines of this communication. Whether the South American forms, for instance, passed over our continued island stepping stones from west to east across the South Pacific, or whether they worked down the coast from North America, we shall not here attempt to determine. Yet, surely between our North Western Indians, say of Vancouver and

Alaska on the one hand, and the Amoor or Ainu races on the other, there must have been much community of blood. That the Eastern branches of the Malay race derived designs from the Polynesian, does not of course prove miscegenation ; but it is clear that there is some degree of consanguinity between the Philippinos and the Japanese. How much weight should be given to tales of Chinese migration—voluntary or involuntary—to American shores, is still obscure ; but it is practically certain that the movement of all these forms was, in general, eastward ; little or no return influence from America being traceable in Western Pacific forms.

It would be interesting also to conjecture how and where the Chinese first entered into the charmed circle ; whether, indeed, in their sheltered abutments upon the Yellow Sea they may not even have originated the movements, which then spread southward as well as eastward. For other reasons it may seem more probable that the ancient centre lay in the south, possibly in lands now submerged, and that the general trends of dispersion lay north and north-east, movements in which the more materially advanced Chinese races eventually shared. But all such difficult problems must be left to the anthropologist ; and his decision may depend upon the study of winds and ocean currents. And, since I am not writing a history of Pacific art, it is not necessary for me to force any conclusions.

Leaving behind us all such fascinating, if fruitless speculations, let us identify some of the common features of Pacific art. Prominent everywhere we find the suggestion of faces more or less human, with two staring eyes and eye-balls in the centre. Upon the lintels and rafter ends of New Zealand huts, and upon the totem poles at their entrance, for all the world like those in the far-away regions of Alaska, we find these faces carved ; and it is a striking feature that almost universally we find these staring eyes slanted at a decided angle, similar to but much more pronounced than the natural eye-slant of Mongolian races. Where upon handles of utensils, or in full relief statues, these faces form logical parts of heads, we can see that many of the pattern marks represent tattooing. Passing farther north we find that this general Macronesian feature is dominant in the art of New Guinea, which in some respects shows more advanced and more Chinese æsthetic forms. The bands of design that play about the features interlock closely in finely spaced planes of relief, something like the

knotting of early Celtic art. The specimens of similar tattooed heads that have come from the Philippines, show eyes of less angle, perhaps, but with a more consciously demoniac expression, as if the spirit represented lent evil force to the use of the dagger whose handle it decorates. This eye form, too, appears modelled upon the sides of Aztec pottery, and sometimes with lines of bosses that suggest derivation from tattooing. This pair of eyes is the most conspicuous feature of Alaskan art, worked as patterns on blankets, and carved or painted on the prows of boats, as we still can see in China of to-day. Everywhere, probably, these eyes denote "spirit," or an animistic symbol of vital use in summoning specific supernatural aid. Demonic force plays below the surface of almost every domestic function.

Now it is a most striking fact that a practically identical use of the face forms, the slanting almond eyes in pairs, the relics of marks of tattooing, and the bosses, appear as the most salient features upon the majority of ancient Chinese bronzes. It seems never to occur to the professed Sinologue that the presence of these various forms may be related to similar appearances in the art of the island peoples. He has found in old Chinese tradition that this face, seen so often on Chinese bronze, is only the "T'ao tieh ogre," who is a glutton with a cannibalistic appetite. Given a name, the phenomenon is familiarized to him, and filed away in a mental pigeon-hole. But this very tradition, probably one out of many from forgotten remote ages of Pacific relationship, only confirms the theory of connection. These very bronzes were used probably for the cooking and serving of food and drink in the most ancient forms of ceremonies for the dead—the origins of " Ancestor Worship " ; and what is more natural than that the face, or pair of eyes—the symbol of the active domestic spirit—should appear full of desire to eat and drink ? Here, we may well conjecture, is the very spirit and source of altar-food conception.

It is true that in the very scanty records we cannot find any evidence among the earliest Chinese of Pacific connections. Indeed, no one knows where the race came from. A Western origin, from the direction of the Caspian, has been vaguely and vainly conjectured. All we know is that the earliest Chinese lived in the North, and near the sea—about the lower reaches of the Hoangho—occupying a very limited area. It is impossible here to enter upon any adequate account of Chinese history. There are Chinese myths of heroic ancestors and

leaders who taught the elements of industry and of agriculture. When we catch our first glimpse of the Chinese under their patriarchal Emperors (from B.C. 2852 to 2204) they were settled along the Hoangho, with a capital probably near Kaifunfu, somewhat inward from the sea, and were working out the details of material civilization. One of these early founders, Huwangti, is clearly recorded to be a foreigner—leader of a cognate tribe, perhaps irrupting from some remote region, and bringing with him higher arts and a more complete organization. This, too, is the time of the invention of written characters, which superseded the making of records with knotted cords. It is quite possible that the most primitive of the bronzes go back to this day.

The early Chinese believed in spirits—spirits oɪ the dead, oɪ nature, and, above nature, of heaven. There was a ruler in heaven, like a tribal leader on earth. The people acted primitive dances, and made offerings to these beings, some of whose faces we probably see upon primitive utensils. The forms of these earliest bronzes are rude and heavy: the patterns are set upon them with only partial æsthetic effect, the bare symbolism remaining of primary importance. In this the art differs from advanced Polynesian modes and the best of the Aztec, where the aim is more polished and the effect charming, like the next stage of Chinese work.

The former accounts of the first Emperor of the so-called Hia Dynasty follow—B.C. 2205 to 1707—the great Yu, who first made the Emperorship hereditary. We do not realise how democratic Chinese institutions originally were ; like free tribal organization everywhere, and the self-governing village commune. Yu, with his predecessors Yan and Shun, have been taken by later philosophers as idyllic leaders in an age of golden peace, and set up as ideals to be followed. This was done especially by Confucius, nearly two thousand years later. At least moral order was already aimed at—the self-governing of the earnest individual. For the material welfare of the land they fought with their primitive engineering methods against the unruly forces of the Hoangho, and they glorified agriculture. There is no clear record of the use of human figures in the art of this period. Primitive, unglazed pottery was almost surely known. China was not yet China, only a peaceful and prosperous, order-loving tribe, quite unconscious of its great destiny. Fishing and hunting

alternated with agricultural pursuits, and whatever maritime tribes lay near the coast, the Chinese must have touched. Our only art records are their rarely dug-up bronze utensils.

Another Pacific feature in the decoration or these bronzes is the fish, or marine, monster, the ancestor of the Chinese dragon, which is identical with forms found from South Pacific Islands to North-Eastern America. This sea-creature has a head unlike a fish, with curved snout, opened nostrils, sometimes with tusks, and a curving tail also unlike a fish. Yet it is often found in connection with forms that are clearly fish-like. It occurs in New Zealand and Micronesian art, carved on the handles of utensils, gourd bottles, and woven into stuffs ; and it reappears in almost identical form in Alaskan patterns. Its shape, identical on the early Chinese bronzes, is probably their dragon ; only we see here that a " dragon " means no lizard monster of Western tradition, but a semi-fish-like or possibly seal form—evidently a spirit symbol connected with water. This figure is carved or moulded on all parts of the oldest Chinese vase. In later forms appear the tusks, which are more like those of the Aztec stone dragon.

Another widespread Pacific form, akin to the pair of eyes, is the mask, detachable, and to be worn by men or priests in impersonating the spirits during ritual. Here we refer to a universal practice recorded for us in the Roman word *persona*, or mask. But the Polynesian and Malay masks have the slanting eyes, the tattooed faces and the ogre-like features of the totem poles ; and in addition possess strange, elongated noses, which sometimes take on the form of a beak. In New Guinea, Borneo, and the Philippines we find these masks, sometimes representing murderous spirits, in the Philippines especially, with enormous noses. Now, although we have no primitive Chinese masks preserved, we do find among the earliest Japanese masks, used in the Shinto sacred dances, identical, though more beautifully-carved forms, with the long nose, the bird-like beak, and the slanting eyes. In Alaskan Ritual art these figures become accentuated in the enormously projecting beak of the bird mask. Among Aztec and Hawaian masks we find sockets, in which movable pieces, such as the jaw or the eyelid, were set, just as in some of the Japanese Shinto dragon-spirit masks. This dragon-world underneath the sea is part of Primitive Chinese myth.

Still another more special form of parallelism in ornament is the frigate-bird pattern, so conspicuous in the finest æsthetic carving of New Guinea. There, through centuries, it has become conventionalised into lovely spiral bands, which we find identically reproduced on some of the ancient Chinese bronzes.

It is here worth while to speak of the help we derive from the work of Chinese archæologists. Cultivated mandarins of the Han, Tang, and Sung dynasties have been great collectors of antiques, and have written and published illustrated accounts of the pieces which they had before them. Doubtless they had evidences of relative age hardly accessible to us ; yet we can see that their critical judgments were largely based upon the literary characters which were even then frequently inscribed, or raised in relief, upon the base of such bronze utensils. These collectors had access to thousands of pieces, where we can see but a few tens at most ; and the printed reproductions in early editions, of which the Ming are now the oldest accessible, cut from wooden blocks, are marvels of careful execution and beautiful printing. I shall hereafter use several of the reproductions from the *Poku tu'u lu* (30 volumes), compiled in the Sung Dynasty, and *Kin shih so* (10 volumes). Yet it does not follow that we must accept all the dicta of these books without further criticism, as some of the Sinologues are inclined to do. On the whole, however, we shall find a great deal of consistency in their massing of patterns according to dates. Only a few plates in the *Poku tu'u lu* and other books are ascribed to so ancient a time as the periods of Hia and the preceding first Emperors.

The second such sub-period of the first great Pacific period in Chinese art comes in with the Shang Dynasty (B.C. 1766—1122). Little historic record is left of this period, but if we judge from the study of original bronzes of the type ascribed in the Chinese book to Shang, we can believe it to be an age of greater polish and more advanced art. The shapes of the bronze vessels have now become specially plastic and beautiful ; severe and strong in design, with simple, firm outline, and of a dignity and variety which make even Greek vases look somewhat thin. Much of that tradition of fine form, which led to repetition after repetition through all the Chinese and Japanese after periods—from which more or less accurate copies we

derive our popular notions of Chinese beauty in bronze—comes down through the ages from this remote time.

Not only are the forms among the grandest that human art has left us, but the execution is worthy of the design. The handling of the hard substance has become an exquisite art, the design is in lower relief, and the surface has a wonderful satin finish, which in existing originals seems now inlaid with drops and bars of green, blue and crimson jewels, a slow chemical incrustation from the alloyed metals.

The patterns, often of much intricacy and grace, are still clearly Pacific, but of a symbolism now frankly cut away from its roots, and persisting chiefly for its decorative opportunities. The face pattern is now smaller, used chiefly for handles and points of accent; the dragon forms have become conventionalized into richer and more bulky curves, and the whole design tends to an interlacing of flat bands, sometimes with straight lines as a basis, but always with some strong, high-tension curves.

As might be expected, this æsthetically modified Pacific pattern is made to play with great nobility into the severe shapes of the vessels it decorates. This is the golden age of primitive Chinese spacing; the ornament not over-elaborate or too accented, and often leaving large cool surfaces of unbroken bronze between the bands.

Another important point to notice is that some of these bronze vases seem clearly to point to clay types that must have preceded them. Not only are the metal shapes plastic to the last degree, but they exhibit at times the very air-holes for draught in cooking which we find is characteristic of primitive unglazed pottery vessels in Japan and China.

The consideration of this rude pottery is now upon us. There seems reason to believe that its home in China is rather towards the south, which was as yet unconquered by the tall black-haired Chinese on the north, but with whom, doubtless, there was early trade. The aborigines of what is now Central and Southern China belonged largely to races far different: Shan tribes related to Burmese, and diminutive Miao-tzu (who still live apart among the hills) more allied to the primitive Japanese.

In the shell-mounds of Japan are found large quantities of vessels of a bluish unglazed clay, tall in form with a long hollow stem, above which rises a bulging central receptacle. Often a cluster of smaller covered vessels are built into the piece, suggesting the common

WAND OR DOUBLE FAN, USED BY
NATIVES IN DANCING.

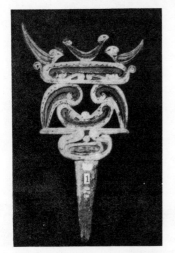

CANOE ORNAMENT.

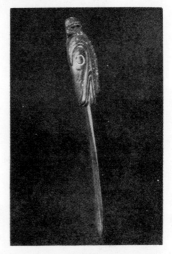

CARVED HANDLE OF LIME SPATULA.
British Museum.

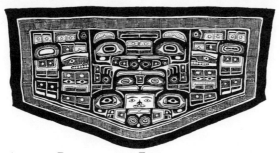

ALASKAN BLANKET, WITH EYES.

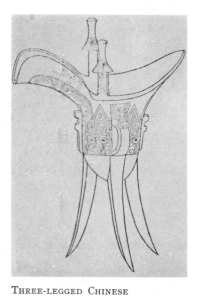

THREE-LEGGED CHINESE
BRONZE.

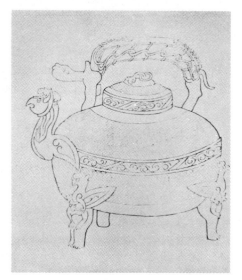

OLD CHINESE BRONZE.

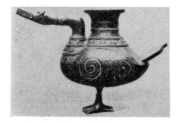

CHINESE BRONZE WITH
LONG-NECKED BIRD.

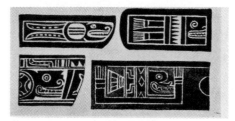

PRIMITIVE FORMS OF THE FISH OR MARINE
MONSTER, THE ANCESTOR OF THE
CHINESE DRAGON.

cooking and eating of the domestic meal. Slashes and holes near the bottom and top of the hollow stem suggest that the latter must have been filled with some kind of fuel, for the draught and smoke-escape of which these orifices gave vent. The vessel was thus an oven, a boiler, and a whole dinner service in one.

As I have already indicated, some of the finest Shang bronzes seem to be built on this model; the splendid bowl on a short stem, owned by Mr. Freer, appearing to be a veritable "chafing-dish," with two large handles precisely like those of the present day. Here the forms of the smoke-orifices are made to work beautifully into the trend of the ornamental design.

Another feature of the prehistoric Japanese pottery, and probably of the Chinese also, was the distribution upon parts of the surface, sometimes crawling up the stem, sometimes set upon the large central globe, of rudely but strongly modelled clay effigies of animals and birds; often turtles, frogs and lizards; but sometimes, also, horned cattle, dogs, and horses. Whether the significance of these forms was to suggest the origin of the flesh substances in the cooking ingredients, or whether it may have had some totem or other symbolical significance, it is hard to say. But it here appears that a Southern and Eastern school of naturalistic sculpture in clay was arising at some early age, and that it had no relation at all to Pacific design. That this animal school led to later bronze work that can be identified as Han, we shall see in Chapter III. Whether any Shang work of this type in either bronze or clay now remains can only be determined after much close comparison has been made of the scanty fragments. But the evident relation of some Shang bronzes to the type of clay vessel that bears these animals suggests that such may have existed. We think then that we detect in Shang the first traces of a Southern realistic art working slowly up against the Northern Pacific patterns.

It will be interesting, before leaving the meagre relics of Shang, to compare the patterns with other well-known Pacific forms. It is not now with the ruder of these that analogy is clear, as is the case with the earlier Hia bronzes. It is rather with the more polished and æsthetically complex forms of New Guinea, New Zealand and Aztec art that the parallelism now holds. For example, the triangular interlacing of the bands upon Mr. Freer's Shang bronze is almost identical with motives carved in stone upon the façades of Mexican temples.

The third sub-species of Chinese primitive art is that of the Chow dynasty, which followed the Shang (B.C. 1249—1122). With the Chow founder, the great Wen Wang, we are already upon pretty firm historic ground. This acute personage, whose name means "King of Literature," was the first great Chinese author and philosopher. It was he who composed in prison the original core of the Y-king, or Book of Changes, which Confucius much later elaborated. In this work the symbolism of "dragon" categories is so bound up with imperial acts as to be the origin of all that is still implied in the terms "dragon-throne," "dragon-face," "dragon banner." In a sense the dragon is the type of a man, self-controlled, and with powers that verge upon the supernatural. Wen Wang's life, too, is the starting-point for Chinese poetry, the Book of Odes, mostly Chow productions, which Confucius collected, and some of which are supposed to eulo-gise the deeds of early Chow monarchs and of virtuous members of their families.

The only art which, to my present knowledge, remains from this age is still the bronzes. Judging from the many Chinese drawings and the few originals, the pattern of these is still remotely Pacific, but much modified, and interspersed with realistic designs. Moreover, the shapes of the vessels themselves are either of bird or animal forms, or else over-elaborate and too consciously æsthetic. The pattern is apt to be overloaded and grotesque in its disposition. In short, the Chow seems to be an age of æsthetic decay, as, soon after the earlier reigns, it became the seat of political decay. The strong empire of the "King of War," son of the "King of Literature," was broken by the seventh century into a ring of semi-independent feudal states. It was the special mission of Confucius * to bemoan the weak politics and morals of his day, and to suggest a strong reconstructive system, based upon the idyllic life of the patriarchs who had preceded Hia, and upon the virtues and philosophy of Wen Wang himself. This Confucian philosophy, which advocated a thorough-going Socialism curbing the individual to act for common ends, though much discussed in later Chow, did not become the basis of administration in China until the next great age, the Han.

Nearly contemporary with Confucius appeared another great sage,

* Confucius, called generally in Japan "Koshi," in modern Mandarin pronunciation "K'ung-tzu," born 550 or 551 B.C., died 478 B.C.

this time from the just awakening and half included South (the Yangtse valley), Laotse, who advocated as thorough-going an Individualism as Confucius did Socialism. The absolute freedom of the Ego is the first principle of Laotse * and from this he would develop a more internal morality than can be mechanically deduced from utilitarian ends. Thus we have set here, clearly opposed in Chinese life, the two main types of man which have created the dramatic unity of Chinese history, by the growing complications of their warring. Which at first appealed with the more force to art it is difficult to decide. Confucius's thought of a social harmony which should literally reproduce the structure of music is sublime and fertile. " Keep your mind pure and free through Art," he writes. Also he advocated the setting up of painted or carved portraits of great men to stimulate a popular ambition ; but whether there ever were such paintings and sculptures in Chow we do not, at present, know.

On the other hand, Laotse's very South, the land of freedom and natural beauty, was already celebrated for its plastic arts, and has always possessed " temperament." It is pretty clear that this Taoist individualism was one of the greatest forces that rendered a later high Chinese art possible at all. And even at the end of the Chow dynasty, we nave in parts of Kutsugen's † great Southern poem, " Riso," or the " Lamentations," elaborated description of a splendid, ancient, non-Chinese shrine in the far South, covered with symbolic paintings of forgotten gods. Kutsugen's was the first great outburst of poetry, and strongly Taoist, after the Chinese Odes, which are Confucian. It is the first great demonstration, too, of Chinese literary imagination ; but we can only conjecture what new beginnings of visual art may possibly have accompanied it.

There is one striking record in the middle of Chow of a first tentative exploring by the Chinese of land lying to the west of their empire. About 600 B.C. the adventurous emperor Wa Tei, with a large retinue, is said to have penetrated as far as the Kunlung Mountains which divide Thibet from Kotan, and there to have met a kind of magical central Asian " Queen of Sheba," the " Mother-Queen of the West," who entertained him in magnificent state. Whatever the measure of truth in the story, the

* Laotse, or in now recognized spelling Loo-tzu, is called in Japan " Roshi." He flourished from 580 to 530 B.C.

† Kutsugen in Chinese is " Ch'ü Yüan."

marvels of a new life and work there seen, expanded into later myths and legends—much as early Greek geographical accounts of outlying nations are like truth seen through a romantic mist—so powerfully affected Chinese imagination that the far western site became identified in later Laoistic worship with the Taoist heaven. Probably some new elements in visual design arose from this contact, which it is difficult now to identify.

The end of Pacific art and of the weakened Chow dynasty came together with the advent of the Shin tyrant—who overthrew the alliance of the feudal states, and subjugated them into the first colossal Empire that included what is now the whole north and centre of China proper. He brought the past consciously to an end, because he wished to rebuild with clean stones ; thus causing the burning of all past books, especially those which dealt with the endless disputations of the Confucian and Taoist philosophers. If there were any philosophy at all in this brief meteoric career, it was a sort of Nietscheism backing raw freedom and force against formalism. Another of his colossal works, less futile, was the building of the great wall for 1,000 miles across the north, to shut out the predatory hordes of barbaric Huns, ancestors of Attila's scourges, which already had begun to threaten China with Tartar invasion.

Probably no new forms of Art could have been introduced during the short reigns of this strenuous man or his son, as he left his subjects little time for the luxury of æstheticism. His is an age of transition, a needed stepping-stone from feudality to Empire, but leaving all real social reconstruction therein to the genius of the Han Dynasty which soon succeeded him. (202 B.C.) Here an entirely new set of forces make their entrance into Chinese life, and particularly into Chinese art, which now takes on new forms, so unrelated to the Pacific that we must devote to them a special chapter.

CHINESE ART OF THE HAN DYNASTY.

Mesopotamian Influence—202 B.C. *to* 221 A.D.

THE rapidly expanding influence of China upon surrounding peoples must have reached our Western world of the Mediterranean precisely at this dramatic moment ; for though the violent Tsin dynasty lasted only forty years, it contributed its name Sin, or Chin ; and Sines, Sinico, and so the final form "China," to the earliest accounts of it written by the Greek geographers of the Ptolemaic school. A little later, the second century B.C., China became known to the Greco-Roman world under an entirely different epithet, the Ser, or Seres, a people far to the north-east, from whom was brought by caravan route the precious fabric known by the Greek-formed adjective Serika or Serik, whence our word silk. The strange fact is that the scholarship of Europe conceived these two peoples to be entirely distinct, an error which was not finally corrected until the explorations of the Jesuit missionaries in the seventeenth century. What is significant for us in this is that the difference of names corresponds to a difference of the routes by which Western travel moved— the Sin fame and exports coming by sea around through the Indian Ocean to Arabia at least ; the Ser products being carried overland on the backs of camels. This difference and its long persistence in the Occidental imagination really correspond to an important and even a racial difference between the North of China and the South. The North, the Seres, were the descendants of the ancient black-haired race in its original bleak seats ; the South, the Sines, were only just becoming known to the Chinese, being loosely incorporated with their empire under Tsin, more firmly under Han. By South, however, we mean also what is now the centre, the Yangtse valley, and the whole eastern projection of Chinkiang, the famous province of Wu (Go). It was from the ports of this new province—in the neighbourhood of the present Amoy or Hangchow—that the first maritime trade was opened to the South and West, though later the still more southern ports in the Canton region came to rival them.

But our concern here is still more strikingly with the fact that while the short-lived Tsin gave its name to the Southern and maritime Chinese, the whole overland line of trade between China and the Greco-Roman Empire—which lasted down to the conquest of the Turks—was opened for the first time by the Tsin's great rival and successor, the Han Dynasty. It is peculiarly the Han, in its sudden wonderful expansion Westward, that represented the Seres proper, the men who made that mysterious substance, silk.

The Han Dynasty came in with great *éclat,* and the refinements of ripe military power, in a violent national reaction against the excesses of Shin. The responsibilities of extended Empire were now for the first time understood, for the small areas and the patriarchal supremacy of tribal heads in earlier days, from Hia to Chow, should hardly be dignified with that name. It was now that the first great historic wave of Chinese culture surged up into a shining spray of forms. There was, first, the intense and widespread literary criticism, which reconstructed the texts of the ancient books destroyed by the Shin tyrant ; much as the scholars of Florence, sixteen centuries later, re-pieced the scattered fragments of Classic culture. Here comes in the first critical study of the language itself, its grammar, its etymology, its epigraphy, works of which some of the most important still remain.

This recovery of the works of the great Chow philosophers, Confucius and Laotse, and of their followers who had warred for eight ineffectual generations, led to new conscious attempts at administrative organisation, based upon broad social principles, the digests of which the new Han rulers had ready to hand. Speaking briefly of this long, fertile period of a hundred years, we can say that at the beginning of Han the Taoist, or Individualist, party achieved a partial triumph, which was followed by the first definitive formulation of Confucianism as an Imperialist constitution at an era considerably ante-dating the birth of Christ. That society should be organized as a great, obedient family, with multiform duties but no personal rights—a sort of ethik-archy or government by Socialistic morality—was the beginning of characteristic Chinese form as we know it ; a form, however, in which the most striking institutions, such as the civil service examinations, were yet far from initiation.

The philosophy was rather a convenient engine for the Han rulers to wield in defence of their dynastic power than a ripe expression of

thought and life in the Chinese people themselves. Here then, too, in Han, the first great national histories were compiled and written, trying to throw into an intelligible whole the fragments of tradition that had filtered down through many motley centuries.

The poetry of Han, however, a noble mass of work, remained largely Taoist or Individualistic, enforcing the prime fact which all later Chinese critics, and their European Sinologist pupils, have ignored, that almost all the great imaginative art work of the Chinese mind has sprung from those elements in Chinese genius, which, if not anti, were at least non-Confucian. This poetry is almost always in the Southern romantic style of Kutsugen in his *Riso*, as opposed to the primitive short-lined moralising Chow balladry of Confucius's compilation.

The causes which soon led to the expansion of Han influences towards the West were twofold; first, military, the outcome of successful campaigns against the various Tartar tribes on the north and north-west, and the coming into more intimate treaty relations with these hordes of Scythians and Huns; and second, philosophical and romantic interest in the Taoist stories of the West, stories which had descended in a halo of myth from the visit of a Chow Emperor to the "Queen-Mother of the West," four centuries earlier. It was especially the monarch Wu Ti (Butei), the sixth of Han, who ascended the throne 140 B.C., to rule for fifty-four years, and whose long reign may be called the golden age of this dynasty, whose military prowess and restless Taoist imagination led him to inaugurate the Turkestan campaigns. He summoned about him the Individualistic genius of his day, professed to believe in and share the Taoist mystical powers, and determined to re-visit the Queen of his Taoist paradise. The first overtures were peaceful, Wutei sending an envoy ostensibly to discover the line of migration to the far West of one of his dependent Scythian tribes, the so-called White Huns. The envoy traced them, after years of detention and difficulty, to the far highlands of Baktria, where he came into contact with the Persians and the Greeks, and whence he brought strange treasures of Western manufacture, the knowledge of grape culture, and a fine breed of Turkestan horses. Other messengers from Wutei, followed by armies—missions that were renewed at times throughout the breadth of the Han centuries—not only carried Chinese civilization and arms past the K'un-lun mountains to the very Pamir plateaus, but opened intercourse

with the Mesopotamian plain, penetrating as far as the Persian Gulf, from which one Chinese general later prepared to embark on a Red Sea voyage to Alexandria. And thus it was that a permanent caravan trade across vast deserts and the roof of the world was established between China and Rome a hundred years before the Christian era. The enormous mass of silken stuffs which the wealthy Romans used for clothing all came from the far-away looms of Han, in return for which the Chinese imported glass and enamels, steel, pottery, elephants and horses. This was the first great line of world trade over the central regions of our globe.

That an enormous impression should have been made by this new intercourse upon the industries and arts of China, is natural enough. The Han people might well discard much of the worn-out Pacific motives, of whose origin they retained no real knowledge, and adopt the more fertile ideas which were pouring in from the West. The strangest fact, perhaps, is that the contact did not reach to deeper intimacy, and a more perfect mastery of Western forms. Here China must have touched the outer surface of a Greek art that had followed in the wake of Alexander's conquests, and of all the treasures of a rich Babylonian, Assyrian and Persian past. Some European writers, indeed, have gone so far as to infer, from the vague indications of literary research, that Han art became very decidedly Greek, at least in its early days. It would seem more strange that we do not find clearer direct evidence of Greek tutelage, were it not for causes which tended to make this continental intercourse fitful and abortive. Why should not the two great empires of the world, China and Rome, have met, affiliated, and established diplomatic intercourse, and we be able to read of Chinese long-robed mandarins at the courts of the Cæsars? The enormous length of the trade-route, occupying some two years i circuit, explains much; but the deeper cause was the jealousy of th Western intermediate people, chiefly the Parthians, who kept the tw ends of the four chains of trade in their own hands. It was t rivalry of such "go-betweeners" that prevented the embarcation f Alexandria of the Chinese general, and, roughly speaking, we may say that the great and celebrated Parthian wars of later Rome were fought chiefly to effect and to obstruct direct intercourse with this most important Eastern market of the Roman world. The sea-trade of the Sins, via India, was obstructed by Arabs; while the land-trade of the Seres,

via Ferghana, was definitely obstructed by Parthian success. Thus the full vitalizing contact was never made until the weakening powers of both Rome and Han destroyed for centuries all chance of it. And thus it was that into the art of Han infiltrated only a somewhat motley group of Western influences for China to transpose to her own alien uses.

It will be worth while now briefly to consider what were some of these Western art forms which, in an imperfect intercourse, would have been the most easily transportable. In older forms of Mesopotamian art, Assyrian and Babylonian, and later in Persian, the Chinese must have noticed the strong prominence of animal motives ; not only bands of animals—horses, deer and lions—used in ornaments of utensils, and often disposed in circular procession, but famous scenes of hunting, with darting horses of the royal guard, chariots, charging lions, wounded animals. Forms of winged animals, too, some with human bodies ; but masks of birds or beasts—winged bulls and lions as vast symbolic ornaments, or perched as capitals of columns ; forms enriched with finer Greek influences, as at Persepolis, and even the flying Pegasus himself, must have come to the Han notice. Strange branching and intertwisting forms of foliage, too—the so-called " Tree of Life " in later Persian pattern—the firm line tracery of stems, and the feathery plumage of leaves ; and more than all this the formal Mesopotamian use of continued flower and rosette patterns in stiff, doubly symmetrical curve system, worked out in their coloured brick façades and interior decoration. Here, too, we should have spoken, perhaps first, of the use of glazed pottery generally in that greatest of all ceramic centres, Persia, and in the Tigris and Euphrates joint valley. Upon some of these vases there is a noticeable lack of design, but at times some relief work. Among the colours are an egg-plant purple glaze, grey-cream, superb blues, and wonderful dark greens. It is still a live problem whence came this finest of the industrial arts ; but since the recent unearthing of ancient collections of pottery in Persia and along the Euphrates, we are coming to believe this the original seat from which the arts of enamel spread, in many directions, possibly to China. Looked at with a purely æsthetic eye, Mesopotamian design has a large massiveness of proportion, and a simple but peculiar circular rhythm of curve relations, which distinguish it from all other racial types. Its Egyptian analogues are more spiky and rectangular ; its Greek more flame and flower like.

But of very special influence upon the new art of Han were evidently the peculiar thin and wiry forms of art, half Persian and half Greek, which obtained in the semi-independent kingdom of Baktria nearly down to the time of Christ. Later Persian forms, seen in engravings of figures upon cylindrical seals, have become lank and dry, as if the juice of their Assyrian prototypes had been pressed out ; and this attenuation of form becomes often combined with effeminate Greek rhythmic curves in Baktrian seals and coins. Figures are reduced to mere filaments and splinters, which band strange angular intervals upon the engraved ground.

If now we turn from this somewhat random enumeration to the few scattered relics of Han art, we can trace something like the revolution in Chinese æsthetic forms which we might be led to expect. A first great innovation is in the glazed pottery, which, so far as I know, did not exist at earlier dates. A considerable mass of this has come into modern American collections, most of which is somewhat rude and repeatedly conventional, showing a late Han degeneration. But studying the finest and most characteristic pieces we shall discover much of interest. The forms are largely low cylindrical jars with covers, and tall finely moulded vases, with small base, full flaring centre, and long neck above expanding into a wider lip. Many of these have no ornamentation whatever ; some have only a few faint circles of geometric marks, often like the cord-marks of primitive pottery. The finest bear a single modest band of decoration in relief about their equators. That some of these have been derived from bronze forms seems proved by their bearing, at two opposite poles of their equatorial region, the relics of handles that imply detachment ; face bosses which show a relic of the old Pacific design, holding in their mouths a ring that should hang free. Other forms, however, and generally the undecorated, show affinities with the tall, oven-containing shapes of the prehistoric unglazed vessels of the South. But over all these varied pieces of modelled clay, harder and more brick-like than the chalky Mesopotamian biscuits, has been poured a nearly identical glaze of dull green, occasionally mottled with a little yellow, and often running into heavy drops as in the finer Japanese pottery. These colours have been largely deoxidized by long burial in the soil, fading into a semi-iridescent colourlessness ; but the glaze can be traced upon the less exposed portions. It would seem as if the Han potters, though

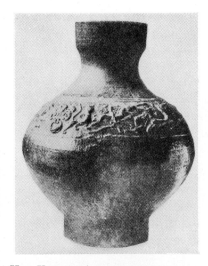

HAN VASE WITH RAISED BAND OF
SLENDER ANIMAL FORMS.
Mr. Freer.

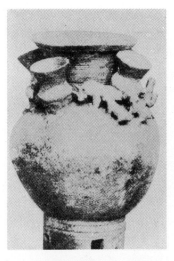

CLAY " CHAFING-DISH " DESIGN :
FORMS OF CATTLE IN FULL
RELIEF.

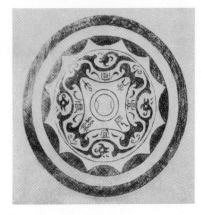

HAN MIRROR WITH TWELVE-POINTED
STAR.
From Kin-shih-so.

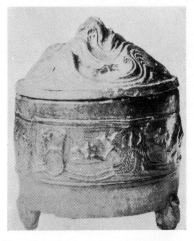

HAN JAR WITH COVER REPRESENTING
HILLS SURROUNDED BY WAVES.

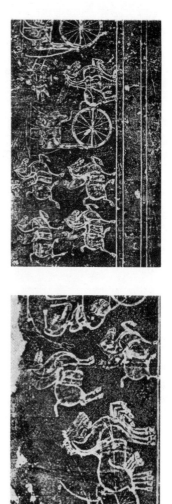

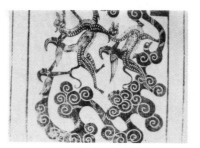
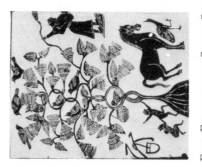

FIVE EXAMPLES OF STONE CARVING,
From stone impressions and from wood engravings of Kin-shih-so.

borrowing the idea of design from the Assyrians and Persians, could not discover the chemical constituents of their finest blues. It should be noted here that, beside the vases and jars, there occur forms of miniature domestic utensils and animal effigies, also worked out in glazed pottery, and which show evident affiliation with the prehistoric animal culture, often upon the oven vases, of the primitive South.

Let us now look more closely at the motives upon the Han vessels that show decoration in sculptural relief. The covers of the jars are mostly heaped into curving ranges of mountains, which seem to symbolize the wonderful fourfold pacing of that Pamian roof of the world which the adventurous Chinese captains and merchants were just learning to cross. The sides of the jars, too, have an underlying network of mountain forms in crude curves, like successive sea-waves, in very low relief. Occasionally upon the lower slopes of the mountain, on the cover, we find the sculptured forms of animals apparently lying dead in the wilderness—figures of horses, cows, or lions. But the chief animal and human forms are found in higher relief in the side bands of the jars, standing strong against the mountain outlines. Here we find men on horseback, hunters; perhaps wounded lions, trailing their hind legs as in Assyrian sculpture; wild cattle, sometimes humpbacked like those on Baktrian coins; forms of flying birds, and inter-connecting traceries that cannot always be identified. Among the animals, too, some are winged, quite in the Mesopotamian style—a strange circumstance were it not for the contact, for in all the old Pacific motive, even in that which delineates dragons, whose written character-analysis seems to mean " flying-flesh," we find no early attempts to portray wings. These animals and hunting scenes, though generally not the mountain forms, are found in bands of closer curve composition upon the vases also. And upon both jars and vases are seen horsemen turning in their saddles and shooting arrows backward, which it is perhaps not a wild conjecture to take for Parthians, or Central Asian tribes akin to them.

After the clay vessels we should touch upon the bronzes, which seem to divide themselves into three or four types. The first of these, and still in use for ancestral rites, are more or less conventional copies of the more ancient bronzes of the Pacific school. But these we need not consider, being only hierarchic survivals and betraying no creative aim. One new form of bronze resembles the glazed vessels with

raised patterns on jars and vases, quite like those already described. Here the Pacific forms of the handles stand out clear against the Mesopotamian motive on the bands. Still a third form is the bronze drums, which Professor Hirth has so well shown to have originated in early Han. The patterns on these are very different from the early Pacific, as from the Northern Han, and seem to point to a far Southern, and perhaps a Malay, origin. Such drums have been dug up mostly in the South, where the records say that a Chinese conqueror originated them, carving native symbolical designs into drum forms imitated from the Chinese drums made of wood and

CHINESE DRUM WITH FROGS.

skin. The ornamentation is incised in fine line pattern, quite unlike the clay reliefs, but surmounted at the top of the drum by rude bronze images of frogs in complete relief. We do not know what symbolism was played by this animal form, but we can clearly say that their modelling is precisely like that of the rude clay figures of unglazed prehistoric pottery in China and Japan, and therefore still further attests its Southern origin.* A fourth form, of bronze, was the mirrors, generally circular discs, the backs of which were ornamented in low and high relief. The use of such mirrors may

* In the spring of 1908, when crossing in the steamer with the well-known Dr. de Groot, of Leyden, Holland, now, 1913, professor at the Berlin University, Professor Fenollosa had an opportunity of discussing many such questions. Dr. de Groot said that among European students of the present day it was generally thought that these frogs typified a desire for rain, and that such drums were almost surely used by the priests in invoking supernatural powers to terminate a drought.

have come from Persian or Greek suggestion, but their patterns probably did not. Here, however, is a great point of dispute, for though a large number of Han mirrors imaged in the antiquarian books, and found in collections, are of a mingled curve and star pattern, interspersed with inscriptions in Han characters—patterns which are clearly congeners of all else that we know in Han ornamental spacing—there are a few exceptional pieces shown in the Chinese wood-cuts, by outline only, and akin to a few actual mirrors which we have in our collections; which I cannot, except for the native judgment, find any evidence of belonging to Han. These are the so-called " grape and sea-horse " mirrors, where the whole back is closely loaded with a most intricate curving pattern in high, carefully moulded relief in bands, and a central rosette of branches and bunches of the grape, intercurving in a most natural manner, and interspersed with delicately-winged flying birds, the inner circles often being most graceful; animal forms of horses, lions, and rabbits, cantering about among a network of graceful foliage, the central medallion having the same animals in airy circuit, or the strange, half bear-like hairy animal called the " sea-horse," of which term there is no explanation. The central knob, through a hole in which plays the cord that holds the mirror, is generally of this sea-horse, but more primitively modelled, more like the frogs upon the bronze drums.

We come now to the consideration of a quite different set of forms from Han art, whose largeness of simple line and space relation are entirely in harmony with the vases and bronzes, and whose patterns also show kinship to Mesopotamian prototypes—namely the famous stone carvings of scenes from Chinese history and life, found in several places lining the interior of caves in the province of Shantung. These are of enormous value, because they are the oldest elaborate representations of human beings remaining in China, because they are *dated*, because they illustrate for us the whole round of Chinese history and tradition as known to Han scholars, and because they give us clear ideas as to the natural limitations of Han power in design. Rubbings from most of these have been published by Professor Chavannes, and printed from wood-cuts in the Kinshih-so.

For the most part these divide themselves into two series, the earlier and more meagre of which belongs to the first century antedating the birth of Christ. These show figures of men, horses,

chariots, etc., incised in lines into the stone, being the earliest representations of human life that have come down to us in Chinese art. Many horses are sometimes driven abreast, and in the profile drawing appear almost super-imposed, as in primitive Egyptian design. These horses are not like the little stocky Tartar ponies, with short necks and legs, but all full-blooded steeds, high-spirited, head and forelegs lifted into lines of proud arch, with much fine rhythm of general curve and with good action in the seated figures. Here are dramatic scenes clearly modelled upon methods and subjects of wall decoration found in Western Asia. This is still more obviously the case in the second and much more voluminous series, found also in Shantung, and dating from the second century after Christ, that is towards the end of the later Han, when the capital had been removed to the ancient Chinese seats in the East (Honan). Here we have a complete round of illustration of all the important mythical and recorded deeds of ancient Chinese history; the heroes, the patriarchs, the emperors, coronations and assassinations, scenes of engineering and of agriculture, the visit of the Chow conqueror to the "Queen of the West," the early deeds of Han itself; beside a whole menagerie of animal forms, frequently representing spiritual beings, flying horses with wings and serpent tails, monkeys and imps—beings half-human, half-animal, with interlacing tails, forming in places net-works of design with added whirls of cloud, of hundreds of figures caught into an interlaced, wriggling pattern. Most of these seem to be Taoist spirits, showing the vigour of that cult even at a day when its rival, Confucianism, had been in some sense adapted for government administration. These figures are raised in relief upon the stone tablets, and so in the rubbings come out into black silhouette. Here are hundreds of horsemen and footmen, showing every rank of noble and soldier—a little compendium of Chinese life at that remote day. Considerable change is noticed from the style of the earlier of Western Han, in that the horses are now more clumsy, with conventional fat curves and weaker legs, but still with an attempt to render them high-stepping and snorting. The action of the figures, too, is very spirited. We can thus conclude that this Mesopotamian-derived school of figure representation did not materially change throughout the whole length of Han, having become a fixed style, of which most of the movements are lost, a style which is quite

in harmony with the strong and somewhat rude curve systems of Han ornamental pattern already noticed. And here finally we can see the representation of the sacred Babylonian tree, the " tree of life," found in modern Persian carpets, growing clearly in the Paradise garden of the Taoist Western Queen.

In æsthetic respects these horse forms of Han are more spirited than any equine delineation of China at a later day, where the native Tartar ill-shaped breed becomes the model; but they are not so fine as the superb horse painting of the Japanese Tosa School in the twelfth century, described in Chapter IX. This Han art, and especially the round of human forms, if studied in close relation to the fine mass of Taoist and social poetry, will give us a clear conception of the mentality of Han, and prevent our importing into it so much that belongs to later Chinese growth. In the latter part of Han probably began a thin stream of commercial relations with India and the Western ocean. An embassy from Marcus Aurelius Antonius, Emperor of Rome, is reported in Chinese annals to have arrived in Southern Han; but Professor Hirth believes this to have been probably a private venture of Parthian or Arabian merchants, subjects of Roman Syria, who assumed the imperial name. Chinese records also show that the Han people were well informed as to the structure and defences of the Syrian capital, Antioch.

But the downfall of the later enervated Han was inevitable, not only because of wasteful civil wars that lasted for generations and broke China up into a second group of feudal states, but through the gradual irruption of Tartar tribes from the North, who, scaling the Great Wall, snatched province after province of the North from the weak hegemony of rapidly changing dynasty, and finally drove what was left of Chinese vigour into the safe recesses of the South, near the Yangtse and below, where they might recruit their fortunes. In this way the unity of Han art was doubtless weakened and lost, though an influence that had acquired so much headway could not suddenly cease. But the chief reason for making our break here, and commencing a new chapter, is that a third great stream of Art forms and motives now began to flow into China from a third direction—the Southern—namely Buddhism, with all its complex and important potentialities for later Chinese civilization. Chinese art is first Pacific, second Mesopotamian, third Indian Buddhist.

CHINESE BUDDHIST ART TO THE TANG DYNASTY.

Indian Influence—Third Century A.D. *to the Sixth Century.*

THE introduction of Buddhism into China from India, and eventually through China to Corea, Mongolia, Manchuria, and Japan, was one of those stupendous revolutions, like the carrying of Christianity to the Gentiles, which well-nigh obliterate racial and national lines, and bring humanity to pay common tribute to spiritual forces. How profoundly Chinese and Japanese civilization in general, and art in particular, were gradually transformed by this quiet, pungent influence, has never been written by any native scholar, and hardly even conceived by any European. On the one hand we have the vague statement of our geographies that 400,000,000 of Buddhists in China alone are to be added to the quota of Sakyamuni's devotees. One naturally infers that Buddhist thought and feeling are still to be found paramount in all the institutions of Mongolian civilization. On the other hand, the impression of actual travellers, and especially foreign scholars, in China, is that Buddhism has become there a decayed and despised cult, having almost no hold on the educated classes, and quite a negligible factor in analysing the spirit of Chinese institutions. The standard works on Chinese life and culture almost ignore it. The place of Buddhist ideals in Chinese literature is seldom discussed ; and the evident necessity of including Indian motive in certain phases of Far Eastern art is explained rather as an isolated phenomenon.

That the mass of the Chinese of the present day are devout Buddhists, as the Ceylonese are, would be quite a misstatement. The fact is that the whole influence of Confucian scholarship and influence, that is, the force of the whole Mandarin order, is implacably opposed to the

spirit of Buddhism, and has been from the eighth century, and even before. This is why the views of Chinese history, and the estimate of relative values among institutions, derived through Chinese scholarship— and most of our Sinologues drink from that source—are entirely false in their prevailing attitude, in that Chinese scholarship, lying entirely in the hands of the Confucian literati, has always been violently partisan and antagonistic. The truth is that a very large part of the finest thought and standards of living that have gone into Chinese life, and the finest part of what has issued therefrom in literature and art, have been strongly tinged with Buddhism. To write the history of the Chinese soul without seriously considering Buddhism, would be like writing the history of Europe under the hypothesis that Christianity was a foreign and alien faith whose re-rooting in Western soil had been sporadic, disturbing, and on the whole deleterious.

How great practical peoples, like these healthy shoots of the Altaic race, the Chinese and the Japanese, could ever have taken up with such a negative, pessimistic, and non-political religion as the Buddhist re-nunciation, may seem to many fairly questionable. The answer is that here, too, partisanship stands in the way of truth-seeing. Most of our information about the Indian religion is derived from Southern sources, Pali, and the whole round of the Ceylonese illumination. It is enough for scholars, who sometimes have a missionary bias, that Southern Buddhism, the " Lesser Vehicle," being the older (and the easier to refute), must lie nearer to the original source, Sakyamuni himself ; and is therefore the only form that we need seriously study or consider, Northern Buddhism, they think, being derivative, revolutionary and corrupt, need be studied only as a perverse curiosity. The great truth which they forget is that Buddhism, like Christianity—and unlike Mohammedanism—has been an evolutionary religion, never content with old formalisms, but, filled with spiritual ardour, continually re-adapting itself to the needs of the human nature with which it finds itself in contact. Thus, becoming Northern or positive Buddhism with the more vigorous Northern races in the North-west of India, it became still more positive, social, and human with the great practical home-loving races of China and Japan.

The attitude of those who would minimize the effect of Buddhism in China is self-contradictory ; in that, on the one hand, they ask how these sane moral peoples should have adopted a " degenerate Southern

pessimism," and, on the other hand, denounce the Northern forms, which have been made practical and optimistic by the vigorous contact, as "corruptions from the pure original doctrine." The truth about it quite corresponds to the commonplace fact in Christian history, that our many modern Catholic and Protestant sects, which cannot all—in spite of their several claims—be identical with the primitive Christianity of the Apostles — have all been sane and broadening efforts of the central truth to meet the almost infinitely varying forms of human need. English Episcopacy and Puritanism may have been equally hateful to a Southerner; and yet really express sides of Christian truth that conform to two powerful strands in the Anglo-Saxon race.

It must be remembered, too, that the introduction of Buddhist art into China was a slow affair, comprising in time a vast number of the great revolutionary movements within the body of universal Buddhism. The date 61 A.D.—so often given by writers who rely chiefly on the written word as the important date of Buddha's introduction to the Han Emperor Ming Ti in the form of a small gilt image— is of no special importance to us; first, because we can hardly identify the form of the image; second, because it belonged probably to early and still negative forms of Buddhism; third, because in fact the new religion hardly began to exercise appreciable influence upon China and Chinese thought before the third century; and fourth, because we can trace no Chinese modifications in Buddhist art, no incorporation of the new æsthetic canons, before the third or fourth century. It is from these latter dates, after the final fall of the Han dynasty, that it is proper to trace the real rise of Buddhist art in China. Let us premise once for all that this art is largely sculpture, and that too sculpture in bronze, including also those forms of decorated industry that entered into temple architecture and ritual.

But before we begin a detailed study of the course of this new art in the Middle Kingdom, it will be clarifying to preface a brief word concerning the little we know of early Buddhist art in the various parts of India. The origins of Indian art are lost in obscurity, though it seems likely that the transition from wooden to stone forms took place as late as the second or third century before Christ. The erections and sculptures of that day are regarded as early creative forms in Buddhist art. In those we seem to trace at least two different

streams of influence, one native and aboriginal, the other exotic and largely Mesopotamian. It is not an accidental phenomenon that late Persian and Greco-Syrian forms should have entered the China of Han at almost the same moment that they were moving south-east also to assist in the expression of Buddhist motive. It was all part of the dislocation and dispersion and eastward driving that followed the great upheaval of Alexander. It was one of Alexander's own generals who first visited Central India and brought back to Europe accurate accounts.

This is not the place to attempt the herculean task of dating or classifying the movements of Indian art. It is enough for our purpose merely to note a few of the typical forms that passed over in the æsthetic transmission to China and Japan. Among the forms of native origin must be mentioned first what appears to be a key form to Buddhist architecture, which Fergusson has conjectured to be derived from the primitive bamboo and bark huts, such as are seen to-day among the hill tribes of Central India, notably the Todas. These are small and low tents, made by bending flexible poles over into a semi-pointed arch, with both ends inserted into the earth ; two or more of which set parallel and connected by longitudinal rafters make a frame over which can be stretched a covering that approximates in form a semi-cylinder. The curve, however, is more subtle than a circular segment, since the pole ends are not quite vertical, and the arch, though blunt, slightly approximates a Gothic point. How thoroughly this form entered into Buddhist architecture may be seen first in the cave temples, where the cylindrical nave opens within this arch into a façade, often filled with a stone discus representing window openings of the same pattern. When independent stone temples were erected, these forms still remained for doors and windows ; and are found, too, in many of the wooden temple erections in China and Japan as an ornamental form for window spacing.

The dome is but such a cylindrical section projected by revolution upon an arch ; and this dome we find in the earliest forms of the stupa, or sacred tumulus, and the derivative forms of the altar niche in the caves, the diminutive tombs in cemeteries, and the reliquaries in priestly treasuries. From this form, too, grew the well-known pagoda which in its earliest form, still occasionally found as far East as Japan, is merely a tiled wooden roof built over a dome formation, and over the

square block member that surmounted it. In such Japanese pagodas
the dome, shown only above the lower roof in a strip of white plaster,
is not itself structural, but only an ornamental relic, the square wooden
framework below being the true erection. A high pagoda is only
a multiplication of these roofs, which needed not to be always of
equal space, as shown in the remarkable Yakushiji pagoda near Nara,
Japan.

Passing now to features of Indian Buddhist art that are wholly or
partly imported, we might point at once to the famous stone gateways
of the primitive Sanchi type, whose wooden architecture seems just to
be passing into clumsy stone. While the crowded small figures in
elaborate carving are not specially Mesopotamian, the rosette forms
set at salient points, and the winged animals, lions and bulls, set on
the pillars and posts, are clearly of Persian influence. How strongly
the rosette form recalls Assyrian, even where it had been already attached
to a lotos centre, is exemplified in the so-called "moon stones" of
Ceylon, which are really the lotos thrones, on which the sacred erection,
dome and terraces and stairways—as if as a whole they formed the
very worshipful altar-piece—stands. Here the concentric bands of moving
animals and birds, intertwined with scrolls of leaf and stem, point back
to early Assyrian animal motives, and forward to the elaborate mirrors
and rich halos of the seventh century in China and Japan.

The Sanchi forms of Indian art, too, were partly incorporated
with the primitive Chinese conception of the dragon, originally Pacific ;
and the lotos is only the chief among Indian plant forms that enter
into later Mongolian symbolism and pattern.

We come now, lastly, to effigies of Buddha and other spiritual
beings which form the very core of Buddhistic art. In early Buddhist
symbolism the human image, as a thing to worship, probably played
no part, the stupa itself as containing a relic, the wheel of the law, and
the sacred "Tricula," taking the place of altar-piece. But such severity
of impersonal restraint probably did not last down to the Christian
epoch ; for we hear of Buddha's image in China, and the earliest or
the cave temples have representations of the sacred figure on the altars.
The most primitive form may well have been a plain naked figure, so
severe as almost to transcend human contour, and with no ornament
whatever. But a standard Southern type, which also extended more or
less through the whole geography of Indian Buddhism, is probably

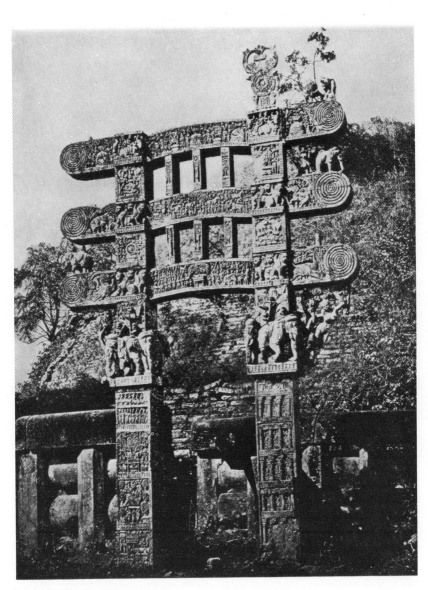

Eastern Gate of Sanchi Tope.

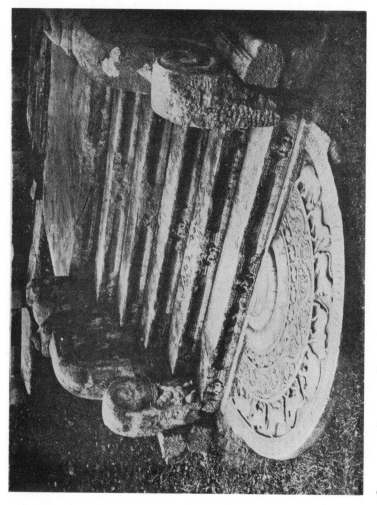

One of the Buddhist Lotos Thrones, often called "Moon Stones." From Ceylon.

given us in those colossal Ceylonese stone figures whose clumsy bodies are swathed in a single gauzy robe whose many thin and nearly parallel lines of fold sweep like a river of wavy curves over body, arm and leg in an expressive ornamental pattern. However simplified and modified these lines of drapery become in a hundred later schools, they are always present in some traceable form.

The Bodhisattwa form seems to be equally primitive with the Buddha. This is of a graceful swaying figure, seemingly feminine, with high tiara set over long flowing locks, and festoons of jewels hanging from various parts of the body. The third order of Buddhist spirit, the violent deities which correspond to Siva in later Hinduism, had not been developed as early as the period of which we speak. They derive doubtless from a closer union between the Buddhism of the early Christian centuries and a revived Hindu mysticism based upon the pre-Buddhist literature. We shall speak of these under the mystical Chinese and Japanese art of later chapters. The forms of imps, however, or elemental spirits lower than man, have already been introduced.

There must already have been a split in the Buddhist ranks between the more conservative Southern sects and the non-Indian races of the North and North-west, the Nepaulese, Cashmerians, and the tribes that worked toward Central Asia over the North plateaus. Here we find evidence of a different art—a Himalayan art, a more Mongolian face, a more decorative catching of the folds of the garment about the legs, long sweeps of mantle over the shoulders, and heavy rosettes and flower festoons upon the hair, twined over the breast, or worked into the strong girdle at the waist. These forms that have remained are mostly in bronze, and small ; and seem to be of a primitive character that would render them the common ancestor of Chinese bronzes, and of the later Thibetan art. That it was some such statuette that was brought to the Han Emperor seems probable; at any rate such statues from the Indus valley, or possibly from Turkestan itself, finally striking the caravan route from China to the Caspian, came Eastward to the Flowery Land as early as the close of Han.

It should be confessed, once for all, that of the enormous mass of primitive bronze statuettes from many Asian sources which have always passed among Japanese antiquaries under the name of " Indo-Butsu,"

or Indian Buddha, it is often difficult to identify the origin. So many of foreign make were copied or slightly modified by centuries of workers in all Northern Buddhist countries, that which is the true Indian, which the Chinese, which the Corean, and which the Japanese, has become the great puzzle of the students for the last twenty years. And while in many cases we can identify with considerable probability the racial element in the school of design, it is often impossible to assert that the object which displays this may not be an early copy executed by a foreign artist. I am not now speaking of modern bronze copies, which can be fairly well distinguished from the antiques; I am referring only to bronze whose certain date must fall between the second and seventh centuries. The same is true, to a less extent, of the wooden statues.

The Han dynasty of China fell in 221 A.D. after a long period of weakness, which was destined to be followed by a break-up into separate feudal states almost as hopeless as the disintegration of the Roman Empire which was already commencing. The third century after Christ was given over in China to the terrible anarchy involved in the sanguinary " Wars of the Three States," a mediæval age of epic heroism, which has been sung in a hundred forms of prose and verse, both in China and Japan, and entered as motive into a dozen dramas. From this wild warfare issues the colossal shape of a hero, Kwan Yü, with a sad face and herculean frame, who is still worshipped as a Chinese Mars.

In such confused times it is improbable that any definite move toward a new Chinese School of Buddhist art could be afforded. The art and the poetry are both confessed off-shoots from the Han stem. And the next century became even worse, for now many Tartar conquerors, emboldened by the dissensions of the Chinese Kingdoms, came down from the North, mingling as mercenaries with their employers, quite as the Teutonic people at the same moment were enslaving in Europe the Roman army ; until, finally, they were able to wrench away from the nominal Chinese Emperor a large portion of his Northern tributaries. It is part of the same great irruption that was beginning to let loose a tidal wave of the kindred Tartar Huns against the Roman Empire.

So far as we can peer back into the arts of this day, they show only a clumsy Chinese modification of the Indian Buddhist types.

The great wooden Buddha of Seirioji, near Kioto, the most primitive of all the Southern types of Chinese Buddhas, is probably a Chinese work of this fourth century, retaining much of the Han clumsiness and angular sharpness of feature, while it turns into a certain symmetrical rude decoration the Indian lines of clinging stuff, which it can afford to raise into heavier carving upon its wooden surface. The ancient tradition is that it is the original contemporary statue of Buddha, brought from India to China, whence it was stolen by a Japanese devotee who surreptitiously substituted a copy. But such manuscript traditions in the records of Japanese Buddhist temples are for the most part of no great weight, and we are free to believe this a Chinese original modified from some Indian statuette or drawing.

By the year 420 of our era a decisive change was wrought for China, full of the most important consequences for the future of her literature and art ; and that was a clear division of the groups of Chinese states into North and South dynasties—the whole North, the ancestral seats, being taken over by Tartar conquerors, and for the first time Emperors of pure Chinese race moving their capital down into the lately civilised South. This separation, with relatively long intervals of peace between the two sections, lasted nearly two centuries, down to 589. In these two full centuries Chinese culture, including poetry and art, entirely re-created themselves.

Of what took place in the Tartar regions of the North we know little, since their dynasties have not been recognised by Chinese historians as legitimate. The true Celestial annals, and indeed the lore of Chinese genius, belong at this time to the stimulus afforded by the new Southern conditions. The new Capital, near the present Nankin, was on the great Yangtse, now just blossoming into her heritage of wealth and commerce, and not far from the centre of a most picturesque region, splendid lakes and magnificent mountains, still almost unexplored, and covered with dense primeval forests. Not only did this sudden revelation of natural beauty impress the Chinese imagination, heretofore fed upon the more arid plains of the more ancient North ; but it must be remembered that it was in this very central district, hardly yet won to Mongol culture, that Laotse, the founder of Individualism and Taoism, had been born some 1,000 years before ; that here the first great elegiac poet, Kutsugen, had poured forth his lamentations in rich splendour of imagery and the long swinging lines of a new

metre. Here, too, a primitive people, of smaller stature, possibly allied to the Japanese, had pursued rude arts of their own from an unpierced antiquity, among which were the plastic forms of unglazed vases, and the rude effigies of animals and birds in the same rough material. Later in the Han dynasty this very plastic genius had found vent in characteristic bronzes, such as the drums and the frogs set upon their face. Here were veins of feeling and susceptibility fresh and unworked, capable of inoculating with new power the somewhat worn imagination of the destroyers of Han. It was the reversal of geographical relationships in Europe, where the dispersed Romans found new springs of effort in the vigorous forests of a German North. It must be noticed, too, that these Southern seats of the Chinese were in closer proximity to a new part of India, the South through Burmah, or along the opening lines of coast trade. A few adventurous Arabian merchants were already seeking the Southern and Eastern ports ; and a revived native dynasty in Persia (the Sassanian) was in some vague communication by sea with the Chinese coast. The Byzantine Empire, on the other hand, the Eastern successor of the Romans, still held a caravan overland trade with the Northern or Tartar provinces. Still, as late as 451, the Hunnish invasions of Europe largely blocked the lines of peaceful traffic. In the great simultaneous dissolving of the Roman and Han Empires, the unstable hordes of Tartar locusts blotted out vast regions of intervening space, and almost obliterated the memory of the earlier contact. Civilisation had to be resown at both ends, and it was the new Southern dynasties of China that began to reap the Eastern harvest.

It was here, too, in the Southern Chinese nests, that Buddhism could drop her most fertile germs. The Northern route from India to China was precarious at best ; the superstitious tribes on the desert border welcomed Indian culture as a new kind of fetich rather than as inner enlightenment, and the Confucian scholars of Wei were, as always, most powerful with their Tartar masters, and even led them at times to kill Buddhist priests and destroy monasteries. It was in the romantic, the Taoist, the Individualistic South that the deeper Buddhism found its natural ally. Taoism was already the sworn foe of the Confucian Socialism, full of mystical leanings, inclined to poetry and art. With it the stronger tenets of a positive Buddhism that regarded the devotee as a kind of spiritual hero, able to conquer

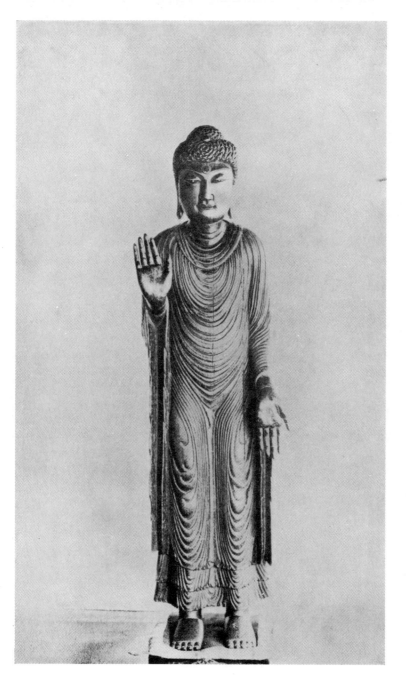

EARLY STATUE OF BUDDHA. At Serioji, near Kioto.

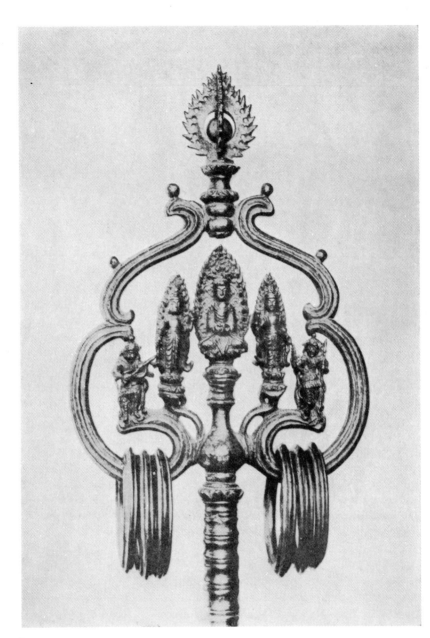

BRONZE FIGURES ON A PRIEST'S STAFF-HEAD.

all regions of matter and spirit, quickly amalgamated. In short, we can assert that the religion of the three Southern dynasties which now ruled successively at Nanking—the Sung, the Ts'i, and the Liang— is a working union between Taoism and Buddhism, which practically excluded for the time all the chilly growth of Confucian classicism. Here, at these Courts upon the Yangtse, or often in picturesque monasteries perched high on the shoulders of wild mountains, the imported Indian priests and their native scholars mastered the greater part of that stupendous translation of Sanscrit and Pali texts which is known as the Chinese canon. The enormously rich literary treasures of the Indian mind, and of Buddhist lore in its successive growths, lay now in the hands of the imaginative Chinese.

One more important factor must be noticed—the general adoption throughout China of a new form of writing material, a fine grained paper, instead of bamboo and clumsy bark papyrus, with flexible silk tissue for æsthetic effort ; the manufacture of a rich dark ink from lamp-black mixed with glue ; and especially an improved form of hair pencil, which, with firm thick base, thinned at the tip into a fine point, afforded great elasticity and modulated thickness to the touch ; and a full reservoir of pigment for prolonged writing. With these tools Chinese written characters became transformed from the several stages of cutting and smearing in clumsy symbolism into a pure caligraphic art where the flexibility of perfect brush stroke could unite with decorative proportioning. Also a new medium for art was now furnished, that could substitute for rudely relieved silhouettes upon bronze, stone, or wooden plates, freer images conceived first in terms of separated and highly decorative lines, which lines could then be filled in with tones of ink, or with colours to differentiate pictorially the value of masses.

It was in the first of the three Southern dynasties, the Sung (So), that all these innovations found notable beginnings. The great poet, Toemmei,* for the first time, praises the life of rustic freedom upon the Yangtse, and forms one of a White Lotos Club of mountain climbers and thinkers organized under the leadership of a Buddhist priest. His contemporary, Ogishi (Wang Hsi-chih), first established the splendid spacing of written characters in manuscripts, and the free thickening and thinning of the strokes, which renders him the " Father

* In Chinese " T'ao Yüan-ming."

of Chinese handwriting," and came later to its fruition with the perfect style of the Tang dynasty. The new opportunity of painting, too, had been seized a little earlier by So Fukko, who had utilized the freer brush stroke to delineate dragons floating in clouds of softer tone. A contemporary of Toemmei and Ogishi, Kogaishi (Ku K'ai-chih), had gone further in trying to make the lines executed by the brush a rhythmic outline for poetically conceived figures. He is thus the father of pure Chinese figure painting.* We know that he painted the first portrait of the Upasaka Yuima, the prototype of the lay Buddhist philosopher who was fast taking the place in this So of the Confucian Mandarin. All later portraits of Yuima, who is traditionally a Hindu metaphysician originally opposed to Sakyamuni, but converted by the latter's disciple Ananda, are developments from the thought of Kogaishi's. It may be that some original or copy sufficiently like the lost Kogaishi original may yet be lurking in the archives of some rustic Chinese noble ; but all those which in Japan lay claim to being such bear evidence of later inspiration. But in the Kinseki So we find two figures which had been cut on stone from drawings by Kogaishi, and which probably give a fair idea of his delineation, but not of his toning in ink and colour. What we are to look for in Kogaishi's pen force is made clear by the statement of later critics that Godoshi really founded his stupendous line upon the key afforded by this master.

The short-lived Sei (Ch'i) dynasty (479-502), which succeeded the So (Sung), only carried these movements further. The great landscape poet, Shareiun, following Toemmei, gives us the metrical praise of wild mountain forms, like a veritable Chinese Wordsworth, introduces the formal stanza of lines of seven characters that come to perfection in Tang, and originates the word for "landscape," which afterwards becomes classic in both China and Japan, namely "sansui" ; that is, *mountain and water*, assuming that in a perfect landscape painting or poem there must occur both the upheaval of form and the contrast, or softening, of it by alluvial motion. Here, too, Buddhist painting practically originates in an effort to substitute tinted drawings of altar-pieces for the statuesque originals. These originals were often coloured when not of bronze, and the

* EDITOR'S NOTE.—The painting by Kogaishi in the British Museum is now recognised as undoubtedly genuine. There is said to be another in the great collection of Tuan-fang, in China.

new pictorial art could well represent the heavy statue on a scroll of silk, capable of easy transportation. The lines for such work would rather be hair lines representing the contours of sculpture than forceful delineations of the thickened brush—a pictorial style which we may suppose to have been imported, too, with Indian drawings. In this way it may well be that the beginnings of strong line work with Kogaishiin So were partly obscured by more delicate colour decorations of Buddhist painting, until revived by Godoshi (Wu Tao-tzu) in the 8th century. An example of such early Buddhist painting, which follows the lines of statuary and delicate carving in halos, is shown in this book.

But the real culmination of this romantic Southern illumination did not appear till the Rio (Liang) dynasty in 502, and especially the long reign of Butei (Wu-ti), its founder, who had been the chief general of the waning Sei ; and who, the namesake of the Han Emperor celebrated for opening intercourse with Western Asia six centuries before, is the first great picturesque figure on the Chinese throne since that famed Han (Kan) reign. Butei, denounced by the later Confucian analysts as a superstitious bigot, is one of those great, generous-minded monarchs who, full of hope and genius, fall into misfortune through their lack of worldly wisdom. At first he was a staunch advocate of Taoism, giving, indeed, to all late Chinese literature that flavour of enthusiasm over hermit life and the mysterious power attainable through mountain freedom which to-day is best preserved in the romanticism of the Japanese soul. But early in his reign the twenty-eighth Buddhist patriarch, Daruma, came to Western China from India, and Butei invited him to his Court, where he became his chief patron and student, affording him perfect seclusion in a cave temple among the mountains. It was this same Daruma who amid these picturesque scenes developed the thought and discipline of a new Buddhist sect, the Dhyā-na or Zen, which, however, did not bear its full fruition of influence upon literature and art until the Sung dynasty. Butei (Wu-ti) has never been forgiven by later Mandarins because, a few years later, he went the extreme length of dedicating himself, though still an Emperor, as full Buddhist priest in the temple of Dotaiji.* In 546 he went about his kingdom preaching Buddha in person, like an itinerant monk. In

* Dotaiji (T'ung-Tai-sü) is one of five temples built by the Emperor Wu Ti.

this way his dynasty weakened, and was soon succeeded by the short-lived Chu (Ch'en).

The development of landscape poetry and of Buddhist painting under Liang was enormous ; but most of the latter is lost in all but name. It is possible that the famous landscape painting in oil upon leather that decorates the Chinese biwa or lute in the Japanese treasury at Nara, dates from this time; but the Tartar nature of the scenery and costume, in spite of the elephant, would lead us to ascribe it, if so early at all, to a Northern contemporary artist. Traces of Buddhist Liang painting are met with, however; the considerably defaced Amidaiji Mandarin * of Nara-Ken probably belonging to this age.

But the bulk of the knowledge which we have of the Buddhist art of Rio (Liang) and Chin (Ch'en), of their Northern contemporary, and of the following Sui dynasty (589-618), which united North and South, after two centuries of separation, into a provisional Empire, is derived from the remains of sculpture rather than of painting. Pictorial art still remained, to the second century of Tang, an inferior and derivative one. The greatest glories of far-Eastern sculpture were still to create ; and here we must give a brief account of their tentative forms.

The statues of this whole separated period—5th and 6th centuries—are divisible into two great forms, as they derive their nature from Northern Tartar or from Southern Chinese influences. The Northern school is more clearly related to the lingering traces of Han and to the early Himalayan Buddhist forms that had first penetrated China by the Northern route. Here the rhythmic curvature and the attenuated forms, partly based upon Persian and Baktrian art, which we studied under Han in the last chapter, find new opportunity to expand in the richer Buddhist iconography. The rhythmic lines of decoration, first shown in Mesopotamian ornament, and afterward in such Ceylonese as the " moonstones," now enter into the lotos and flame halos of delicate bronzes, often in low relief. The figures in these reliefs, sometimes to be studied from stone copies, are generally, to the North, much attenuated, long, thin, and graceful, not unlike the Greekish figures found in relief upon Baktrian coins. The earliest Chinese Himalayan bronzes,

* Amidaiji, or "Amida-in," is a temple of the Yōdo sect.—Professor Petrucci.

though ruder, had this tendency to slimness and height. These two features, attenuation and decorative curvature, distinguish the finest North Chinese sculpture of the 6th century.

But in the South we have a different movement, which perhaps is to be regarded as double. On the one side, more graceful Buddhas of a South Indian type, with concentric lines of clinging drapery, persist down to the Tang; but, more important, there is a movement, particularly located in the Eastern provinces of the South—called Go*—to utilize for purposes of Buddhist sculpture the indigenous plastic genius which had created the unglazed pottery, the bronze drums, and the clay and bronze animals, such as the frogs. This plastic genius of the South, long lying dormant and confined to secular decoration, now suddenly expanded in the new field of Buddhist creation. The bronze Buddhas of this school, like the Han and post-Han animals, are heavy and severe in type, square in their main shapes—square heads, square crowns, square bodies to which the flying draperies closely cling—the heads, hands and feet too large for the bodies; the draperies opening in little shell-shaped folds, the features hard and sharp, with projecting angular nose—not unlike what the heads in the Han stone silhouettes suggest. We can feel that this is a more primitive art than the Northern, with not the faintest suggestion of Greco-Baktrian grace in it, and hardly more than a trace of Indian suavity. It is not specifically Pacific either, although there remains a chance that what I have spoken of as the Southern prehistoric school of unglazed clay modelling may be remotely related to Pacific. The type of such Buddhas and Bodhisattwas, for the two are not greatly differentiated, is the gilt bronze statuette still at Horiuji. It comes like a being from a new Buddhist world.

We have many reasons to believe that a considerable intercourse had grown up between the Eastern Chinese of Go and the early Japanese, as far back as the fifth century at least. Hence came by the evident sea-route the knowledge of Chinese writing and classical literature, and the first hints of Buddhism. The Japanese still call their earliest pronunciation of Chinese characters—preserved by their syllabury—"the Go sound." There must have been immigration to Japan from Go, for we have such traditions as that a Chinese

* "Go" signifies in Japanese "Southern."—Professor Petrucci.

Buddhist sculptor of the Go School came over to Japan about the year 500, and became naturalized in Yamato under the family name Tori. We shall notice the work of the descendants of this man in the next chapter.

A most interesting merging of these several Northern and Southern schools of art, and of the social tendencies to which they belonged, was achieved in the year 589 by the foundation of the first solid Imperial dynasty since the fall of Han, 350 years before. This Sui (Zui) dynasty, passionately devoted to Buddhism, proved to be short-lived, serving as a mere introduction to the great Tang (To) dynasty, as the Tsin had done for the Han 800 years earlier. For purposes of the history of culture we may take the Sui and the earliest years of Han as if they formed a single movement. The characteristics of this movement are clearly involved in a fertile union of so many rich diverging tendencies.

For a moment the lordly Confucians of the North, rejoicing in the re-achieved national unity, joined hands with their Buddhist and Taoist brothers from the South, mingling tendencies to literary and art impulse which had diverged or grown up under widely differing conditions. The whole rich past of Chinese experience could be brought under a single view, and creation could be attempted in a new and freer form that should transcend all the other forms, while incorporating their material. This is the central reason for that extraordinary flowing of the Chinese genius in the early Tang dynasty. We shall follow it only in its very first steps, up say to about 640 A.D., and again only so far as it affects Buddhist sculpture.

It is fairly clear just how the bronze types were enriched by a conjunction of the two main tendencies, although for a time, as in the early Corean work, we notice a good deal of oscillation between the two poles, and some ineffective effort. In general we may point to a reconciliation between the two main æsthetic features of North and South—the tall slim grace and exquisite curvature of the former, and the heavy and solid sobriety of plastic form in the latter. The strong bronze modelling of the Tori type, mentioned above, now became used to execute more rounded, tall and human figures, of perfected contour. Such bronze statuettes as the Buddha of Healing, Yakushi catching up his long robes in his left hand, probably belong to this new movement. So does the larger seated figure formerly belonging to M. S. Bing, of

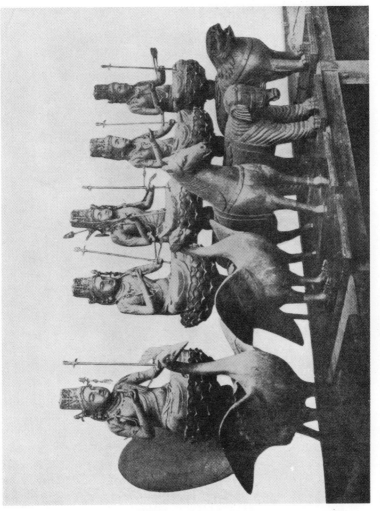

The "Five Kokuzo." At Toji, Kioto.

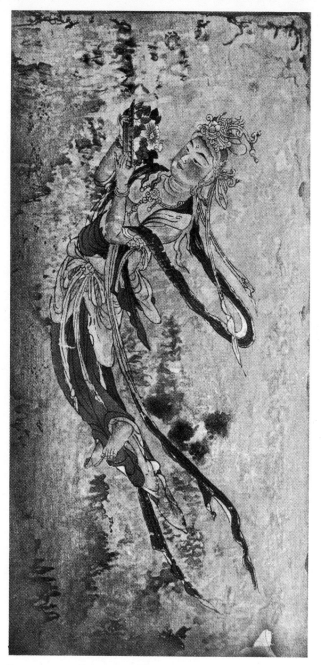

DETAIL OF THE FRESCOES AT HORIUJI.

Paris, with the beautiful plates and the base of angels in low relief seated on lotos thrones and playing on musical instruments. These latter figures have a combination of grace and sweetness in conception, and of a certain rude *naïveté* in style, that reminds us of the early work of Donatello. A still more perfect example is the little bronze Kwannon of Contemplation, owned by the Fine Arts Academy in Kioto. This was found by one of my Japanese colleagues and myself during one of our early explorations, and purchased by us as a nucleus for treasures which we hoped that a museum attached to the coming school would eventually collect. This has perfect suavity of contour combined with restraint, as naive as an Egyptian bronze, yet human as archaic Greek, using the fold system of the bronze drapery in the Go School as the starting-point of wonderfully rich and unsymmetrical line relations. But one of the finest groups of this period (from 580 to 640 A.D.) are the hard, dark wooden statues, more than half of the size of life, of the so-called " 5 Kokuzo," now owned by the temple of Toji in Southern Kioto. These retain all the quality and feeling of bronze ; the splendid naive animals, peacock, horse, etc., on which the figures sit, recalling the early Southern animal sculptures in clay and metal. The figures here show that projection of the face line in profile over the line of the depressed chest, and nearly in line with the projecting abdomen, which belongs to most all the work of this day (600 A.D.) in China, Corea, and Japan. It is possible that this characteristic contour implies the mystical depression of the diaphragm and the withholding of inspiration—a feature entirely changed in later work. Here too the lengthening of the lobes of the ears is shown to be due to the insertion of heavy cylindrical ornaments enlarged at each end. This feature is found in other Chinese statues of this date, as in the Chin or Dzin Bisjamon of Seiroji, near Kioto. Here we have the very type of a North Chinese warrior, with oblique rolling eyes, but of a tall slender figure clothed in armour, utterly opposed to the dumpy Chinese warriors of modern art.

That we should make a break at this point is due to the facts—first, that Corean and Japanese art have already started under influences derived from North, South, and the Sui union ; so that we should study these important branches in connection with the parent stem ; and the fact that Chinese art itself is about to take on several new features with the rising Tang, notably the modifications of the Greco-Buddhist

School. Before we come to consider that powerful solvent, we must make a full inventory of those naive but charming forms of Far-Eastern Buddhist art that centre about the illumination of Sui. In Japan especially we shall find records of this art far richer and more splendid than any which have yet been discovered by us in China. But the Japanese branch grew partly from Corean transplanting, so that we must first consider briefly the art of the Peninsula.

Chapter IV.

EARLY COREAN AND JAPANESE BUDDHIST ART. CHINESE INFLUENCE. BRONZE SCULPTURE.

6th and 7th Centuries A.D.

CHINA is, in fact, what she names herself, " The Middle Kingdom." She is like a great central tower encircled with powerful buttresses of races, partly akin to her in blood, partly tributary, but all feeling the weight of her great ideals. Her neighbours on the west and south—Thibetans, Burmese, Malays of Siam and Annam—we do not specially consider in this monograph, what is strongest in their early art being more related to Indian than Mongolian. But on the north and north-east China is fringed with a line of states and peoples, often hostile, sometimes servile, but of a blood and thought closely akin to her own. These, too, have all been submerged by very similar waves of Northern Buddhism ; and they have imported from the common centre Taoist and Confucian principles in varying proportions.

The Hunnish, Scythian and Mongolian hordes to the north have seldom entered sufficiently into the pale of civilization to produce even a branch art, except when, for short periods, they have put themselves in possession of the Imperial throne. They have little in common with what we have called the Pacific affiliations of the primitive Chinese. But for the tribes on the Amoor river—to a less extent the Manchus—for the Coreans, and especially for the Japanese, what is primitive and what is fine in Chinese life and art have had a vital meaning, so that we may regard their several, and often robust, civilizations as almost integral parts of the central movement. The most original and the most independent of all these surrounding states has been, of course, the Japanese. The civilization of this complex island race has often proved itself, and is proving itself again to-day, to be for incisive idea and flexibility of spirit—less a subordinate or

tributary than an independent leader in the whole group. No doubt it can be made the object of a separate study ; and yet, especially for the purposes of Art, there is sound value in regarding its work as a variation, though a very unruly one, upon the Chinese norm.

Closer to China than is Japan, closer in spirit if not in race, because closer in communication, lies the peninsula of Corea, originally a wealthy, prosperous, and progressive country, though now so feeble. Corea has only in part, and then for very short periods, been included within the limits of the Chinese empire. At other periods she has been dominated, and now seems finally to be dominated, by the Japanese. But in the early days of her civilization, from the 4th to the 7th centuries of our era, she betrayed so much of independent vigour and genius as to make her art, though only for a short illumination, a special and important centre of creation. This happened, too, at a time when Japan, still in the grasp of semi-barbarism, was prepared to take her first great step out into the light. That the neighbouring states of Corea, only a few days' sail across the narrow straits, should have become the special tutor of Japan at the time of Japan's most critical youth, is a circumstance so fortunate as to make at least a brief study of her early Art a part of the study of Chinese and Japanese. Corea, in some real sense, was a link between the two ; and for a moment, about the year 600, her Art flared up into a splendour which fairly surpassed the achievements of her two chief rivals.

A still juster view of the relationship is found, if we consider the juxtaposition of three important land projections into the China Sea : the peninsula of Corea pointing south-east, the Southern islands of Japan sweeping to the south-west, and the Chinese province of Go projecting to the north of east. Between these three early sea communication had been easy, and both Corea and Japan had been influenced by the Art of Go while they were still in their barbarous beginnings.

Some European writers have appeared to hold that Corean Art in the 6th century must have been influenced quite specially by the Art of Persia. This seems to be due to their assumption that Persian Art in the 6th century was like what it became after contact with Mongolic races in the 13th century and onward. The Persian Art of this day was Sassanian, which can be described as a mixture of debased Assyrian with debased Roman. We have already seen that

the early Tang dynasty of China was in some sort of communication with the Sassanian coast. Whatever small Persian influence entered Corea and Japan at this time was Sassanian, and in both cases probably derived from intercourse with Go, where commercial relations with the ports of the Indian Ocean were already centering. The likeness of Corean, Chinese and Japanese Art of the 7th century, however, to the Persian of a later day, such as it is, is much more likely due to a counter-wave of influence, which carried Eastern motive into West Asia. This movement, however, and in fact the many refluxes of influence between China, India and Persia, lie beyond our scope.

The early Buddhist Art of Corea, of which we hardly get satisfactory glimpses before the 6th century, is derived from a convergence of the same two streams which, as we have seen, were to enrich the central-ized Art of the Dzin dynasty in China; that is, motives from both North and South. By overland route Corea remained in close touch with the Tartar north, with its Corean trade with the Mongols and Manchus and Amoor peoples, and thus with a more primitive slender Buddhist type that ran somewhat to effeminacy of curve decoration. By mari-time route, on the other hand, Corea had come under the influence of the southern Yangtse provinces, with their severe sculpturesque style and their skill for modelling in bronze. In a special sense, therefore, Corea had already forestalled the Dzin dynasty in its ability to unite the two streams of south and north, and therefore rose upon a sudden wave of artistic power which in China itself was slower in gathering. Corean Art, however, is not just like Dzin ; partly because of a new racial genius, partly because the elements were to be combined in different proportions. In the finest Corean work the Go element probably played a more decisive part, because while to China Go was only a part of the south, to Corea it was the south itself. We find, then, in Corean 6th century Art a wider range of forms between the two extremes of excessive attenuation and short dumpy figures with large heads.

The Corean race was probably in prehistoric times, like its neighbours, strongly affiliated in custom with the Northern Pacific races ; but records of this early day are mostly lost. As in Japan, the relics dug from primitive graves reveal forms related to the Han dynasty of China, under which Pacific motive is already submerged. But during the days of Han itself, Corea and Japan, quite independent of the Chinese

monarch, had come into close relations through an invasion of Japan. If we could see the rude art of both peoples at this time we should probably find it Pacific. Corea paid tribute to Japan for many years. Still neither of those peoples could have been regarded as highly civilized. The beginnings of Corean culture, which preceded Japanese, themselves followed the dispersion of Chinese peoples due to the long disturbance of the civil wars of the 3rd century. Feudal, as distinguished from dynastic Han, held out until 263. Go, one of the most important of the three fighting states, submitted to Western Shin, thus ending the war in 280. Doubtless whole groups of colonizers from Han and Go had sought shelter in the neutral peninsula, thus bringing the industries of civilization. The study of Chinese writing and of one or two Confucian classics came even as far as Japan, but from Corea, in 285. Through the 4th century these disturbances persisted, and little new culture could have been gained. But with the division between north and south in the 3rd, the new Buddhist Art, sweeping over China in two separate waves, could reunite in Corean creative efforts. It is from this date that we consider a high Corean Buddhist culture to begin that finally displaces the relics of Han Art. But perhaps nothing that we have to show of Corean Art dates from before the 6th century. It is almost entirely derived from early importations into Japan. No attempt will here be made to distinguish between the arts of the three states into which Corea was early divided, but we shall merely say that the state called Hiakusai, the nearest both to Japan and to Go, produced most of the pieces which have been preserved to Japan.

One of the earliest Corean Buddhist types which we possess is the very attenuated bronze seated Kwannon of contemplation, a small statuette. Its extreme thinness is almost grotesque, and its sharp features are a mixture of Han and Himalayan. On the other hand, the draperies show influence of the Go method. A much larger figure of the same subject is worked up in wood and leather, the latter substance being used for the connecting bands of drapery. By far the tallest of the Corean figures is the standing Kwannon with a vase, still on the great altar of the Kondo of Horiuji. The head is small and well formed, but the body of excessive length, some fifteen heads perhaps. The close fitting of the long downward drapery lines, with almost no relief, is essentially Corean, but that phase of it which may be Sassanian is native. A stiff formal curvature is given to the openings of folds,

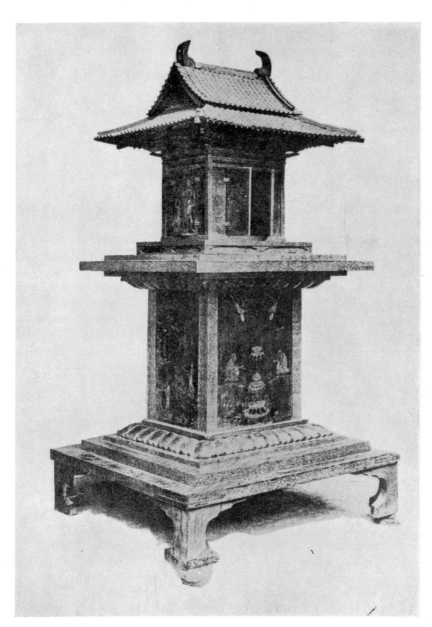

THE FAMOUS COREAN TAMAMUSHI SHRINE
 at Horiuji.

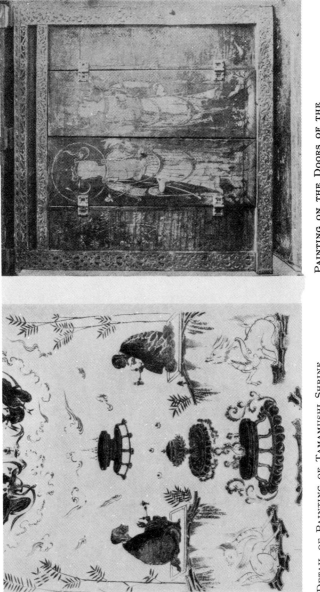

PAINTING ON THE DOORS OF THE
TAMAMUSHI SHRINE.

DETAIL OF PAINTING OF TAMAMUSHI SHRINE.
Horiuji.

the ends of mantles curving up like flower petals. For primitive painting and early writing in the Go style we have the illuminated Scripture roll, where little dumpy Buddhas are surrounded by equally crude disciples, all in harsh primitive colours. The vague suggestions of rock and tree are in a free scratchy style that recalls the early Chinese landscape in oil previously mentioned.

That this is the very nature of Corean landscape is also shown by the paintings, also probably in thin oil, upon the so-called Tamamushi Shrine. But elaborate Corean secular painting is best exemplified in the portrait of the Japanese Prince Shotoku, made at the beginning of the 7th century by his guest, the Corean Prince Asa.

Two great monuments of sixth-century Corean art still remain. The Tamamushi Shrine, already mentioned, is a miniature two-story temple made of wood, to be used as a kind of reliquary, which was presented to the Japanese Empress about 590 A.D., and which still stands in perfect preservation upon the great altar at Horiuji, near Nara. The roof is finished in metal in the form of tiling. The lower story is hardly more than a great box, with paintings upon its four sides. But the upper story opens with miniature temple doors, which, as well as the solid parts of the walls, are elaborately painted on the exterior. The paintings below are much defaced, but the landscape portions show mountain forms that are probably akin to the Han clay reliefs of the Kunlung range. Long, lanky Buddhist angels fly through the air, amid bamboo trees. The finest paintings, and best preserved, are the two tall, thin Buddhist deities upon the doors, which show a relationship to the thin art of the Northern Wei. Here is a hint of the flying draperies, which sculpture for the most part eschewed. But the most striking feature about this shrine is the elaborate finish of all the corners and pillars and transverse beams with an overlay of plates of perforated bronze, which were probably gilded, the patterns of the perforation being among the finest specimens of the Corean power over abstract curvature. These repeating patterns are full of unique pictorial tangles of long, cool curves of restraint, knotting themselves at unexpected foci. This fine Corean curvature we must explain as an outcome of the Babylonian of Han, reinforced by the Persio-Indian of Buddhist originals, like the "moonstones," made delicate by Tartar Art in the divided centuries, and strong again by the specially decorative genius of the Coreans.

How early the Coreans began their plastic work in glazed pottery, for which they later became so famous, is still a disputed question. No examples of it are found in the Japanese treasury of the 8th century. Corean temple architecture is exemplified by the oldest buildings of Horiuji in Japan, which we shall soon describe ; and the decorative arts are still further shown in the hangings and carvings upon the Kondo of Horiuji. Some of the priests' vestments, showing Sassanian designs of rosettes essentially Babylonian, and Persian groups of hunting kings and lions were probably brought from Hiakusai at this time.

But the greatest perfect monument of Corean Art that has come down to us, without which we could only conjecture as to the height reached by the peninsula creations, is the great standing Buddha, or possibly Bodhisattwa, of the Yumedono pavilion at Horiuji. This most beautiful statue, a little larger than life, was discovered by me and a Japanese colleague in the summer of 1884. I had credentials from the central government which enabled me to requisition the opening of godowns and shrines. The central space of the octagonal Yumedono was occupied by a great closed shrine, which ascended like a pillar towards the apex. The priests of Horiuji confessed that tradition ascribed the contents of the shrine to Corean work of the days of Suiko, but that it had not been opened for more than two hundred years. On fire with the prospect of such a unique treasure, we urged the priests to open it by every argument at our command. They resisted long, alleging that in punishment for the sacrilege an earthquake might well destroy the temple. Finally we prevailed, and I shall never forget our feelings as the long disused key rattled in the rusty lock. Within the shrine appeared a tall mass closely wrapped about in swathing bands of cotton cloth, upon which the dust of ages had gathered. It was no light task to unwrap the contents, some 500 yards of cloth having been used, and our eyes and nostrils were in danger of being choked with the pungent dust. But at last the final folds of the covering fell away, and this marvellous statue, unique in the world, came forth to human sight for the first time in centuries. It was a little taller than life, but hollow at the back, carved most carefully from some hard wood which had been covered with gilding, now stained to the yellow-brown of bronze. The head was ornamented with a wonderful crown of Corean openwork gilt bronze, from which hung long streamers of the same material set with jewels.

But it was the æsthetic wonders of this work that attracted us most. From the front the figure is not quite so noble, but seen in profile it seemed to rise to the height of archaic Greek art. The long lines of drapery, sweeping at the two sides from shoulders to feet, were unbroken in single quiet curves approximating straight lines, giving great height and dignity to the figure. The chest was depressed, the abdomen slightly protruding, the action of the hands, holding between them a jewel or casket of medicine, rendered with vigorous modelling. But the finest feature was the profile view of the head, with its sharp Han nose, its straight clear forehead, and its rather large—almost negroid —lips, on which a quiet mysterious smile played, not unlike Da Vinci's Mona Lisa's. Recalling the archaic stiffness of Egyptian Art at its finest, it appeared still finer in the sharpness and individuality of the cutting. In slimness it was like a Gothic statue from Amiens, but far more peaceful and unified in its single system of lines. Its arrangement of draperies seemed to be based upon the bronze statuette type of Go, but suddenly expanded to unexpected beauty by the addition of such slender proportions. We saw at once that it was the supreme masterpiece of Corean creation, and must have proved a most powerful model to the artists of Suiko, especially to Shotoku; but all that we have to speak of later.

The one additional feature which here merits the highest praise is the wonderful flower-like tangle of the curved lines in the openwork crown which twine about the focus of a crescent moon. Whatever the promise of decorative beauty in low relief or perforated plates already approached by Han mirrors, or Wei groups, or the Corean scroll work upon Tamamushi, all were far surpassed by the richness and æsthetic unity of this splendid crown. It must ever remain a chief monument of the temporary supremacy of Corean Art at the end of the sixth century.

This must end our special account of Corean Art, which we introduce here only because it forms the fitting and necessary preface to the study of early Japanese Buddhistic art. If the Go influence came directly into Japan with the Tori family and others, it recoiled again in a second more fluent wave and mingled with other fertile germs from the shores of Corea. So many were the types that came pouring into Japan from all parts of Asia, India, North China, Go and Corea, that at first the Japanese sculptors were almost bewildered. The

variety of choice, however, brought with it freedom ; and certainly among all the most delicate and æsthetic models were those which little Corea furnished.

* * * * * * * *

In entering upon the study of the total Art of Japan we have a subject which might well be detached for a separate monograph. And yet we deliberately renounce the privilege of that more obvious unity for the difficult task of describing the larger unity into which the creations of all East Asian peoples were really swept. It may seem presumptuous for one who is neither a scholar nor a sociologist to group cultures which no scholar yet understands in their separation ; and yet just because art work furnishes such a large amount of evidence, impressive even where it lacks explanatory record, it is most important to weigh the unique testimony of these æsthetic documents.

Japan ! What romantic thoughts and memories arise at the name ! Set uniquely along the coming paths of traffic between East and West, endowed by temperament to become the interpreter of East to West and of West to East, we have here an illuminated corner of history's scroll, a flash of human genius at highest tension, which in our records only the sensitively organized Greek, and that for only a few centuries, ever reached. The land itself—a fitting casket for the soul— is as broken into islands, peaks and promontories as the Greek Archi- pelago, but swathed with a far richer garment of semi-tropical foliage. The charm of the South Sea Islands is all here without their excessive enervation ; for along her second unique line of geographical setting, Japan, washed on opposite sides by currents from the Equator and the Pole, declares also kinship to that bright North with its mysterious races who still seem to retain the keys of Pacific Art.

It would be folly here to attempt even a succinct view of Japanese history or culture, or to enter into those deep studies of Shinto motive and family cult which Lafcadio Hearn has illuminated. I shall have to assume that the reader already knows much of this, and confine myself to those additional bits of information which throw direct light upon the path of Art.

Japanese civilized Art probably begins at the end of the 6th century with the almost simultaneous introduction of Buddhism from Go, from Dzin, and from Hiakusai. And yet there is never a beginning to a national art ; pursue it as far back as we may to some primitive guiding

impulse, beyond that we still find traces of indigenous power. The long interval between the 3rd and the 6th century was for Japan a period of slow acquisition, of semi-civilization, of the dim dawning of industry and letters—a period whose almost prehistoric art is known to us only by the recent exploration of rude stone-cut tombs. But still beyond that stretches a far vaguer world of unknown derivation, which has left almost savage traces in the primitive shell-heaps, and which must have had close affiliation with the Ainos of the north and the Miaotse of Go on the south.

The Japanese people, though of extraordinarily complex origin, have been welded by time into an almost homogeneous race. And yet we can trace in their art signs of successive immigrations, much as Dr. Schliemann traces the nine superimposed ages of Ilium. At the bottom, or near it, lie the broken shards of unglazed pottery from the primitive shell-heaps. Above this, perhaps, and connecting it with the Han period, are various relics of the Pacific Age, conventional designs upon bronze ornaments, comma-shaped jewels of hard stone which were once strung into necklaces like bear's claws, and the first hint of masks which, even among their later Shinto derivations, show close analogies with both the south—New Guinea and the Philippines, and the north-east—Alaska and Mexico. In some cases this analogy amounts to identity.

But perhaps the most satisfactory evidence of this early art is found in a comparison of the architecture of the primitive Ise shrines with Filippino huts on the one hand and the Aino villages of Yezo on the other. In a view of the one-storied Aino thatched houses with their narrow streets we probably have a correct glimpse of a Japanese " city " of, say, about the time of Christ, among which the dwelling of the chief or " emperor " was a mere enlargement of the type upon a raised platform much in the Ise style. Aino or Kumaso or Yebisu settlements remained common all over Japan until the 7th century, and lingered in Northern Hondo even down to the 12th. Many Japanese geographical names are derived from this primitive source. It is said to have been in the 2nd year B.C. that an imperial decree abolished the immolation of living human beings at Court funerals, clay figures being substituted. And it was not till 468 A.D. that even the emperor's " palace " enjoyed the addition of a second story.

The first great semi-civilised age, the dawn of civilisation as opposed

to this primitive barbarism, extends from the 3rd century to the 6th, and is conterminous with the slow dispersion of Han Art and blood eastward into Corea and over the Yellow Sea. Yet even this pre-Buddhistic Japan retains Pacific forms in its ornament, mixed with some Han-like patterns derived from Corea and Go. The building of military and industrial roads began in 250 ; weavers were sent as tribute from Corea in 283 ; a finer breed of horse was received the following year ; a Corean Professor of Chinese classics introduced the written characters in 285 ; Chinese came from Han in 289; Corean physicians came in 414 ; mulberries were planted in 457; an imperial commission to Go returned in 462 ; Go sends special Chinese weavers in 470 ; carpenters and masons are ordered from Corea in 493 ; a special embassy from the Buddhist Emperor Butei of Liang arrives in 522 ; but the decisive step that marks the limit of this acquisitive age was taken when a Corean prince sent over to the Japanese Emperor Kimmei in 552 a partial set of Buddhist scripture and images presumably bronze.

The chief source of our knowledge of the art of this transition period is the grave tumuli of Yamato and elsewhere, from which modern archæology has unearthed the objects buried with kings, heroes and statesmen. These tombs are narrow chambers lined with large faced stone blocks, over which a large mound of earth was heaped. In the centre of the chamber stands a massive stone coffin, with an enormously heavy board cover in a single piece. From within such capacious receptacles have been disinterred the human bones, armour, swords, jewels, vessels, mirrors and clay figures of men and horses belonging to this interesting day. The unglazed clay work is essentially like Southern Chinese, with its oven-pots surmounted with communal service, and with horses and other animals not unlike in shape the Han pottery derived from Southern sources. This pottery is only a refinement upon the savage fragments found in the primitive shell heaps, only that was more blue in tone, whereas this tends toward cream-yellow. The human figures are rude, mostly like those of wood and stone found throughout Pacific lands, hardly inferior to the best of Mexico and Peru, and at their best rising to a vigour of action, as in the clay bowmen, which foreshadows the civilized Buddhist art of the seventh and eighth centuries.

The metal work is bronze and iron, showing a mixture of at least two influences ; one akin to the work of North-Eastern Asiatic tribes

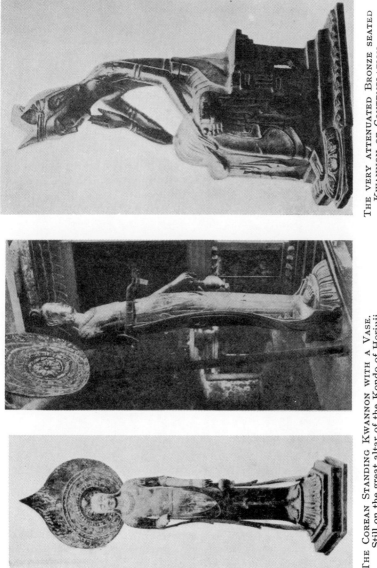

The very attenuated Bronze seated
Kwannon of Contemplation.
At Horiuji.

The Corean Standing Kwannon with a Vase.
Still on the great altar of the Kondo of Horiuji.
Front and profile views.

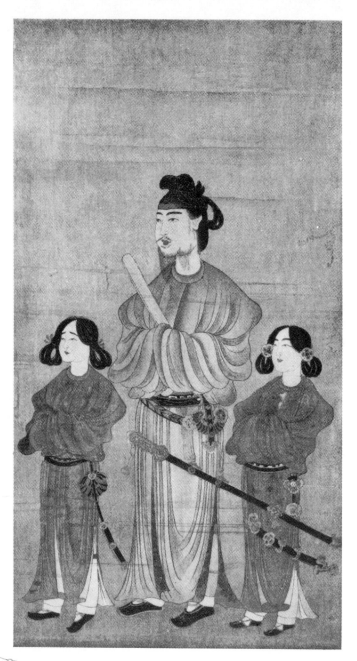

PORTRAIT OF SHOTOKU-TAISHI
AND HIS TWO CHILDREN.
By the Corean Prince Asa.

and essentially Pacific in ornament, the other essentially Han. The Corean derived element is probably itself already a mixture of these two. The sword blades are straight for thrusting, and quite unlike the later curved sword of Japan. Armour is made of a few thin plates of steel sewn or riveted together. Casques are simple pointed domes tightly fitting. Bronze mirrors are clearly Han in type, the simple star and circle ornament relieved on the back, sometimes accompanied by rusty Han inscriptions also in relief. An immense amount of bead work is found, mostly in carved shell and stone, among which the comma-shaped magatama, often of a clear green stone, plays a powerful part. In short, it is all the arts of a crude people rising upon the circumference of civilization through importations from the centre, and not yet sufficient master of itself or of technique to invent indigenous forms.

Upon this simple island people, with its patriarchal organization, its village groups, its crude domestic industries, and its primitive Shinto Shamanism, descended rapidly towards the end of the sixth century the full splendour and force of continental civilization, with its imperial institutes, its rich city life, its imaginative literature, and especially with its deeper moral questioning, religious theories, and vast views of spiritual hierarchy in the world of Buddhist gods. Buddhism crept in slowly, and with some preliminary storms, between the middle and the end of the century, the noble Soga family becoming its strongest patron. But in 593, on the sudden death of the Emperor Sushun, his widow ascended the throne as the Empress Suiko, who thereafter enjoyed an uninterrupted reign of 36 years, dying at the ripe age of 75, a reign so fraught with wonderful changes that we must speak of this first illumination of Japanese culture as we do of the reigns of Elizabeth and Victoria, and call it the age of Suiko. Now the husband of Suiko had, as a younger man, taken part, as had also his son, Shotoku, in the first Buddhist nobles' war that had been declared against the new religion on purist Shinto grounds by the rebel Moriya. On coming to the throne, after substantial victory, Sushun had registered his intention to take the new religion out of private aristocratic patronage, and make it the imperial faith, in short a State religion, as it was already in Corea. This vow of her dead husband the great

Empress Suiko made it her long life work to carry into effect, more than seconded as she was by the Prince Imperial, a man of such extraordinary mind that he takes his place among the great creative sages of Eastern Asia. He has sometimes been called the "Constantine of Buddhism" for Japan. And, though he never ascended the throne, dying some years before his mother, this Prince Shotoku was evidently the core of all reforms. His friend, the King of Hiakusai, delighted at the new move in Japan, sent over his son, Prince Asa, in 597, who then painted the famous portrait of Shotoku already alluded to ; and we may presume that it was at this time that the Tamamushi Shrine, which we have elaborately described, was presented to the Empress Suiko. In 603 and 604, Shotoku himself composed and promulgated a new constitution, which divided the government into graded offices with appropriate rules and costumes. Not content with this, the Empress sent, in 606, a student of the noble class to study constitutional and court law in Dzin, the newly reunited Chinese Empire. Besides his report, the Coreans were zealous in sending Dzin books to Yamato. A history of Japan had been ordered in 620 ; but Shotoku died in the following year.

But the greatest work of Suiko and Shotoku was undoubtedly the founding of Buddhism and of Buddhist Art upon solid and splendid foundations. The first school of Japanese Art proper is the Suiko school. In the second year of the Empress's reign, 594, an imperial decree ordered the building of Buddhist temples, and especially entrusted the work to the young prince. Shotoku now bent all his energies to import from Corea, scholars, priests, architects, wood carvers, bronze founders, clay modellers, masons, gilders, tile makers and weavers ; in short, all skilled artisans whose work was involved in creating and installing a great Buddhist temple such as were already known in the peninsula kingdom. Not content with this, and realizing how utterly the success of such complicated and novel work would depend upon his personal inspection, he deliberately studied craftsmanship in these several arts, placed himself under the most learned and devout of the Corean Buddhist scholars, and in due time allowed himself to take holy orders under the name Shotoku, somewhat like but with more serious purpose than the Chinese Emperor Butei of Liang a century before. Full of modesty, zeal, and piety, Shotoku gave lectures, interpreting the new religion, not only to his relatives

in the Court, but to the people, who, dazed with the splendour and soul-stimulus of the new culture, thronged earnestly to hear him in the temples.

But Shotoku never lost sight of his central purpose to erect a great dominating monastery in grounds not far removed from the imperial residence. The capital of Japan, which had been removed by successive monarchs from point to point of Yamato provinces ever since the days of its conqueror, Jimmu Tenno, was now located on the site of the present town of Tatsuta, a little station on the Nara-Ozaka railway, where the picturesque winding Tatsuta river, famous in even the earliest Japanese poetry for its fringe of maples emerging from the slopes of Mount Kaminabi, debouches upon the gravelly northern slopes of the great Yamato plain. Here, upon the last curvetting of the foothills, between whose grim and scarred domes ran up little bays of level green that might support the monastery with abundant harvest, Shotoku decided to erect his master temple. A labour of disappointing years it was to accumulate rare craftsmen and expensive materials, mostly by importation ; but Shotoku in person superintended the levelling of terraces, the cutting and hauling of the great cedar log pillars from the mountain slopes, the kilns and the forges and the thousand temporary workshops, saw rise slowly into the air architectural piles of storied pavilion and pagoda that dwarfed to toadstools the wildest architectural fancies of any West Pacific islanders ; until at last the dream of his father Sujun stood completed before him, the great monastery temple Horiuji, built in arcades with tower gates about an enormous sanded court, and centred with blue-tiled palaces that rose up the mountain slopes terrace behind terrace. Here now was the enormous structure dedicated in presence of prelates and ambassadors from Hiakusai and Dzin, and here the regular work of a great cathedral church was inaugurated in 616. Many branch temples, dependent upon it, were built during the next twenty years in neighbouring parts of the province, especially on sites where later was to stand the metropolitan city of Nara.

The early history of Horiuji is obscure, and it is possible to infer that a disastrous fire destroyed a large part, but not all, of the original structures, in 680. But there is fair reason to believe that three of the buildings at present existing date from before the fire, and back to the age of Suiko—namely, the front gate guarded by the

"Two Kings," the great pagoda in the forecourt, and the massive Golden Hall (Kondo) containing the central altar. Otherwise we must suppose that the Suiko hangings above this altar were faithfully copied after the fire in a style that had already grown archaic—an improbable supposition. Though the pagoda is somewhat heavy and flaring in proportions, in the Kondo we have one of the noblest examples of Japanese or of early Chinese architecture. Though the material be but wood, we must remember that in this earthquake country good wood is the most permanent material, proved, as in this case, to out-last many a stone erection of mediæval Europe. Already fine pro-portion is in it, and a wonderful and unusual relation between base and pitch of roof. If the front gate contains, as Mr. Cram seems to think, evidence of Greco-Buddhist structure, that would be a reason for dating it from after the conflagration, for there is no evidence of any specific Greek influence in the art of the Suiko age.

In this temple of Horiuji were placed many of the great treasures of Corean art that had already, as models, found their way into Japan. Here, to-day, on the great altar of the Kondo, a solid block of masonry, some 80 feet in length by 30 feet in width, and raised five feet above the floor, stands the Tamamushi shrine, and several other shrines of inferior workmanship, the excessively tall wooden Kwannon already described, and other smaller pieces. When the Yumedono Kwannon was removed to its present position we do not know, but it would probably have stood originally on some part of the great altar in the Kondo. The present contents of the many buildings of Horiuji are made up of a motley aggregation of paintings, statues, and sacred utensils, designed or collected at many different ages, and of workmanship ranging from Indian and Persian through Chinese and Corean to Japanese, sacred treasures which have been brought to this central monastery as from age to age their original possessions crumbled away or were burned through carelessness or in wars. This process has made of Horiuji a natural and national museum, especially of those forms of art which belonged to the worship of its antique Sarson sect, a form of Buddhism which has now no other representa-tive than Horiuji in the Japanese islands. As Sarson temple after Sarson temple decayed, the mother, Horiuji, became the national custodian of their treasures.

But of this enormous mass of material I intend to speak now, at

first, only of those portions which belong specifically to the Suiko age, leaving the others to subsequent chapters. As one stands upon the altar of Kondo, he gets to-day a strange, weird feeling of Greekish frescoes, Norman hangings, Gothic statues, and Egyptian bronzes, so varied is the jumble of forms of a hundred sizes. The store-house, too, might be ransacked for pieces that would over-fill the altar ; and it must be remembered that of the hundred or more ancient bronze statuettes which formerly were treasured here, the larger number, though not the largest pieces, were taken at the restoration for the Imperial archives.

Picking out now the Suiko specimens in something like their historic order, we ought first to refer back to their ancestor in that stiff, square, gilt-bronze statuette which we have already taken as the *Go* type of the fifth century. This was still kept at Horiuji, in the godown, at the end of the 19th century. It will be remembered that a Chinese sculptor of Go, possibly the author of this very piece, had been naturalised, with other emigrants, as a Japanese citizen in the early part of the sixth century, taking the Japanese family name, Tori. That he could have practised the art of Buddhist sculpture in Japan in those early years we have no evidence. But we do have reason to believe that his son, who must have kept up through the interval the knowledge and exercise of his plastic art, found opportunity, when Buddhism was coming into his father's adopted country at the end of the century, to return to the original home of inspiration, and give us perhaps the first bronze statuette that we can identify as made in Japan. This bears an inscription which, ascribing it to the second Tori, seems to date it as of the year 589, in the reign of Sushun. It is thin, being forced up out of a single sheet of metal, but of a sombre dignity and primitive proportion which recalls the solidity of Go. But to this has clearly been superadded something of the Corean delicacy of curvature, a greater slimness of figure, a finer symmetrical sweep of the mantles at the side. It is most interesting to compare this with, on the one hand, the Go gilt Kwannon, and on the other with the far larger figure of the Yumedono. It clearly partakes of the nature of both, and establishes a sort of canon for the Suiko style.

Of those of the many existing statuettes which are probably not of Indian, Chinese, or Corean workmanship, there are several others which

exhibit the unity of this early Suiko type ; but the group which finally establishes it as a school, and which is the most elaborate exemplification of it, is the bronze altar-piece which was modelled and cast, under Shotoku's supervision, by the third generation of the Tori family, the grandson of the original immigrant, as the holy of holies for the Kondo of Horiuji. There it still stands, enthroned, near the centre of the south side of the great railed altar. It is an elaborate group, richer than any Chinese or Corean piece which to my knowledge we now possess ; being a complete trinity of statues, thin but detached, composed against a magnificent bronze halo-screen. The central figure sits in attitude of a Buddha ; the side figures, Bodhisattwas, stand upon lotos seed-pods. These side figures have separate flame halos detached from the general screen-halo, which contains as its central feature the circular halo of the Buddha's head. The side figures have the large square head and stiff proportions of the Go statuette, but with a sweep of draperies which relates them clearly to the Yumedono Corean. The open-work crown of the latter has here become a solid curved plate, whose height gives the already large head too much prominence. This Buddha must be taken, in lack of any other such perfect specimen, to be the type of Suiko bronze Buddhas, and probably not far from the type of fifth-century Go Buddhas. The head, though uncrowned, is far too heavy and square, the features seeming not merely Indian, but almost negro. The hands, too, are large and clumsy. But in the disposition of the drapery, in spite of its primitiveness, we have a pyramidal line system that approaches grandeur. The simple shawl-like outer garment, open at the breast, folds on the arms, and then flowing down over the crossed knees, enshrouds the throne below in a broad rich set of curving folds that reveals a decorative beauty close to antique Greek. It is a tremendous tribute to the genius of the sculptor, Tori Busshi, that, overlooking the awkwardness of the human forms, we are absorbed in the architectural splendours of the group. Not only do the three figures build up into a finely flanked pyramid, but their unity and beauty are enormously enhanced by the spacing and the lines of the bronze screen. This is a large flat plate of bronze elaborately ornamented in low relief. It rises in the form of two concentric arches the inner of which contains within lotos tracery the main halo that centres behind the Buddha's forehead. The outer arch holds heavy clouded forms writhing upward like smoke and flame, among which

sit in higher relief a group of small Buddhas. Between all, even the minutest parts of this astonishing work, we find the most subtle curve rhythm, that carries out into original creation germs of line feeling already involved in Corean Art. Yet, far removed from the over-warm sphere of Indian sensuousness, and without possible contact with West Asian forms, it takes on much of the severity and dignity of archaic Greek work. It strikes a happy compound of the three kindred geniuses of Go, Corea, and Japan; and as the initial creative work of the new land, it augurs wonderful wealth for the coming art. And indeed in the element of architectural beauty in sculpture it has only once been surpassed in the second Trinity with a screen described at the end of this chapter.

Nothing like a complete enumeration of the Suiko pieces known to us can be attempted. Another bronze Buddha in fragmentary condition stands upon the same altar. But a second interesting group of studies is found in the wooden figures which chiefly belong to two temples, Horiuji, and the Rokkakudo of Udzumasa near Kioto. Closely akin to the Bodhisattwa of the bronze Trinity is the separate wooden Kwannon, holding a vase in her left hand. Here we find the flame halo, the large head with heavy features, and the lotos throne of petals that bend downward—all characteristic of Suiko Corean work, but there is an attempt to model naturally the exposed upper portion of the body. In the two gilded Bodhisattwa that stand on the Kondo altar, we have a still greater pensive sweetness, the heads are rounded, and bound with a wreath that really feels half Greek. Of an entirely different type, being almost Aztec in feeling, we have the small and earliest Kwannon of eleven heads, cut out of a hard dark mahogany-like wood resembling bronze. This is most elaborately carved and undercut in very deep relief; evincing probably a phase of Chinese genius rather than Corean; and possibly a Southern phase in which Annamese and Himalayan influences combine with the genius of Go. This was originally the central secret deity of the Buddhist auxiliary shrines at Tonomine in Yamato. It can now be studied in the art school at Tokio.

Other wooden forms are the portrait statues of this day, of which the group of Shotoku Taishi, surrounded by his young children, kept in the Taishiden of Horiuji, where the spirit of the prince-saint is still worshipped, is the most elaborate. Here we find a timidity and effemi-

nacy of curvature in the drapery, which the artist has not quite mastered. The faces of some of the children, awkward and even Kamskatkan in type, recall the faces of the crude clay figures dug from earlier Yamato tombs. Other statues of girls and children retain in original paint the very patterns of the dress. Perhaps the finest portrait is that of one of the Sojos, said to have been the first abbot of Horiuji, installed under the auspices of the prince-priest. Here, while we find Corean traces in the pleated folds at the bottom of his robe and in the curvature of wrinkles upon the face, in strength and individuality it is only a little inferior to the portraits of the eighth century.

Still another form of wooden Suiko statue is the militant type of altar guardian, the group of four statues called the Shi Ten O, or Four Heavenly (Deva) Kings, who were set at the four corners of the great square altars, facing outward. Early Chinese painted types of these are shown in the Amadaji Mandara ; and in the Bisjamon of Seirioji we have the slender North Chinese Tartar type of the sixth century. But in the four guardian kings of the Horiuji altar, nearly life-size, we have the only remaining specimens of the pure Suiko type, whose prototype was the group formerly in the Kaidendo of Shodaiji, near Nara, destroyed by fire in the early part of the 19th century. The peculiarities of this type are great. The faces are heavy, square, and almost negroid, like the Tori bronzes. The bodies are chunky, and stand evenly straight upon both feet, which are encased in a kind of moccasin. Though carrying spears, these spiritual warriors wear no armour, unless the fairly tight-fitting body-piece, edged upon the statue in openwork metal, can be supposed to represent a leathern cuirass. This is bound tightly about the waist by a very heavy rope. Over the upper part of this, and tied loosely over the shoulders, is a small mantle or shawl, knotted over the breast in closely flat ironed lines, and giving a strange Egyptian or Persian feeling. But what makes the Persian feeling still stronger is that both legs are encased in heavy very loose trousers, which bag about the ankles, where a closely ironed ruffle emerges that half covers the feet. Twisting ends of a girdle, also flat as if closely ironed, fall nearly to the feet from under the cuirass. It is this shawl, these trousers, and the element of ironed ruffling that have led me to feel that this type may have been built partly out of Sassanian elements. But the strangest feature of all is the heavily carved wooden crouching animals upon which these figures stand, some cow-shaped but with human hands,

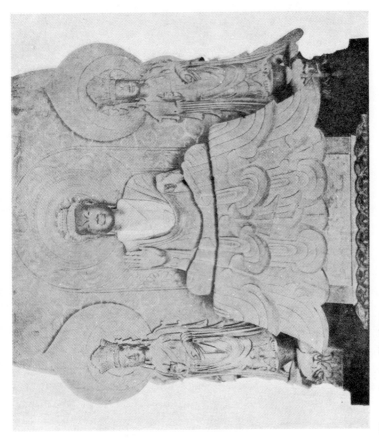

Kondo Altar Trinity.
By Tori Busshi, at Horiuji.

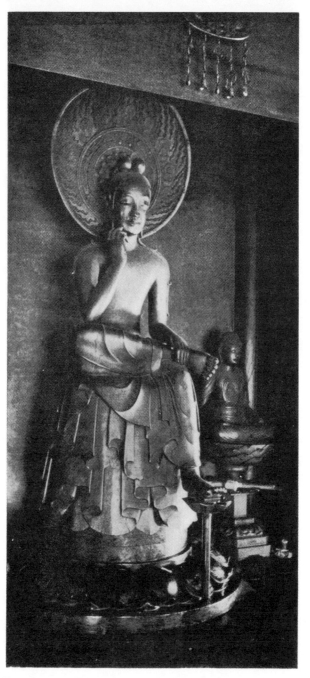

THE CHUGUJI KWANNON. By Shotoku-Taishi.

themselves supported upon rock forms that curve like Suiko drapery. It is recorded that this Horiuji set was carved by two Japanese; but it is possible that the original Shodaiji set may have been brought from the continent. It hardly seems possible to believe this the costume of a Corean warrior; it certainly is not Chinese; and it has no relation to any Greek influence such as might be exerted from Khotan. The type remains a mystery; but at present we call it provisionally a Go type with Persian features, and modified in details by Corea-Suiko ornament.

Suiko pure decoration is best exemplified by the baldachian hangings above the main altar of the Kondo at Horiuji. This, too, is unlike all else in the Buddhist art of any known race. These baldachians, of which there are several, are a kind of pointed box opening downwards, lined with square, rectangular, and triangular panels, many of which show traces of stiff painting of flowers and rosettes, and fringed with an intertwisted gold tasselling. An upper flaring cornice is covered with very delicate tracery in openwork bronze, as in the finishings of the Tamamushi shrine. But the whole body of the box, under the cornice and above it, is bossed on the exterior by rows of little detached wooden angels upon open brass-work flower thrones, or of cockatoo birds in flight. Openwork finials flare at the corners. The barbaric painting in reds, blues, greens, and cream whites of these stiffly spaced members, of some red much discoloured, makes us feel for all the world as if we were looking into an Egyptian tomb. The forms of the angels are rounded and slim, and the cockatoos curve in strong line, not unlike the forms upon the Chinese Wei relief of the sixth century figured by Dr. Bushell.

I have reserved for the last the greatest masterpiece of Suiko art, a pure bit of spiritual interpretation, more sculpturesque, more human and more divine than the bronze altar Trinity—namely, the large carving from dark bronze-like wood of an unornamented Kwannon in contemplation, now kept in the little nunnery of Chuguji, in the rear of Horiuji. This follows the attitude already shown us by the little bronze statuette of Liang or Dzin in the former chapter. The body, modelled like Egyptian, with great restrained beauty, is nude to the waist. Even the hair is indicated only as a smooth mass slightly relieved from the skin. The drapery, falling from a girdle at the waist, heavily envelops the limbs, making fine, archaic Greek transitions of curve from the horizontal to the vertical leg. The drapery that surrounds the dome-like throne seems to be another portion of the same mantle, as in the Buddha of the altar Trinity, though

its lines are less flamboyant. But the great beauty of this statue, in which it is only equalled by the profile of the Yumedono Corean, is in the face, which has its finest effect from the front. It is the face of a sweet, loving spirit, pathetic and tender, with eyes closed in inner contemplation. The negroid coarseness of the Tori faces has disappeared.

The impression of this figure, as one views it for the first time, is of intense holiness. No serious, broad-minded Christian could quite free himself from the impulse to bow down before its sweet powerful smile. With all its primitive coarseness of detail, as in the feet especially, it dominates the whole room like an actual presence. This finely imaginative work, whose genius we can trace from the suggestions of preceding models, is clearly the work of an original master mind, one capable of transcending conventions, or rather of moulding them to express a free spiritual conception. This is why we more than give ear to the Horiuji tradition that the work came from the hands of Prince Shotoku himself. His was certainly a mind capable of conceiving it ; and the varied elements from which he drew suggestions of form, Chinese, Corean and Japanese, lay ready to his hand. We must call it the first great creative Japanese work of art in the matter of spiritual power, as the Kondo Trinity is the first in the matter of decorative form.

From these promising beginnings of the Suiko age we find the young Japanese art advancing through the successive decades of the seventh century by leaps and bounds. The next Emperor, Jomei Tenno, who ruled from 629 to 641, also favoured Buddhism, and enjoyed the advice of a good Minister, Kamatori, who was hailed as the ancestor of the great noble family of Fujiwara, in a later age. His contemporary portrait has come down to our day. Meanwhile the Tang dynasty in China had succeeded the Dzin, and diplomatic relations were opened up with it by Jomei. In the next somewhat troubled reign of the Emperor Seimei, with interruptions from 642 to 668, Chinese Court costumes, rank, and receptions of courtiers were established by imperial decree. Corea was partly cut off from Japan through invasion from Tang ; and thus, in some sense, Japan was left for the moment to her own artistic resources. These were a large stock of originals, mostly Indian, Chinese and Corean, and her own budding genius. The art of

this age is a conscious recasting in a long series of trial forms of the elements involved in this stock. The chief advance is found in the series of bronze statuettes which were manufactured for altar-pieces of the many Buddhist temples that now spread all over Yamato. Hokkeiji and Horinji were sites not far from Horiuji; but the slopes of Kasuga mountain, about twelve miles to the east, later to be the eastern suburb of the Emperor Shomu's capital of Nara, were already the seats of several flourishing temples. There is a persistent Nara tradition that at one of these, called Iwabuchi-dera, a special school of bronze statuette modelling and casting was instituted. However that may be, we can trace in the many existing remains a clear and fairly single artistic effort to discard the clumsier, weaker, and more external features of the primitive models, and to aim ever at a more human grace and spiritual sweetness. If we were to place before our eyes a series of the statuettes of Bhodisattwa, we should see clearly this intentional experiment of proportion and modelling, the structural elements in many cases remaining unchanged. The draperies become more simple and natural, the peculiar shell-like Suiko fold being soon discarded. So graceful do the statues quickly become, and so beautiful the faces, that it seems as if a specific Greek archaic influence must have been at work. It is true that we are here on the historic verge of a Greek influence coming down through the Chinese of Tang; but this is an influence not at all of archaic Attic work but of a somewhat late and coarsened Greco-Indian proportion. Besides this, Greco-Buddhist influence was hardly naturalized in China until after the middle of the century, and it was not till then that Japan, under Tenchi, began a systematic study of Tang institutions. We must rather believe that in the post-Suiko series of small bronzes we have a Greek-like beauty which is an independent discovery of the Japanese genius. But of course one cannot dogmatically deny that some sporadic intrusions from Chinese and Corean sources may have been superadded.

I can speak here in detail of only a few of the more striking members of this series. One early feature is a rounding and broadening of the face, which is a Dzin or early Tang trait, as opposed to the earlier Go. The lines of mantles and jewelled ornaments, too, become more relieved—detached something in the style of the wooden eleven-headed Kwannon before mentioned.

An early form, only slightly removed from Suiko, and possibly one that adheres to Horiuji traditions rather than the newer experiments of Iwabuchi, is the statuette with heavy round negroid head, nude to the waist, but with mantle caught up into a large, round, knot at the waist.

A much larger bronze, nearly three feet in height, is the figure of Kwannon kept in the storehouse at Horiuji, which is clearly a deliberate improvement upon the Korean lanky Kwannon upon the Kondo altar. It holds a vase in its half-raised left hand. The crown upon the head so protrudes at the sides as to give the effect of a flat top. But the body is charming and graceful in modelling, and the face pleasant.

The most beautiful of the standing Buddhas in this statuette series is undoubtedly the small figurine, hardly more than a foot in height, of the Tathàgata of Healing, Yakushi Niorai, symbolical of Buddha as the great soul physician. This is the most sacred altar-piece of the Shin Yakushiji temple in Nara, of which we shall speak more fully in the next chapter. It is beautifully proportioned, the face round and sweet, with small nose and delicate mouth ; the hair, like that of the Chuguji Kwannon, being only a smooth raised surface. The hands and feet, too, are small. But the most interesting feature of all is the drapery, which is a beautiful translation into bronze designing of the cross concentric folds of the Buddha's mantle, as exemplified in the colossal stone images of Ceylon and in the primitive Chinese wooden Buddha now at Seirioji. Here, instead of the countless little crinkly folds of the Indian gauze, we have a few simple, clear folds, whose stiff repetition from chest to ankle gives the figure much naive dignity. The Suiko folding is entirely eschewed in the skirt. Members of this statuette series are also to be found in wood, generally as in the Suiko "Aztec" example of an eleven-headed Kwannon.

A decidedly Greek impression is given us by the upper part at least of the most delicately modelled Kwannon among the Horiuji pieces. Here every detail of costume is but a refined imitation of another Chinese one already described as closer to the Suiko type. The hands and feet are especially beautiful. The finest view is in profile, where the beautiful free lock of hair escaping from the twist at the top of the head, combined with the fillet or crown, gives to the head

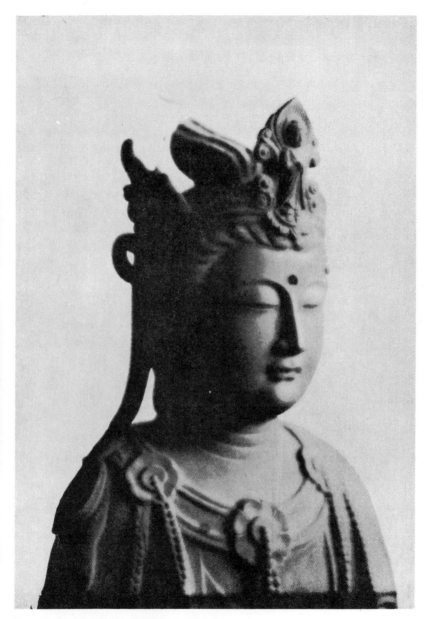

BRONZE STATUETTE SHOWING CLEARLY THE
GREEK INFLUENCE. Temple of Horiuji.

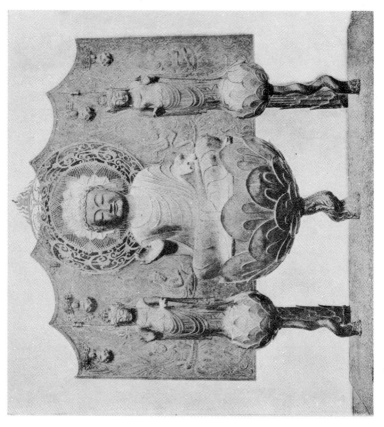

BRONZE TRINITY, WITH SCREEN. Horiuji, Nara.

the effect of a Mercury. The antique Greek effect is enhanced by the extreme delicacy and beauty of the features, the mouth and chin especially. This is the first Japanese profile which compares in beauty with the Corean Yumedono Kwannon of the sixth century. But to realize the full beauty of the head and face, and to recognize that, after all, it is not Greek, it should be seen enlarged in a two-thirds pose. It was thus that I specially photographed it in 1883. The little standing Buddha in the crown is a new type with free drapery. The hair is beautifully modelled in waves flowing back from the forehead. The curves of the brows run unbroken into the nose, as in all finest Japanese Buddhist bronzes. The mouth is the most naturalistic feature, giving us the most delicately curved surfaces in the lips. But what we notice here especially is the perfection of casting and finish in all the surfaces, shown particularly in the skin of the face, where it appears as if the bronze came with perfect satin texture from the mould, requiring no after finish of tool or file. This quality is characteristic of the very finest Chinese and Japanese bronzes, which are now to come to our notice, and is probably obtained by first making a perfect model in wax. An extreme refinement in such delicacy of finish will be shown in the Tang mirrors.

Another Bodhisattwa statuette, also of considerable size and kept at Horiuji, gives as a whole, though perhaps not so specially in the face, the feeling of the archaic Greek Mercury or Athene. The head is more spherical than the preceding; the raised right hand is stronger. The feet, the skirt on the bronze pedestal, the upper half of whose lotos petals open upward, are like the Shin Yakushiji Buddha. What is here most beautiful in the drapery are the festoons over the shoulders and breast, and falling from the waist to bind the skirt inward at the knee. It is the double curve theme of those festoons and of the thin crossing statues that gives this statuette its unique beauty. Taking the head, raised hand, and festooned breast together, we could hardly avoid, were it not for the somewhat thick and formal neck, the impression that we were before a Greek bronze. It is indeed a beauty parallel to the Greek, but one to which a possible Greek element may have remotely entered only through the roundabout roads of Baktrian influence upon Han, or of Greco-Persian influence upon early Indian Buddhism. The specific Greco-Buddhist influence has yet to appear.

This brings us down to the age of the next great Emperor, Tenchi, whose short reign, beginning in 668, was celebrated by the removal of the capital to Shiga, near the present Otsu, on Lake Biwa. The famous Karasaki pine, covering more than an acre of ground, is believed to be the last relic of his palace gardens. It was he who determined to make a more serious study of Chinese institutions, and especially of Chinese law, for which purpose he dispatched a special mission to Tang. The Emperor Temmei, who reigned as his successor till 686, carried on the policy.

It must have been in one of their two reigns, probably the earlier, that the supreme masterpiece of this rapidly advancing statuette school was executed in the same white bronze of which the mirrors were composed. It came just at a moment when the delicate problems involved were about to be overshadowed by new powerful impulses surging in from Tang with Greco-Buddhist art. It is. a perfect product which could have occurred only at this one moment in the history of the world, reaching the highest æsthetic range of early Buddhist art among any race from India to the Pacific. It is possible that specially fine sporadic examples from Tang may have helped to the culmination, but we have no trace of them.

The new piece is a second elaborate Trinity with a screen, and seems to have been designed with conscious reference to the earlier one by Tori Busshi, as a point of departure. We do not know the name of the designer of this, but he is the next greatest artist of Japan after Shotoku Taishi, and one of the greatest bronze artists of the whole world.

To realise what enormous artistic gains the gap of some sixty years has won for this piece, we ought to compare the two Trinities in a single blow of the eye. We should find that the stiff vertical lines of the Suiko type have been changed into more graceful and laterally interflowing rhythms, and that every delicacy and sweetness of type in the statuettes reach their height in the latter piece. It is like passing from Egyptian to Greek art.

The figures of the Trinity are placed much as before, only the three all rest upon lotos thrones that grow with twisted stems out of a horizontal bronze sea. It is the blessed beings realised in their own garden Paradise. And it is doubtless a clearer importation from the best of this thought of Sukhāvati, the heaven of Amitabha or the

Buddha of Boundless Light, that is embodied in this piece. The three statues are fully rounded, detached, and finished at the back. Between the Buddha and the screen a magnificent openwork halo of bronze lace is set in an independent plane. The screen, which rises into pointed waves at the top, and is flanked with panels that might fold on hinges, is modelled in three distinct planes of relief, little Buddhas at the top, half-round as in the Tori example, blessed figures of angels, much flatter, who kneel upon lotos thrones in the background, and lotos leaves mixed with flying mantles from those angels that form a tracery in very low relief. Once more, within the interstices of this elaborate pattern, and into the smooth surface of the screen, are incised little cloud forms descending and little groups of growing flowers, making as it were a sixth plane for the whole design.

Between this large number of elements on many planes it might be thought that, as seen from the front, a certain confusion or at least inconsequence would reign. But the truth is that no more unified system of curves was ever conceived, even on a Greek façade or frieze. Not one of these thousand flowing curves that is not infinitely harmonious with all the others. They interplay like melodic phrases in music. The blending of strong architectural plan in the composition with naive sweetness in the separate rhythms, can find as analogue in Western art only the spirit of the work on Ghiberti's bronze doors in the Florentine baptistery. The decorative lines are stronger and more orderly than in the naive reliefs at Perugio and Rimini of Agostino Duccio.

The central Buddha is clearly an æsthetic advance upon the standing statuette of the Yakushiji. While we have lines of drapery of the same simple forms, their parallel cross curves are now caught up, as in archaic Greek, into converging catenary curves, here firmly tangent to the almost vertical line of the garment's edge that falls from the left shoulder, and from which other sets of radiating curves enfold the left arm. The disposition of this drapery, too, over the crossed legs enables the artist to convert horizontal curves directly into vertical, thus giving a most beautiful variety. But perhaps supreme mastery by the rhythm of line is best shown by the modeller in his treatment of the hands and the break of the drapery from the wrists. The hands and attitudes of the fingers are so

conceived as to centre into their strong action the curve vitality of the whole complicated design. It vibrates to the very tips of the fingers, which nod as naively as flower petals on a stem. These hands too are thick and firm, like the whole body, not weak and effeminate as in some of the Kwannon statuettes. It is noticeable that the webbing between the fingers that appears in the larger statues of a little later date, is here used not only with structural but for æsthetic value, the curves of these webs entering magnificently into the contour. This artist knew to the minutest degree the rights of conventional treatment in decorative bronze relief; and in this respect at least the piece becomes the world's masterpiece. The hair, instead of rising into the ugly convention of lumpy curls, as in the Tori Trinity, or lying in a quite smooth layer as in the Shin * Yakushiji Buddha, cuts the latter into a few thinly relieved spiral locks, apparently a unique convention which does not occur again, being apparently displaced by Greco-Buddhist forms.

The standing Bodhisattwa at the sides are of a grace and sweetness transcending all the Kwannon statuettes. There is the slight sideways swing of the hip noticed in the last wooden eleven-headed Kwannon; but a perfect subordination of relief in ornament to the decorative value of the figures as wholes, to which the swing of all the broad mantles beautifully contributes. The hands here are not too small and refined as in the statuettes, but, if anything, just so much too large as to act as perfect accents in the architecture of the total group.

In the low relief angels of the screen we find that, studied in detail, they only exemplify still further the absolute artistic value of this work. Never, down to their smallest detail of drapery, is there a lack of invention or of perfect taste in subordinating the inessential and the merely pretty to the interpenetrating idea. These figures are like, but far more graceful and sweet than, the somewhat similar bronze angels of China and Dzin, shown in the last chapter. Somehow in charm they seem to lie between Orcagna, Donatello and della Robbia. No European, however, not even a Greek, ever conceived such perfection of formal line and surface in low relief as is shown in these lotos forms, and the angels' mantles seemingly caught upward

* "Shin" means here the sect Jōdo and is still applied to this temple.—PROFESSOR PETRUCCI.

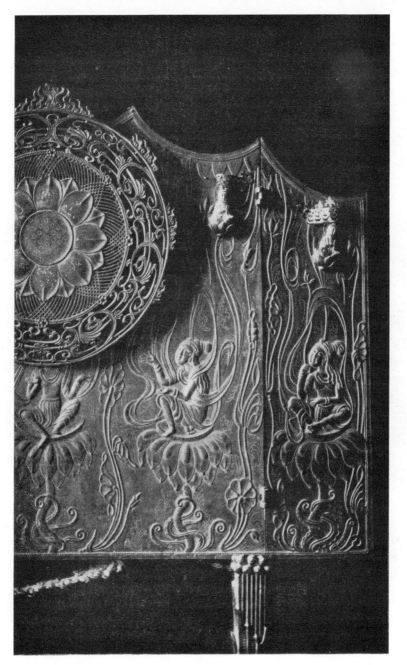

Detail of Screen from the Bronze
Trinity at Horiuji.

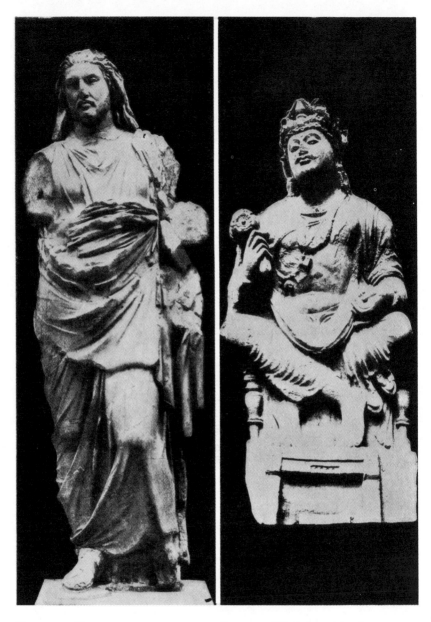

STATUE OF MAUSOLOS.

STATUE OF BUDDHA AS AN INDIAN
PRINCE.

into the intense spiral lines of some great spiritual draft. It is this prevailing tension of the screen lines toward the vertical which saves them from what they would often become with Europeans, weak, insipid decorative flourishes.

But to realise what is the true scale of remove here from decorative weakness, rather, what is its supreme vitality and power, in a formal æsthetic of which elsewhere Greek art is the typical example, we must refer to the detached circular halo, which I photographed separately in 1882. This consists of a single flat disc, which has not only been perforated in the Corean manner, but had every one of its thin surfaces undercut, so that not a single member of this narrow scale that does not pulsate with finely modelled surfaces in space of three dimensions. Though the execution must have been a triumph of bronze-lace casting, yet the vigorous plasticity of the curves suggests rapid paring with a knife, the method frankly employed in carving the original wax. The body of this most beautiful halo in the world consists of three main members :—The lotos centre, the rich grill interlude of fine crossed curves, and the border of arabesques. The lotos centre has itself a centre of the circular seed-pod, surrounded by sixteen petals, all so exquisitely modelled in the infinitesimal relief as to appear like an actual flower. The brilliant colour of this member is got by its solidity contrasted with the openwork beyond. The grill, in its fine spacing, gives us a grayer colour in two tones, also kept in subordination by the simplicity of its forms. But upon the broad circular band of the border the artist's whole wealth of purely decorative openwork curvature has been lavished. There is nothing here so representative as the lotos leaves and stems in the screen relief. This is leaf form, but drawn out into splendid scrolls and bands, like the finest Classic and Renaissance arabesques. Only these are no imitations of Classic suggestion, *but a new creation along parallel lines*. What the volute and the acanthus and anthemion are to Greek ornament, these interplaying organic spirals, of large and small curvature, crossing, meeting, intertwisting, are to Japanese. It is a glorious thing to know that some creators have been able to do this thing without that abject subserviency to Greek pattern which Western art has exhibited for two thousand years. There are men who can create with the same *naïveté* and beauty as the Ionians. And, let it be noted, too, that these curves, so intricate, are the farthest removed in all art from the insipidity of the Renaissance flourishes, which we sometimes teach as a poisonous miasma in our art schools. These

are curves of extreme tension, as of substances pulled out lengthwise with a force that has found its utmost resistance, lines of strain, long, *cool* curves of vital springing, that bear the strength of their intrinsic unity in their rhythms.

Perhaps I have given too much space to this exquisite Trinity ; but it is, so far as I now know, the unique flower of the early East Asian stage of Buddhist art. It is fortunate that it could bloom before more powerful currents from without and within, already gathering, could tear its archaic elements to pieces. It is in these momentarily balanced opportune calms in all human history that supreme art arises ; and this is true of Asia as of Europe. How utterly then must Art History become a record of the causes that have produced unique individuals, rather than non-chronological and abstract essays upon industrial technique.

CHAPTER V.

GRECO-BUDDHIST ART IN CHINA.

7th and 8th Centuries A.D.

IN the history of Chinese art we have already sharply marked three periods :—the Pacific, the Mesopotamian, and the early Buddhist from India. We have seen only the third of these forms falling within the limits of Corean and Japanese civilization, though traces of the two earlier remain in the barbaric art of Japan. And we have noted as the æsthetic culmination of this total complex movement, up to the second half of the seventh century, the second Japanese bronze Trinity with a screen.

We have now to look at what is properly a fourth wave of influence upon Chinese art, the so-called Greco-Buddhist—a wave that was long in gathering in Western Asia, swift and brief in its passage across China, and somewhat more deliberate in its breaking and dissipating upon the shores of Japan.

It seems strange at first sight to think that Greek art has really conquered a second and greater continent on the East, as it has manifestly dominated Europe on the West. It will be news to many that such a potent factor in what they have always regarded as the romantic art of Japan should be that very classic art which they boast as its opposite. So potent indeed is the classic spirit that in time it has spread to the bournes of the ultimate oceans, and in fact encircled the earth. A full account of its slow passage north-eastward across the continent of Asia will, some day, fill a most romantic chapter in Art History.

Many immediate doubts rise naturally to the lips—If Greek art reached Japan by way of China, why did it come so late ? If it was so potent throughout East Asia in the seventh century, why should its force have been spent so early as the eighth ? If China came into

contact with Baktria in the second century before Christ, why was it not then that Greek art obtained its strongest grip over her ? Since Japanese early Buddhist bronzes offer so many analogies with archaic Greek art, must not this latter be somehow concerned in the transmission ? Is the Greco-Buddhist art, after all, of Greek, Roman or Byzantine origin ? So difficult have seemed the answers to these and other questions that some writers, like Mr. Okakura, seem inclined to deny that there has been any classic influence upon Indian, Chinese and Japanese art at all—just as I am inclined to deny that any specifically Greek influence helped model the Japanese statuettes of Jomei, Saimei, and Tenchi. On the other hand, Professor Hirth would throw back the specific Greek influence as far as the Han.

If we look at the graphic curve of the ups and downs of European art as a whole, drawn upon a single time scale, we see that it piles into two great and sharply-pointed waves whose summits are separated by a gigantic trough of 2,000 years. Our pride is somewhat shocked to see that the great European mind has been stricken with æsthetic disease and decay during by far the largest part of its course. The long, tiresome, and apparently hopeless descent of classic art in both Europe and Asia filled more than a millennium. But, upon inserting against the same time scale the curves of Chinese and Japanese art, we see that their rise to culmination under remote classic influence in the seventh century is contemporary with the moment of deepest depression in Europe. A specifically Christian art, the Gothic, rising from Greek ruins in the West, comes much later than a specifically Buddhist art arising from Greek ruins in the East. Yet it would not be surprising if the process upon the two sides presented many features in parallel.

If there were any way of showing how archaic Greek art could have got into Central Asia, and then exerted influence a thousand years after it was dead in the West, we should eagerly invoke it to explain a thousand pseudo-parallels. Not only should we find like technique in the convergence of simple catenary curves, and the shell-like openings of downwards falling drapery, and in the character of face-modelling, as we have already indicated ; but we should discover the identical corkscrew curls upon a Buddha's head and in the thick beards of ancient Dorian sages and heroes. In æsthetic dignity the simple long folds of the Yumedono Kwannon just match those of the Greek bronze

charioteer, and the intertwining lines of the three famous figures upon a tomb show rich systems of tension curves comparable with the screen Trinity. The sway of the figures in the finest Japanese bronzes of the eighth century recall that in the winged Victory of the Louvre ; even the stocky little short-headed horses of the Parthenon might serve in comparisons. And yet we must dismiss all these striking analogies as independent growths of a common human genius.

It is not the great culminating Attic or Rhodian art of Greece that pierced its way into the West body of Asia ; but rather a native Ionian form that already had found independent, if lower, development among the cities of Asia Minor. As the Mesopotamian powers, especially Persia, spread to those and absorbed them, they left Oriental features in their wake. Perhaps there were three waves of intermingling between the Eastern Mediterranean and the Euphrates —a prehistoric one which involved both in Asiatic origins, the Persian domination, and more potent still, the Hellenic intermingling that followed Alexander's conquest of Syria and Persia. Thus we find among Greeks such a purely Asiatic type, we would almost like to say such a *Buddhist* type as the Diana of the Ephesians, with the many forms of relief upon its halo, and its multiplicity of function denoted by repetition, as in the eleven-headed Kwannon. Greek painted portraits found among the tombs of Egypt, indeed the whole range of Byzantine figure art is stiffly Persian, not to say hieratically Buddhist in its design, and upon late Byzantine Christian marble reliefs we find symmetrically arranged birds and grape vines, not unlike, but much ruder than ancient Nara decoration of the eighth century, and the lovely designs upon Tang mirrors. It is noticeable that the twisting stems of such vines are for all the world like the lotos stems under the angels upon the Japanese bronze screen ; both apparently deriving from Assyrian tree forms of a thousand years before Christ. So much for possible reflex waves.

It cannot be doubted, however, that the remote origin of Greco-Buddhist dates from the conquest of Alexander. To be sure, Greek influence had already spread Eastward from the Ionian settlements in Asia ; but such sporadic transmission was confirmed, rendered official and usual, as it were, when Greek monarchs ruled almost as far East as India. Megasthenes indeed, one of the Greek generals, made friendly visits to the Central Indian Buddhist kingdom of Maghada. And yet it can hardly be said that Greek æsthetic canons and sculptural technique

made at first much headway against Mesopotamian formation. For the most part, Persian forms were only a little modified ; and the Selencida did not hold Persia long. It was rather to the North-East, among a freer mountain people, not enervated with ancient Assyrian tradition, the Baktrians, that Greek art took specific hold. Here an independent dynasty of Greek sovereigns, not tributary to either Antioch or Macedonia, maintained itself down to the second century before Christ.

The sources of Greco-Baktrian art were probably as follows:— First, the school of Greek sculpture already located and hardened in Syria. The type of this is the famous mausoleum of the King of Coria, whose name has added a noun to our vocabulary. If we compare the very statue of Mausolos with the winged Victory of Samothrace, or the Parthenon fragments, for instance, we find, along with like technical processes, a great change in æsthetic ideals. The lines of drapery are now heavy, unimaginative, and grouped with poor decorative intention ; the actual number of convolutions is far fewer ; the grace of the figure is lost ; and a method of cutting the eye very deeply under a projecting brow has come in. In short, the method is coarse and realistic, like certain late phases of Roman work ; and the features reveal a materialistic face, a sort of gorged satrap type, which seems to indicate the evil influences of Oriental luxury upon Greek manhood. That this is quite the type of sculptured figure which occurs in the Ghandara relics will shortly be seen.

Another source, which may have in part counteracted the heaviness of the first, was the kind of terra-cotta work exemplified by the Tanagra figurines. This, though realistic, found a new kind of grace in their slim proportions and plastic movement. It is possible from this very attenuated suavity that the thinness which we have noticed in North Chinese and Corean early Buddhist bronzes ultimately derives.

A third source, which would naturally help to confirm the slimness, is the seal engraving and the medalling in which Greek art is so happy. Here, where whole figures are grouped into a design, a tendency to give them a thin line feeling shows a natural æsthetic impulse. This prevailing thinness of seal work is characteristic of Persian art also. It enters from both sources into the designs of Greco-Baktrian coins. Where these are almost pure Greek, they show thin classic figures in rhythmic pose or motion, combined often with animal forms, of lions and hump-backed bulls of similar

attenuation. That this Perso-Baktrian slimness really did condition Chinese Han ornament upon the first glazed vases, we have already seen in the third chapter.

A fourth source was, of course, architectural structure and ornament —the column, the volute capital, the acanthus scroll, the anthemion, and other leaf forms. All these are found in endless fragments among the Ghandara relics of the Lahore Museum.

How then can we account for the bodily transference of these Greek traditions massed in Baktria to Ghandara kingdoms in the north-west corner of India ? When the Chinese Emperor Butei of Han sent his first commission to the West 120 years B.C., as mentioned in Chapter II., it was with the primary purpose of tracing the migrations of the Yuechi, a prominent Tartar or Scythian band, sometimes called the White Huns, who had suddenly vacated their seats in Northern Mongolia. The commission found them, after long years' search, settled peacefully among the mountain valleys and plateaus of that same Baktria which had already enjoyed Greek tuition in Art for two hundred years. It was then that the Baktrian sources opened up by the great caravan way to the knowledge of Han ; though it is hardly to be supposed that, at that difficult distance, much in the way of heavy sculpture would have been available for transportation. Indeed, the intercourse was too sporadic and indirect to lead then to any thorough-going transplanting of a style. If Greek art, after centuries of far closer contact with Persia and India, had been able to exert so little effect upon their conservative design, it is not conceivable that a few small models or drawings, approximately Greek, could have transplanted anything like classic technique to the alien and distant provinces of China. It is rather in the slowly accumulating influence over the Tartar mind of these domesticated Scythians during a century or more that we must look for a possible line of transmission. We know that it was those very Scythian tribes, now grown strong, populous, settled, and civilized among their Greco-Baktrian adopters, who, somewhere probably in the first century before Christ, or at latest just after, grew restless again in their contracted seats, envied the rich possibilities of that splendid north-west plain where Indus leaps down toward the sea from its mountain cradle, and in a series of unrecorded migrations or violent campaigns, made themselves masters of it. Here was a Tartar race

upon Indian soil, with Greek methods in its hand—indeed a fresh, hopeful combination. Here, in a great North Indian empire, which has been called Ghandara, they lived and ruled for at least four centuries, undergoing varying vicissitudes in their peaceful, or warlike, influences with the other races of Central and Northern India.

Yet even this would hardly have availed to perpetuate Greek art as a mere remote tradition were it not that here a distinct new work was given to Greek art to do—that cut it from its decaying roots and transplanted it into a new vitality. This work was the creation of a complete new iconography for the early stages of a positive Northern Buddhism. In strong contrast to the effeminate pessimism of the South of India, the races of North India were already restless in their efforts to recast the parent faith, or, as they believed, restore it to its primitive, ante-metaphysical usefulness. Among these the half-polished Scythian conquerors of the North, of fresh, positive, healthful mind, found themselves in the position of leaders ; and to the capital of their sovereigns, near the present Peshawur, flocked the more independent sages of the Buddhist world. It was something like a Gothic Emperor Charlemagne saving Roman Europe by fostering the first new life of a northern and mediæval scholarship. And just as the spiritual and philosophical leadership of Christendom fell to Scotsmen, Saxons, and Irish, so did that of Buddha-dom to scholars of Mongolian blood. Here it was that Asaṁgha and Vasubandhu formulated the positive tenets of an idealism so searching and vast that it well-nigh surpasses the scope of Hegel, and may yet be recognised as the intellectual flowering of Asia. Here, too, the Scythian Emperor Kanishka, perhaps in the first century of our era, held that fourth Pan-Buddhist council which formulated the larger policy of the North, and led to a final split with the metaphysical bishops from Ceylon and the South. This was the decisive move which made a deeper Buddhism possible for North China and Japan.

For determining the exact age and derivation of this Scythian movement in Buddhism, we have much conflicting evidence to sift. That it was largely confined to its primitive seats in the Punjab until perhaps the third century is probable. Between that time and the sixth it spread, in its forms of art at least, to the south-east as far as Java, and to the north-east along the Khotan route on the south edge of the desert, until it had almost penetrated China. That this slow process

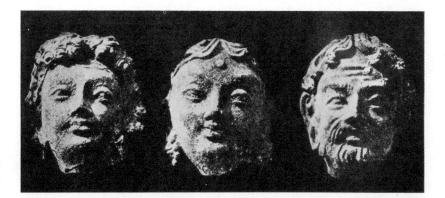

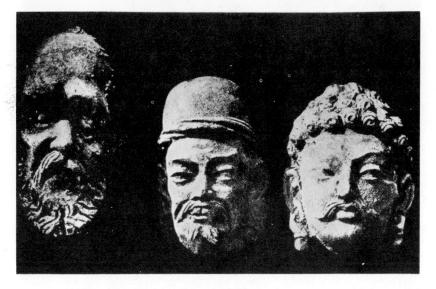

GROUP OF HEADS FROM THE LAHORE MUSEUM.

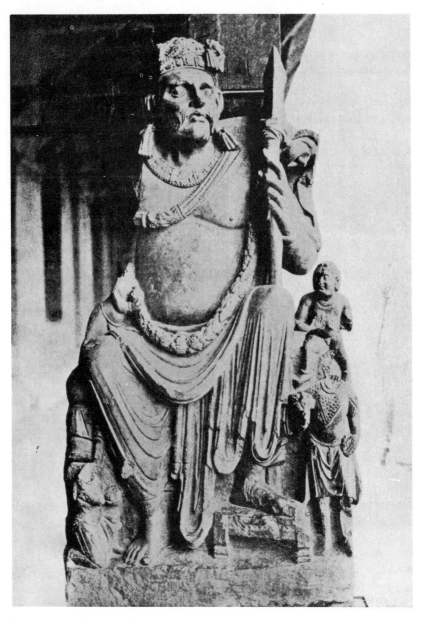

STATUE OF A SCYTHIAN EMPEROR.

involves wave after wave of doctrinal evolution is probable enough ; and there is probably no singleness in the transmission of artistic models. Nevertheless there seems to be a certain degree of unity to the many efforts which for the moment we have to group together as Greco-Buddhist art.

The monuments of this art, as found in the ancient seats of Ghandara, have been explored by General Cunningham and others of the Archæological Survey of India, and their ruined fragments, kept by the fanatical Hindu iconoclasts of the fourth century, have been collected into the museum at Lahore. Lesser fragments are dispersed through many of the museums of Europe.

The relations of this art to the Syrian Greek are especially notable in the portrait statues of the Scythian rulers. The drapery is more formal, not unlike debased Roman ; but the attempt to give muscular detail and the deep cutting of the features is not primitive Indian, and has no relation to the cramped Persian. Some of these monarchs are girdled in festoons of flowers. They wear heavy mustachios. And some of the heads of warriors are crowned with a cobra cap. Later examples cut the eye in degenerate Greek fashion without depth, making only the two lids.

It is most interesting to compare with these portraits the favourite statues of Sakyamuni as a young prince, before his conversion. Here he stands in marble effigy, dressed in almost identically the costume of the Ghandara grandees, with heavy mantles passing over the shoulders and arms, and the luxuriant waving hair, purely Greek in style of cutting, descending over the shoulders and caught up in a beautiful dome-like lock on the top of the head. A flat circular slab for halo relieves the face, which is sometimes round and smiling, now lean, sharp, anxious, and almost "Baktrian." The chest, ribs, and abdominal portions are finely modelled in classic style.

A most interesting transition can now be marked, in comparing the Lahore statues, between these Buddha princes and the detached statues, generally seated, of the ascetic Buddha, the Sakyamuni of renouncement, approximating in its cross-legged attitude to the familiar Buddha altar-pieces of so many countries and centuries. Here the robe is a single ample garment swathing in its many lines of fold the whole body, or all but one shoulder. But the lines of these folds are now far more Greek, more realistic, deeper cut, and much more beautiful

than primitive Indian in the folds of the catenary curves. The hair, too, at first shows the top lock, though simpler than the prince's curls, yet displaying itself as a natural bunch of hair flowing in small waves. As hieratic tradition hardens or skill decreases, the lines of the garment become more formal, the eyes more prominently set under formal brows, the topknot more like a domed excrescence upon the Buddha's head ; and the hair waves on both head and knot reduced to formal and parallel lines, between which the old lumps reappear as individual curls.

Among the finest of the Buddha heads, illustrating this transition, is that of the so-called Taxila Buddha, a fragment named from its place of discovery, the identical place where Alexander fought his battle with Porus. It can be seen here that the lobes of the ears were elongated and pierced to receive the weight of some heavy jewelled ornament. We have already noticed in Chapter IV. that an ornament still remains as ear weight in the Chinese Dzin statues. This Taxila head has a decidedly Napoleonic cast. In some Lahore Museum photographs it is expressly compared with a Greek head, an Egyptian, and a Scythian portrait.

But to realize the wealth of type, beauty, and classic quality of Ghandara heads, we ought to study the female or Bodhisattwa portraits. Here we find some that are for all the world like Roman portraits of ladies in the Naples Museum. The female Bodhisattwa type is very beautiful, catching the hair up into a domed topknot like the Buddhas, but in which there is no suggestion of implied cerebral monstrosity. This beautiful form of coiffure remains in the finest Greco-Buddhist statues of Japan. There are portraits of old men, too, with long straight falling beards, like a tragic mask ; and fine clear-faced youths with riotous curls escaping under a Phrygian cap. Other details familiar in Northern Buddhism are found on every hand : the lion and the elephant thrones for instance. Upon a lion sits a headless youth playing an instrument that seems nearly identical with a Japanese biwa, called the Vinã.

But another most notable feature are the architectural panels heavily carved with sculpture in high relief, for all the world like degenerate Greek on the one hand, and still more like the early Italian revival decorations of the Pisani. Here are countless scenes from the life of Buddha, the familiar figure being surrounded by figures in turbans ; now working in with those dramatically ; now seated enthroned, and with the hand raised in attitude of preaching ; and now reclining

upon the bier of Nirvana. One of the most beautiful decorations is in three concentric lunettes of Buddhist pointed window arches, where three groups of figures are well-spaced, the angles of the upper band being filled with graceful semi-classic chimeras of rolling snake's body, a leaf tail, shoulder wings, a centaur's foot, and a Greco-Buddhist beast. Processions of figures with animal heads, serio-comic, are for all the world like sculptures on the façade of Orvieto.

Specially characteristic are the groups of classic figures, masses standing, and in half or almost full relief, about the faces of high rectangular altars, and separated into panels by columns. Of these, some of the finest, though headless, are nude below the hips, with thoroughly classical drapery, and, what is more to the purpose, of a graceful attenuated proportion which recalls the Ionic statuette type of the past, and points forward, as does this very disposition about the altar, to the Khotan sculptures of Central Asia. That terra-cottas themselves are not absent in Ghandara is proved by many vigorous clay heads of Buddhas and children, and humorous types of old men and vagabonds. It is here possibly that we have a connected relic of dramatic types descended from Greek comedy, and not unlike Greek comic masks. Scythian coins, too, show the persistence of the Greco-Baktrian type.

But if after all this evidence any sceptic were to doubt at least the semi-classic origin of this Ghandara art, we could still point to goat-like Silenus statues, representations of Atlases; but more conclusively than all to the elaborate capitals with their ornaments of fine acanthus leaves and the modified volutes of their corners. Here it is startling to find a keen realization of the strange combination of East and West, in the little graceful Buddha, with head bent in contemplation, and hand stretched out for support to a fold of giant Greek acanthus.

I have given so much space to the description of an art which is properly not included in the history of Chinese, partly because it is specially interesting to us Westerners to trace the steps of our own Greek art in its trans-Asiatic passage to Japan; partly because its Scythian authors are, after all, of the same Tartar race as the Buddhists of North China and the Coreans; but especially because it is this very Ghandara art that was studied by the Chinese pilgrim Hiuan-tsang which gradually expanded north-eastward toward the Chinese boundaries, and which did eventually in the seventh century make its triumphant and

vivifying entry into the new great Buddhist theatre of China, Corea and Japan. We can hardly understand the meaning of dominant Japanese types at Nara without this reference to their Indian sources.

How far this Greco-Buddhist art of the North-West affected the rest of India is still a problem. It has been supposed that at least it passed south-east across India to the port near the topes of Amravati, whence ships weighed anchor for Java. Whether the magnificent sculptures of Borobodor in the great Southern Island are in reality Greco-Buddhist of Ghandara origin, or whether they may not have been developed into Greek-like beauty by a fresh island genius, akin to the Japanese, out of elements already latent in Ceylonese art—I am not called upon to decide. But that this wave of civilization from Ghandara passed northward from the Indus valley, into the great mountain passes of Balkh and Swat, leaving an earlier Himalayan type stranded in the side stations of Cashmere and Nepaul, and advancing over the roof of the world to the great Turkestan plain lying beyond the Pamirs, pushing up toward Kashgar and Samarcand, and downward again to skirt the southern borders of the great deserts which the Kunlung range, with its treasures of native jades, separates from Thibet, and so on kingdoms far toward the Chinese border, has been verified by the important recent explorations of Sven Hedin, Mr. Stein of the Indian Government, and others. There from the sands of Taklamakan deserts, which, blowing from the North, had swallowed up as early as the ninth century populous Buddhist Kingdoms, visited and described by the Chinese travellers Fahien and Hiuan-tsang, have been dug, and six years since, manuscripts written upon leather in the Karōsthi script used in Ghandara, and clasped with seals impressed by Greek figures, vast altars decorated with life-sized relief Greco-Buddhist figures in stucco, Greco-Buddhist heads in terra-cotta mixed in the strata with Chinese coins, figures of classic females holding a child, clay Buddhas more or less rude with the full Ghandara drapery, fragments of great clay halos with Buddhas in half relief, and tinted in brilliant colours, and paintings upon leather of figures riding horses, whose bodies seem at first like modern Persian, but show rounded heads with the Greco-Buddhist topknot very close to the heads of the famous frescoes at Horiuji. To-day the original wooden posts of these submerged buildings, and worn by the storms of a thousand seasons, project in sad desolation from the great low plains that stretch for hundreds of miles to the

BUDDHIST CARVINGS FROM KHOTAN.

KHOTAN BODHISATTWA,
SLIM TYPE.

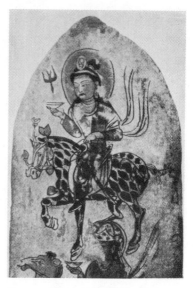

PAINTING FROM KHOTAN,
FIGURE ON HORSE.

SMALL STATUE OF BUDDHA CARVED IN STONE
AMONG GREEK ACANTHUS LEAVES.

north-east of the Khotan oasis. Khotan was from ancient days the centre of this region, and near it the finest and richest of the ruins lie. Manuscripts, Karōsthi and Chinese, prove that this rich region had a flourishing Greco-Buddhist art as early as the third century, and that it was destroyed not later than the eighth or ninth.

Looking at the terra-cotta sculptures of a certain great altar, we see that they are almost identical in noble, tall æsthetic type with the Greek headless figures on the Ghandara altar. We shall soon see, too, their close relations with the Greco-Buddhist sculptures and paintings in China and Japan. Here then is the missing link which enables us to carry classic proportions and drapery from Baktria to China, and eight centuries later than the Western expedition of Han.

In the neighbourhood of Khotan, Mr. Stein visited an early temple, perhaps of the third century, where some ancient conqueror, coming from the West, perhaps from Ghandara, had become deified into the great warrior champion of Buddha in those regions, a Constantine in helmet and linked armour who treads down the dwarfed spirits of evil. This object of local worship is included among the four great archangels of the Buddhist altars, and is specially worshipped in a separate altar-piece, as we shall see, in his cult imported from Khotan into Japan along with its Greco-Buddhist art. The very leather boots of these militant figures, into which the trousers are tucked, their suits of armour and leather aprons, appear in the Chinese sculpture of the next age.

One more notable feature is that in some of these sculptures, which are perhaps later, we find a tendency to great attenuation and height, with small rounded head and small waist, which seems to imply a new mixture with the older Himalayan type, like that which was pouring northward into Thibet, and to foreshadow that slim Northern Tartar type of East Asia, which passes into Corean art. Certain paintings, too, upon the walls of these excavated houses give us the small heads, rounded shoulders and simple colours of the earliest Corean Buddhist painting, such as we find as illuminations on primitive scripture rolls.

Perhaps the Khotan pieces of great æsthetic value are few, but among others we must point to the very fine terra-cotta head, only slightly injured, which will compare very favourably with the Taxila

Buddha. We shall regard this in a special sense as an artistic link between the latter and the Chinese clay Buddha of Udzumasa.

We come back now to Chinese art, at the point where we left it, to mark the extraordinary harvest sown by it in the adjoining fields of Corea and Japan. Already at the end of Chapter III. we have described the extraordinary invigoration of Chinese genius due to the sudden fusion into the Dzin and Tang empires, apparently for the moment complete, of all hitherto separate movements and scattered elements: Buddhist, Taoist, Confucian, Northern, Southern, Tartar and Miaotse. The Tang (To) dynasty had come in as a military colossus in 618 ; but the great soldier and leader of Tang who consolidated Chinese strength and expanded it again far toward the West, was the second Tang emperor, Taiso *— one of the greatest and wisest of Chinese rulers, who reigned from 627 to 650. It was in this great westward expansion that the introduction of Greco-Buddhist art was effected. Chinese armies and peaceful missions now marched again westward into Turkestan ; and the pious pilgrim Hiuan-tsang stopped at all the famous Greco-Buddhist sites in Khotan, Turkestan, Ghandara and Central India, collecting manuscripts, drawings and models of every description, which were all safely brought back to China in the year 645.

Meanwhile, communication by sea had been opened up with Sassanian Persia ; princes and scholars of the Western kingdom had been received as guests in Taiso's capital, and wrote in Persian the world's first careful notes of the Middle Empire, which have only recently been made available to Europe in translation. There is reason to believe, too, that the Byzantine emperors, or their governors in Syria, had held communication with China, and even implored the assistance of her powerful ruler to make common cause against the firebrand Mohammed, who was just starting a conflagration on the borders of both. Taiso apparently agreed to the alliance, and his armies were preparing to advance from Turkestan to the relief of Persia, when the Saracens, with Napoleonic haste, frustrated the junction by driving a wedge eastward across the Chinese path.

One seems forced to trace some providential meaning in this second blocking of a direct union between Europe and Asia. Only twice in Chinese history was it conceivable that Celestial commissioners should

* Taiso, in Chinese Tai Tsung.

have fraternized with Roman ; once about the time of Christ in the Han dynasty, the first Chinese expanded empire ; and again in the second great Chinese empire, the Tang (To) of the seventh century. Both were powerful enough to pierce a continent ; both were anxious to meet face to face the renowned Rome of their day. But Parthian trade jealousy had blocked the first meeting in the days when Western Rome had started on her decline ; and now Mohammedan religious fanaticism was to block the second when Eastern Rome already felt weak before the foe that was to dismember and destroy her.

Here is the true explanation of why Greco-Buddhist art was so late in reaching China, and why its contact was so brief and its force so rapidly spent. It was a tragic moment for the whole East, a mere touch-and-go. This new Ghandara Buddhism with its fine art had been smouldering at the very western gates of China for three centuries, but the weakness of internal dissension had helped the barriers of the desert. Just now, when the power of Tang was fraternizing, after a lapse of 400 years, with Khotan, Kashgar and North-Western India, and claiming share in the great religious harvest, it was all about to be blotted out by a mighty Saracen sirocco that would soon obliterate its faintest trace and change the whole current of Central Asiatic thought and art for ever. It was high time that Hiuan-tsang should go the rounds, make notes and amass relics before the great black curtain shut down. Destruction lay for Buddhism on every hand, not the Mohammedan blast alone, but a threatened final onslaught of the Northern sands that had already swallowed kingdoms, and a fanatical rising in India itself, which was to wipe out the peaceful monasteries from the Peninsula in a wave of darkness and blood.

So much for the reason why Greco-Buddhist contact was short. But in China itself the new inspiration was enthusiastically welcomed by the Buddhist party. Hiuan-tsang and his relics were installed in a rich temple, and he given charge of a body of scholars to translate and interpret the manuscripts he had brought. We have Chinese evidence that Khotan art rapidly penetrated eastward. Scions of the royal house of Khotan became guests in China, were naturalized, and brought in their national arts, of which the records of painting declare that the new style modelled the Buddhist figures into an appearance of full relief. No examples of this kind of painting exist, unless, as

I suspect, it be partially preserved in the great frescoes at Horiuji, which I am soon to describe. Along the newly re-opened route learned immigrants, driven, perhaps, by already growing disturbances in the South, came up over the mountains from India, bringing the germs of a new esoteric Buddhism which was to flame into proportions of grandeur in the next century.

It is possible that the early Chinese landscape, painted in oil upon leather in the Horiuji collection, and showing Tartars on a white elephant in the foreground of a great valley lighted by a sunset, belongs to this early Tang date, though I have already conjectured its attribution to the sixth century. But if we compare the statue of the Khotan hero, Bisjamon, now in Toji of Kioto, with the Dzin or pre-Dzin example in Seiroji, we shall see how much richer modelling and grace Chinese art was absorbing. Here the details of the armour fully carved, and the group upon which the warrior stands, a female with Greco-Buddhist top-knot in the centre, flanked with large headed dwarfs or barbarians, exactly correspond with features of the stucco Bisjamon unearthed by Mr. Stein near Khotan. Of late seventh century is another fine Chinese Bisjamon, somewhat weather-worn, kept in the Japanese temple of Udzumasa.

In North-West China, near Suifu, is cut into the face of a great sandstone cliff the whole paraphernalia of a Buddhist paradise, the Trinity on thrones, a congregation of the faithful in realistic grouping at the sides, and great terraced stories of palace temples at the back. Here the disposition of the drapery, rather than the grace of the figures, leads us to ascribe Greco-Buddhist origin. But smaller Chinese carvings of the same subject, some in closable pocket shrines of wood, show much more clearly the Greco-Buddhist style.

But the finest and most classic forms that have come down to our day from this brief movement, of which there is no clear connected account in Chinese history, are the great statues, miniatures, and relief tablets, done in marble, in hard-baked clay, and in soft composition clay. The marble statues of Buddhist deities, full-size and very beautiful, were found lying buried beneath the grass that covers ruined mounds, in the outskirts of the present Western capital of Sin-nan-fu. Just here stood the early capital of Tang, nearly upon the ruins of the early capital of Han, and close by the site of the capital of the still earlier founders of Chow. What a field for the archæologist of

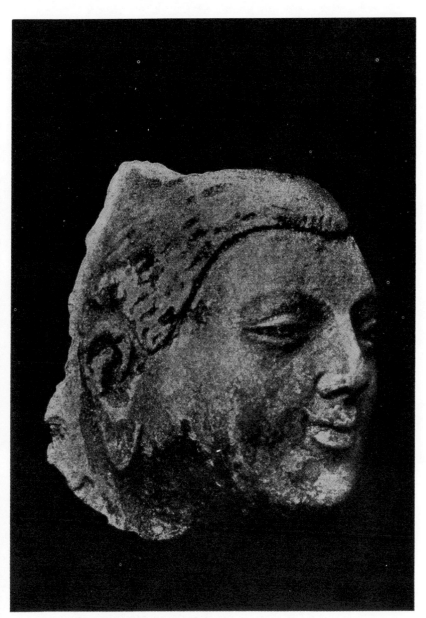

CLAY HEAD OF A BOY DUG UP AT KHOTAN.
By permission of Dr. Aurel Stein.

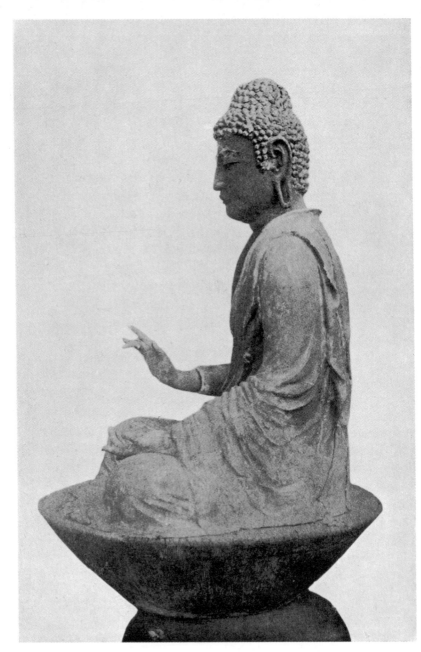

THE SOFT CLAY STATUE OF BUDDHA SEATED,
at Udzumasa, near Kioto.

some future century, who will have been able to overcome the superstitious dread of excavation; and who will find, layer after layer, first at the bottom the veritable bronze vessels and unglazed shards of Chow; next the walls and bas-reliefs of Han; and then the broken columns and prone altar-pieces in marble of the Greco-Buddhist monasteries of Tang (To).

Samples of the hard clay reliefs, in graceful, crisp, and exquisite finish, not unworthy of the Japanese bronze Trinity, are preserved in Horiuji. Here the grouping is almost identical with some of the panels of the Horiuji frescoes. The placid Buddha sits on a throne with feet not drawn up into the cross-legged attitude, but falling over as if from a chair, and resting upon a lotos footstand below. The lines of single drapery here, disposed in a new fashion, are crisp and wonderfully beautiful. Graceful Bodhisattwa are at the side, shaven monks in the background. Fragments of the elaborate halo are beautifully plastic.

But the most typical example of Chinese Greco-Buddhist art is probably the soft clay sitting statue of a Buddha, kept at Udzumasa near Kioto. There is no clear record that this is Chinese; tradition had rather called it Corean. The Japanese would probably like to claim it. But, even in the clay figures of Sangetsudo, there are no Japanese examples of such realistically plastic modelling, quite omitting all such decorative line passages as we find in the bronze statuettes. Here the figure is clearly Greco-Buddhist, quite like the first Ghandara Prince Sakyamuni, of the Lahore Museum; but more powerful in conception and execution, in proportioning and spiritual presence, than any Indian piece. The great heavy folds are deeply cut as if by firm pressure of the thumb, quite as we block out the masses in our wet clay models. The small curls in the hair, too, are like waxy lumps which we had just pinched together with three fingers. Perhaps some of the roughness is due to repairs; but it seems probable that this statue was left undecorated and as massively virile as an untouched photograph. The profile, too, is almost as fine as the Yumedono Kwannon. That this statue became in a clear sense the model for the colossal Japanese bronze Buddhas of the Wado and Yoro epochs can hardly be doubted.

One more phase of Greco-Buddhist art in China must be touched on, namely, the white bronze mirrors. We know from Chinese records that the proportion of metals in their alloy was nearly equal parts

of copper and tin. The more common form of these circular mirrors is to fill many elaborate concentric bands with astronomical and necromantic symbols mixed with delicate Chinese writing. These symbols show actual constellations, or groups of triglyphs from the Y-king categories, the tortoise and hoo-bird, and the so-called zodiacal animals. These are manifestly in subject of Chinese origin, and only in their delicacy of tracery superior to the gems of such Taoist symbolism found in Han. More graceful mirrors than these are figured in the Chinese archæological books sometime as Han, where the most delicious arabesque traceries clasp into spirals the vivacious outlines of hoos and lions; while flowers, butterflies and birds on wing fill the ten-pointed star of their border. But by far the most beautiful mirrors are those entirely covered with exquisitely modelled relief, almost surpassing the Japanese angel screen in easy grace and perfect finish, of heron-like birds flying among grape vines in the border; and animals that look now like a lion, now a bear, and now a squirrel, plunging among still stronger compositions of grape bunches in the centre. The hollow piece that holds the string is as like a glorified frog on a Han bronze drum. We have already spoken in Chapter II. of the controversy over these pieces ; how the Chinese books call them Han, how Professor Hirth argues that they are Han; but of the æsthetic impossibility how, judging from examples I have yet seen, my sincere doubt that they can be Han; that they are not pure Greek, though Greek-like in effect, seems clear. We find the grape-vine pattern used upon late Greek work, but with nowhere this degree of grace. These pieces, of which many large specimens are kept in the Shosoin storehouse at Nara, must for the present be ascribed by me to an inner decorative flowering of Chinese genius to perfect with Chinese shapes rude motives that may be derived from Ghandara. We shall speak of these once more under Shosoin.

We have already explained why this specific Greco-Buddhist movement in China was cut away at the stem before it had absorbed sufficient vitality from the parent root to render it more than a sporadic form. Pure Chinese causes working from within, making nobler use of native elements, forgetting the pagan non-symbolic grapes and squirrels, and substituting more Chinese proportions and rich passages of brush delineation for tall and realistic Buddhist modelling,

were about to follow the rapid rise of Tang poetry to the veritable splendour of an illumination. By the year 698, when the Emperor removed his capital far to the east, at Loyang,* this momentary quickening had well-nigh ceased.

It seems a tendency with some writers to claim all that followed for centuries in Chinese and Japanese art to the credit of the Greco-Buddhist movement ; but this is to confuse classifications. In this work we aim to seize the peculiar creative impulse of each period, and thus explain the uniqueness of its art. Judged by such aim the Khotan influence was brief, and the specific form only in part assimilated. It is doubtless true that a certain legacy of nobleness and grace was left to later ages by this brief passage, just as a certain naive solidity was deposited by Han—but little that is specifically of Greek type. No doubt Chinese art grew with every step, incorporating successive powers ; but the elements that now entered into the quick evolution of Tang were more internal, spiritual, and formally Chinese.

* Japanese pronunciation " Rakuyo."

CHAPTER VI.

GRECO-BUDDHIST ART IN JAPAN.

The Culmination of Sculpture—Nara.

LET us observe now the outflow of this sudden classic wave in China to Kingdoms lying on her eastern border. Tang (To) ambition had essayed to annex Corea in 645, and temporarily succeeded in 668 ; thereby almost leading to serious friction with Corea's friend, and nominal superior, Japan. This is why Japan was so much more cut off from Corean contact in the seventh century than in the sixth, and why she was forced first to evolve art from within, second to be influenced by Tang. Corea, too, could not avoid this influence ; and we have evidence that her art, already so fine, was lifted up into something like new Greco-Buddhist proportions before the end of the century.

The royal palace in Seoul, set in the midst of fine gardens, with its beautiful carved marble terraces, railings, bridges and columns, and its specially fine swing of tiled roof, shows clear traces, through its many rebuildings, of that great day when Corea was swayed by Tang. It is not certain whether the cream glazed pottery for which Corea afterward became so famous can date from this seventh century. But we have one large Corean bronze of the first rank, which was presented from the continent toward the end of the century, and which exhibits clearly the Greco-Buddhist influence, though in combination with inveterate Corean traits. This is the splendid life-sized standing Kwannon, worshipped as the central altar-piece of the Toindo pavilion in Yakushiji, near Nara.

To mark exactly what Corean art has gained—and possibly lost—in the interval of a century, it is a privilege to compare this Toindo Kwannon with the Yumedono Kwannon of almost similar size described in Chapter III. In these two pieces we have the supreme summits—so far as we now know—of Corean art.

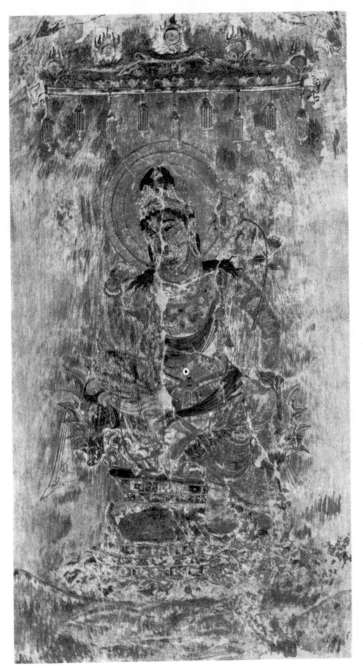

DETAIL OF THE FRESCOES AT HORIUJI.

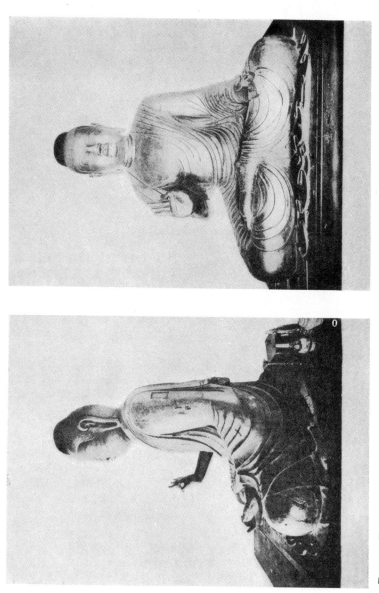

BRONZE BUDDHA AT KANIMANJI.

The later Kwannon stands a little stiffly, with almost no hip-sway, upon a new type of lotos throne, the upper petals of which rise stiffly, like an artichoke, from an octagonal box member whose curving sides are decorated with relief flower scroll that may well be modified acanthus. The modelling of this bronze throne is of the utmost power and semi-classic beauty. The lower part of the figure retains much of South Indian and early Corean feeling, with its drapery close winding about the legs, the fine outward swing of Go folds at the side, and the somewhat thin and wiry mantle that twines to the feet over shoulder, hips, and arms. But in the upper half of the body we return to an approximately Greco-Buddhist type : primarily the proportion, the fine long chest and slightly suggested swell of the bosom, the graceful waist, the long arms, the small well-modelled hands, and especially the small beautifully ovalled head. The hair is of the pure Greco-Buddhist Bodhisattwa type, the very large top-knot being encased in a filigree net with conventional scrolls. Finely moulded jewels encircle the neck, crisply relieved from the satin texture of the skin. Above all, the face possesses great beauty, enhancing under its semi-classic sweetness that beneficent mysterious smile which we noticed in the Yumedono and Chuguji Kwannons. It remains to add that the bronze of which it is composed is of a lovely yellow brown, an alloy which the Japanese Buddhists call " Embudagon," but which was rarely attempted by them. It may be said that this was the first large bronze statue ever seen in Japan, and that it had immediately great influence upon Japanese work.

It is possible that the colossal bronze-seated Buddha of Kanimanji, which we are soon to describe, is also a Corean masterpiece of this date. There is no record of the fact ; indeed, all tradition regarding it is lost ; but it has almost as clear a golden tone in its alloy as the Embudagon Kwannon ; and the folds of drapery about the body and legs, though large and grand, are somewhat wiry and formal, and like the lower portion of the Toindo Kwannon. It seems more probable that it is a first Japanese experiment made with Corean material and under the influence of Corean genius.

Let us pass over the Straits of Tsushima, and resume our study of Japanese art where we dropped it at the end of the fourth chapter. We had there watched Japan's long series of experiments with bronze statuettes culminate in the brilliant Trinity of the Angel screen. We

make this the dividing line, because almost immediately after this achievement strong Chinese imperial and Greco-Buddhist forces were to sweep all such experiments away into new and wider channels.

The study of Chinese institutions begun by the Emperor Tenchi was followed up by his successor, Temmu, and the latter's widowed Empress, Jito. The latter in 690 organized the ladies of her palace into a corps of female officials. She also established a mint. But her greatest achievement, though now ruling as a retired Buddhist in the name of her son, was the drafting and first promulgation of the great Taihorio code of laws in 702. These were based on a deep study of Chinese precedent, and had for their primary object a just redistribution of the land, which had been absorbed by the nobles, among the agricultural population at a fixed rental. A separate soldier caste, with special privileges and means of support, was devised. Moreover, the Empress and her young *protégé* held quiet receptions of nobles and officials in the palace of Daikiokuden, quite in the style of Chinese sovereigns. Confucius, too, was publicly worshipped for the first time, along with Buddha. A student of the new Chinese mysticism, En no Giōgi, came over to Japan, but was not at first well received.

These incidents are mentioned chiefly to call attention to the enormous influence upon Japan which the vigorous Empire of Tang was exerting ; and with it could not fail to intrude the new æsthetic canons of the Greco-Buddhists. Already the clay Buddha of Udzumasa and the terra-cotta tablets must have been imported, and this Corean bronze Kwannon of Toindo lay ready to hand as additional motive. It was apparently in the western side of the Nara plain, close up under the sand hills, and a little north of the present town of Koriyama, that the first great experiments in Japanese Greco-Buddhist art were made. Here stands Yakushiji itself with the Toindo ; and just south of it lies Shodaiji, an institution founded a little later, but probably on an early Buddhist site. Here, amid a mass of broken statues and interesting refuse, I found in 1880 a life-sized piece which seems to have been one of the original Greco-Buddhist models, or at least experiments. It is like a great doll of wood, apparently finished into surface with over-layers of modelled clay. The Greekish modification of Indian drapery over the legs is under-cut in deep, strong catenary folds ; the body, nude above

the waist, shows strong markings of the primary muscular tracts; the long, tapering arm has been separately modelled and set into the shoulder with a plug; the neck is short, the head rather too large, but semi-Greek in profile, and a projecting plug shows where a top-knot was added to the Greco-Buddhist hair.

But our enumeration of the sources of Japanese Greco-Buddhism would be inadequate without the famous frescoes that now completely cover the inside surface of the four outer walls of the great Kondo at Horiuji, five miles to the west of Koriyama. I have described this first great temple of the Suiko age in Chapter IV.; and there I mentioned that a great fire about 680 ruined the first erections, with the possible exception of the gate, the pagoda, and the Kondo. Some Japanese archæologists believe that these, too, are not the original structures, but belong to the general rebuilding, *which must have been achieved under Greco-Buddhist influences coming from China!* I will not repeat the arguments there briefly canvassed; but go on to assert that the great frescoes of the Kondo, whether the original building was old or new, must surely have been painted at this time. The low pent-house which runs about the lower story, injuring its effect, was doubtless no part of the original architecture, but a device either added to the old building to protect the frescoes from exterior damp, or added later to the new building, as it was found that protection would be needed. In either case, the interior of the Kondo presents a strange agglomeration of styles; the whole altar, most of the statues thereon, and the great hanging baldachins being purely Suiko, while the frescoed walls behind them and a few of the statues are purely Greco-Buddhist.

It seems good to call these elaborate paintings frescoes, since they form one of the very few examples of mural painting on plaster which have come down to us in Eastern Asia; but it is improbable that their method was pure fresco, that is, of the application of the pigment to a wet surface: rather does it seem certain that the chipping off of the colour shows that it was applied to the dry finish of the wall, quite as it might have been painted over paper, silk, or wood. Some English travellers have exclaimed before these Horiuji frescoes upon their likeness to the wall paintings in the Adjanta and other Buddhist cave-temples in Northern India. But it seems to me that between the two æsthetic types there lies a wide gap. It is true that in both we find the flesh afterward outlined in red, and that somewhat similar Indian types are

found in both. But in all that concerns æsthetic classification, in spacing, in proportion, in line dignity and solidity of colouring, and in the noble presentation of spiritual beings, the Horiuji panels, though East Asian, have far more merit than the more sensuous, squirmy, crowded and over-ornamented Indian examples. In the latter little of Greek proportion and suggestions remains. It seems fair to conjecture that, granting the existence in Ghandara of great Greco-Buddhist frescoes, they and the cave works may have slightly influenced each other ; the proportion of the Greek element being far greater in the Ghandara. It would then happen that the Horiuji paintings, derived from Ghandara, would present certain features that Ghandara shared with Adjanta. It is interesting in this connection to compare the best of the Horiuji compositions with the classic frescoes unearthed at Pompeii ; and to realize that here we have almost surely a real, though remote, genetic connection.

The long band of Horiuji frescoing, broken only by the four doors which cut the centre of the four walls—a band of some 300 feet in length by 15 in width—is broken into separate quadrangular compositions of varying proportion, the largest of which show seated Buddhas, some with down-falling feet, standing Bodhisattwas of tall Greek type—not always stiffly in pairs as members of a trinity, but in groups of two, four and more—and holy men as spectators in the background, quite as in the Ghandara fragments. The Buddhas' halos are circular ; rich painted baldachins overhang, and flying angels with backward sweeping drapery descend from heaven with dropping flowers. Other groups have only dignified Bodhisattwa without Buddhas. These always have the great domed Greco-Buddhist top-knot, not as formal in line as the sculptures, but painted wavy, as are also the loose locks that fall on the shoulders, much as the hair falls in the Ghandara marble princes. The colours are rich and deep, dark claret and green garments for the Buddhas, and dark reddish or purple flesh tones for their faces ; but gayer warm tints for the bodies and the faces of the feminine types.

Who painted these unique frescoes we do not know. The temple guess that it was Doncho, one of the Corean priests who came over for Shotoku, is nonsense. It is hardly possible that any Japanese artist who might have studied in China could so perfectly have mastered an alien style. It seems far more likely that the author was either an

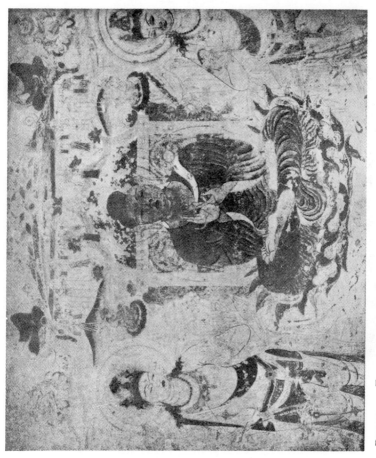

Detail of Frescoes at the Temple of Horiuji, Nara.

GRECO-BUDDHIST SCULPTURES IN STONE.
From the Crypt of the almost vanished
Temple of Gangoji, in Nara.

imported Chinese master who had worked under Michi I-Tsing or some other devotee of the Khotan style, or possibly a so-called " Indian," that is, not necessarily a native of India proper, but an importation from Khotan itself or from farther Turkestan. In either case we ought properly to have described these works under the heading of Chinese Greco-Buddhist art in the earlier part of this chapter. But because of their relation to the history of Horiuji, and of their dominating influence upon the Greco-Buddhist style in Japan, I have deliberately postponed the account to this point. Enough to say that the proportion and grace of these painted deities could never be made to coalesce with the influence of such imported sculptural types as the Udzumasa Buddha and the Toindo Kwannon.

The influence of these paintings and of the small clay relief upon Japanese sculpture of the age of Temmu (673—688) is clearly seen in some remarkable large reliefs in stone in the crypt of the almost vanished temple of Gangoji in Nara. These are deeply chiselled out of solid slabs of stone let into the wall. The chief of these consist of a very beautiful eleven-headed Kwannon, and several Trinities. The style of the Kwannon retains some trace of the bronze statuettes ; but the lines are more suave and the proportions are newer. The figure has been cut out of a niche, and stands in such high relief as almost to seem detached. It is perhaps Japan's finest piece of stone sculpture. The Trinities are arranged in the regular Greco-Buddhist style, but the spectators are omitted. The Bodhisattwa sway strongly at the hips. Suiko Ghandara lions crowd up by the Buddha's footstools. The flame-shaped halo is retained from Corean models ; but within the Buddha's is a round Ghandara halo. In one instance, instead of a baldachin, we have the sacred tree carved in flat relief, with concentric bands of leaves ; a persistence into Buddhism of Han art derived from Mesopotamia.

But soon a new discovery in Japan lent weight to the coming change. In 708, the first year of the Emperor Gemmei of the Wado period, copper was discovered in Japan in large quantities ; and thus it became possible to make bronze images of large size. For the statuettes of the preceding age most of the metal had to be imported. Now it became no longer necessary to limit the scale of work, for which the Greco-Buddhist models demanded generous proportions. The imported Toindo Corean Kwannon set the pace ; and thus in bronze sculpture we now have splendid statues of life-size or larger replacing the statuettes.

The style of this new and culminating bronze work may be described as a synthesis between the new Greco-Buddhist ideals coming from China, and the qualities of the statuettes themselves. We have seen what wonderful delicacy of feeling and what finish of surface could be obtained in the Trinity with the angel screen. It is possible that some of the more graceful features of this may be due to a first partial introduction of the new Greek forms. But Japan was rather too far removed from the Central Asian sources to absorb Ghandara canons in their purity ; so that they may be said to have acted rather in the way of enhancing, dignifying, and broadening the excellences already found in germ in the statuettes. With this modification, Greco-Buddhist art, such as it is, really comes to take deeper root in Japan than in China, just because the native genius was more adapted to it. In China it only advances art one peg toward the Tang culmination of 730. In Japan it becomes itself the very culmination of the first period.

The groups of large bronze deities which belong to this culminating age, Wado and Yoro, from 708 to 721, and which now remain for our study, are chiefly four. The earliest is probably the great Kanimanji Buddha already mentioned, which may possibly be Corean, or possibly made in Japan of Corean metals earlier than 708. This we have already described.

The next group is the trinity of colossal statues now set up in the Kodo or lecture hall of the temple of Yakushiji, in the western suburbs of Nara. The history of this most interesting temple is obscure ; but probably it was originally founded somewhat to the north of its present site ; and it is said that this Kodo trinity was cast as its main altar-piece. When the temple burned a few years later, it was rebuilt on its present site about 716 ; and æsthetic taste having advanced with strides during the short interval, the awkwardness of the old altar group caused their abandonment to the secondary building or Kodo, the finer black trinity being newly cast for the new Kondo. This first Yakushiji trinity, which is considerably larger than life, shows clear traces of its dependence upon the statuette model. It is just an expansion of these to new scale, with an evident effort to achieve new proportions and realistic modelling. In spite of such criticism, the Buddha is very fine, the drapery falling over the shoulders more in the Chinese manner than does that of the Kanimanji figure. Nothing of that hard Corean fold line here remains. A very original method has been tried in swathing the upper of the crossed feet in their drapery ; but the legs and feet have apparently been made too insignificant

and thin, in trying to get away from such an enormous exaggeration as the Kanimanji Buddha gave them. The hair is not flat as in the latter, but covered with wavy short curls. The support is an immense solid circular lotos throne, which, while fine for statuettes, takes on a certain awkwardness from the excessive scale. The standing Bodhisattwa are impressive, but somewhat fail in reaching perfect naturalness in the hip-swing.

This old temple of Yakushiji contains one more feature which I ought to notice before coming to the Kondo, and that is the ancient pagoda, which was saved from the fires that destroyed the Kondo and Kodo a few centuries ago, and perhaps dates from Yoro. It is unique in the varying breadth of its stories, achieving an original impression in Buddhist architecture.

But perhaps the most powerful æsthetic grip that will seize the astonished traveller in Japan will burst upon him as he turns to the north, and enters the broad open doors of Yakushiji's Kondo and faces the forty-foot breadth of the great stone altar with its trinity of colossal statues in shining black bronze, relieved against enormous boat-shaped halos of gold. These halos are new, the original, undoubtedly of bronze, having been probably melted in the great fire. Other figures of Yakushi's generals, of modern clumsy form and garish colouring, help to mar the unity of the group. Moreover, the space in front of the altar of the modern building is so narrow that no single front view of the three wonders can be obtained. It is only by photographing them far at the side that we can obtain them in a single composition, by no means their best view. We must be content then to study each for itself—premising that the whole group is made of a black polished bronze—perhaps the same alloy heavy in gold called Shakudo, and often used for small sword ornaments—as black as ebony, and which the conflagration could only slightly injure.

Taking the Bodhisattwa first—the Sun and Moon goddess, so-called, who attend Yakushi as Kwannon and Seishido Amida—we may say that every precaution has been taken to guard against the defects of preceding examples, large and small. The figures, of perfect grace and restrained sway, are neither attenuated nor stout, but of solid, substantial proportion, the head given dignity by the specially large Greek top-knot. The muscular contours of the body are revealed with perfect restraint. The drapery about the legs is far freer and purer in fold than the Toindo model. The double curved systems of linked

jewels, and of the thin mantles, are so perfected and harmonized as to carry the beauties of the screen trinity up to the grandeur of the new scale. They are, perhaps, the finest standing bronze figures of the whole world. The chasing of the surfaces of hair and crown give a splendid contrast of dusty colour with the liquid black of the flesh.

The Buddha is a splendid compromise in proportions between the big head and legs of Kanimanji, and the weak features of the Kodo. The lines of drapery have less decorative depth than the screen trinity. The head is modelled into a splendid front oval, but gives a sharp profile quite like the Udzumasa clay Yakushi. The flow of the drapery over the left arm and across the left knee is as beautiful as the rhythms in a genuine Greek statue. The left hand, too, is as beautifully modelled as the Buddha's of the screen, and, although being webbed, of more realistic proportions.

A word must be added about the great massive bronze box or throne, upon which the Yakushi sits, and over the front of which his falling drapery pours. This is unique in Asiatic art, and hard to classify, though it seems pretty clear that its elements must have come in with waves from Chinese Tang concomitant with Greco-Buddhist. The edge of the upper projecting band is beautifully done in vine scroll-work, strongly recalling the grape-vine mirrors, and very close to the grape-vine scrolls of later Greek work. The panelled rosettes, lozenges and crosses of the four other bands, also in low relief, bear relation to primitive designs found among the tribes that live along the Amoor region, and which we find in some Han decoration. A long low writhing dragon, in the middle of one of the side bands, seems to be a transition from the dragon type of Han to that of Tang. But the most remarkable and unique features are the groups of crouching figures, two and two, set within decorative Buddhist arches.

These show a most realistic representation of dwarfed figures of some negrito race, nearly naked, and with enormous heads of fuzzy hair like the Somali peoples in Africa, or the Negritos of Borneo, Australia, or the Philippines. It seems as if these have been studied as types of a lower world, sub-human, which Buddhism came to dominate, or, as a theosophist would say, relics of a third race. It is probable that the genius of the artist here substituted these realistic forms for the Greco-Buddhist dwarfs or imps. But the most incredible feature of all is the built-up pillar at the back, held by a grotesque figure with

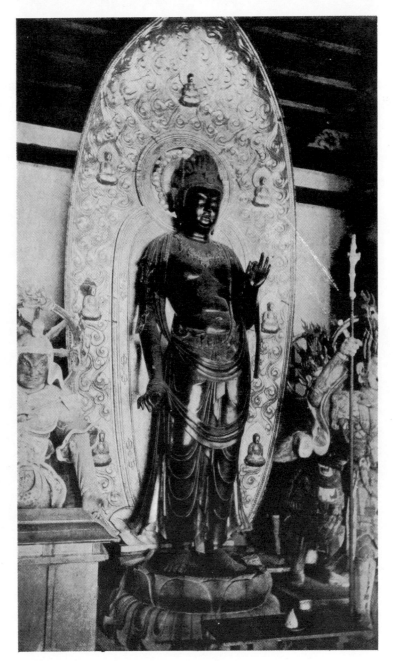

THE BODHISATTWA STANDING AT THE LEFT OF THE YAKUSHIJI TRINITY.
From the Black Bronze Trinity at Yakushiji.

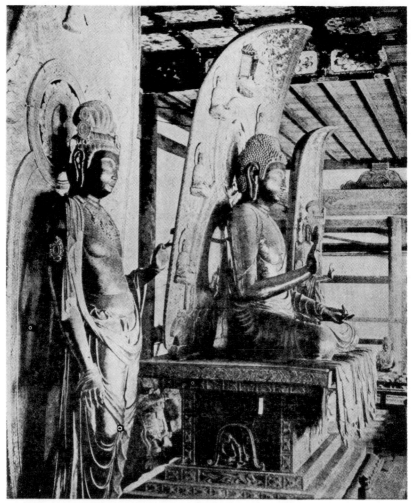

YAKUSHIJI BLACK BRONZE TRINITY
seen in profile.

fish tails instead of legs. This seems indeed to be a deliberate re-importation, based upon contemporary studies of Polynesian life, of the principle in ornament of the totem pole. It is of course more beautifully and conventionally rounded than in any Polynesian specimens.

Taking the Yakushiji group as a whole, it does not seem extravagant to say that its æsthetic value would alone repay a student the whole time and expense of a trip from America to Japan. What a ripe genius its author must have been! And fortunately we know him, the third identifiable personality in our list of great Japanese sculptors, coming nearly a century after Tori Busshi and Shotoku Taishi. He is Giōgi, called for his marvellous wisdom, "Bosatsu" or Bodhisattwa. Not only was he an artist, but a great prelate, and a great statesman and adviser of the Japanese emperors. Fortunately, too, we have his portrait statue in wood, the work of his own hand, which, in spite of its crumbling paint, reveals the same splendid plastic use of drapery that we find in his Yakushi. The portrait is to be found in Saidaiji, north of Yakushiji.

In order to understand how these brief periods of Wado and Yoro really contain the first æsthetic flowering of the Japanese race, we must remember that a great activity in literary form accompanied these triumphs of sculpture. At this time lived the two supreme masters of early Japanese poetry, Hitomaro and Akahito. The Manyoshiu, the first great Japanese anthology, began as a private collection in the family of Yakamochi Otomo, grew by accretion and was published, probably between 750 and 760 A.D. The Kojiki, a reduction from traditions of the religious annals of Japan, was completed in 712. The first critical history of Japan as a whole, the Nihonji, was printed in 720. It was a wonderful outburst of intellect and refined feeling, on its literary side almost pure Japanese, and unrelated to the great contemporary Chinese literary outburst of Tang. That is, Chinese ideals had not yet penetrated Japanese literature, as they had Japanese Buddhist art.

To add new evidence of how this illumination worked toward perfect and original art, especially bronze, we must point to the Kagenkei, that wonderful hanging bronze drum, which is one of the treasures of the Shinto temple at Kasuga. It is a circular bronze drum suspended between the interlaced bodies of two dragons, which twine upward from a stem which rests upon a lotos saddle on the

back of a crouching dog-like figure, probably a Buddhist lion. The modelling is all as vigorous and rich as a Benvenuto Cellini, without any of his rococo exuberance. In restraint it is more like the Mercury of John of Bologna. These are typical dragons of Tang; and the working out of their scaly folds and of fanciful reptilian legs is as realistic as if it had been mastered in long study at a zoological garden. The concentric relief bands of the drum, covered with rich scroll work, and its fine lotos centre recall the moonstones of Ceylon and their antecedents in Mesopotamia.

But it should not be supposed that the æsthetic triumphs of this day are confined to sculpture in bronze. Several other substances lent themselves readily to the plastic genius of Japan, foremost being the medium of clay, which had been used in various forms and textures in China, in Khotan, in Ghandara, in Baktria, in Tanagra, and in Nineveh. This Japanese clay is of a beautiful light silvery-grey, unbaked, composed of sifted Nara earth mixed with finely shredded paper fibre. It yields with ease to the thumb, takes a polished surface that hardens with mere drying, and resists ordinary atmospheric disintegration.

A large number of statuettes in this new material — invented apparently for the very purpose of introducing the Greco-Buddhist forms, and based upon such importations as the Udzumasa Buddha— are found in several striking groups set with modelled landscape background in the lowest story of the Horiuji pagoda. Here are little Greco top-knotted angels sitting about, and Bodhisattwa mingled with kings, saints and mediæval monks. The Nirvana scene, among others, is thus worked out into detail ; many of these clay figures of priests in deep sorrow being naive and even comic, but fine in action. The last is especially true of the man who throws himself over backwards. These groups are probably early, and may date from the very rebuilding of Horiuji.

Another and more striking set are the " 12 generals " accompanying Yakushi, life-sized statues which were originally set about the great circular clay altar of Shin Yakushiji at Nara. These are 12 militant figures in violent attitudes, some of them with spears, some with swords, and some arrows. Their costume seems based upon the primitive Khotan Bisjamons, with variations undoubtedly Chinese. Here too must lie great play of Japanese fancy, for no two attitudes

are in the least alike. The finest is probably the figure with the long upraised arm. This temple was restored at the expense of the Japanese Government several years ago, so that it is specially interesting now to see the photographs taken in the early 'eighties with the dim figures of gigantic Bodhisattwas looming up under the dark apexed space of the octagonal pavilion.

Still finer in modelling and preservation are the four life-sized guardians (Shi Ten O or "Four Deva Kings") which are set upon the great raised altar of the Kaidando (Baptistery) of Todaiji in Nara. So vigorous is their action that they seem almost veritable photographs of scowling Chinese knights in armour. So fine is their modelling that the effect is given of perfect marble sculpture. The hands have been broken and restored, and what they hold is modern. But the faces, bodies and hair are nearly perfect. Especially fine is the action of the figure which holds up a pagoda in his raised right palm ; and his Greco top-knot is striking. Another has his head completely covered in a fine Chinese helmet. All these figures stand upon the bodies of misshapen brutal imps, the very ideal of what our "theosophists" call an "elemental." It is probable that in these fine statues we have very close approximation to Chinese originals ; and we can therefore feel that we are in them virtually studying the art of early Tang.

Another single statue of the violent type is the Mace thrower— Shikkougo-Shin, a kind of Buddhist Thor—kept in the adjunct pavilion of Sangetsudo in the grounds of Todaiji. This shows the utmost passion of battle in the face. The muscles and tendons of the arms and of the elevated fists are worked to the utmost perfection of the veins. The lines of the flying drapery, though somewhat broken, are so fine that we are inclined to place this as contemporary with the culminating black bronze Trinity of Yakushiji, and to conjecture that it may be the work of Giōgi himself. The original painting over the clay has been almost perfectly preserved, giving detailed textures and patterns—the damascening of the gorget—the scales of the waist piece, and the brocade arabesques of the close-fitting shirt.

But the finest pieces that have come down to us, doubtless also the work of the culminating periods Wado and Yoro, are the large, even sometimes colossal, Bodhisattwa in clay ; especially the two large figures with hands clasped in prayer, upon the great altar of

Sangetsudo. If one has been sceptical of any real Greek influence up to this point, he will be converted on beholding these so-called statues of Brahma and Indra (Bonten and Taishaku). This is probably a misnomer; for the figures are the most feminine of all early sculpture, feminine in the sense of grand solid proportions that bring them into a sort of rivalry with the Parthenon torsos and the Venus of Milo. Of course we must remember, in the case of these as in the case of the black trinity, that the ideal is necessarily different from the classic, translating the suggestion of the human into godlike proportion, rather than reducing the godlike to the typical human. Nevertheless, the deep modelled drapery folds seem as fine as the best of archaic Greek, and the low relief of the knotted girdle is as delicate as the angels of the screen trinity. The faces, too, have the sweet nobility of the little Bodhisattwa in that statuette group, the profiles being especially beautiful. We must rank these as the finest work of the day along with the Yakushiji colossi.

We come now to the great age of Nara, which the Japanese vaguely identify by the period name Tempei. But the age begins yet earlier than Tempei, with the accession of the Emperor Shomu in 724, who was destined to rule till his death in 748, which is also the last year of Tempei proper. We should better designate this as the age of Shomu; but it is something of a mistake to regard it as an æsthetic culmination. No doubt it was Japan's first age of really imperial splendour: Shomu's new capital, Nara, covering some thirty-five square miles and having more than a million people. Shomu himself was the nearest to an imperial autocrat that Japan ever saw. He was supreme king, general, judge, and priest in one. Moreover, his reign was contemporary with the central part of that romantic Chinese reign of Genso (713-756) which is the real absolute culmination of Chinese genius. It was followed by the great decay of life and ideals under the Emperor Kobun.* Why, then, should we not regard it, as writers have generally done, to be the first flowering age of Japanese genius also?

The difference in the cases of China and Japan—between Genso and Shomu—is that the former was formulating and organizing new forces from within, already superseding the somewhat alien Greco-Buddhism with stronger nation growths; but that the latter had no new elements from within to incorporate, and became partially cut off

* In Chinese the Emperor Hüan Tsong.

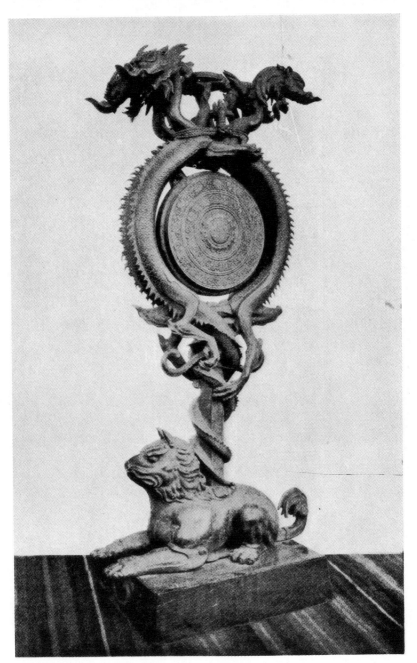

The "Kagenkei," or Hanging Bronze Drum,
at the Shinto Temple of Kasuga, Nara.

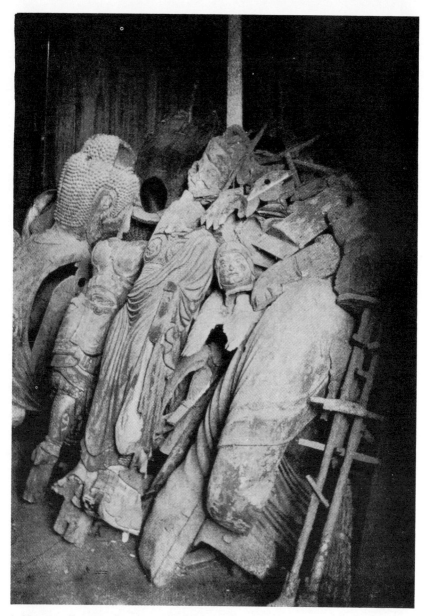

A Mass of Broken Statues and Interesting Refuse, such as was found by Professor Fenollosa in the year 1880, at Shodaiji.

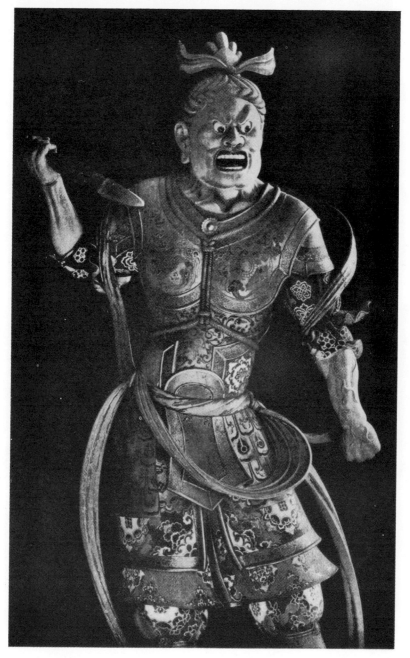

THE SANGETSUDO "MACE-THROWER"
at Todaiji.

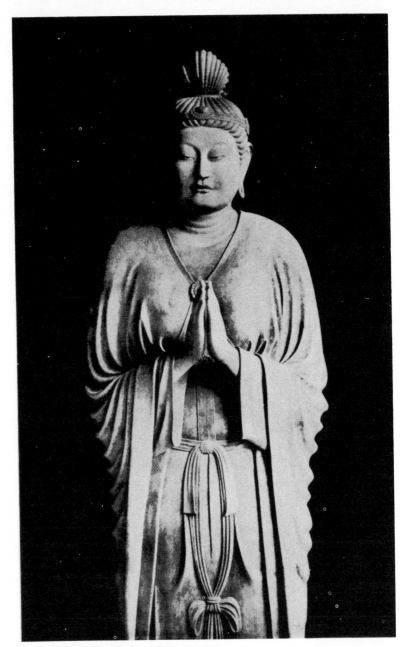

LARGE CLAY FIGURE OF A BODHISATTWA,
SOMETIMES CALLED " BONTEN."
Temple of Sangetsudo

from that new Central China of Tang which might have supplied new motive. Hence, Shomu, who at once removed the national capital to Nara, thought only of gathering up and enjoying the fruits of previous contact with the continent. In his early years he abolished the practice, begun by Tenchi, of sending Japanese students to study abroad. The new literature had already given Japan a kind of self-consciousness. China was herself partially divided between Buddhist and Confucian camps. Shomu determined to reign in independent splendour as the sole great Buddhist potentate of his day. His superstitious reign reminds us somewhat of the early Chinese Emperor Butei of Liang.

Moreover, inspiration was already succumbing to splendour and the temptations of imperial favour. The demoralization of Koken was already beginning. The great poet Hitomaro died during the first year of Shomu. The great artist Giōgi had passed away. The nation was rather cut off from a new supply of Chinese and Corean genius. Even its Buddhist principles were not deeply and soundly enough rooted. Culture was based rather on sentiment than on character. The young Japanese nation could not know that luxury and success were really the greatest enemies of supreme art. Yet the undermining forces did not clearly reveal themselves during Shomu's earlier years.

The use of clay, as an alternative medium for sculpture with bronze, apparently did not last late into Shomu's reign. A new and purely Japanese substitute for it was now invented, whose greater tenacity and lighter weight made it possible to build and move really colossal statues from place to place. This was a method of hollow sculpture worked in a kind of lacquer composition. A high wooden frame was first covered with planes of coarse cloth soaked in glue, which could be made to harden into the primary blocking of the statue. Over this was modelled by thumb and spatula successive layers, progressively refined in texture, of a mixture of lacquer juice with powdered bark. This could be made in the lower contours as thin as paper, but deepened for the relief portions. The lacquer dried to the hardness of rock, and could be finished in shining black, gold leaf, or heavy oil paint. When finished, a life-size statue weighed only a few pounds. This seems to have been the favourite substance for artists, especially during the earlier years of Shomu. Its danger lay in making the core of wooden supports too stiff to bring out all the graces of action; but this defect hardly appeared at first. Several hundred statues in this form, large and small, whole or in fragments,

still remain in the great temples about Nara, especially in Horiuji, Sangetsudo, Akishino, and Kofukuji. The Dembodo pavilion of Horiuji is largely filled with such, mostly in gilt finish. The others are mostly painted. The guardian Kings of Sangetsudo and some of the gilt Bodhisattwa are eighteen feet in height.

One of the most beautifully modelled, hardly inferior to the clay "Indra," yet showing the Shomu modification of the Greco-Buddhist top-knot in locks that play loose about the domed excrescence, is the seated Bodhisattwa owned by the Art School in Tokio. Here the pure plastic of the thumbing is only surpassed by the Chinese indigenous clay Buddha. The somewhat bronzy stiffness of finish that still lingers in the Japanese clay pieces is here thrown away. But the very facility of execution leads to a certain picturesque carelessness in the composition.

The Dembodo statues are mostly in gilded trinities, and a little smaller than life. The best set of these has a grace and finish almost worthy of Giōgi and his black bronzes. The top-knot breaks with a special catch in the centre part. In the Bodhisattwa, whose top-knot and left arm are broken, the beautiful plastic play of the drapery over the shoulder gives us the feeling of a Roman emperor's portrait statue. Since the day in 1880 when I first discovered it, I have always affectionately called it "Cæsar." The slim painted composition statues upon the altar of the Chukondo at Kofukuji in Nara, are of the generals of Yakushi and of priests. The broken statues already illustrated are of this series. Their faces have a small boyish Indian look which gives them a naive charm. Tradition has it that their modeller was an Indian priest who came directly to the world's new Buddhist Constantine, Shomu, rather than to China. The finest priest's statue with the small Indian head is probably his self portrait.

To this early Shomu age, say of 724 to 740, belongs also the rare humorous bronze group of two priests, one praying, and one walking slowly and sanctimoniously with a censer. The drapery is of the very finest cast and modelling.

But the true Japanese substance—as it was also the leading Chinese substance—for Buddhist statues, and especially for those of Shomu's later days, was undoubtedly wood. We find wood used only exceptionally and chiefly for the rare eleven-headed Kwannons, in the Suiko, Yomei, and Seimei eras (593 to 667). In the following reigns, including the Empresses Gemmei of Wado and Gensei of Yoro, wood remained quite subordinated to bronze and clay. But by the early years of

Shomu's reign, the eleven-headed Kwannon was promoted to stand among the chief of Nara's deities ; and for it the retained material of wood was carved with all the new grace of Giōgi himself. Here, too, the feminine attributes of this favourite, almost one might say the motherly quality of her—corresponding on the one side to the fecundity of the Ephesian Diana, on the other to the mediæval Virgin of Europe—became more strongly marked than in any Buddhist statue outside of India.

The earliest, most beautiful, and most Greek of these wooden Juichimen * is the sumptuously-modelled figure of the Itsushi Island, in Lake Biwa. Here the chief face is most sweet and beautiful, the figure splendidly swaying, the contours of the upper nude body suggesting rather than realizing the female bosom, the action of the hand in holding the large bottle fine. The profile is equally splendid, showing traces of the antique depression of the thorax. All the drapery lines are as graceful as the finest bronzes. This is the finest wooden statue, and may possibly belong to the Yoro epoch.

Later in Shomu's career, when he had become quite absorbed in temple erections, his young wife, the Empress Komio, said to be the most beautiful woman of Japan, entered into his enthusiasm, and is said at times to have become possessed by the spirit of the eleven-headed Kwannon, her person at such moments of inspiration glowing like gold. Other tradition has it that she used this alleged piety as a cloak for scandalous intimacy with one of Shomu's priests. It is generally believed that she allowed her unveiled person to be used as a model for a Juichiman Kwannon, which is generally identified with the statue of Hokkuji, that evidently belongs to Shomu's middle or later period. But this, though it has much effeminate grace and unique fancy in the draperies that engulf the legs as in a whirlwind, does not seem quite feminine or beautiful enough to have been made from the alleged model. The Lake Biwa Kwannon, though the most feminine, would seem to be too early for this episode. Somewhat less feminine, though almost equally beautiful, is the eleven-headed Kwannon of the Toindo at Yakushiji, which formerly occupied a niche at the side of the big Corean bronze. The white priming of this gives the impression of marble. The figure is so light and graceful, almost seeming to poise against wind currents, that I have sometimes likened it to the most

* Juichimen is really here another epithet for the Kwannon of the Eleven Faces.—
PROFESSOR PETRUCCI.

graceful tall French Gothic statues upon the façades of Amiens and Rheims. Indeed, this Japanese naturalization of far-away Greek types so parallels the mediæval unconsciousness of the classic tradition that remotely conditioned its work, as to justify us in adopting for this style, if not for the Greco-Buddhist art as a whole, "the Buddhist Gothic." Mr. Cram has independently noted this parallelism in this suggestive term.

But the wooden sculpture of Shomu was far from being limited to such graceful feminine forms as Juichimans. Buddhas, Bodhisattwas, Deva kings, priests, knights of Yakushiji's, elementals, and a dozen other forms, sought to realise plastic beauty under the carver's tool. As the reign passes towards its close, these forms grow stouter and heavier, a proportion that, for male figures especially, is not without its dignity. These are found everywhere in temples throughout Yamato province, the most notable being in temples erected or re-dedicated in Shomu's own Tempei, many of them being in a half-ruinous condition. As temples fell or were burned, those statues, or parts of them, which could be saved were transferred to neighbouring sites. In this way we find some splendid heavy, semi-Greek male figures in Todaiji, Shodaiji, Yakushiji, and Akishino. The Kondo of Shodaiji is almost filled with them—knights, Indras, and Buddhas. The sweetly stooping Bodhisattwa of Art at Akishino is a specially well-preserved example. But to get a conception of the masses of remains of such statues, it is necessary to see the photograph which I took in 1882 of the rubbish heaps at the back of the Chukondo altar, and the Tokondo also, at Kofukuji. Here the broken "bones" of composition statues mingle with splendid contours of Buddha torsos or the armour of knights. It is possible that what remains to us to-day is only a very small percentage of what once existed.

Here is perhaps the place to say a word upon the nature of the Bodhisattwa in general as worshipped in this early Nara Buddhism, and of its special adaptability for sculpturesque types. The general Buddhist idea of a Bodhisattwa is of a being who has advanced so far in the scale of wisdom and insight, and the renunciation of fleshly ties, as to be just on the point of entrance into Nirvana and salvation. Spoken of human beings, it means their last earthly incarnation. But it comes to have a much more special sense in Northern Buddhism: namely, a being who, though having the right to enter

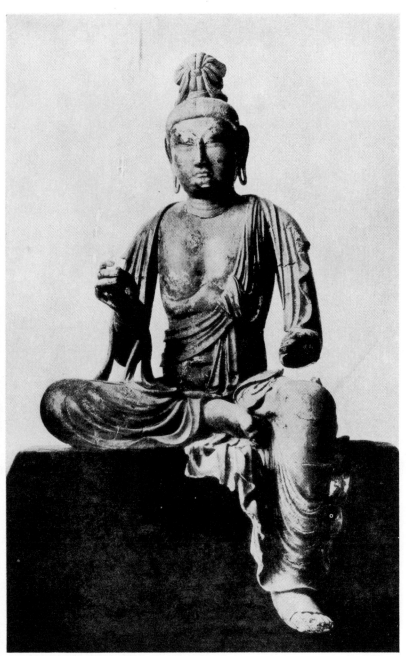

SEATED LACQUER FIGURE.
Now in the Tokio Fine Arts School.

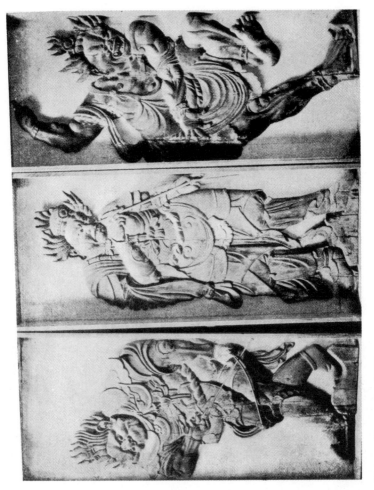

THREE HUMOROUS IMPS.
At Kofukuji.

Nirvana, *deliberately renounces it*, electing to work under the conditions and possibly renewed temptations of the world, for the love of one's fellow-man or of the whole sentient world. It thus denotes a new kind of renunciation, the renunciation of renunciation, or rather the renunciation of salvation. In so doing it ceases to be negative and self-seeking, entering upon a positive and masterful path of love and help. The Bodhisattwa vow in Northern Buddhism, especially in the Tendai sect, as we shall see in the next chapter, is a vow made as early as baptism to lead the strenuous path of battling for the right, to consecrate one's career throughout any number of necessary incarnations to loving service. The Bodhisattwa idea, therefore, comes very near to the Christ idea.

Now if a soul should, not rising in evolutional course from man, but descending in special dispensation from a paradise already attained, devote itself to such loving service *without the need of more than occasional incarnation*, it would become a Bodhisattwa of a higher type, still more Christlike—a perpetual Bodhisattwa, so to speak—a great spirit making for love and righteousness, invisible to man, but assisting him, whose answer to man's prayer comes with every accelerating throb of human devotion. Such a Bodhisattwa would become worshipped as a sort of personification of the great moral or spiritual principle for which he specially stood. Such a Bodhisattwa would be Aizen, the spirit of love; Bisjamon, the spirit of courage; Jizo, the spirit of pity, particularly of care for little children; Monju, the Bodhisattwa of wisdom, or spiritual interpretation; Kwannon, the Bodhisattwa of providence, sustenance, and salvation from physical evil. So there are Bodhisattwas of fortitude, piety, church organization, faith, domestic peace, and, as we have just seen, of beauty and art. The simple attitude of the Suiko and Nara congregations may be said to have regarded these virtues and graces, not as ethical abstractions in their souls, but as living and gracious spiritual presences, with just personality enough to pray to. It is the idyllic deification of all the good in man and society.

Now to have turned this Pantheon of gods into an equally gracious group of æsthetic types was just the kind of achievement that a great fresh sculptural genius would be adequate for. Their semi-personality made adaptable the Greco - Buddhist degree of achievement in personal realism ; while their vast generalization into moral types could utilise

to the full the formal, preter-human beauty of sculptural conventions. For such Bodhisattwa, abstractions named with worship, such gifted sculpture as the triumphs of Yoro seems to offer an utterly sympathetic form. These lofty serene presences in bronze, clay, and wood seem themselves to be just the very personification of great principles that make for righteousness. We shall see, in later chapters, how the Bodhisattwa idea undergoes change or evolution toward new forms, which equally well relate themselves to new arts.

The latter days of Shomu's art carried the tendency toward heaviness and coarseness to a much greater degree. It would seem as if the drying up of spiritual grace reduced to gradual insipidity æsthetic grace. The order of 741 to build temples and found monasteries and Buddhist colleges in every province of the empire, required hasty work to fulfil. The great Chinese and Corean models became lost in the copying of copies. As in the decay of Roman art, the loss of spacing and fine rhythms was not perceived. The standard of taste itself had become perverted.

The growing stiffness and materiality are well illustrated in the large painted wooden Kwannon, with body, head and flame halo, which stands at the back of the Horiuji Kondo altar, not far from the attenuated Corean Kwannon. It goes through the motions of being Greco-Buddhist, but its graces and rhythms are hard and unimaginative. It falls below the art of Yoro much as Syrian Greek falls below Attic. Another phase of this decaying art is the grotesques. These are exemplified in the Shi Ten O of Nanzendo at Kofukuji. Their clever attitudes suggest the pompous energy of small conceited men. Their bodies have now become so thick that the neck has disappeared within the collar of the gorget. Still another and charming phase is given in the sacred masks, mostly from the Kasuga collection, which mingle prehistoric Shinto types, related to Alaskan and Philippine dance masks, with Indian and Bodhisattwa types. Here are Greek comic masks, side by side with the bird-snouts and the long-nosed murder types of Pacific art. But the skill of their carving is the skill of Tempei. And the much later masks of the No comedies are only weakened adaptations of suggestions from these.

Still another phase of the late Tempei sculpture is the realistic representation of child life and female life, whether dignified as Buddhist forms or as mere portraits. For example, the little over-elaborate and heavily bejewelled statues which the learned editor of Shimbi Taikwan

calls "Soi, the Indian goddess of Fortune," are manifestly modelled after little fat Japanese girls, with one of the coiffures of the day, the long hair falling over the shoulders in thick locks. These are coloured like nature. And there are corresponding paintings of "Soi" with flesh half-modelled, as in European and our supposed Khotan art. Other paintings, more Buddhistic but not the least Greco-Buddhist, show probably a mixture of Chinese and Corean traits. These are only hair outlines, but all the drapery falls into hard, wiry, formal curves, of no force and little beauty, which attract the eye with a gaudiness of colour and minute patterns of colour on colour which are much like the painted patterns on the clay Kongoji and the colossal composition pieces of Sangetsudo. Between these fall the drawings of the ladies upon the few screens that remain in Shosoin. These have eyes near together, as in the Buddhist fat types, but hair falling over the head in great bags, as in the sculptured "Soi's." Other fine portrait statues of this day are those of priests, as of Taishin-osho, the founder of Shodaiji, who is there worshipped.

One of the last great acts of Shomu, two years before his death, was to decree and start the erection of a colossal bronze statue of Roshara Buddha * (the Buddha of Light), to be placed in a great monastery erected on the plateau east of Nara, and at the foot of Mikasa mountain. This was to be called "Todaiji," the Eastern great monastery, or, as the Japanese and foreigners have always called it, "The Daibutsu." Shomu died in 748—four years before its completion, but the plans were his. The enormous building of the Kondo, some 300 feet long and more than 100 feet in height, has been partly reproduced in the present middle-age building erected after a destructive fire. The image itself sat 53 feet high upon its throne. Its present ugly big head replaces the original which was melted off in the fire. But even judging from the small model, which remains, the figure was ugly enough at first. It apparently was not only the inherent difficulty of designing for such an unheard-of scale, and for such difficult construction, but the very taste of the day was for fat and neckless types. Here both sources of monstrosity were present.

But one really beautiful piece of work accompanied the building and the solid casting of the Buddha, and that is the large bronze

* This Roshara Buddha is known also as Vairoçana the All-illuminating.

lantern which, some 20 feet in height, stands in front of the main entrance to the Daibutsu-Kondo. The pedestal is of granite ; the lantern itself a great octagonal birdcage of open-work cast bronze. Upon the four unbroken panels stand in low relief the overloaded but not ungracious figures of Bodhisattwa. Upon the four groups of opening door panels fly downwards in clouds lion-like animals that rise into relief like the so-called " sea-horses " of the Chinese grape mirrors. We can hardly judge, after twelve hundred years of exposure to weather, of the original finish of this unique bronze.

The whole wealth of a great and growing Empire had literally been cast by Shomu into this proud creation of a colossus. For it special taxes from provinces a thousand miles away and recently wrested from the Ainus, now for the first time smiling with harvests, had been collected, and stores of copper and gold from Japan and Corea had been amassed in monasteries. Shomu was really master of great works like an Egyptian Pharaoh. But one other big thing he did before he died, and on his death-bed—the biggest thing of its kind that any human being has ever done—he left by will the total material contents of his palace at the time of his death as a present to the new Buddha, and ordered to be erected a special storehouse within the monastery grounds for the custody of these articles.

That storehouse is the famous Shosoin of Nara, erected in 749 and still existing ; and the articles now therein are by far the larger part of the deposits of that year, as can be seen by comparison of the original inventory. It is the greatest place of its kind in the world, a unique domestic museum ; the only competitor being the combination of Pompeii itself with the unearthed Roman treasures stored in the Naples museum. But there the articles are only those that could defy damp and heat—stone, metal, earthenware, and frescoed plaster. Whereas in Shosoin every kind of article is represented, however perishable : writing paper in rolls from Shomu's own desk, garments of every grade from his wardrobe, the perishable furs and frail feather slippers of the Empress; jewels *ad libitum*, including infinite variety of stone and glass beads ; all the utensils of house-keeping, pans for cooking, bowls for eating, spoons and knives and forks, yes, and glass finger bowls ; bedsteads and couches, and vases and boxes, and cabinets, and floss silk for embroidery, and accoutrement for horses, and court banners, and rare manuscripts, and painted

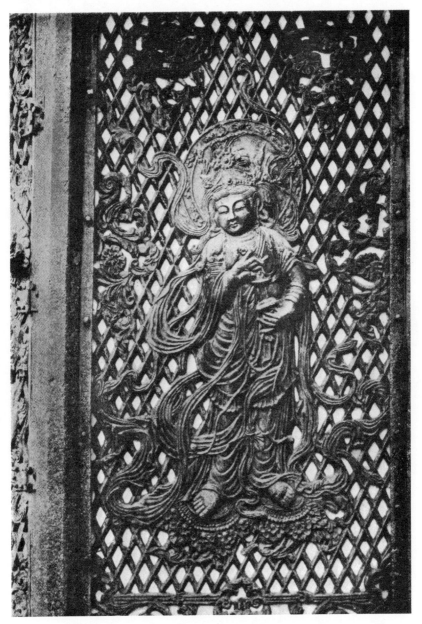

PANEL FROM THE GREAT BRONZE LANTERN IN FRONT OF
THE DAI BUTSU TEMPLE AT NARA.

DESIGNS PAINTED ON LEATHER
FROM SHOSOIN.

PAINTED DESIGNS
FROM SHOSOIN.

screens, and metal mirrors, and musical instruments, and weapons of war, and a thousand other articles of unique interest. Nowhere else exists such an opportunity for studying the daily life and art of a vanished civilization. Through it we know more of Nara life, and reflected in it of Chinese life in early Tang, than most of us know even of the China and Japan of to-day.

The Japanese are right to prize it as something sacred, for it has been held as a kind of mystic legacy from Emperor to Emperor since the day of its founding. Never has there been an era in the imperial household when three commissioners with three sets of keys have not been appointed its official custodians. It is true that in the distractions and imperial poverty of the middle ages there were times when the museum was not opened for many years, once during the gap of a century. At that time storms and damp broke through one part of the roof, and a portion of the perishable articles, unfortunately all but three or four of some 200 screens, then mouldered away. But two out of three partitions remained intact with all their contents. Very little has been added from age to age ; we have many successive inventories to compare with the original. When the new government came in with 1868 the exploration of this place became an unparalleled piece of romantic work. Mr. Uchida, the chief commissioner, made the first archæological study of its contents and constructed the present system of museum shelves and glass cases, in which samples of all species of articles can be exhibited to those few who have the favour of a visit. Nowadays the museum is opened only once a year, for drying, and an imperial rescript is necessary for each visitor admitted.* Some drawings were made by antiquaries in the early nineteenth century, and a few such photographs were taken for the government exhibit at the French Exposition in 1898. A few copies are in the museum at Tokio and the imperial archives. But for the most part the contents remain still unillustrated. As imperial commissioner I had a chance to study these treasures on three separate occasions in the 'eighties. And the little I can say here is taken from my note-books of those years.

The value of the collection as a whole is perhaps more archæologic than æsthetic ; nevertheless a vast number of specimens of high artistic beauty and importance are included, some of which I have

* This rigidity was afterwards considerably relaxed.— THE ED.

already described. What I shall now add refers mostly to these. Facts of mere social interest—as for example that there are no chopsticks in Shosoin, only spoons and forks ; and that stirrups and locks are quite like European—cannot be dwelt upon.

The building itself is some 100 feet long, two storeys in height, and raised 20 feet into the air on heavy open piling, which allows no damp to arise from the ground. The unpainted wood of enormous trunks, in being eaten with the slow oxidation of a millennium some three inches, exhibits exposed surfaces of the toughness of iron. It is a more precious privilege to climb about its rickety stairways than to ascend to the dome of St. Peter's.

The first impression one gets is of being in a second resurrected Rome, of the continental scale of an Asia. Apparently the whole range of the massive continent had poured its treasures into the lap of Nara : Babylon and the Persia of the Sassanids, and India and Ghandara, and Annam, and the Amoor, and of course China and Corea, all contributing substantial quota. In how far these waifs are Chinese is a matter of growing interest. Mr. Uchida and the archæologist of 1868 were inclined to regard them and most of the Horiuji articles (Horiuji was found to be almost a second Shosoin) as Japanese products. But we can now be sure that much of Shomu's prized furniture was made up of gifts from continental sovereigns or from unique importation. The beautiful glass and enamels came from Persia and China. The glazed tableware pieces—yes, plates and cups and bowls of a mottled yellow and green, in a kind of Castile soap pattern— abound by the gross. Not a piece like this ware exists so far as I know in any other Japanese or foreign collection of pottery ; so it is hard to place. But it is probably Chinese of early Tang, based on the relics and colours of Han pottery and glazes.

Other Chinese pieces of unique value are the biwas, or pear-shaped lutes, across whose surface under the striking point of the strings painted leather panels have been glued. The sunrise landscape elephant is one of these. Another is the scene of lion hunting among the mountains. Still other biwa are inlaid with delicate flower arabesques and birds of tinted ivory. Lacquered boxes and other utensils inlaid with Chinese patterns in pearl and ivory are common. We have already noted one Tang ornamental piece with Taoist figures in a bamboo garden. And other remarkable pieces are small slabs of marble, possibly tent weights, heavily carved with fights between animals. The one here shown of a wild boar and a kind of

hound is taken from a rude drawing in white made in the early 19th century. This must be Chinese Greco-Buddhist modelling of early Tang, as powerful and perfect as Egyptian animals of the old empire, or even as Greek. Still other pieces are beautiful silver boxes and vases, ornamented partly in relief, partly with patterns incised in the Greek manner. Some of the shapes are so delicate as to recall Mohammedan Persian art, say of coffee pots and hookahs ; and this is one ground of the hasty assertion that the Corean Japanese art of the Nara period is based upon Persian. Rather, to take a fine example—the large silver pitcher with cover and handle—ought we to say that beautiful Eastern forms like this, probably Chinese of early Tang, must themselves have been the originals from which the late Mohammedan art of Persia and India was derived. Sir Purdon Clarke, expert on Central Asian art, with whom I discussed such problems at South Kensington in 1887, agreed with me in Chinese attribution.

To analyse the present specimen we should have to say that its shape is a refinement of Han bronzes and pottery, that its cover is a relic of Pacific dragon modified by Babylonian drawing, and that the winged horse so beautifully engraved on its side is an exquisite specimen of Greco-Buddhist art. This horse I have myself traced from an early Japanese drawing. We have already seen winged horses in the Han reliefs, but these were strenuous and massive in their lines. Here the wings are as European as those of the painted cherub baldachi at Yakushiji. If not Greco-Buddhist, it must be Greek art coming at this day by sea through Persian sources.

Another Persian controversy concerns the flower ornamentation of the inlaid biwas. Here we have daintily carved pomegranate-like leaves for all the world like those of modern Persian carpets and Indian shawls. Mohammedan influence, one might allege ; yes, but too late in the day, for the Arabs were still concerned with Egypt and Spain, and the Sassanid dynasty of Persia did not fall before 637 A.D. Plenty of Sassanid ornament there is in Shosoin and Horiuji, especially in the patterns of Buddhist stuffs. But it is all, as we should expect, in the form of debased Assyrian combined with debased Roman. Such Sassanian art is well represented by the brass dish with concentric circles in the British Museum. But of the flower style of the inlaid biwas we have yet to prove the existence in any Mohammedan art before the twelfth century.

But the greatest æsthetic triumph among the Shosoin pieces, and incidentally the most interesting controversy, is found in the hundred or more magnificent specimens of Chinese bronze mirrors. These were formerly believed to be Japanese. Some are only six inches in diameter, some as large as two feet. All are finished with a delicacy of modelled relief on the back and a satin smoothness of surface that match the angel screen of the trinity. Many of them are undoubtedly Tang design, with scroll-work and dragons and tortoises exactly like the decoration of the Yukushiji bronze pedestal. The controversial ones are the grape vine mirrors, already twice spoken of, of which the Shosoin collection possesses a large number, of exactly the same freshness as the undoubtedly Tang examples and as the white snake trinity. It is incredible that thirty or forty pieces of Han age should have lasted in full perfection through eight centuries of Chinese change down to Shomu's time. The only statable hypothesis consistent with their Han origin is that some rare Han pieces had been copied and played upon with infinite variation by artists of Tang, or Nara, or both. It is possible that some pieces are Japanese, just as the angel trinity is probably Japanese. But the type is more absolutely Chinese than the latter, in which all the elements of design are pure Buddhist. Not a Buddhist symbol enters into the grape vine mirrors. Moreover, as I have said, not one feature of this elaborate workmanship has any kinship with any other Han design yet seen by me; whereas in æsthetic feeling it is in close touch with all the more delicate phases of Greco-Buddhist art contemporary with early Tang—with Tang bronzes, Tang mirrors, Corean statues, the angel trinity, the Yakushiji pedestal, the Todaiji lantern, and the Yakushiji painted cherubim.

The final phase of Nara degeneration is most interesting to trace. The Empress Koka, who ruled until 769, though a devout Buddhist, could not check palace and temple rottenness, and had no new phase of thought or action to substitute. The only hint of such a thing is the first worshipping of Confucius in 767. Confucius had been given posthumous nobility in China in 739. The Confucian party at the Tang capital, headed by the great Han, master prose writer of the Empire, had publicly, but in vain, denounced Buddhism. China was already threatening to divide against herself. If the wreck had been more serious in Japan history might have been changed; as it was, the

PAINTINGS ON THE BACK OF MUSICAL INSTRUMENTS CALLED "BIWA."
From Shosoin.

OUTLINE OF THE BUILDING KNOWN AS SHOSOIN.

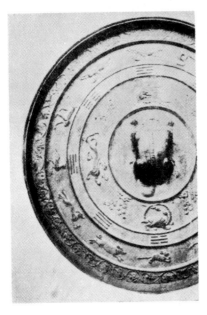

MIRROR FROM SHOSOIN.

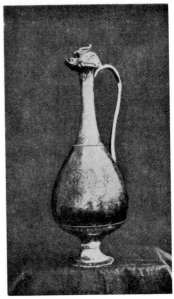

SILVER EWER SHOWING A
DESIGN OF A WINGED
HORSE.
At Horiuji.

Confucian worship, only sporadic, was a sign of returning intercourse with China. For in almost the same year the Empress created her Buddhist prime minister "King of Religion." The laws of Taiho, guaranteeing the land to the people, were falling into disuse ; no re-apportioning and re-appraising were ordered, and the selfish nobles confiscated where they could. Such demoralization could end only in disaster.

The art of the day shows the change : the bronze wooden statues of Dembodo, without a real organic rhythm, all stiff as a board, being typical Koken art. A last good phase is seen in the ugly and awkward low-relief "generals" of the Tokando of Kofukuji. Then follow the unspeakable atrocities of the large bronze Shi Ten O of Saidaiji.

A ray of light comes from attempts at painting ; many of these are fat and roly-poly, and of a misplaced gorgeousness. Yet there is an attempt to introduce low relief in Amida's Western Heaven, with its bands of trinities and angels. The woven colossal Paradise of Taimadera belongs to this day, as also the statue of the imperial nun Chujo-hime, who was translated at her death to Heaven. Thus to this day persists the Bodhisattwa club among the young men of the village, who once a year dress as Amida, Kwannon, and the twenty-five Bosatsu, build a great bridge over the court of Taima, and cross with elaborate dancing to carry the statuette of Chujo-hime to Heaven. A true relic of the Buddhist miracle dance is this, which I saw in 1888, analogue of the Oberammergau performances in Christian Europe. The Bodhisattwa masks are late beautiful examples of Koken carving. The successor, Kuōnin, did no better for her few years ; and the whole fate of Japan lay with the power to do new things of Kwammu, who succeeded to the throne in 782. Such is our brief account of the rise and fall of Greco-Buddhist art in Japan.

MYSTICAL BUDDHIST PAINTING IN CHINA AND JAPAN.

Eighth Century to Eleventh.

Loyang and Kioto.

IT would be a decided mistake to suppose that Greco-Buddhist art served as more than a single short step in the climb of Chinese genius toward its apex. It was a mere interlude in the perpetual overlaying of the faith in China with form after form. It helped the subsequent art, no doubt, by its training in proportion and in fine line rhythms. But as a special æsthetic form it was forgotten in China almost as soon as it had begun. We have now to see what were the real causes of the further advance of Chinese art to the Tang culmination.

It must be remembered that in such a large, complex, yet loosely jointed mass as the Chinese Empire, great movements are rarely single, but overlapping with others, the germs of subsequent creation slumbering along for centuries side by side with their antagonists. It is thus true that all through the Greco-Buddhist days of the eighth century at least two great earlier art movements never died out—one the love of pure land-scape in poetry and painting, which had been fostered by the long residence of the Chinese Court in the south, especially the Court of Liang ; the other an art of religious painting, which itself had subdivided into two main forms : a Northern or Tartar form in which the hair lines were quite subordinate to colour masses, and a Southern form, originated by Kogaishi (Ku K'ai-chih), in which the flexible brush line played a powerful part. Though little remains to illustrate either of these early beginnings, we know from written history that all received some attention during the formative years of early Tang. It was now, at the end of the seventh

century, new natural and spiritual forces acting widely throughout the nation that tended to bring these half-neglected æsthetic styles more into the foreground.

We have seen that the root of the exceptional genius of Tang lay in the variety of its sources, and in their fertile reaction upon each other when brought into contact at a common capital. The wealth, too, of the empire had never before reached such height. Buildings were grander, stuffs and clothing more exquisite, food more plentiful, the people happier, engineering works more stupendous, than in the Han dynasty or in any preceding period of Chinese history. The Eastern capital, Loyang, in the ancient peaceful seats of the Hoangho valley, became now rebuilt upon a scale which accommodated more than two million people. Great public gardens and museums gave recreation to the people. The private palace gardens were raised on mighty walled terraces, pavilion crowned, that enjoyed far prospect over lakes and bays—or sunk into cool shady wells where plum trees shot their scaly arms into the shape of dragons, and ancient pines had been trained to writhe like serpents through the interstices of water-worn stone. Great jars of hard paste pottery covered with creamy glazes, and tiles of deeper hue, probably purple and yellow—an art descended from the glazed ware of the long extinct Han—gave brilliancy to the landscape architecture. Pavilions rose above granite and marble foundations in rainbow tier after tier : great banquetting halls, and blue silk awnings, and heavy portières shot with golden thread adding alike to the exalted coolness and to the æsthetic transitions. A vast commerce had opened up from the southern and eastern ports with the Indian Ocean and even the Persian Gulf. Colonies of Arab merchants already had alien settlements in the Chinese cities. Religious liberty was fairly respected, for Mohammedan mosques and Jewish synagogues, and even temples of Nestorian Christians, arose side by side in some of the more populous capitals. Indeed, in these great days of early Tang, China had become the metropolitan garden of Asia, surpassing the splendours of Khan or Caliph at Samarcand and Damascus and Bagdad.

But beside these material advantages, the Chinese mind, and especially the Chinese literature, must be said also to have blossomed into luxurious perfection. Great scholars, Buddhist and Confucian, thronged the receptions of the imperial court ; the greatest hand-writers of China wrote mighty thoughts into exquisite manuscript ; the culmination of

forceful dignified prose came with the memorials of Han wei Kung
(Kantaishi) ; and, more than all, the wonderful experiments in perfect-
ing poetic forms which had followed the beginnings of Toemmei and
Shareiwun in the South now came to their final blossoming in a host
of great poets who fired the various resources of form with their fresh
genius and unfettered taste.

The very centre and core of this mighty illumination of Tang was
the long reign of the Emperor Genso, who ascended the throne in 713,
after the Greco-Buddhist inspiration had spent its course, and who out-
lived the tremendous experiments of the Chinese soul to find perfect
form for expression that preceded the insurrections and disasters of 755.
Now it was that the very China of China began to take on her per-
fected institutions. The civil service examinations were broadened and
made compulsory as an anteroom to officialdom ; the University was
organized, the Boards of History and Morals purified, and the tendencies
of literature and art concentrated into that supreme achievement which
soon gives rise to canons.

The career of Genso (Hsuan-Tsung) himself is most romantic and
pitiful. Set at the very acme of Chinese power and feeling, his good-
humoured weakness—and, as the later Confucian scholars would say,
superstitions and dissipations—led him into intertangled nests of palace
intrigue, and into a sort of æsthetic excess that well-nigh undermined
not only him, but his whole dynasty. If we are to believe the purist
censors who have denounced this age, it was almost as bad as the days
of Nero and the mediæval popes. But we must remember that even
the China of this early day was already threatened with a duality that
has since become her fate and her curse, a growing antagonism between
the Confucian scholars and all other believers and thinkers, who entered
with joy and hopefulness upon a new life, new religious sanctions, and
a new art. It was a situation somewhat parallel to the split between
Puritans and Cavaliers that had declared itself in England by the reigns
of the first James and Charles. If Wycliff had been the prime English
sage of ancient years who had laid down full philosophic foundations
for British character, as Confucius had done for Chinese, and if the
Catholic love for gaiety and drama and art and light verse had come
as a passionate after-outreach for freedom, as the newer and newer
waves of idealistic Buddhism flowed into China, the parallelism would
be closer.

But we may well suspect the Puritan chroniclers of China of falsifying the record when they lay such deep stress upon the gap as already existing in Genso's day. It is as if we imagined Elizabeth and her Court to take their nominal Protestantism with the same seriousness as Cromwell and Milton. The age of Genso and the strength of its whole illumination lie just in the fact that the stress and joy of genius for the time quite drowned the muttering of the storm ; people acted and wrote and painted, hardly knowing or caring whether they were Confucians, Taoists, or Buddhists, weaving coloured threads from each into their splendid fabric as the fancy suited. It was, indeed, a kind of glorified Elizabethan age for China.

Among the satellites at this gay Court none were more in evidence and more honoured than the lyric poets. Genso sent invitations far and wide to the hopeful geniuses of the provinces. It was as if Marlowe, Green, and Peale, and Shakespeare, Jonson, Donne, should have become the very bulwark and the intimate advisers of the English throne. Rank and salaries and splendid clothes they received ; and so highly was their real genius understood and craved that its prime condition—freedom—was allowed. Rihaku,* the lyric laureate of China, openly lampooned the Emperor and his mistresses. He played on a grand scale the roystering Lovelace and the scurrilous Herrick to the long-faced Marvell of Kantaishi, or the passionate Vaughan of Omakitsu. He tried, at times, the taste of their several styles ; and the poetical wealth of the man and of his day is proved by the fact that nature, man, ethics, Taoist fancies and Buddhist devotion, all enter his verses as natural friends, and all pulsing with sympathy toward the social betterment and freedom of man.

The great landscape poet of the day, who was also a great landscape painter as well as statesman, Omakitsu Oi (Wang Wei), lived in a beautiful villa with hillocks and lakes, a few miles from the capital. Here his paintings of rural scenes in fine ink monochrome were distributed to his friends, pictures which became the pride of later collectors. But he was no Confucian pedant—far from it ; and the attempt of late and degenerate critics of the present dynasty to fasten upon him the narrow juiceless canon of their so-called "Southern School" is absurd. It is also quite untrue that black-and-white work began with him, and quite untrue that it was the fact

* Rihaku or, in China, "Li Po."

of working in black-and-white which distinguished the "Southern," or "Bunjingwa" School, from the "Northern," or official. His style, instead of being soft and soaky and blotchy—the trick of the modern formalists—was strong and hard and scratchy, the brush strokes falling in incredibly varied forms, as we see in his great waterfall of Chishakuin in Kioto,* the only important specimen of his work preserved in Japan, or perhaps in the world. It was the spontaneous literary form of Oi that led after centuries to a worn, pared-off canon by which he became travestied and misunderstood.

His great friend and rival in the ink landscape school, borrowed from the traditions of Liang, was the otherwise celebrated artist *Godoshi* (Wu Tao-tzu), who has left us the finest early specimens of Chinese monochrome landscape in the pair owned by Shinjuan Daitokuji in Kioto. Here, too, we can see that the very style is scratchy and occupied with the setting of strong, crisp masses of infinite variety upon sized paper or silk. The impressionism of blur and accident came in at a far later day with the Confucian exquisites of Sung (So), and especially of Yuen. I shall refer to these sporadic ink landscapes of Tang again when I come to consider the landscape art of Sung.

It is rather to the Buddhist art, and especially the Buddhist painting of Tang, that we have to turn, if we are to follow our plan of characterizing each age by its strongest, most creative, most original work. The enthusiasm of Genso was all for Buddhism and Taoism. These elements of personal freedom play the greatest part in Rihaku's imagery. And it was in this line that Genso's (Hsuan-Tsung) greatest artist, Godoshi, achieved first a national and then a world-wide reputation. Let us now see how the several Buddhist movements lead up to the culminating art of Godoshi (Wu Tao-tzu).

Already we have marked how, in the Southern dynasties, the contemplative school of Buddhism, the Zen, founded by Daruma, had led to landscape art and literature, and to a more human rendering of sacred scenes and deities. Now this Zen movement, although it does not reach its creative apex until the following Sung, played some part in the Buddhist art of Genso. But, as we have seen, the Northern formal and tinted Buddhist art of Tartar tradition had also its part to play. Indeed, for the moment the sects half blurred

* Modern Japanese critics are now inclined to think this waterfall a copy.—THE ED.

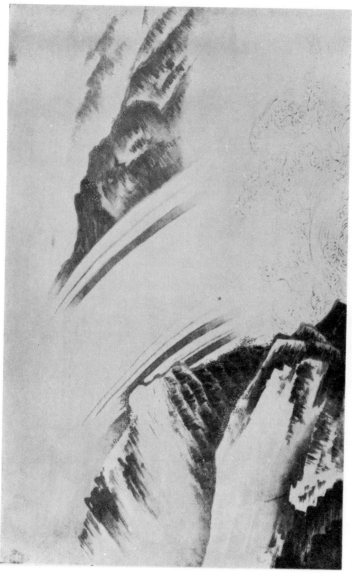

FAMOUS PAINTING OF A WATERFALL, said to be an original.
By Omakitsu (Wang Wei).
At the temple of Chishakuin in Kioto.

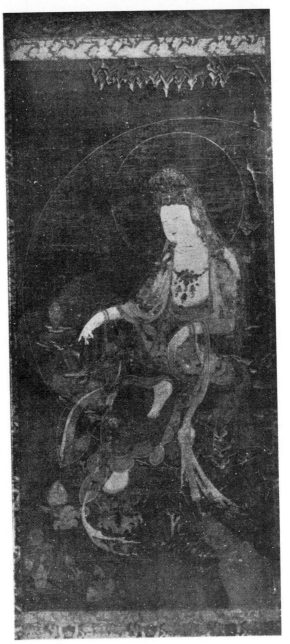

FAMOUS KWANNON.
Probably a copy of Enriuhon by a Sung Master.
Mr. Charles L. Freer.

their outlines, so as to let in freely all tentative elements that might be found to have æsthetic efficacy. In brief, there is something of a union or " pooling " of styles.

Into this seething Buddhist mixture of the Chinese Tang capitals was now poured a new and powerful solvent which had come into China in the wake of the Greco-Buddhist art. This was the mystical or esoteric form of the belief, which, founded on the philosophical idealism of Nagajuna, Vasubandhu, and Asamgha, had incorporated all the mystical psychology which seems to have been a part of India since Vedic days, and had concentrated all these into a special doctrinal discipline. This had been specially introduced by an Indian heresiarch, Amoghavajra, about the year 719. By this time it had grown into a dominant sect, of great piety and wealthy patronage, with its central sect located upon the famous Tientai mountain. Here the success of the Indian teacher, as the Japanese call him, Tendai Daishi, had set up a great school for the transmission of the doctrine ; and the young aristocrats of Loyang were prostrated before him in their efforts to realise the mystic union with divinity, a kind of neo - Platonic ecstasy, which he professed. This great esoteric sect, which ascribes magical power and direct contact with spirit to the human soul, was called, from its central sect, the Tendai sect. The mastery of self, the spiritual knighthood which it preached, its Bodhisattwa vow, and the higher communion of the saints, awakened extraordinary enthusiasm, much as a great leader of Theosophy might do among us if he really worked great miracles, really were able to identify thought and intuition, and to prove his system in harmony with all healthy, moral, and social movements, and only an expansion of preceding religious forms. With such earnestness as this the Christian Scientists seem to move among us to-day.

But the mysticism of the Tendai sect went to a range of psychological analysis which dwarfs the neo-Platonist. It assumes the world to be real rather than illusory ; striving, evolution : a salvation through process—a salvation to be achieved within the body of society and human law—a salvation of personal freedom and self-directed illumination—a salvation by renouncing salvation for loving work. The opening of the inner eye to natural facts and spiritual presences that are veiled from lower forms is not the aim but the incident of

discipline. It is this, however, which gives the accompanying art its vivid value and piercing imagination. The power to image forth truth in forms of glowing vision, to see the very presences of Buddhas and Bodhisattwas clad with dazzling light, to project angelic groups upon the background of contemplation and to behold the inner circulation of native affinities and sympathies working in intertwisted lines of physical and moral law—the psychologic armies of elementals working through storms of molecules and currents—all this is of the very substance, not of poetry and music, but of visual art.

How different is all this direct challenging of co-operating spirits, often as Mahatma or conquerors in the flesh, from the vague though vast moral abstractions of the exoteric sects ! There it was but the enhancement of a natural moral potency—a vast abstraction projecting into a Brocken shadow against the sky traits which might not be highly reverenced if conceived as frankly human. Here it is the actual presence of spiritual hierarchy : as if the devotee were a soldier in the ranks privileged to see his captain and general occasionally pass his tent, keenly inspect, and scatter glances of encouragement. Man thus became, or thought he became, visible co-ruler of history, with superman. He could foreknow the passwords and the plan of campaign, and provide the restoratives of the hospital wards. It was vision, concrete, inspiring, personal even, rather than abstraction. The very electricity of these spirits could be seen pulsing through the flesh as through the adamant of mountains.

And how perfectly the difference between these two visions corresponded to a broad cleavage between sister arts. The exoteric worship of the abstract principle needed body, yet a body as severe as itself. Hence sculpture and the satiny hardness of bronze became the natural mediums. But for flashing armies of light and colour, and the enthronement of the general, and the piercing of hell and earthly squalor, in short the whole normal entanglement of human function in social background with a skein of spiritual forces about its head, as the dog plays unconsciously his part in the master's milieu—for this transfigured life-panorama—only the art of painting ventures to be adequate. There, the very rhythms of line may suggest motion and transitory phases which are forbidden to sculpture. The latter normally registers the permanent ; the former the process. Colour, too, and light have endless range of suggestions, not only realistic

backgrounds but symbolic range of expressing well-nigh inexpressible relations. Heretofore in these chapters we have dealt almost exclusively with the severer form ; sculpture seems to come first within the grasp of all religious peoples. But now we are to follow Chinese and Japanese art into the greater subtleties of painting, the ripe stage of infinite modulation in line and colour. It is not that sculpture will be quite absent from any age, but it will never again become the leader of creative forms. All this relates too to new phases of temple worship, the more personal seclusion of the small shrine with its painted insetting for an altar-piece, instead of the more public and more dominating statue.

Chinese Buddhist painting comes down to us with the slim hair line, derived originally from sculpture, filled in with richer and richer colouring, until the severity of line becomes almost overlaid with the gorgeousness of mass. As the Tang dynasty came in and incorporated the Tartar style, which rather ran to decoration, the fine synthesis of sculptural line with pictorial colour could well begin. The great Tang Court painters who came before the culminating age of Genso, like Enriuhon (Yen-Li-pen) and Enriutoku,* doubtless practised this style. A type of it, which may be ascribed ultimately to Enriuhon, is the great seated Kwannon, shrouded in rich lace, of which we have dozens of replicas made during the Tang and the Sung dynasties. This type in Japan is usually ascribed to Godoshi ; but I believe that to be a mistake, quite like the mistake of ascribing, say, all sixteenth-century Japanese paintings to Motonobu. The one name we know is used to cover a multitude of styles. The largest and perhaps finest replica of the Enriuhon type of Kwannon is the great painted kakemono, ascribed to Godoshi, kept in Daitokuji. This may well be of Tang workmanship, though not necessarily from Enriuhon's own hand. A smaller example, but of very beautiful workmanship, probably Sung, is in Mr. Freer's collection. This I shall now describe, as giving a fair account, probably, of Enriuhon's lost original. The figure sits on a rough rock of blue, green, and gold in a cave whose stalactites hang in points above her (or his) head. It is a grand Kwannon, the Bodhisattwa of Providence or human sustenance, and here, as in most Tang examples of this subject, wears a light moustache. This, and the fact that the Sung Kwannons are

* In Chinese " Yen-Li-tê."

markedly feminine, has led certain learned scholars to conclude that Avalokiteçvara was primarily masculine, and that the change was due to a clerical error of gender in transcribing some Sanscrit or Pali term. How shallow this view is can be seen from the fact that other previous Kwannons, the Chuguji, for instance, of 620 and the eleven-headed Lake Biwa (755), are markedly feminine. The truth is that a great Bodhisattwa is in its own nature indeterminate as to sex, having risen above the distinction, or rather embodying in itself the united spiritual graces of both sexes. It is a matter of accident which one it may assume upon incarnation. It just happens that Tang thought, or preferred to think, of Kwannon as a great demiurge or creator, while Sung preferred to lay stress upon the element of motherhood.

But let me proceed with my description. The lines are of hair thickness; the shirt is caught over the crossed legs in the remains of sculpturesque folds and openings, not unlike the Corean bronze type of Toindo. Tartar Buddhist art retained something of this stiff wiry drapery even down to Ming. But there is little of stiffness above. The flesh is of gold, always a feature of the Enriuhon type, and found thus combined with thick colouring in the costume down to later times in Northern work. The head is shaped differently from the Greco statues, being long and oval, with rather a narrow forehead. The head-dress is built up into an elaborate tiara of coloured gems and flowers. But the peculiar feature of this type is the enshrouding of the whole body in an elaborate lace veil, painted in thin tones of cream over the heavy colours, and which hangs from the top of the tiara. It is the hair line contour of the veil which gives the peculiar proportion and line system to these figures. There is a kind of Gothic aspiring of all the lines to the tip of the head. A crystal vase stands upon a jutting slab of rock on the right. There are two halos, both circular, and both traced only in a fine gold line—one small, for the head; one large, for the whole body. From the water at his feet grow rich corals and lotos buds, in a Tang style derived from Babylonian Han. But a chief feature of the thought, if not of the composition, is a small Chinese child standing upon a rock in the foreground, with hands upraised in prayer. The Kwannon seems graciously to bend his glance down to it. This doubtless typifies man's helplessness without supernatural guiding—the reality of the primary transcendental relation. The

colours are rich reds, carmines, orange, greens and blues, heightened with touches of gold. There is no gold in the cream lace.

Perhaps here were best said what we have to say once for all concerning the question of genuineness in ancient Chinese paintings, and of the importance of copies. To the collectors and the museum owners, in short to the whole range of the market aspect of art, it is a vital question whether an individual work be ascribable to the pen of any great master, or whether it be probably a copy of some later date. The market value naturally rests upon this point. But the æsthetic, archæologic and historical value may be only slightly lessened by an uncertainty. Great masterpieces that existed in Tang, and before, became great models on which later masters of Tang and Sung formed their styles ; and, though the ripe personal styles of these latter might vary from these models, it was part of the discipline and pleasure of work to make accurate copies, or else transcripts with slight variation. These copies Time has so softened that to-day they probably appear not very unlike what the originals would seem if we had them, though doubtless something of technical beauty has been lost. Yet, in the absence of the originals, the æsthetic beauties and types of the copies become of priceless value in determining and appreciating qualities that otherwise would be lost for ever.

It is quite like the state of our present knowledge of great Greek masterpieces of sculpture, which have mostly vanished. We read in Pausanias of the beauties of Scopas and Praxiteles, and the pictorial beauties of Polyclites' Venuses and Apollos. We know that these were all copied in countless replicas, some of which made their way to the Roman palaces and villas. In a certain sense all later classic art was remotely built upon the traditions of such models, just as our postal cards and porcelains of to-day reflect Fra Angelicos, Raphaels, and Bellinis. The case of Greek paintings is worse, for even the sketch drawings and copies have mostly vanished, and even a hint of the æsthetic value of that great phase of art has to be manufactured. Greek sculpture is not quite so conjectural as this, for in addition to the slender stock of proved originals we have the suggestions of a vast mass of replicas to build inferences upon. It is only in this way, for example, that we know the type of the Phidias Athene.

Now the case of ancient Chinese painting stands at present much as does that of Greek masterpieces in sculpture. There are very few originals of whose authenticity we can have documentary proof. But there are a fair stock of pictures whose æsthetic excellences are so supreme that we can hardly imagine where the greater power of an original could possibly lie ; and so, as in the perfection of the Hermes of Praxiteles for parallel, we take this markedly individual quality as the very standard of the original. Such, for example, is the case with the Mokkei Kwannon at Daitokuji. Now, from this standard we judge the other claimants, identifying followers, and judging pieces that exhibit slightly inferior execution of sublime conceptions as probably replicas from this master. For, after all—and this is what distinguishes the real student of beauty in art, of the world's great types of beauty, from the personal pride of the mere collector—the supreme thing in the world of art is *conception*. Only the greatest men can create the supreme types of imaginative beauty. It is the followers, lesser men, who approximate more or less closely to the details of execution. When they copy a great work of their master, a conception far beyond their own inspiration, there appears in their work, in spite of its possible shortcomings in technique, a borrowed splendour which far transcends the finest example of their independent creations. Thus a fairly adequate copy of Mokkei or Kakei * is a thousand times more valuable for any real æsthetic study than a whole gallery full of Ming originals.

And when we go back to Tang and pre-Tang, the case stands differently only to this extent : that we, perhaps, have no originals at all capable of documentary proof, and very few of which we can say, like the Mokkei Kwannon of Sung, that no higher æsthetic accomplishment along its special line is conceivable. Nevertheless, we have a fair number of pieces in which we can feel that the conception is so fine and the execution so high that we are face to face with at least a direct and close transcript of the original splendour. And such pieces, however overshadowed with the ultimate doubt, are of immeasurably greater value for the student of beauty than undoubted originals of later and inferior men. The case is thus not unlike that of many of the great Greek sculptors. When we try to translate the bare words of Pausanias into real images of the beauties of Scopas, Myson, and Praxiteles, we

* Mokkei and Kakei, in Chinese " Muh-Ki " and " Hsia Kuei."

derive what help we may from the finest extant fragments which seem to embody their individual traits. The case is far more hopeful than that of Greek painting, for there we have, in such dish-water copies of copies as Pompeii presents, hardly a hint of what their real æsthetic merit must have been. If we should unearth to-day or to-morrow from long-buried ruins a group of encaustics immeasurably superior to later Roman pictures, but without documentary evidence, we should esteem it an unspeakable fortune, and should devote the utmost effort to establish, on æsthetic grounds, the possibility that here we had the replica of such and such a vanished masterpiece. If, on the other hand, the few transcendent pieces of ancient Chinese painting were lost to us, we should be in the same sad state as we now are concerning Greek. We should never divine even a hint of what a glorious school of art China had once possessed. The case is just that of the sudden unearthing of the Greek masterpieces—alas, hardly to be hoped for—for we have unearthed dozens of supreme pictures which we are forced to relate back to the master conceptions of Tang genius. It is in this sense, then, that we shall speak of Enriuhon, Godoshi, Zengetsu Daishi, and Ririomin with at least as much right as we speak of the styles of all Greek sculptors but Phidias.

We do not know whether any great Tang masterpieces yet remain in Chinese collections ; for an archæological exploration of China cannot even be said to have begun. But Japanese critics of this and recent ages who have had the privilege of examining the collections of Peking mandarins, or of deriving traces through Peking dealers, assert that there is almost no probability of finding such work in that capital. It is more probable that changes of taste have so distorted the eye of modern China, that not a scholar of Peking to-day has the least power of conceiving what an original of Tang would be like. Modern Chinese alleged copies have about as much weight as if a New York dealer in American impressionists should mark one of these as based upon an original Giotto.*

In Japan, at present, we may still look for hopeful traces. Into Japan have been imported for centuries—especially at first in

* Since this was written much has occurred in China which would have given the writer a different point of view.—THE ED.

the eighth and ninth centuries, later in the eleventh and twelfth, and still later in the fifteenth century—what great masterpieces of China could be seized upon. It is not probable that they always got the supreme examples which they claimed; yet, at the first at least of these periods, Japanese artists and scholars of the ripest power made the selections. Granting that most pieces extant in Japan came in with Ashikaga importation in the fifteenth century, it was as keen an eye as Sesshu's that passed judgment on them, Sesshu who had travelled for years as China's honoured guest, and been recognized by the Chinese Court as a greater artist than any of their contemporary Ming. He must have had every opportunity to distinguish the really great old masterpieces of China from shallow copies, just as an American critic can distinguish to-day between a real and a sham Rembrandt that a European dealer might send us. Indeed, Japan was then herself the successor and leader of " the Chinese school," and could command genuine examples. Most later Japanese tradition as to genuineness and attribution has been based upon the Ashikaga knowledge of Sesshu and his compeers, quite as Ming traditions of Tang had been based upon Sung criticisms. And we must remember that in Sesshu's day, a Sung copy would appear only 200 years old, whereas an early Tang copy or original would appear 700. The gap to his eye would be far greater than it would to ours, for after about 400 years of age all silks, barring accidents, become of nearly equal tone. And just as Sesshu was able to sift the traditions of Sung through Ming; and the early Kanos, Masanobu and Motonobu, inherited them through Sesshu; and Tanyu, the great early Tokugawa Court painter, inherited from Motonobu; and Kano Isen, the great eclectic painter and critic of 1840, based his re-examination of the whole amount of evidence upon Tanyu; so I, in humbler degree, have tried to resift the accumulation of tradition and fresh evidence with the critical instrument put into my hand by Isen's son and grandson, my personal teachers. It is in my opinion the Japanese line of examples and traditions therefore, rather than the effete and diluted Chinese, which must become the starting-point of European evaluation. A certain school of young Japanese of to-day, however—who came too late to be trained by an unbroken line of feeling from the past, and who have almost forgotten the great Kanos who worked under the Shogun before 1868—seem

disposed to throw away all key of tradition and to reject all evidence that cannot be proved to be documentary. In this spirit they assert that no Tang masterpieces whatever exist, and of even such a recent Japanese artist as Matahei, that he never lived. But they make the mistake of rejecting the unrivalled documentary value that lives in a work of art itself. To an eye for whom supreme proportions and rhythms are eloquent, documents themselves that may be forged are far more suspicious. Those European sinologues who regard one Chinese inscription as good as another, unless they have also the keen eye for artistic individuality, are at the mercy of an unknown pen. It is a mistake not to build at least, however much we may modify the superstructure, upon the foundation of contemporary tradition, a kind of living intellectual substance, that came down from Sung through Sesshu to the Japanese of 1868. With this body of tradition thrown aside, a Japanese scholar to-day is as far removed from Ming, and even Kano Isen, as we are removed by the cataclysm of the Middle Ages from classic tradition.

One more thing should be added of the copies which generations of later Japanese artists have made from what they deemed Chinese originals. In so far as these artists have been careful and skilful, these replicas, even with modifications, are true lines of insight into the past, as much so as those of the old Chinese copyists, down to early Ming. It is quite different with the modern Chinese copyists, for their taste is changed and their tradition lost. But the Japanese are in some sense the true custodians of the secret— and consciously careful copies made as late as Isen and Tanshin of the 19th century, are of very great value. These artists had practically the whole range of all the daimios and temple collections, as we shall see in a later chapter. Further research will only demonstrate the fundamental truths of those bases of criticism which I have just laid down.

It is time we returned from this digression to the great period of Genso Kotei at Loyang. Here the great pictorial genius who overshadowed the world was Godoshi (Wu-Tao-tzu), whom we have already noticed as a painter of landscape. Godoshi was first of all a great Buddhist painter, who had to find ways of expressing the new vast conceptions of his day. Such antique and hieratic forms even as

the charming lace Kwannon of Enriuhon he wished to discard ; to become more direct, more human, more like an actual vision. For this he determined upon a technique which had wrapped up in it the whole future destiny of Oriental art. This was to go back to the flexible brush stroke and thick line of Kogaishi (Ku-Kai-Chih), expand its force, make it more flexible, more capable of passing in a single stroke from a solid mass to a hair line, more able to achieve passages of contrast between rough-edged strokes and smoother sleek ones.

The power of the pen in writing had now advanced far beyond the southern beginnings of Ogishi (Wang Hsi-Chih) and Kogaishi. The Tang dynasty, and particularly the eighth century, is the very culmination of power and beauty in Chinese writing. It is natural that a similar force should pass into the line with painting. After all, there has never been another painter's tool in the world, brush, charcoal, or burin, which compares in force, ease and gradation with the great Chinese brush. To be sure it enwraps all painting in a convention—the convention that the line which bounds things shall be visible. But no art can be free from some convention. Its characteristic beauties lie in the very terms of the convention. Convention is not an inevitable restraint which we deplore, but the fertile language of an invention which we joy to use. It would be absurd to deplore that the ecstasies of music are limited by the conventions of sound-relationships, nay, of the very instruments that produce the sound. So fresco painting thrives on its technique ; the beauty of perfect bronze work is inimitable in other material. So in oil painting, the great craftsman gets beauty by the placing of his broad flat strokes—the brushwork is the art. And in Chinese painting of the grand school of Tang it is only another kind of brushwork. Why should painting eschew line, in order for ever to make of itself a kind of coloured sculpture ? It is not things that we want in art, but the beauty of things ; and if this beauty dwells largely in their *line*, their boundaries of space, their proportions and shapes, and the unity and system of the line rhythms, it is a glorious convention that can seize on just that and make supreme music out of it. As Godoshi used them, the brush lines became great "lead lines," much as we use them in our best stained-glass windows, making the lead supports carry the eye to the form elements of the composition. Only

the Godoshi lead-line is far more flexible and suave, in that it can thin itself out to a hair when it likes. Probably the great early Greek painting of Polyclites was of this sort, and line is primary in all their vase-painting and mosaic. It does not follow, either, that because line is so strong that colour and mass must necessarily be thin. Godoshi would fill up his interspaces, the openings between the lines, with strong patches of colour, relieved in deep mosaic effect one against another, not necessarily quite flat, but relying more for their modulation upon the turn of the line and the deepening of colour which supported it than upon the eternal modelling of the colour, as with hair-line or no-line painting.

It may suit some of us to cast slurs upon this as a "primitive" method; and indeed, if "ripe" or "advanced" be defined by that realism which always precedes decay, it *is* primitive. But it is the very method of *health*. It is one of the noblest conventions of art, even if not the only one. For the aim of real art evolution is not to come nearer and nearer to a coloured photograph, but if possible to put more and more grandeur and refined beauty into our spaces, our proportions, and our systems of line rhythm. This is the very language of visual art, as much so as tone is of musical. Therefore there is a certain primal and universal energy in Godoshi's design which has hardly been surpassed in the whole range of the world's art. It establishes itself side by side with Phidias and Michel Angelo; not that its convention is just like theirs, but that its space and line ideas possess a parallel grandeur. It may almost be declared to be the world's supreme type in grandeur of delineation. And it must not fail of recognition that this very grandeur of type and of proportion is indeed a relic imbedded in Chinese art by Greco-Buddhist taste, even though the specifically Greek form be changed. Godoshi's art thus uses all that has come down to it from the past—Pacific ruggedness, Han rhythm, the fine sculpture of the early South, the rich colour of the Tartar North, the dignity of Greco-Buddhism, and now the absolute pictorial form of independent brushwork.

That Godoshi achieved mighty fame in his own day we have it from contemporary records. We have glimpses of him as the idol of the people, watched by them as he covered enormous wall surfaces with great rolling or fighting masses of spiritual beings: panoramas of heaven and hell, strange adventures from the life of the saints, flaming deities,

and the wrath of gods upon the world, and the imperial splendours of a great Buddhist Court. He is not like Michel Angelo toiling lonely in the Sistine Chapel among a generation out of sympathy with his sternness ; rather like Phidias satisfying ripe public taste with the highest expression of its own beliefs. In the absence of newspapers such a public art becomes a kind of organ for self-realization.

Some critics claim that no genuine pieces of Godoshi have come down to our own day ; but we can come very close to him at a number of points, close enough to understand his dominion over the Eastern world, close enough to evaluate him in relation to the Western world. There remain three or four main types of his design which have come down to us in several more or less accurate copies. The first that we shall consider is the lace Kwannon and child type. This may have been an early thought of his, taking the conception of the very richly veiled Bosatsu from Enriuhon and early masters, but translating it into a magnificence of thick juicy line never before conceived. This type has probably existed in Japan in more than one version. One of these must have been seen by Kano Hogai in his early youth, for it was evidently used by him in making up his two great versions of the "Creation of Man." The version which I shall now describe, and which was brought to America from Japan in 1904, is in the great collection of Mr. Freer, and is doubtless the pen-work of some great master of Sung. The superlative grandeur, however — far beyond ordinary Sung reach and clearly Tang in flavour—proves that the main elements of the design must have belonged to Godoshi. There are rumours of another version, possibly older, concealed in one of Japan's great hereditary collections—all of which have not yet been thoroughly explored.

The design, which is very large, shows a standing Kwannon of great dignity and height, and enveloped in a lace veil, which descends from Heaven upon a cloud-like mass that breaks into the actual foam of water as it pierces space. This method of exhibiting water as the pure elementary symbol of Kwannon is unique so far as I know. Kwannon usually sits by the sea, she has holy water in a crystal vase ; but to descend through space on leaping foaming water is a Godoshi creation which Hogai has borrowed. The remains of a great cloud-curtain pull aside at the top, half concealing the tiara, which in this case is not pointed but heavy and square. This raised canopy of the

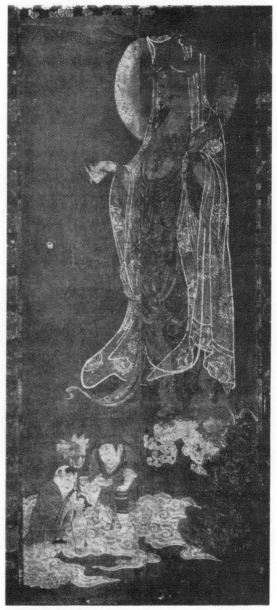

STANDING KWANNON.
 The painting is a copy of Godoshi
 (Wu Tao-tzu), probably by some
 Great Sung Master.
 Collection of Mr. Charles L. Freer.

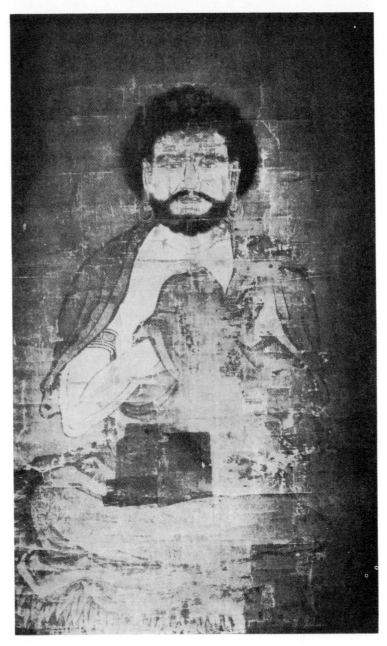

" SHAKA " of Godoshi type, and
Tang or Sung adaptation.
Mr. Charles L. Freer.

curtain makes the figure seem more like an actual revelation, as in the Sistine Madonna of Raphael. But to what does he—there is clearly a moustache—descend ? This time to two boys who are playing innocently upon a bright cloud, trying to plant fresh lotos flowers in vases. These boys typify the originally spiritual nature of man, and their occupation his naturally religious instinct. But rolling in from the right is a sinister dark-green cloud, which seems like a crouching dragon with a flat toad head. Godoshi has not deigned to represent an actual dragon, as Cho Densu has done in his front-faced Kwannon. The mere cloud is more suggestive of the coming evil and of man's dual nature. But the great gracious figure, looking down upon these unconscious children with the hint of a beneficent smile, bears for them salvation and spiritual sustenance. In his raised left hand he sways the wisp of willow which in other pictures sits in a vase, as if he were actually sprinkling his protégés with the water of baptism; and in his right he carries in a wicker basket a great tai fish as the symbol of spiritual sustenance. Here is where I think I detect a trace of Sung imagination. The Sung Kwannon with a fish is dressed as a fisherman's daughter. The tai here is too large, too much in evidence, and its somewhat coarse symbolism is not in harmony with that treatment which only suggested a dragon in the green cloud. Therefore, I believe that this fish-basket did not exist in the Godoshi original, but that the right hand took some other attitude, possibly pouring water from a vase, as in Hogai's version. But, leaving out this one feature, I believe we have substantially the Godoshi creation.

Æsthetically the first noticeable feature is the magnificent spacing. The vertical mass of the Kwannon, which dominates three-quarters of the picture's height, gets space from the large mass of sky on the left, and breaks at the bottom into the horizontal masses of the water, clouds, and boys, that form for her a kind of æsthetic base. This sumptuous simplicity of spacing only the fish breaks. And the rhythms of the transition are not graceful and decorative, but massive and rugged. There is no obvious premeditated system of curvature. The boys are drawn with naive simplicity, of a size which is a great gain upon the little insignificant figure in the Enriuhon conception. Even the lotos is spiky, scorning the pretty sculptural outlines of petals.

The drawing of the Kwannon, set at an angle to the spectator, is superb. Not only the drapery but the flesh portions are full of

life and movement. The two feet, swathed in crinkly masses of soft stuff, sit with fine solidity upon the small lotos shoes. The raised arm and hand with the willow are the most graceful things in art. But perhaps nothing can surpass the fine rounded head, with its short nose, its wonderful slits of eyes, and its lotos-bud of a mouth; probably the finest Kwannon face in all Chinese and Japanese art.

If we were to dilate upon all the intricate rhythms of the drapery lines, of the splendours of crown, jewelry, and lace mantle, we should have to expand this book to another volume. Of course words quite fail, and yet it is worth pointing out that all which I have said of "lead-lines" in general, and of Godoshi's line in particular, is here magnificently exemplified. What the rhythm of such flexible line may become is seen in the complicated yet easy knotting of the loose end of the under-garment gathered over the abdomen. Again, when the several kinds of drapery flow over the feet—under-skirt, garment, mantle, and veil—there is line-wealth almost worthy of the Parthenon female torsos. Here in the very photograph colour is indicated: in the lines even, the relative forces of which, translated from colour and texture with dark and light, exemplify well the technical quality "notan of line." The drawing of the veil in cream-white is a new thing, the lines being more thick, more forceful, and more decisive than the gauzy suggestions of Enriuhon. That still retains Indian feeling. This is frankly Chinese; the whole picture, indeed, shows just how Chinese Buddhist painting takes rank in spiritual force and expression far above Indian, or any other racial species, in fact. For it is true that though a few Japanese painters come somewhere near this ripe line-grandeur of Godoshi, they do not quite reach it.

It remains to speak a word of the colour. This is far less opulent and gaudy than the Enriuhon piece. A little strong red, blue, and green are found on the boys. The Kwannon's drapery has subdued shades of these, tending to olives. Fine patterning, low tone upon tone, overlies the garments. There is no gold anywhere, not even on the crown and the jewels. All is suggested by firm tint only. It is the flesh colour of the Kwannon, however, that dominates all, being now an intimate grouping of rich, warm tones of purplish reds, not unlike the tones that Abbot Thayer puts into his flesh, but more glowing. Really, the colour is hardly inferior to the line.

Another Godoshi type, preserved in several replicas by Yeiga, Cho Densu, and Motonobu, is of a seated front-facing Kwannon. Somewhere may be hidden a Chinese original from which all of these were taken between the fourteenth and sixteenth centuries, and which is not known to our generation. We believe the great Motonobu painting, formerly one of the greatest treasures of Marquis Hachisuka's collection, and now in the Fenollosa collection at Boston, to come the nearest to Godoshi. This was a most celebrated picture in both Ashikaga and early Tokugawa days, as is shown by the existence in the Kano archives of a magnificent copy of it by Tanyu. I knew this copy before the original turned up in the great emporium of Yamanaka in Osaka, about 1882. It had been given away to a retainer by the Marquis, as so many daimo treasures were given in the sad parting of ten years before, when families of faithful retainers, loyal through seven centuries some of them, were absolved from their feudal vows and became citizens of a new democratic Japan. Treasures like this soon found their way into pawnshops, and so, at a day when the revived taste of a new aristocracy had not yet formed, into the general market. I thus bought for twenty-five yen what would be worth thousands were it sold in Japan to-day.

The noble figure, clothed in a single ample mantle of solid white, shows flesh tints, and a little green at waist and in crown. The severity of the composition is to be remarked. The veil has been discarded. Jewels have been reduced to a minimum. There is nothing but the lines of the one drapery, but these are most magnificent—like the complicated massing of folds in a splendid marble statue. Only the utmost care has been lavished on these brush lines, their purity, their tapering, their length, their strength. The force in the stroke is transcendent. What strikes one chiefly about these lines is their angularity, very different from the rounded touches that Motonobu frequently delights in. It is this unwonted dignity of the line systems that leads me to ascribe the essential in the creation to Godoshi's mind. The background is naturally treated, a gap between two cliffs through which two large circular halos are faintly seen. Waves plash up at the bottom. Since similar landscape occurs in the Yeiga version, it probably goes back to China, though the details have been modified by Motonobu.

We come now to the great Godoshi design of Sakyamuni (Shaka), the last historical Buddha. This exists in at least two versions, one of

which, the centre of the Tofukuji triptych, has always been held by Japanese critics as not only a genuine Godoshi, but the standard of Godoshi. I am inclined to believe it the genuine thing, partly because the face is so much superior to even the great Sung heads. If a Sung copy, it should be by Ririomin. It has influenced Sesshu and all the great Japanese creators. The Buddha sits cross-legged on a rock, with hands folded under his robe in one of the mystic and secret finger symbols. (In.) The robe is of a quiet smouldering red that flames up at the angles into orange. A fine lotos pattern is worked over this robe, which in the gleaming orange portions heightens into gold. The colour of the face is rich Venetian flesh. But the extraordinary power lies in the line, the most spiky, splintery, modulating and solid of any of the Godoshi pieces. It takes on the very splendour of textures while it stands as supreme decoration. The solid masses of the head, aided by the rich notan of the colours, make it and the shoulders and the hands rise up like great cliffs of mountains. There is something elemental and ultimate about it. All that is small in one actually shrivels before the original. As you sit before it, it grips you with a direct spiritual power which no one of the early statues but Shotoku Taishi's Chuguji Kwannon possesses. This shows the very finest use of the Tang lead-lines.

The other replica of this piece, of about the same size, is the great Shaka owned by Mr. Freer—which will be in the national collection at Washington, and which came from the collection of the Japanese artist Zeshin, along with the Rakans by Ririomin. It probably was imported into Japan at the same time with the Rakans, and was used with them in temple service. The disposition of the drapery is exactly the same as the Godoshi piece, and only the lines are a bit less juicy than the Tofukuji piece, and the colour is colder. The chief difference, however, lies in the head, which is more clearly of a Sung type, something like the heads of Shojōkō-ji's Shakas. That is, the face is more emaciated, like a sorrowing Christ's, and the hair is less sculptural, being scattered into long fine locks tossing in the wind. The Tofukuji, if not the original, is probably a Tang copy of it; the Freer is probably an early Sung adaptation, but probably not by Ririomin. Both are among the finest paintings left us by any ancient race.

The other two paintings of the Tofukuji triptych, are a young Monju with his lion, and a young Fugen upon an elephant: the

regular companions of the Sakyamuni Trinity in both the Tendai and the Ten sects, as distinct from the Amida and Yakushi Trinities. Both of these were probably historical personages, the Monju being identified with an early Indian missionary to Nepaul. However this may be, Monju is generally represented with a roll of scripture in one hand, and a jewelled wand in the other; and he symbolizes the power of scripture, of inspiration, of divine interpretation. Fugen varies, sometimes holding a mace like Monju's, sometimes an open book, or a lettered scroll; and he symbolizes the power of church organization, of ritual, of the communion of the saints. So that we may regard this well-known Trinity as a human embodiment of the original "Three Precious Things," so often recurring in scripture and in prayer—"the Law, the Church, and the Buddha"—corresponding indeed in a certain real sense to "Father, Holy Ghost, and Son."

In this Monju of Tofukuji we have Godoshi's most charming and gracious figure; a youth with beautiful Greek head, long hair falling over his shoulders, and a splendid drawing of soft drapery not unlike that of the standing Kwannon. The gold upon the jewels has probably been retouched, detracting a little from the solid power of the presence. The Fugen is more crabbed in line, and seems more like a copy than the other two. But there is another splendid Fugen at Mioshinji, which, though ascribed to the Sung artist Ma Lin, can have no relation to him except as a copyist. It is surely a design of Tang (To), though possibly, on account of its unquiet lines of drapery—more like those of Fugetsu—to be ascribed to a later date in Tang than Godoshi. Even so, it has probably been originally based upon Godoshi, and exhibits his power and presence. This is of an older man, square-headed, with hair matted as if wet, yet swept forward in the same spiritual draft that disarranges the drapery. The lines do not have the Godoshi modulation. This piece has strongly influenced Sesshu.

Altogether we must regard Godoshi, whether as compared with architects, sculptors, or painters, as one of the very greatest of the line masters of the world. His figures do not look cheap, even when seen in the same blow of the eye with photographs of Phidias and Michel Angelo.

Of early Tang paintings, not related to Godoshi, there are many in the form of Rakan pictures, nearly square, showing the doings of the Arhats, or Buddhist saints in the flesh. Animals and primitive tree

drawing enter into these. The flesh is often outlined in red. The composition is not elaborate. Yet there is sometimes a solid grandeur about the spacing, and a very rich colour—working between blue, green and strange oranges—which raise them to high rank.*

The æsthetic reign of Genso was disturbed in 755 by a great palace intrigue headed by the powerful alien courtier whom Genso had befriended, and who is popularly supposed to have been in collusion with the " Helen " of China, Genso's lovely young comrade, Yokihi.† In the mad flight from the capital, Yokihi paid for her sins with her life; and Genso was forced by his few faithful generals to abdicate in favour of his son. The revolt was finally put down, but Genso returned, a solitary old man, to a ruined capital. Rihaku and Toshimi have left powerful political satires upon these disordered times, and later poets have dwelt upon their pathos. The supposed perfect union between Buddhism and Confucianism had shown the rift deep down in the former. Puritanism was driven at least one stage toward self-consciousness, and had now a weapon in its hand.

But, far away from the capital, on beautiful Tendai mountain, the secret Buddhism of lofty rights and superhuman purification went on under the great Daishi and his successor, Enchin of Onjō-ji. A peculiar art grew up in those sacred regions, which partakes of the general nature of Tang art, yet forms a special brand of it. I refer first to the hieratic altar-pieces, or Mandara (mystic circles), which, hung before the advanced pupil or officiating priest, showed him the higher spiritual categories in their proper involution and integrating, gave him a detailed inventory both of the cosmos and of the psychic, and helped him in the verbal invocation. Such Mandara were brought back to Japan by students from that island who had gone to China especially to enrol themselves as neophytes at Tendai. Some of them are in

* The enumeration and location of other Tang (To) paintings in Japan were among the things the writer left blank. He intended to supply these and all other deficiencies when he could get to Japan again, have access to archives, and consult with old colleagues. In attempting to follow out his wishes the editor went in person to Japan, remaining through the spring of 1910, and received priceless assistance upon all such points of doubt. In this case, the one piece of information concerned a picture called "Tenjukoku Mandara," Tenjukoku being the "after-name" of the Japanese Prince "Shotoku." It is not even a painting, but a very ancient piece of fine embroidery, said to have been done by the ladies of the Tang court from a design by a contemporary artist. It is now mounted in the shape of a kakemono, is quite a good deal rubbed and defaced, and is kept in the temple of Chuguji at Horiuji, Nara.

† In Chinese "Yan Kuei-fei."

colour, some in fine gold lines drawn upon a dark ground. The lines, though fine, have a certain thickening and pen quality which render them objects of great beauty. Rich flower designs, largely of lotos, and scroll work also in gold, surround the separate panels. The central panel contains the spirit of the central category, the God of the Shingon sect—a still more esoteric branch of the Tendai—Dai Nichi Niorai, or the great Sun Tathagata. He is not even called a Buddha. He is the central demiurge, in Bodhisattwa costume, but with supreme power in the cosmos ; in short, to the spiritual universe what the sun is to our system. The art is pretty close to imported Indian, already working toward those forms which later become the Gods of Hinduism. How strongly this kind of Tang art affected Japan we shall soon see.

Another fine form of Tendai painting was the portraits of great priests, from Nagarjuna downward, the man who had founded this mystic ritual. These portraits are very characteristic of Tang, being very strong, with flesh tint, and lined in simple powerful brush strokes, generally of ink, that do not thicken to Godoshi's scale, but remain everywhere something like thick firm wires In this respect they are more like the Rakan of early Tang. Many such portraits were brought to Japan by the new founders. Probably the greatest of all, and one of the most powerful portraits of the world, is the painting of Dengio Daishi himself, preaching, owned by the great shipbuilder of Kobe, Mr. Kawasaki. Here the lines are of wonderful fineness, the features transcendent, and the colour most delicate and beautiful. It is nearly of life-size, and must be by one of the greatest Buddhist masters of Tang.

But beside these works of painting in the eighth century, sculpture still took an important place, even if subordinate. In the large ceramic Buddha's head, found by me in the ash barrel at Daigoji in 1884 and now owned by the Art School in Tokio, we have one of the earliest relics of Tendai sculpture. Doubtless it formed a portion of a complete ceramic Buddha which was destroyed, all but this head, in the great fire of Daigoji in the twelfth century. After 1868 the priests were tired of keeping the fragment, whose tradition was lost, and so had thrown it away. It is not only most important because the rounded form of the head and the somewhat flat features show us just the sculptural type of head which Godoshi followed in his painting of the Tofukuji

Buddha; but also because it is an authentic piece of hard glazed ceramic belonging to the eighth—and probably the early eighth—century. The clay is whitish, midway between pottery and true porcelain. The glaze, which is used chiefly on the curls of the hair, is whitish with a little green streaked through it. It is handed down, but on tradition only, that there was real porcelain in Tang; and this piece seems to confirm it.* There was softer glazed ware in several colours, cream, white, olive, brown, grey and yellow, although in Shosoin there is no glazed ware but the mottled green and yellow. The white, which seems either an ancestor or a contemporary of the famous Corean white glazed ware, may well be an invention of the later eighth century.

But another splendid form of Tendai sculpture was in wood; and, chiefly as coming down to our day, the strong portrait statues of great philosophers and priests. Two of the finest are the figures, somewhat larger than life, of Vasubandhu and Asāmgha, which formerly stood together on the altar of Chukondo at Kofukuji. These are sometimes considered by Japanese critics to be native and of a later date. But in their transcendent simple style, faces of utmost power, Chinese details in drapery, and realistic modelling as free as the finest Greco-Buddhist, we can find no analogy with typical Japanese sculpture. They are far grander, and have the force of the great painted portraits of Tendai Tang. In spite of the peeling off of the paint which once covered them, and of the broken hands, they seem rather to be actual human presences than statues.

By the ninth century, under Genso's successors Tokuso (Su Tsung) and Kenso (Tai Tsung), belief in Buddhism again took strong hold upon the Imperial Court; but now there was no such naïve unconsciousness of difference between the two halves of Japanese genius. The leader of the Puritan Confucians, Kentaishi,† China's greatest prose writer, and one of the best of Tang poets, dared, though already under the Imperial ban, to write strongly against what he believed to be degrading superstitions. In the year 818 Kenso had ordered precious relics, reported to be some of the very bones of Buddha, to be brought from India to China, and he and his court undertook to worship them. Then Kentaishi

* Mr. Charles L. Freer of Detroit, one of the world's greatest experts and collectors of ancient pottery, asserts that at this time there was pottery.—THE ED.

† Kentaishi, in Chinese "Han Wĕn-kung."

THE MONJU OF TOFUKUJI.
By Godoshi (Wu Tao-tzu).

PORTRAIT OF A PRIEST. By Kobo Daishi.

spoke out, and declared, in a rescript which has ever since been a kind of constitution for the Confucian scholars, that Kenso was violating the sacredness of ancestral customs and would only bring disaster on the empire. This was the first "rift within the lute," which was destined to rise to an all-threatening problem of policy in Sung, and to lead to a palsying of the Chinese mind in later Ming. Now began a kind of see-saw between the two great Court parties, now one triumphing, now the other. In 845, for instance, many Buddhist temples were destroyed and the building of new ones forbidden. Faction leads to internal revolt, and the end of the century finds the Tang power tottering, with the capital again moved eastward to Loyang.

The Tang paintings of the ninth century are a greater elaboration of the style found in the ancient Rakans. The line is not as thick as Godoshi's, but thickens as if it were a wire ribbon seen at different angles. The faces are a little coarse, the forms ungraceful, but there is great wealth of colour, a Chinese vermilion being used which seems to be almost as dark as crimson. The large Nirvana painting at Tofukuji, ascribed to Godoshi, is of this age. Also the large painting of Buddha preaching.* The Rakan pictures of this day are carefully drawn, and have rich landscape backgrounds. The trees, drawn in rich opaque colours like jades, are a manifest advance upon the early Tang and pre-Tang Tartar trees.

Ink painting is also in vogue at this day, and the hieratic Shingon style, which now uses exquisite opaque Tartar colouring for the original fine gold lines. An example of this is the splendid Bodhisattwa of the peacock at Ninnaji of Kioto.

By the tenth century the Kih-tan—a rising Tartar tribe from the North-west—had almost annihilated the Northern provinces. In the south, west, and south-east, localities were declaring their independence of Tang. According to Chinese reckoning Tang is officially abolished in 905 and a series of petty dynasties, each lasting a few years, brings on an interregnum of great confusion between 905 and 960, which may be called the " interpolation of the 5 dynasties." As in all such disordered times, the Confucians, with their ready organization, came to the front ; and they now succeeded in 955 in having a large number

* Probably the T'ang painting in Chonoji temple, in the village of O'Toku-ni, Yamasho.

of ancient bronze Buddhas destroyed and cast into coins. It is this deep reaction in the Chinese mind which has led to so many destructions and revolutions in art, and which has made Tang art of the great Buddhist period so rare in China itself.

But in this very confusion a last independent phase of Tang art flared up. The local geniuses of the provinces found expression ; and even great Buddhist priests like Zengetsu have left us stupendous conceptions. His great work is sets of the Rakan, single figures of large size—the finest being the 18 Rakan of Kodaiji. The drawing of tree forms here is gnarly and powerful to the last degree. The line is the wire line of the early Rakan, but used with wonderful originality and twisting into strange splendid systems. The colour is more wonderful still, quite eschewing the bright reds, greens, and blues of Tartar tradition, and confining both flesh and draperies to strange quiet transparent tones of browns, olives, and unnamable purples. All grace is lacking : the figures are elemental like great lumps of rock ; the heads are often distorted ; yet a powerful realism that can even deal minutely with textures remains.

It is a question whether the strange set of " Jewish " Rakans belongs to this or the preceding century ; they are kept at Kataiji, at Higashiyama, near Kioto. Though Buddhist and with halos the Semitic cast of countenances is evidently intentional. These exceptional pieces may have arisen by a mistaking in later Tang the officiators in the half-ruined synagogues in China for Indian, that is, Western, types. The Arabs hated Buddhism so heartily that they would hardly have become mistaken for Rakan.

Taking Tang Buddhist art as a whole, we have seen how Greco-Buddhism gave it an inspiration in the seventh century ; and how internal causes carried it to a kind of culmination under Godoshi in the eighth, from which point it rapidly declined through the ninth and tenth centuries. The revival of art which now supervenes, though even beginning during the five short dynasties, properly belongs to the history of the all-conquering Sung that came in in 960.

CHAPTER VIII.

MYSTICAL BUDDHIST ART IN JAPAN.
Fujiwara.

MYSTICAL Buddhist art, or the arts of the mystical sects of Buddhism (Tendai and Shingon as named in Japan), which we have been studying in its Chinese phases of Tang and Sung, was introduced into Japan from Tang in the eighth century. In order to understand what a change this was for Japanese art, and with what political and social changes for Japan this new art was bound, we must go back to the end of Chapter VI., where I briefly described the decay of the Nara life and art which followed after the death of Shomu Tenno in 748. Under the Empress Koken many abuses were practised, statesmen were exiled, priests exalted to high rank, and art became coarse and traditional. The good days of Genso's reign in Tang were passing over China without leaving any contemporary mark on the island capital. Quite a number of Japanese scholars, like Abe no Nakamaro, were studying in Tang, but their pro-Chinese recommendations had little weight. A great religious revival, that of Tendai, was passing over China, filling even the ranks of the court with the inspiration of spiritual knighthood, but it left Japan cold. To be sure, one waif from the crest of this new wave had been thrown upon Japan as early as 699. The hermit, En no Shōkaku, was a Chinese disciple of the new cult, and, coming to Japan, had tried to interest the people in his mysticism. But the devotees of the older abstract views had denounced him as a magician, and banished him to the mountains of Idzu. There he is said to have practised his mystic contemplations, communing with nature and with the elemental spirits of rock and stream ready to respond to his bidding. In this way he was a despised forerunner of mysticism,

afterwards honoured as a pioneer and often represented as a holy hermit—as in the fine bronze group of the fifteenth century. But in spite of the languid curiosity of a few persons concerning his doctrine, the Nara Court was ready to go with the old worn-out formulas, hardly virile enough in their moral generalizations or in their æsthetic beauty to withstand the undermining of luxury.

So things went on in the luxurious capital of Nara, with a decayed Greco-Buddhist art, until the year 782, when a new and powerful emperor, Kwammu, destined to reign twenty-four years, came to the throne. In his first thought he identified Buddhism with all the abuses of his predecessors, and so he ordered that no more temples should be built and that no more of the people's land should be diverted to temple support. Moreover, he conceived that the city of Nara, although such an enormous mass of capital was invested therein, was too much associated with old ways to be longer retained, and so in his third year he sent a surveyor to the neighbouring province of Yamashiro to look for a promising site. Already his thought was that the new civilization of China—the wonderful poetry, and painting, and laws, and court officers and functions, the stately music, the universities, the diffusing of learning throughout the Court—that all these ripe elements of culture—should be carefully studied, and transplanted bodily to a new Japan which he himself would create. Confucius was already publicly worshipped. If the Confucian scholars of China had not been such unmitigated Chauvinists they might well have transplanted their own cult to the neighbouring state. But fortunately for Japan these Bourbons considered China a divine essence apart from a negligible world. It is interesting to see that the Japanese nature was so far back, as now, ready to accept and incorporate every element of any foreign civilization that could be put to the national advantage. Kwammu, in short, was to his day what the illustrious Mutsuhito, already in the 39th year of his reign, is to the present. Thus we can say that he stands at the commencement of a second great era in Japanese civilized history—the first having been opened by Shotoku Taishi nearly two centuries before—a second period both of general culture and of art. This second period was marked by a strong upward wave at the close of the eighth century. We have only to note that it is contemporary with the culmination of the parallel Tang wave.

Now it happened that just as Kwammu was meditating these sweeping changes, a great Japanese genius—a young man who had been studying for years with Dosui,* the hierarch of the mystical Buddhist sect on Tendai mountain—returned to his native country fully prepared to become the apostle of this powerful new doctrine in its island world. This is the man known to us as Dengio Daishi, who, whether he could, as alleged, perform physical miracles or no, at least had that reach of mind which enabled him to appreciate, utilize and direct the forces involved in Kwammu's projected reforms. His first step was to convince Kwammu that it was really the Tendai spirit that lay at the basis of China's greatness, and that it would be a most powerful makeweight as a new court Buddhism against the effete Nara sects. Thus what might have been a too thorough Chauvinizing of Japan was diverted by Dengio into a kind of mystical theocracy such as never existed in China or any other Buddhist kingdom. In 788 Dengio, foreknowing Kwammu's decision concerning the new site, built his first cathedral church, Enriakuji, near the top of Mount Hiyei, which rises from the waves of Lake Biwa, thus trying to reproduce the isolated conditions of Tendai itself. But Dengio and Kwammu were working in perfect accord ; and in 794 the capital was formally transferred from Nara to the new Yamashiro site, at the land base of Mount Hiyei. Here a fine valley, some five miles wide, had been selected, sloping gradually to the open South from foot hills, and flanked on East and West with lofty mountain ranges. Here the ground was laid out as much as possible like the Chinese capital of Genso, with fine North and South running thoroughfares crossed regularly with broad avenues from East to West. From a large rectangular tract in the centre of the North side arose the many buildings and garden hillocks of the Imperial palace. In a few years the population had deserted Nara, and adapted themselves to these more spacious accommodations. Canals faced with stone carried fresh water from the mountains through the city. Within twenty-five years a considerable portion of Central Nara had relapsed to its original rice-fields ; but Kioto could boast of more than a million citizens. It was the thousandth anniversary of this great removal which the Japanese celebrated by an international exposition at Kioto in 1894. The new buildings erected at that time, the Taikiokuden, were intended to be a

* Dosui, or " Saichō."

close approximation to the style of Chinese architecture which Kwammu himself used.

A few years later, in 806, a second great prelate came back from China to Japan with the prestige of a much longer study on Tendai mountain than Dengio. No doubt this Kūkai, or Kobo Daishi, was a far more powerful religious genius than Dengio, as also a far greater artist. He founded the special and concentratedly mystical sect of Shingon, as supplementary to Tendai. This was the first great sect originated by a Japanese. Kobo is said to have performed most startling miracles before the Kioto court; and he probably did a still more wonderful service in inventing the Japanese syllabary, a phonetic semi-substitute for the difficult Chinese writing. He was likewise a great metaphysical philosopher, Professor Inouye of the Imperial University holding that we shall eventually find his work to be the ripest piece of speculation in all Asia, building superstructures upon Vasabandhu and Asamgha, as these build both on Buddha and on the Vedas. Had he arrived upon the scene a few years earlier he might have made more effective and more liberal the very reforms undertaken by Dengio. As it was, he removed his first Cathedral seat far away from Kioto to Mount Koya in the Southern part of Yamato in 816. He travelled also all over Japan, even to the barbarous North, founding monasteries on his way. He was more for the people, and less for an Imperial theocracy.

A special mission to study in China was sent in 803. The Tokaido highway was opened eastward as far as Hikone. The whole East of Japan had finally been won from the Ainos in a big battle in 801. Special Chinese court ceremonies were adopted in 820. In 827 Kobo had become so powerful in the palace that at his request the Emperor ordered the bones of Buddha to be brought to him at the palace. Meanwhile several histories of Japan and books of law had been compiled. Ono-no Nakamura, the friend of Kobo, and who painted his portrait, was sent as special student to China in 836.

But perhaps the greatest service of Kobo Daishi to Japan was that he introduced Tang art, and especially Tendai art, into Japan; and with such firm ingrafting that it became thoroughly naturalized, even if slightly modified. It was Kobo who personally brought back hundreds of paintings, among them the great portraits of the founders of mysticism, and the largest specimens of the magic Mandara, which

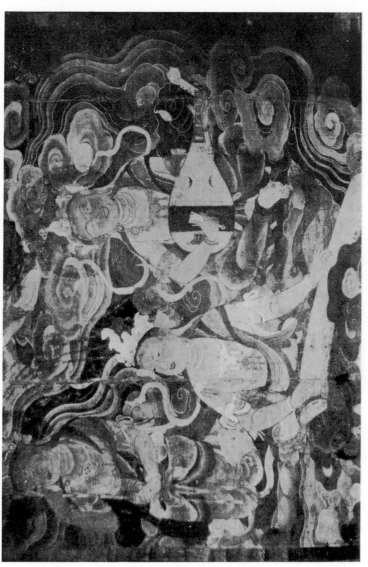

Laughing Angel with Biwa (Detail).
By Kobo Daishi.

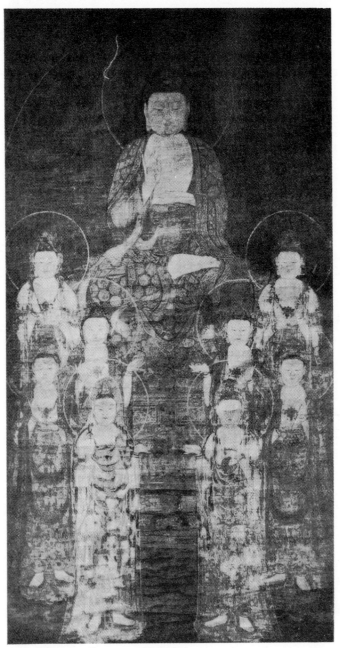

EARLY CHINESE BUDDHIST PAINTING.
Collection of Mr. Charles L. Freer.

are found in somewhat dilapidated condition at his favourite Kioto temple, Toji. Toji has always been the great Shingon temple of Kioto, as Enriakuji has been the Tendai, and Daitokuji the Zen. Kobo made himself the intimate friend of all the young Japanese who aspired to Chinese learning, among them the famous Ono-no Nakamura ; and, being a great painter and sculptor himself, he taught them to create in the strong Tang style. Indeed from his day it has been part of the discipline and function of every Shingon priest both to paint and to carve Buddhist altar-pieces. The first school of the new civilization is therefore a school of priestly artists with Kobo at their head.

It should be added that in 864 a third great Japanese prelate returned from Tendai and founded a branch sect of that name at Miidera of Otsu, near Lake Biwa, which has maintained to this day a hierarchical organization separate from that of Hiyei-zan. This man, Chishō Daishi, was almost as great a man as Kobo, but more of a recluse. Perhaps the highest Mahatmaship of Japan has been practised in the temple which he founded. My first great teacher in Buddhism, Keitoku Ajari (Ajari is Bishop), became the hierarch of this sect just before his death, and my fellow-pupil, Kwanrio Ajari, officiates to-day as Archbishop of Miidera.* Chishō, like Kobo, was also a great painter and also brought back with him many Chinese Tang portraits and models. Other prelates followed during the century, such as Jukiku Daishi, but these three (Dengio, Kobo, and Chishō) may be called the founders of mystical Buddhism and its art in Japan.

The art of the inceptive stage of this new period, roughly the ninth century, may be said to be a mixture of the new Tang style with the somewhat over-decorative traditions of the old Nara style that could not be at once wholly discarded. Moreover, the very predominance of the Shingon, or Mandara, among the general Tang styles in Japan tended rather to encourage the effeminate tendencies of Nara art than would have the style of Godoshi had it then been known. This tendency was partly counteracted by the strength of the portrait style as introduced from Tang. In sculpture is found the same double tendency—a strength in portraiture and in militant types, but an effeminacy in carved Buddhas and Bodhisattwas and other

* The Ajari Kwanrio, having already appointed his young successor, has taken the name " Keiyen "—under which he still presides over the important Archbishopric of Miidera.

Mandara deities. Yet, in spite of all conservation, it can be said that the art of the days of Kobo is more nearly like Chinese than the more culminating art that comes a little later in Kwampyō and Engi.

The transition from Nara art to Kwammu art is probably given us, in painting, with the splendidly-preserved representation on silk, and in brilliant colours, of the eleven - headed Kwannon seated, formerly at Horiuji, and now in the collection of Marquis Inouye. It is possible that the grace of this fine piece is an example of Shomu work in Tempei, rather than of Kwammu. But in sculpture undoubted transitions are the big, heavy, standing Buddha of Miroku in Todaiji, so fat and clumsy that it looks about to burst, and the large seated fat gilt trinity upon the altar of Bisjamondo at Seirioji.

Perhaps by Kobo Daishi himself, and with the transition to the new Tang type much more complete, is the great painted triptych of the coming of Buddha in glory through clouds filled with Bodhisattwa. This uses full colour, rather than gilding, and there are traces of the Greco - Buddhist manner, but nothing of the hard, wiry, Corean lines of Tempei painting. The effect is broad and the notan fine. The side panels with Bodhisattwa playing on instruments are beautiful and naïve. In some faces the effect of laughing is given.

Other paintings by Kobo Daishi are the portrait of Ono-no Nakamura in Koninji, at Yamato, and the large, standing figure of Jizo in the Fenollosa collection at Boston. Quite like him, and very Tang in style, are the portrait of Kobo and the front-faced standing Jizo by Ono no Takamura. Several paintings remain ascribed to Chisho Daishi, the strong yellow Fudo of Nara shrine and the strange Fudo with many doji (boys) at Miooin, in Koyasan, which is very much like Tang.

Many sculptures are attributed to Kobo, one of the most probable being the great Fudo of Toji. This is the first time that this subject, a distinctly mystic motive, has been mentioned in our history. Fudo is a type of the apparently violent beings in the spiritual world who take rank with Bodhisattwa. His flesh is blue, he has torches in his mouth, his face writhes, he holds a sword in his right hand, a cord in his left. This seems related to the more terrible Shivaistic deities of modern Hinduism. To the thoughtless foreign commentator

they are one and all abominable relics of "devil" worship. But Fudo may properly be called the Bodhisattwa of the will, of self-restraint, the power to cut out temptation, to bind the unruly passions. Fudo means "The Unmoved," and he is usually represented as surrounded with a halo of fire, which he does not feel. In the Toji statue, the square logs of his throne are really a pyre of wood for flames. Jizo, too, is a new Bodhisattwa type, this time gracious and peaceful, the guardian of little children and of travellers, the descender into Hell, where he intercedes for the souls of infants. Japan is full of wayside shrines to Jizo, whose stone images are almost covered by votive offerings of pebbles by travellers. One of the most striking of these early Jizos is cut, life-size and in high relief, out of a mountain ledge on the little path across the Hakone mountains from Ashinoyu to Hakone. This is said to have been carved by Kobo himself on his journey to the North ; yet, though the conception is primitive Tang and mostly of Kobo, he would hardly have spared time for its execution. It is more likely that it was afterwards prepared from his drawings.

But probably the most powerful sculpture of this day is found in the militant spirits, Bisjamon's Shi Ten O and Yakushi's generals, often very large carvings in wood, and with fine spirit and motion. These are much fuller of drapery than the corresponding Chinese work of the seventh century There is little of the effeminacy and merely decorative quality of Tempyō sculpture. It is all robust and large and realistic, deeply carved, with the bigness of Tang feeling in it. It is hard to say whether some of the finest examples may not be originals from Tang. Typical specimens are found in Nanyendo of Kofukuji, in Toji, in Koyasan.

The study of ornament too in smaller articles is of great interest ; boxes and vases of lacquer and metal, and stuffs. Of this there is much in Koyasan and at Saidaiji.

The ripe harvest of all this Chinese sowing comes on slowly, after three generations, with the advent of the Emperor Daigo in 898. His glorious reign lasted down to 930, of which 22 years are reckoned under the famous era, Engi (901-922). This period named "Engi" must doubtless be reckoned the high-water mark of Japanese

civilization, as Genso's "K'ai-yuan" had been that of China. Never again would either China or Japan be quite so rich, splendid, and full of free genius. In Japan, however, it might not be quite correct to speak of this as a supreme culmination in *art*, since it is only the second apex of five nearly equal mountain heights. But in general culture and in luxurious refinement of a life which equally ministered to mind and to body, not only not in Japan, but perhaps not in the world, was there ever again anything quite so exquisite. Shomu's day at Nara had been great, but it was a childish though over-grown patriarchship. Genso at Loyang and Pericles at Athens had seen stronger, more daring creation. The later Florence of the Medici was to surpass it in sheer intellectual force and the Hangchow of Sung in naturalness and vitality of art. But in a delicate aristocratic culture on a scale comprising a vast city, and whose finest essences are original poetry and music, nothing before or since probably has possessed a more perfect flavour. It was like the production of a wonderful, unique, and unheard-of flower whose shape and colour transcend the limits of all known species.

I have already intimated that this great world of palace culture was in some real sense a theocracy ; and this is another feature which differentiates it from all the world's great illuminations. Athens and Florence were frankly pagan. Loyang and Hangchow were half-pagan. But the Kioto of Engi practically worshipped in one vast temple, without decay of heart or intellect. Here, indeed, the mystical Buddhism of Tendai and Shingon came to its social throne ; nowhere in China did it take such absolute root and bear such luscious harvest. It may be said that Dengio on his Mount Hiyei, if not Kwammu by his Kamo river, had foreseen much of this. The compact between these two founders, the spiritual and the temporal, was one that the successors of the former would enforce. The Tendai prelate was to be the Emperor's adviser and father confessor, the vicegerent on earth of those very spiritual forms that should guarantee the Imperial throne. Before Gods and the archbishop should the Mikado kneel; while armed monks from the populous monasteries should if necessary defend the temporal sovereignty. It was a sort of compact between Church and State, not at all unlike that which Charlemagne was to make with Pope Leo the Third, and curiously enough only six years later. Kwammu founded Kioto in 794, and the great Charles of Germany

signed the convention of Rome in 800. It may be no great strain of analogy to designate this duplex authority which thereafter underlay Japanese civilization as "The Holy Kioto Empire." It is true that Tendai Buddhism was in time partially superseded; and it is true that for 700 years feudal Shoguns, who had often scant respect for priests, sheared the Mikado of all real power. Nevertheless, in some weak but real sense the "Holy Kioto Empire" lived down to 1868, when many princes of the Imperial blood, like Prince Kitashirakawa at Ninnaji, were officiating with shaved heads as imperial incumbents of great Tendai and Shingon abbeys at the old capital. It was through the early Kioto centuries, however, that the strength of this double power ran through society like the fire of a holy wine; and it was in Engi especially that it reached its highest power. There in the heart of Kioto to-day, under the roof of an ancient temple gate of Daigo's palace, can still be seen the far-away peaks of Hiyei-zan dominating the devoted city and testifying eloquently to the pride with which the Tendai pope must have looked down upon his Imperial puppet.

For there were several things that the far-sighted Kwammu forgot in laying his wise plans for empire. He had chafed against Koken's Nara hierarch, Dokio; he had resented the cupidity of the Nara nobles, who had gradually and surreptitiously neutralized Tenchi's fine laws of land distribution to the people. He had intended to rule as the new father of a great people relieved from their abuses; and doubtless Dengio was equally sincere in good intentions. But neither of them could foresee how the new Chinese ranking of Imperial ministers as a court *entourage*, strengthened with a caste allegiance to the theocratic power on the hill, would soon lead to the throttling of imperialism with oligarchy. Four estates you may say there were— the Emperor, the people, the nobles, and the clergy. The Emperor and the people should have been strong enough then to build the Japanese *nation*, which was delayed till 1868; for the village organization of the farmers and the artisans, for which indeed the Taihori laws had been chiefly drafted, was not yet far in abeyance. But a working combination of a vast civic aristocracy drawing its wealth from country estates with the ramifications of a perfect administration would be well-nigh too powerful.

This aristocracy was vested largely in one vast family, the Fujiwara, which had trained its hundreds of collateral houses upon a single grand

scale of policy and education. A well managed family in Japan is always an *imperium in imperio* ; and the early history of Japan is largely a record of civic, or even civil, struggle between rival houses. Thus the Soga family, the first great patrons of Buddhism, had been supported by Prince Shotoku in their fight with Moriya. It was only a little later that the great minister Kamatori, the reputed founder of the Fujiwara, fell into deadly feud with the jealous Soga. It was against this very growth of the aristocracy that Tenchi's and Mommu's laws had been directed. Nevertheless in Nara times the old land-grabbing had crept back and the Fujiwara clan was rising to considerable wealth and influence. And when Kwammu in his new Kioto assembled his courtiers about him into a consolidated cabinet with subordinate bureaus and a large officialdom, the scions of the populous Fujiwara were there in large numbers, ready to fill the posts. Especially had this house been eager to follow all the new currents of learning that had filtered in from China and Corea. They were trained scholars as well as statesmen ; and now they threw themselves with solid enthusiasm into the union of learning with the personal ecstasy of the new mysticism. It was they who became the principal pupils of the Tendai hierophants ; they the artists, the poets, the musicians, the dancers—nay, the Confucians also—who should realize in their own lives a mingling of the best in both China and Japan. They were "aristocrats" in a literal sense. It was a government by the best. This is why we call this second great period of Japanese civilization, centred at Kioto and lasting down to the twelfth century, the *Fujiwara epoch*.

But it was not till just before the culminating period of Engi that the inner significance of this aristocratic predominance began to be felt. The nobles had begun with supporting Kwammu in his alliance with the priesthood. It now became clear that the Fujiwara, in this alliance, were about to overweigh the Emperor. In 881, the head of the Fujiwara house, a man of vast ability and ambition, Mototsune, became prime minister, with a strong backing of his house in subordinate offices. By 884 his cabinet became so powerful that it dethroned the reigning Emperor and put up his son. In 892, Mototsune's daughter was married to the Emperor Uda. This was the beginning of a series of such marriages, through which the heads of the Fujiwara clan became grandfathers of a whole line of Emperors.

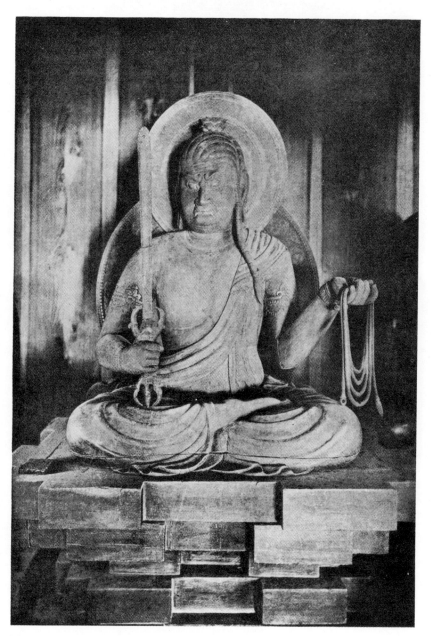

WOODEN IMAGE OF FUDO. By Kôbô Daishı.

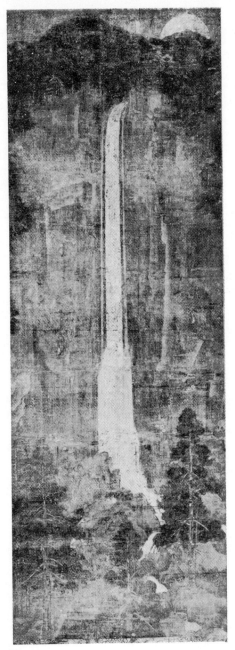

WATERFALL,
Kanawoka.

The dangers of this one-sided supremacy were of course apparent to the other nobles ; and one of these, Sugawara no Michizane, through his talents and learning, which really surpassed the Fujiwaras', rose into rival rank. He was the great Chinese scholar of his day—a great prose writer, a great historian, a great poet in the Chinese style of Tang— following Rihaku and Omakitsu—a great painter, a man of staunch integrity, an incorruptible statesman. Such a man really stood in the way of Fujiwara ambition ; and through a romantic series of Court intrigues he was eventually removed by banishment. His story has since entered into many a novel and play, and forms the theme of the great panoramic paintings by Nobuzane spoken of in the next chapter. His soul has been promoted to the rank of Shinto deity, and he is worshipped to-day, under the name of Tenjin, as a sort of Japanese god of letters.

The Fujiwara, from this time onward, really reigned supreme for two centuries. And one of their methods of controlling the Emperors was in that alliance of the church which urged them as they grew to manhood to take holy orders, shave their heads, retire to a monastery and leave the young prince to the guidance of his ministers. If a great man he might still exert much authority, but only through channels which were controlled by the church. This was not quite a new procedure ; but as an almost compulsory measure under Fujiwara custom it became a new instrument. Uda became the first type of these retired Emperors in 889, and was given the complimentary ecclesiastical title of Ho-ö (that is *pope*). The real power was of course held by the Hiyei-zan prelate. The young Daigo, grandson of Fujiwara Mototsune, was now the civil Emperor, and his long reign is both a sign of and establishes the Fujiwara domination in its perfect form. Daigo is the great Emperor of Engi, and under him the splendour of literature and art rise to their zenith.

It is worth while here to say just a word more about this Fujiwara culture. On the physical side it reached its splendour with enormous palaces—enormous in extent rather than height—and fine gardens in a style not more than half Chinese. Silks of the richest texture and colour were worn in many layers whose edges were tinted into gradations. Gold and colours and ivory and bronze and pearl were used to finish the interiors. Music became a passion—a mixture or alternation of Chinese music and Japanese music—demanding a department of music

with a minister of state at its head, who also supervised the Court dances, which were reckoned a part of music. These dances were pantomimic, *i.e.*, dramatic, and composed on historical or romantic themes. Nobles themselves, and refined Court ladies, at first took part in the dancing. Later a chanted text was added, sung by aristocratic choruses. Other kindred dances were the Buddhist miracle pantomimes already noticed, and the Shinto Matsuri dances, which the nobles also affected ; for one of Kobo Daishi's great works had been an effected union between Shinto and Buddhism, through which they exchanged deities. It was largely through the retention of Shinto—pure Japanese ideality, nature and family worship—that Japan, even in her Chinese copying, remained so largely herself.

In literature, for example, though Chinese poetry was known and practised, as by Michizane, the pure well of native speech—in its polysyllabic sound wealth, its loose verbal construction, and its host of little particles, so utterly removed from the solid, trip-hammer metre of Chinese—bubbled up too copiously for serious soiling. In 905 the poet Tsurayuki presented to the Engi Emperor the second great national anthology, the Kokinshu, in which so many of the thousands of supreme masterpieces are by Court ladies and priests. Ono no Komachi becomes Japan's romantic Sappho. Narihira plays the part of Theocritus, or at least a Byron. The archbishop Henjo blends Buddhist ecstasy with pure Japanese nature feeling. From these days the Fujiwara lords and ladies were all trained as poets, and among the intellectual pastimes of Court ceremonies, parties and picnics were minnesinger contests and the capping of verses.

Prose, too, took on splendid romantic forms, especially in the great novels of life, the Monogataris, largely written by the Court ladies. Certainly the Genji Monogatari, by the lady Murasaki, is almost the most perfect picture of refined contemporary life that the literature of any race has left us. Without any deep-laid plot it contrives to describe every phase of public and private life, showing especially how men and women are almost equally educated and stand on terms of perfect social equality. It may seem strange to some that any race of Oriental women can ever have been as free as are ours to-day. Chinese subordination of women played no part in an aristocracy which was training its daughters to an intellectual emulation that should prove their fitness to be Empresses. The subjugation of

women through feudal violence did not supervene till the twelfth century. The very individual training of the new Buddhism allowed women to essay the spiritual emancipation. Orders of Shingon nuns had been founded even by Kobo Daishi. In 990 the Empress herself becomes a nun and starts an order of retired female popes, parallel with the shaved emperors. It seemed a natural process in this naïvely refined society that men and women who had plunged in youth into social and domestic joys and responsibilities should leave the emoluments to their children and devote their waning strength to the more inward ecstasies of divine vision. Thus, throughout all their strange lives Fujiwara men and women worked on equal terms and indulged most romantic intercourse. All these thousand involutions are revealed to us in the pages of the Monogataris, through which we can know the Engi age as minutely as we can know the material side of Tempyo through the Shosoin Museum.

But, after all, the core of this wonderful life is chiefly explained by its religious enthusiasm. Recent Christian visitors to Japan have observed of this remarkable race that, in spite of modern Confucian agnosticism, they seem to be a people "on fire with religion." This passionate idealism nobly displayed itself in the sacrifices of the recent Russian war. It was the same divine flame, but reddened a thousand years ago with a stronger Buddhist tinge, that made Fujiwara lords and ladies feel even the most gorgeous human life to be only a threshold for an actual spiritual life. This intermingling of social and spiritual interests sounds a key-note. To make and administer sound laws, to effect hospital, charitable, and university organization, to play a bird-like part in the variegated paradises of court and villa, to beautify the person, and flash poetry as fountains do water—was only to play naturally what the gods wished done upon the hardened circumference of heaven, for, after all, the earth is only an outlying province, and the very best of the flesh-bound soul is in touch with the central molten life of Paradise. Thus men do their most menial functions in the very eyes of gods, and there becomes practically no difference between a palace and a temple. The two architectures are the same. The lovely little shrine of Biodoin at Uji, which, dating from the next century, is almost the sole architectural Fujiwara remainder, exhibits

in its corridors and pavilion wings the type of a private villa. Its interior finish of black lacquer inlaid with plates of gold, silver, ivory and pearl realises on earth the flashing splendour of heavenly mansions. You come out of the palace robed in trailing purple mixed with trailing hair, and you enter the palace with the shining pate and the girded Keisa of a nun. This double life permeates the habits and thought of all classes down to the very people. The temple worship of our day, the processions, the banners, the incense, the breathless exaltation of the shrine, all these are only ghostly echoes of the religious passion of Fujiwara.

To realize the ecstasies of the inner vision that alternated with the outer, we must realize the individuality of this worship. It was no mere force of sacrament, no sentimental evangel of brotherhood. The young soul had to win the spurs of its knighthood alone, in struggle, in effort to feel and see, in invocation to the gods to tear his heart open—alone before the altar in his cell, or his own chamber shrine. To pray to the spirit beside your bed was as much a part of life as to sleep. But you entered the holy presence naked, with bared motive, with discounted pretensions. Some one of the great Bodhisattwa was selected by your preceptor as your most fitting guardian presence, and to him, or her, you made your first trembling prayers, sniffing the rich smoke of incense, learning to tinkle in time your gilded bell, and twisting your fingers into the magnetic language of the *in*. You gaze into the white, round mirror on which is painted in Sanskrit the golden breathing "ah-h!" and you watch while its surface deliquesces, expands to an infinite crystal sphere, in which floats the living soul of the deity you have invoked—Kwannon, perhaps, who now is so white that she burns out the dross in you; or Jizo, who melts you into the torrent of his own pity; or Amida, who lets you sit as calm in his sun as if you were an atom of helium; or Aizen, who kindles your passion till it bursts and reveals itself as no-passion; or Fudo, who ties you to the stake, and lights the pyre, and cuts out your heart, and you sip in the glorious pain as if it were a holy draught. These and many more you will see to-day, as you travel through Japan, standing as statues, or niched as painted altar-pieces, in the side chapels of monasteries, under some wayside shed, or still in the chambers of the old-fashioned. Such a motley collection of deities that have glared to the prayers of

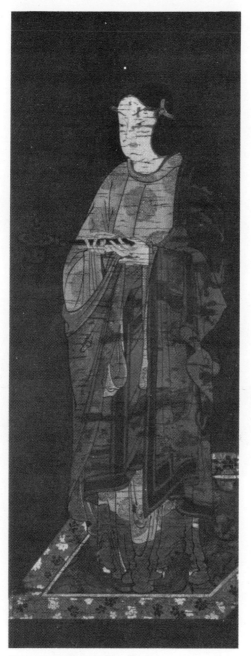

PORTRAIT OF PRINCE SHO TOKU.
By Kanawoka.

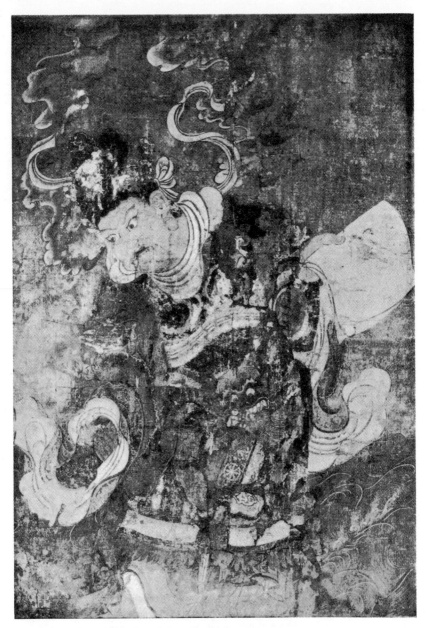

PAINTING IN THE GODOSHI STYLE of Kanawoka of one
of the Shi Ten O, formerly at Todaiji, Nara. Now in
the Fenollosa-Weld Collection, Boston.

a hundred generations is that which I once saw in 1884 in a chapel at Udzumasa, since destroyed. Here you might see the whole Pantheon, seated or standing, gilt or in colour, and before them the small, square lacquered altar, with silver mirror and gilded apex, and four candlesticks which burn lights of four colours, and the small square mat, where you might sit and make of yourself a purged circle immune of the devil.

I say and illustrate all this, not only because we cannot otherwise quite realize the Fujiwara life, in which all men were great priests, but also because in this mutual heightening of the inner and outer vision is found just the very key to the soul of Fujiwara art. The art of the priests in the temples went on much as in the inceptive days of Kobo Daishi; but now in Engi arose for the first time, among the same educated nobles who danced to flutes and sang lyrics to flowers, a class of lay masters who gave their whole professional career to painting, and that chiefly to Buddhist painting. The founder of this new Court order, and the founder of the first professional family of artists, was Kose no Kanawoka, a courtier who was specialized for painting by Daigo, as Godoshi had been in China by Genso. It has been customary for writers upon Japanese artists, whether native or alien, to commence their account with Kanawoka as the "father" of the art. But as we see him he is only the central spirit of the second stage of the second great period of the art. Unfortunately myth has been busy with his name, and it is difficult to penetrate back to his personality. No doubt he was the friend of Daigo, Michizane, Narihira, and the Lady Ono no Komachi. No doubt he shared in all the refinements and passionate enthusiasms of his day. It is difficult also to identify his work, which has come down through later troubled ages as hardly more than a tradition, quite as the Tang Godoshi has come. And in the same way we must try to identify his work by approximation. We can see the kind of excellence that the. whole Kose school arrived at. A large number of very fine paintings have been preserved in temples from the Fujiwara age, and are mostly ascribed to Godoshi by their custodians. If we follow the clue of regarding the very best of these as our best available standard, we shall come the nearest to the truth. For it will not avail here, any more than with the relics of Tang art, to throw away all tradition. As we shall see in a later chapter, the tradition of reproducing and judging

the mystical Buddhist painting finally passed into the hands of the late Tosa school, and from this to its branch, the Sumiyoshi ; just as the professional criticisms of Chinese work fell into the hands of Sesshu, and to the early middle and late Kano. The last Sumiyoshi, Hirokata, who died in 1885, was for years my teacher in Tosa and Buddhist painting, as Yeitoku had been in the Chinese and the Kano. It was from Hirokata that I derived the traditional views of a thousand years.

What sources had Kanawoka from which to derive the elements of his style ? On the one hand he possessed the two priestly styles of Tang, coming down through Kobo and Chishō Daishi's : that is the delicate Mandara style, and the large wired portrait style. He had the inspiration which came from the large architecture and the brilliant decoration of his day. He was a *spacer*. We have it on record that he was chief among the landscape gardeners of Engi. Moreover, the break-up of Tang itself was bringing in refugees from the Eastern Chinese provinces, who doubtless imported some traces of the contemporary styles of later Tang. In 935, during the five short dynasties, men from the coast cities of Go and Etsu arrived with what is called in the record "tribute." This may be only a phrase flourish, or it may mean that in the distracted partitioning of the Tang Empire, those ancient seats which centuries before, in the troublous decay of Han, had furnished immigrants in a quite parallel way, were even anxious to transfer their allegiance from petty tyrants to the great island Emperor. Again in 957 commissioners from Go arrive in Kioto. This is only three years before the happy reuniting of the empire under Sung ; and it may well be that some of the earliest Sung artists had their work represented in importations of that time. But by this time Kanawoka had probably left his artistic inheritance to his sons, Kanataka and Ahimi.

The more important question is how far had the great work of early Tang—yes, even the very central work of Godoshi himself— become familiar to the Japanese of Daigo's day. It had apparently not been closely influential upon Kobo Daishi. But constant intercourse between Kioto and central Tang must have brought in the thick strong pen style of Godoshi along with the poetry of Rihaku and the prose of Kantaishi. The very comprehensive scholarship implied by such a career as Michizane's can hardly have been unfamiliar with such an important ornament of Genso's Court. Rather are we inclined to

believe that Kanawoka deliberately undertook to play something of the Godoshi part to his master of Engi ; and to him we are disposed to ascribe the full naturalization of a strong Godoshi penmanship, and of a strong Godoshi-like realization of his subject. Two theories about Kanawoka's style have apparently conflicted in recent years : one that it was most minute—in short the very hair-thick gold-lined style which we know to have been prominent a century later with Yeishin Sozu ; the other that of the Sumiyoshi's, that the characteristic Kanawokas have a fine thickening Tang line, a little more wiry than Godoshi's but much more masculine than Tang ninth-century work. With the latter theory I agree, merely adding that it is not unlikely that Kanawoka may at times have personally effected a sort of synthesis between these two systems. Painting altar-pieces as he did for Shingon temples, he probably thinned his line without making it effeminate ; but indulging in warriors, battles, and scenes from Hell, he probably employed the most that he knew of Godoshi's powerful lead-line stroke. There is also reason to believe that he knew even of the ink monochrome style of Godoshi and Omakitsu.

Of the pieces which may be reckoned as possible Kanawokas are several strong seated Fudos, with his two doji or attendant boys. Of one of these, a well-known copy by Sumiyoshi shows clearly the Kanawoka lead-lines. Another, in which there is possibly later handling, is the fine Fudo that was first noticed by Dr. Anderson of England at Daishoji, in Shiba of Tokio in 1879, and which is now in the Fenollosa collection at Boston.* The beautiful standing portrait of Shotoku Taishi as a youth, owned by the temple Nennaji of Kioto, has always been believed to be one of the authentic pieces. It expresses a nobility of fine line, colour and expression not to be found in later Tosa work. The great painting of lotoses and wild ducks, which strangely enough has from old days been ascribed to Godoshi by the traditions of Horiuji, its owner, is a most interesting piece of relatively secular work and in almost pure Chinese style. The lotoses are as finely drawn as if in the throne of an altar-piece. It is possible that we have here the direct influence upon Kanawoka of contemporary Chinese artists of the five dynasties, such as Joki.† The relatively free-lined work of Kanawoka is well illustrated by the beautiful Monju formerly in Koyasan, and

* This Fudo was formerly owned by priests at Kamakura and sold by them to Daishoji.
† In Chinese " Hsu Hi."

now owned by Mr. Freer. The ink school is probably represented by the broad strokes and clouds of the great thunder gods and dragons owned by the Anju-in, temple of Bizen, of Kuni Tomi Village. But what I call the Godoshi style of Kanawoka is finely shown in the large and unfortunately much-defaced paintings of nearly life-size Shi Tenno, formerly one of the great treasures of Todaiji in Nara, and now in possession of the art museum in Boston (Fenollosa collection). A head of one of these is here shown, which exhibits the crumbly touch of the broad lead lines, and suggests the deep Titian-like colour of the powerful face. The great sweep of the draperies into the scalloped edges of the Tang cloud is like the great Tang-like militant statues of Nanzen-ji. It was this phase of the Kanawoka style which was carried over to the Shingon temple of Daigoji in Yamashina, where I found the porcelain head, and where a great school of powerful Buddhist painting in the Tang style was inaugurated.

Of Kanawoka's sons a few ascribable designs are extant. To Ahimi was given the fine Chinese Rakan in the Sumiyoshi collection of copies; and Kanetaka may be the author of the great Bisjamon, photographed from the set of the twelve deva in Horiuji of Kioto. Another Bisjamon, of identical touch in the draperies, but of stronger Godoshi-ish drawing in the red devil under foot, is in the collection at Boston. By him too is probably the fine Jizo brought by Mr. Wakai to Paris, and reproduced in M. Gonse's "L'Art Japonais." This was formerly in the pope's temple of Enriakuji on Hiyei-zan. This grouping of the twelve devas is a new Buddhist subject brought in with the Shingon sect by Kobo Daishi, and soon popularised in Japan. Many of our old friends appear here in other dress, as this same Bisjamon, the Sun and Moon spirits, and the deva of Fire and Water. The pictures or statues of these twelve are required on the occasion of a baptism in the Shingon sect; also a screen is required, which shows an old-fashioned coloured landscape, the idea apparently being to sit in the presence of Nature. One of the oldest of such screens, now at Toji, may possibly be by Kanetaka. It shows hills and trees in solid green, the trees drooping in the old Chinese Tartar style, something between the trees of the Shosoin screen and later Tosa landscape. This quality of landscape, hardened a little by gold, is also found in works by the grandson, Kose Kanemochi. The Benten in Boston is one of these. In the garden background we probably

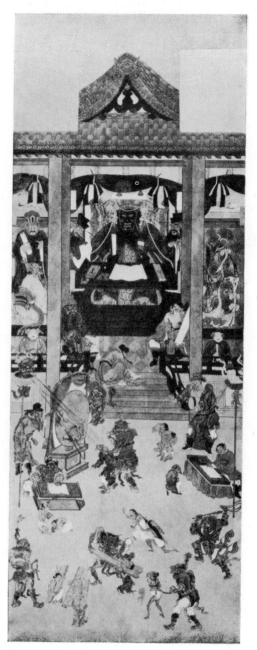

ONE OF THE HELL SERIES
"EMMA'S JUDGMENT." By Kanawoka.
Copied by Hirotaka Sumiyoshi.

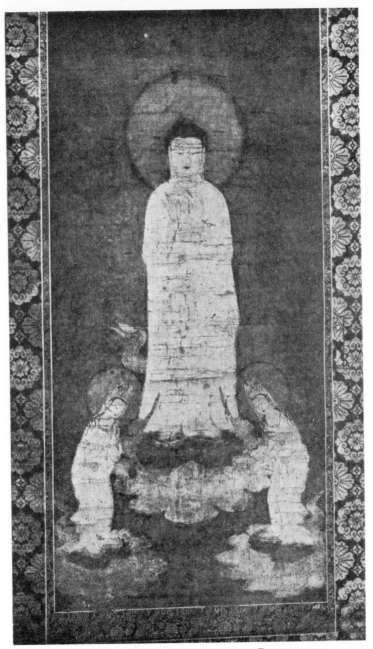

A BUDDHIST TRINITY: AMIDA WITH ATTENDANT BODHISATTWA
KWANNON AND SEISHI. By Yeishin Sozu.

see something of the style of Kanawoka's gardens. Kanemochi also is said to have left one or two secular designs of Fujiwara life.

The great-grandson of Kanawoka, fourth of the Kose line, and the best known after Kanawoka, put more delicacy, grace and realism into his work. His Jizos are very delicate and noble in feeling. (One in Boston.) His Monjus and Fugens are in many places. In short, his style becomes an imitable type—a sort of fixed Kose type for the Fujiwara remainder, in which it is hard to distinguish the master from his followers. Of his semi-secular works is the screen painted with scenes of Court dancing in colours. The musicians in gorgeous costume sit with drum, fife and sho-o at the back before a heavy curtain. A large mass of Hiyei-zan monks, muffled with white to their mouths, stand about on the right. Doubtless they are fully armed beneath their free grey robes. There are ferocity and determination in the small exposed parts of their faces. In the centre dances a young boy, dressed probably in ancient Chinese costume, and with a long white train curving on the ground. But the greatest work of Hirotaka is the remainder of what was once a series of 60 large paintings showing the doings of beings in "The Ten Worlds," still kept at Raikoji of Sakamoto. These are very varied in subject, for the scenery includes Heaven, Hell, the animal world, the world of deva, of elemental spirits, of ordinary humanity, etc. This appears a splendid chance for realistic work. The best of those which have not been lost or destroyed deal with scenes from the many parts of the Buddhist Hell. The splendour of fire, the gorgeousness of the panorama, where green and red devils actually are shown keeping up the fires by shovelling in great black lumps that can be no other than coal, perhaps reflect a weak tradition of what Godoshi did with a similar subject on the walls of Changan. The piece which we here reproduce is the upper portion of the judgment hall, where Emma, the king of Hell, sits horrible, red-faced, listening to the incriminating evidence dished up for him by clerks and attorneys. The scene quite mirrors an ancient Chinese Tang court of criminal justice. Below the steps is the magic mirror which reflects truly the heart of the accused, whatever be his verbal defence. Here one of the attorneys points in glee to its testimony of murder, while the victim crouches at the foot of the steps. Below is the courtyard where condemned prisoners are being dragged away or tortured. The style

of drawing and colouring here is a fine Chinese of Tang, translated into a growing Kose formalism. In the scenes of human life and strife, such as for instance the armoured knights in the battles of Hell, the movements of horses and the fleeing of peasants, we have a first suggestion of the kind of moving composition which will become familiar to us in the next chapter as "Tosa." But the movement of the brush is much stiffer than that of Tosa, the limbs and armour being as precisely drawn in fine modulated line as if it were part of a hieratic altar-piece.

The tenth century went out without any decisive modification of the Fujiwara *régime* at Kioto. The Emperors were mostly puppets, the Empresses mostly the daughters of the dominant house. The type of culture was the relic of what had been learned from Tang more than a century before. For Tang had now long fallen, and the Sung come in ; but as yet the Sung, far more restricted in empire than the Tang, was more concerned in consolidating its conquests at home than in communicating with outlying peoples. The danger of such a state is a threatening stagnation. Poetry begins to show weakness and repetition. The Monogataris are poorer ; painting more effeminate. The growing luxury of the ruling caste is breeding personal ambition and mutual jealousy. Revolts, like the rebellion of Masakado, have to be put down. The priestly estate is becoming unruly and jealous of its pampered allies. How carefully was maintained the vicious circle of the Fujiwara tyranny is proved by its prohibition of all intercourse with the new Sung powers of China. It was afraid of new and liberal ideas. The Sung men were reported to be free-thinkers. On the one hand, in 1034, Japanese students in the Kioto University were being forced through examinations in the Confucian classics. By 1069 Chinese students in the Kaifong University of Sung were being prohibited from the use of Confucian classics by order of the great reformer Oansaki. What an anomalous change of positions. One of the Japanese nobles, curious as to the other world's doings, attempted to escape to China in 1047, was apprehended, and banished for his audacity to the island of Sado.

But nature never stands still, and it is hard to make man do so either.

Forces were already at work to disrupt Fujiwara, such as the gradual rise of a military class. Armies had often been raised and officered by Fujiwara partisans ; but as these armies became a standing force to

operate against the barbarians of both North and South, their general, though nobly loyal, came to possess hereditary power. The Taira family of generals had been founded as far back as 889. The rebel Masakado was a Taira. The Minamoto family of generals came about 100 years later.

The complicated and expensive ritual of the dominant Buddhist sects, and the growing worldliness and ambition of Enriakuji, led in the early eleventh century to several attempts at simplifying the religion— making it more popular, bringing it home to the hearts of all men.

This was the work of several Tendai priests like Eikwan, who started the movement to make the worship of Amida dominant, a movement which eventually became a separate organization in the Jodo (free land) sect. The paradise of Amida was no new thing in either China or Japan. The whole miracle play of Taimadera had been based upon it in the Nara days. But earlier representations had been woven or painted in elaborate colours only. Now the mystic vision of the reformers wished to discard the elaborate rituals of Fudo and Kwannon and focus all force into the invocation of the central Amida, the Buddha of boundless light, who was seen in ecstasy as a form of dazzling light, surrounded by a gorgeous company of Bosatsu, all equally luminous. Such light—curiously like what the neo-Platonists of Alexandria say of the luminosity of their vision—was too intense for colour ; nothing but the splendour of gold could suggest it—gold not only in the flesh, but in the draperies down to the last detail of pattern. The movement was only an intensifying of the mystic tendencies of the age ; but it led to something of a new departure in art. The growing effeminacy of Tang line could now be erected into a new canon ; for brushwork cannot thicken freely lines made with gold paint. Moreover, the method was rather of applying the gold in finely cut strips by glue, or of painting fine lines in glue and affixing the gold leaf. The figures were to be rendered more worshipful by an incredible suggestion of delicacy, rather than of power through delineation. It was in some sense a return to suggestions of the fine line gold Mandara figures of early Tang ; but those had always been done with a brush filled with gold pigment, and were hardly more than outline. In another sense, it was a kind of return to the delicate hair lines of Nara painting. In any case, it was a distinct reaction against the alien Chinese feeling of early Fujiwara, a mixing of national elements, a school of real Japanese

art arising at this end of the Fujiwara *régime*. It is this which has been in later days dignified by a significant name, the Yamato school. It must not be supposed, however, that there was any violent change, or that Chinese elements were really discarded. Japan never makes a complete change of any sort. She always recovers herself and unites organically past with present.

The new school of art was really led by another great priest, Yeishin Sozu, who possessed at once a childlike belief in the truth of his own visions and a pictorial genius adequate to fixing them as a revelation for others. In this respect he is not unlike our own Fra Angelico of San Marco in Florence. And, curiously enough, their almost identical visions of the angel host are drawn in lines of similar delicacy and dominated with gold. Yeishin generally used more gold than Angelico; though other artists of his day mingled colour in nearly Florentine proportions.

Examples of Yeishin's work are not so rare as Kanawoka's. His favourite subjects are the Amida golden trinity, Amida's descent in glory—Amida's paradise—the happy life of the musical angels. One that was probably quite new with him is the appearance of the Amida trinity as colossal suns rising over the edge of the Eastern mountains. There is a superstition yet existing in Japan that on a certain night in August true believers in Amida can see this effect with their mortal eyes; and it is said that in remote places crowds sit up the night for it—gazing with possibly self-hypnotic eyes into the luminous East.

A fine front Amida trinity by Yeishin is here reproduced. The attendant Bodhisattwa, Kwannon and Seishi, bend graciously at either side of his feet, as if to invite his arrival. The gold is so evenly distributed in microscopic pattern as to present in small photographs an almost continuous blaze. A fine radiation of light from Amida's body is rendered in thin gold pigment over a dark blue ground. Another fine trinity, two-thirds turned, is in Boston. Chionin in Kioto is one of the great temple centres of this Jodo worship and possesses several fine examples; as the great descent of Amida and his angels in an expanding fan-shaped cloud sweeping across the face of Hiyei-zan, spotted with cherry blooms, toward the little pavilion in the corner where Yeishin has naïvely depicted himself as sitting. It is a vision of great originality in spacing,

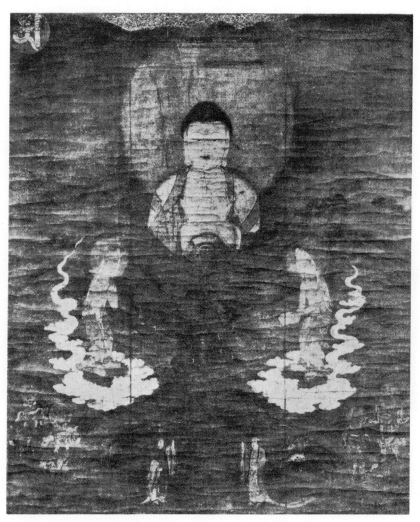

SUNRISE AMIDA. By Yeishin Sozu.

TEMPLE OF BIODOIN.

and of a new splendour in gold and colour, wherein the Chinese element is almost obliterated. The Japanese foliage of the mountain side is drawn realistically, in a style half-way between Kanawoka's gardens and Tosa landscape. The angel panels, hinged for shrine doors, remind us strongly of the musical angels of Angelico on the gold doors at the Ufizzi. Gracious figures they are, of childlike happiness and innocence. The most splendid sunrise Amida is the famous triptych of panels in Kin-kui-kio-miyoji Kurodani of Kioto. Here the pure oval type of Yeishin at his best is conspicuous. To the actual cord that issues from the Amida's gold breast many Emperors, famous warriors and great priests have died clinging. Before its majestic purity even the foreign spectator is hushed into a kind of awe. Another sunrise with more elements of colour is in Zenrinji, Kioto. Here the two Bodhisattwa have already crossed the mountains to welcome from the front the rising Amida; and a whole congregation of spirits, led by two small queenly figures in the foreground, throng through the valleys below.

This new movement in art led, about 1000, to the separation and firm independent founding of two professional Buddhist schools that would otherwise have remained branches of the Kose. I refer to the Kasuga and Takuma families. The early work of the latter is not very easily identified; but we know that the whole interior of the lovely shrine at Biodoin, already referred to, and which was built in 1051, was painted by Takuma Tamanari. These show visions of life in Paradise, but are mostly defaced. The real splendour is in the unspoiled ceiling and baldachin, whose inlaying has been already described as typical Fujiwara luxury.

The Kasuga school, said to be continuous in family blood with the late Tosa, was founded by Motomitsu, whose work seems so closely affiliated with both Hirotaka's and Yeishin's that we are almost bound to believe him at first a Kose pupil who learned closely to follow the vision-seeing priest. The family name Kasuga probably denotes that he officiated as Court painter to the much patronized Shinto shrine of that name in Nara. A fine example is his enthroned Kwannon in Toji, where the halo is made up of inlaid lozenges of gold. The delicious minute tracery of his gold draperies, as also of Yeishin Sozu's, is exemplified in the fine Amida of the panel triptych at Boston. The gorgeous twelve paintings of the Juni Ten at Jingoji

of Takawo—one of Kobo's picturesque foundations—I have ascribed to him. Here the colour, gorgeous yellow-greens and oranges spotted over deeper oranges and purples, is a new expanded glorification of the sort of colouring found on the new Tempei painted altar-pieces. Here there is again exemplified that semi-conscious return to Nara art as a pre-Tang native type suggested by such names as "Yamato" and "Kasuga." Motomitsu is also said to be the author of a secular painting of wrestlers, and has no great merit.

But one of his most striking works is the unique profile view across some of the pavilions of Amida's gardens, owned by Mr. Freer. Here we get an added suggestion of the light Fujiwara architecture ; here outlined in gold. The little gold figures of the trinities sit about on the floors receiving as guests their angel friends, or work and teach at the open casement windows of the upper storeys. Now they take a walk down the fine curves of the garden, or stoop at the edge of a pond to pluck the gold lotoses.

Others of the Kasuga family are the priest Chinkai—noted for his Monjus—the inheriting son Takayoshi, and the grandson Takachika. By Takayoshi, or some unidentified pupil of Yeishin, are the best of the great gold and coloured Paradises owned by Chionin. The style is not so free and naïve—full of unexpected line feeling—as with either Yeishin or Motomitsu. The crowded figures are more based upon the hieratic Nara traditional composition, which was itself based upon a pre-Tang original of about the year 600.

The third generation, Takachika, shews a decidedly weak effeminacy in even this late Fujiwara movement. His line is reduced to the finest hair's-breadth, his faces are like dolls', their eyes and mouths being drawn with single microscopic lines. Yet the gold in his altar-pieces, and the over-delicate colours, as in his Fugen at Boston—seem more like a film deposited by the breath than by any kind of handwork. The famous illustrations to the Monogataris by him, showing a secular painting of Fujiwara life in its last stage of weakness, are more cele-brated for their naïveté and historical interest, and for their delicacy of colour, than for the beauty of their figure drawing. It is a pure convention which makes the thin black stream of a woman's hair flow down the sides of these dolls ; but their charm was great enough to influence the late Tosa art of such a remote age as Tokugawa, and even the art of Korin. In short, the decay of Fujiwara art implies a

complete break-up of the tradition of at least a noble form and pro-
portion that came from early Tang. Now, as in Takachika, the figures
may be but seven heads high ; in contemporary Takuma they may
rise to eleven and twelve. The Chinese key even to the Japanese
efflorescence is lost.

But before closing this chapter it is necessary to refer to a very
interesting revival of sculpture which accompanied the late Fujiwara
renaissance of Yeishin in painting. Of course, sculpture, the pre-
dominant art of the Nara age, had never wholly died away, for there
was always some demand for wooden altar-pieces. These at first, as we
have seen, tended to follow Tang models. Later, during Engi, we
find occasional carved Buddhas based evidently upon the semi-Japanese
proportions of Kanawoka. But these are exceptional ; since the very
inwardness of the new visional worship led to small altars before which
the neophyte dreamed, entirely different from the vast spectacular
platforms covered with statuary of the Nara day. In Shingon and
Tendai—still more in Jodo—the altar tends to be only a separate
receptacle for a central closed shrine, with space for candlesticks and
vases. Even these became relegated to a table in front of the shrinking
altar. So no room was left for large statues. However, in the days
of the Yeishin revival there was a thought to get back to Nara
sculpture, though in smaller pieces ; to have a Yamato school in statues
also ; and elaborate altars were prepared with smoothly carved gold
Amidas, to take the place, at times, of the painted altar panels. A
great sculptor too arose, contemporary with Hirotaka and Motomitsu,
who lent genius to the school, namely Jocho, who left behind him a
tradition parallel with the waning Kasuga. Jocho is the first great
sculptor of lay origin, as Kanawoka was the first professional painter.
Though he went back to Nara for some of his types, he modified
them, no doubt to conform with the more rounded proportions of the
deities painted by Yeishin. Typical of his work is the profile Amida.
It is dumpy and sleek as compared with Yakushiji bronzes, but sweetly
peaceful and sleepy. It is well to note here that the great gold
Amida statue in the centre of the Hoodo of Biodoin, as well as the
Gothic flame halo—all covered with gold—is the work of Yeishin
Sozu, working as sculptor in the style of Jocho. The fine set of small
militant figures, imitated with changes from eighth-century Yakushi
generals, and kept in the Tokondo of Kofukuji, is by Jocho. In

the best of these is seen some of the finest action in Japanese art. The general in helmet gazing down his arrow to test its straightness is almost as fine as the clay Shi Tenno of Kaidendo. In the fine proportion and action of these figures we see reflected the best features of Kose drawing, derived from Kanawoka. Still more in the manner of Hirotaka is the fine carved pocket shrine with opening covers showing in high relief Monju riding sidewise on his lion. This is, perhaps, by a pupil of Jocho. Another one of the very late Jocho's sculptures is the violent action of a stamping devil with a spear.

Just here we should perhaps notice typical Fujiwara bronze work in the mirrors with fine flower and butterfly patterns and the inlaid lacquer of stiff scroll design. There the gleaming plates of pearl well illustrate on a small scale Fujiwara interior decoration. Other wooden utensils of the day are painted in similar scrolls.

CHAPTER IX.

FEUDAL ART IN JAPAN.

Kamakura—The Tosa School.

IF Hegel's theory that all forms of existence tend to pass into their opposites needed historic confirmation, a better example could not be found than what happened to Japanese society in the twelfth century. It is as if a cataclysm had suddenly set a new Japan at the antipodes of the old. The revolution of 1868 which destroyed the Feudal system was more rapid indeed, but not more decisive than the one of seven hundred years earlier that inaugurated it.

Yet, as in all such strangest extremes of change, the causes were natural, weighty and cumulative. No phase or school of art in human society, however beautiful, but contains within itself the germs of its own destruction. The longer and finer it has been, the more violent becomes the disruption, the more striking the reaction. So with the ultra-refined aristocratic idealism of Fujiwara : in spite of its beauty, its culture, its power, its cunningly devised alliance of the ruling estates, it could not master, tame or fully allow for that unruly demon of selfishness in man, who when he finds forms inconvenient incontinently smashes them. With all its benefits to the land—its proposed peace, its unique enlightenment—this *régime* had been, after all, the selfish aggrandizement of a single noble clan. So long as great men could rule that clan it bade fair to rule the world. But if as the clan expanded dissensions should arise among its members its power would quickly totter. As a fact, some small dissensions began as far back as the tenth century. In 939 Fujiwara Sumitomo had revolted against his fellows, but had been quickly put down. Through the rest of the tenth and through most of the eleventh centuries the system reigned supreme. It had to encounter,

however, the growing opposition of the religious estate. The priests of Enriakuji, forming an army in themselves, sometimes came down to the Kioto civil court to interfere and threaten. The causes of dissension were religious as well, and there were battles between the hooded monks of Nara and Otsu. In 1113 the temple-castle of the Tendai popes upon the hill declared war upon Kioto, but suffered defeat. In 1143 the Nara priests, following the cue of one of the Fujiwara factions, attacked and burned Enriakuji. The Enriakuji armies retorted by burning the entire city of Otsu.

The whole first half of the twelfth century was thus filled with omens of decay and disaster in Kioto. The Fujiwara factions, divided hopelessly, called in not only the mountain priests, with swords hidden under their robes, but undertook to throw the Imperial estate into the melting pot by setting up rival emperors as figure-heads for each; thus splitting the whole nation with the crevasse of a divided loyalty. This happened in 1157, and it was now necessary for the standing armies and their generals, who heretofore had held themselves loyal to the Fujiwara civil ministers and the Imperial seal which they wielded, to choose sides. In fact the Fujiwara of both sides, enervated by centuries of luxurious and peaceful living, were far from erecting themselves into adequate warriors. They were rather like the astute politicians of fifteenth century Italian cities, who employed mercenaries to do their fighting. And it now, indeed, became a matter of life and death to the leaders who could offer the largest bribes to the ablest generals. In the great civil war of three years that ensued—called the Hogen Heiji war—both sides fought with the ferocity of rankling family feuds. Kioto became a cockpit, with the centre of operations now on the flanks of Hiyei-zan, now in the Western side of the valley. The palaces, the wealth, the books, the temples, the treasures of art—the luxurious and æsthetic institutions that had accumulated through peaceful centuries— were now almost as suddenly and utterly swept away as was San Francisco in her three terrible days of earthquake and fire.

The sanguinary quality of these campaigns and the nature of government power which soon built itself upon the ruins of the Fujiwara has now to be explained in the new factor of the standing military, which would seem to have had no legitimate footing in the complicated circle of the oligarchy. In early Nara days there had existed no separate class of soldiers. From the age of Jimmu Tenno downward the army was

theoretically the whole nation, just as it is with the semi-savage hordes of the Pacific Islands. The emperor was their natural general first of all—a great war chief—who only gradually, and hardly before Kwammu's time too, took on much of Chinese Imperial isolation. It was the very cordon of Fujiwara courtiers drawn so tightly about the emperor that quite obscured his military function and made it necessary, for purposes of local campaigns, to appoint substitutes in the persons of national generals, subordinate to their civil administration. As vast cities rose, too, with the industrial classes; and as the fields of disturbance—wars chiefly waged against the half-subdued tribes of North and South—became located farther and farther from the populous centres, it became imperative to organise standing armies under these generals, who should live permanently near the frontiers, without the necessity of difficult marches through hundreds of miles.

Such a general indeed had been appointed in the very first years of the new Heian capital, by the need of making a tremendous effort to dislodge the still powerful Ainos of the East, who held the mountain passes about the base of Fujiyama. It was these primitive inhabitants of the land who had been heirs of many of the Pacific traditions and arts, and in the already conquered provinces had contributed relics and names to their western congeners with whom they amalgamated. But few dwellers of the Yamato race—Corean, Malay or both, and perhaps at first not so superior to or different from their despised predecessors—yet lived in the dark East and North. So Tamura-maro received for the first time the title of " Sei-i Tai Shōgun," "great barbarian-conquering general," which title was held by the Tokugawa Shoguns at Yedo, down to 1868. He conducted a successful campaign for eight years, in the course of which he seized and opened the great Hakone mountain highway to the fertile plains of the North East. One of the great dramas of the later No is based upon his deeds.

In 854 and 857 there was further trouble with barbarians on both the North and the South. The inhabitants of Lower Kiushiu and even the island of Tsushima were in some kind of revolt. It does not clearly appear who these Southern barbarians, often spoken of, were. That they had affiliation with people from China seems clear from the fact that their armies were sometimes reinforced from the mainland. They were probably the remains of primitive races, officered by Chinese refugees or pirates. Even hostile parties from Corea are said to have

come over in 894. There was fighting with Coreans again in 935. By 994 the troublesome bands in various parts of the empire are called, in the annals, "Robber Western Barbarians"; they invaded Japan in 999. In 1020 it is expressly said that barbarians from the South East of China attacked the province of Satsuma. In 1091 the enemies against which the armies proceed are officered by Japanese generals who have revolted from Fujiwara allegiance. In 1135 the enemies are spoken of as "pirates." And by this time, too, the Northern armies were encamped far up beyond the plain of Musashi in the mountain depths (Oka). It was the possession of the Eastern plain, doubtless—the granary of Japan—which overthrew the Aino power, made it possible for the soldiers in the intervals of fighting to till the fertile lands and store up supplies for later campaigns, and eventually gave the preponderating power to the Northern generals.

But the Fujiwaras had been shrewd enough to create several families of generals, each to be held in a sort of clan bond with hostages at Kioto, and whose individual members should enjoy only limited commands. Prince Takamochi had been given the family name of "Taira," as far back as 889. Taira generals descended from him ruled in the North. One of them, Masakado, who held court near the present site of Yedo, then a wild swamp in a province but recently conquered by Tamura, became so impressed with his far and independent sources of wealth that he actually revolted, not only against his Fujiwara overlords, but against the Mikado, calling himself an independent Emperor. This is said to be the only case of such supreme treason in Japanese history; a fact probably due to the enormous advantage of the Mikado's divine (Shinto) descent, which could be much better utilized through craft than assumed or ignored. Other generals, some of them Taira, more loyal or more politic, defeated and killed Masakado. Strangely enough, his spirit is still worshipped as the Shinto deity, "Kanda Miyojin," in the heart of modern Tokio.

In the last years of the tenth century a general of the newly-prominent Minamoto family, Mitsunaba, had supplanted some of the Taira in the North. In 1051 the beautiful shrine of Biodoin was built by Minamoto Yorimichi, who now took rank, though so near Kioo, as a powerful noble. It was at this time, between 1053 and 1066, that the rising influence of the two families, Taira and Minamoto, brought them into something like rivalry. At the same time,

in spite of Fujiwara precautions, the power of each family tended to centre in a single clan head. The loyalty of the junior members of each house and of their soldiers, half agricultural, half campaigning, became hereditary, because a necessity in the petty trickeries and conflicts that were arising. It is not strange that the half-wild soldiers, cut off permanently from the traditions of city life and only dreading the strange far-away name of Fujiwara, sharing the perils of campaign with their trusted leader and in times of peace receiving largesse from him out of accumulated stores, should come to have their loyalty take on the intensity of a passion. It is just here, and especially in the camps of the Minamoto, who had come to hold the whole North-East, that first arose that code of exaggerated feudal loyalty and honour that five centuries later played such a brilliant part in Tokugawa legend and character. Through centuries it hardened into an institution and love, like the almost insane love that Napoleon's soldiers felt for their semi-detached campaigner in Italy and Austria.

Such was the unstable state of the armies and their generals when the bitter feuds among the Fujiwaras called them in as decisive factors in 1153. There had already been causes of growing enmity and rivalry between the two clans of leaders. Minamoto Yoriyoshi, who had spent all his life in baiting Tairas, had died in 1082, and his still greater son, Yoshiiye, had been sent by a Fujiwara minister in 1091 to put down two rebellious Tairas.

The Tairas then tried to turn the Minamotos against each other. Yoshimitsu had become the single head of the clan before 1127. But just here the head of the Taira house, Tadamori, rose into great prominence by his brilliant and successful campaign against the pirates of the South-West in 1135. Kiyomori had become his successor as head of the Southern armies in 1153. Yoshitomo had become the hereditary leader of the Northern Minamoto in 1127. As a crisis drew near in Fujiwara dissensions both of these ambitious generals, smarting with several generations of heated rivalry, began to assemble the pick of their troops to the neighbourhood of Kioto. When the crash came it was they and their captains who let the violence of their civil campaigning derive far more from professional hatred than from any real loyalty to the Fujiwara factions who paid them, or to the puppet Emperors which it became their respective

policies to acknowledge. Thus it was that when the holocaust of
Kioto in the Hogen Heiji war ended with the triumph of the
Taira's employees, it was not the Fujiwara remnants who found
themselves reinstated in the old family power, but a new military
tyrant, Kiyomori, who for the time used his noble patrons as his
puppets, just as they were using the Emperor. Minamoto Yoshitomo
was defeated and killed, and his retainers dispersed in flight to their
seats in the far North. Kiyomori began to rebuild Kioto, and as
military dictator devise new laws for its governing. The puppet
Emperor of the Fujiwaras died in 1165, aged only twenty-three,
and his successor immediately made Taira Kiyomori prime minister,
thus elevating him over the heads of the Fujiwara. In 1171 Kiyomori
married his daughter to the Mikado as legitimate Empress. Thus a
general of the army, lawless and uncultured, had learned to play the
same political game taught him by the cultured Fujiwara, in whose
hands, indeed, it had been less disastrous to the nation. In 1179
Kiyomori had banished the old ex-Emperor, Go-Shirakawa, who had ruled
before the Hogen Heiji *débâcle*. The Fujiwara were thus reduced to
a handful of clerks, and Kiyomori and his family enjoyed the sweets
and splendours of power in peace at Kioto for twenty years, from
1160 to 1180. In this time they borrowed much of external cul-
ture from their enemies, built fine palaces and wore rich clothing.
This intermediate age can be called the age of Taira domination.

It is now important to question what had become of the fine
arts of Japan during the last stages of Fujiwara weakness, and during
the Taira ascendency. The connecting link is the secular painting of
that last Kasuga artist of the Fujiwara, Takachika, of whom we spoke
at the end of the preceding chapter. He gives us pictures of this
over-ripe society indeed—but in a formal weakness as decadent as
the reality. What particularly contrasts with the powerful times to
follow—in fact, the work of his own sons—is the minuteness
and absence of all dramatic instinct in his hair line. It is beautiful,
but forceless. It breathes an atmosphere, but one that is of incense
and calm waiting. With what a shock the " Prætorian Guards " of
Minamoto and Taira must have burst into these sleepy precincts.
Their tough swords would have cut such flesh like cheese.

The real founder of a new style, that strikes just an antipodal
note, was the priest Kakuyu, better known by the title Toba Sojo.

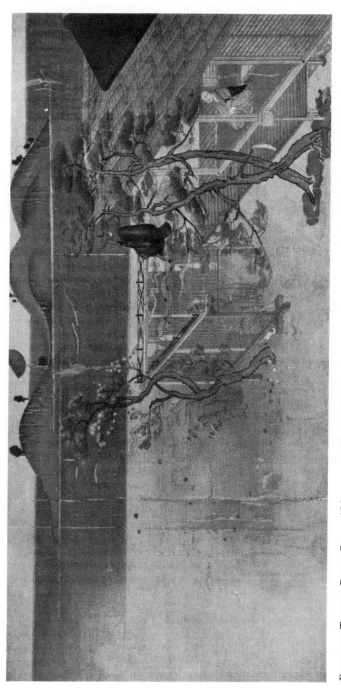

From the Twenty Rolls Called "Miracles of Kasuga."
By Takakane.
Owned by the Imperial Household of Japan.

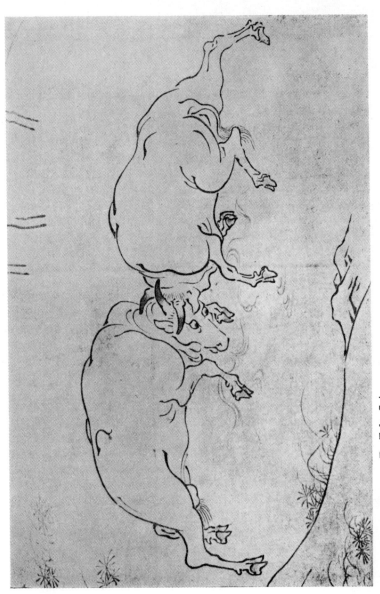

BATTLE OF THE BULLS. By Toba Sojo.

He could look at all this Imperial ruin falling about him and laugh. He it was who determined to relieve the dire distress of the Emperor Toba-in* by making panoramas of humorous sketches, largely of animals—horses, bulls, dogs, frogs and goats—acting as if they were human beings. Doubtless some sting of Buddhist satire lay behind the seeming joke. The work was dashed off in almost pure line, but with a racy vigour and sweep of motion that make it live. A number of rolls of these historic drawings are preserved in the little temple of Kozanji among the hills to the north-west of Kioto. These are reckoned among the great treasures of the Empire. We reproduce here the famous "Battle of the Bulls," which illustrates well Toba Sojo's extraordinary power, and seems, in spite of its simplicity of line, to realize the utmost impression of shock.

What this new work actually accomplished was something like half a dozen revolutions. It is the real beginning of secular art in Japan, as opposed to the religious forms, sculpture and painting, with which alone we have been engrossed so far in this work. It is the first important display of humour since the decadent statues of Nara. It employs bare black and white instead of Takachika's illuminated colour. It gives us an absolutely new line, flexible like the Buddhist, thickening like Godoshi's, yet as far removed from lead lines as flesh is from metal. It infuses juice into Takachika's delineation without becoming abstract penmanship.

What it does is to give us flexibility of muscles in action; and here is one of the greatest of the revolutions—*motion*. The mystical Buddhist art gave us splendid poses, the suggestion of freedom to act, especially in Godoshi, Ririomin and Kanawoka. Still, upon the whole it was a statuesque art, dramatically grouped, yet with severe dignity. But Toba Sojo has thrown dignity to the winds, yet gives us a full impression of life. In all these points he foreshadows qualities that are to become dominant in a new school for the next two centuries.

Another important work of Toba Sojo is the "Shigi-zan Engi," kept in the temple on the top of Shigi mountain in Yamato, to the north-west of Tatsuta. This, too, is humorous, narrating the miracle by which a whole storehouse full of rice is said to have been carried

* The name of this Emperor while reigning was Sutaku [PROFESSOR PETRUCCI], after retirement he was known as Toba-in.

up through the air to the needy abbots during the time of a siege. Here we get the wonderful crisp short stroke of the coming Tosa, done with a soft yet free pen, in human figures and their draperies. The efforts of an aged, fat Fujiwara lord to mount his horse are humorous indeed.

The other chief innovator, who worked at first in Kiyomori's time, was a scion of the hitherto reigning aristocratic house, Fujiwara Takanobu, who, like so many of his relatives, is found in this and the succeeding age ready to turn fine education and ripe talents to good use in earning a living. These threadbare nobles, whose ancestors had been the literary lights of ages, writing for power, fame or imperial patronage, now had to set to in earnest, and pen it away for daily rice. It is only fair to say that they did it with such fine dignity as to win new encomiums from their rivals. The tales of these poor " kuge," emperors and nobles alike shabbily neglected by a new brutal race of lords, afford one of the chief romantic motives of the middle ages, in story and in plays.

Takanobu's work is rare ; but one of his important pieces is the elaborate set of large paintings in the Boston Art Museum, narrating the whole romantic life of Shotoku Taishi in separate dramatic scenes. This set was the most important heirloom of the Sumiyoshi family at the death of its last patriarch, my teacher Hirokata, in 1885. To save it from the possible wrangling of heirs, and to leave ready money to his estimable widow, he, on his death-bed, sold it to me. His signature, painfully affixed to the receipt, is treasured by me as his last autograph. It is only next in importance to the Keion roll, in the Tosa paintings of the Fenollosa Collection. It was regarded by generations of Tosas and Sumiyoshis as the typical example of Takanobu in Japan.

In its drawing of hundreds of men, horses and other animals it is not so racy and free as Toba Sojo's, retaining something of the stiffness displayed by Kose Hirotaka in the secular portions of his " Scenes of Hell " at Sakamoto. But the strokes are softer and freer than the latter, less like a design in wonderfully graded wires, flowing together more like small and continuous streams. The action and grouping are both striking, and a new special effect is produced in the individuality of the faces. Here no trace remains of Chinese Buddhist countenances, as found in Kose ; rather it is the every-day type of

Japanese countenance, veritable portraits, as seen about him in the Kioto streets. The effect of realism is further enhanced by the revolutionary convention of discarding all attempts at archæological accuracy in costume. To reproduce the dress and armour of his vivid exciting days was enough for Takanobu, even though his subject reverted to six hundred year old scenes. In this innovation he is followed by the whole line of Tosa artists. He has retained colour in this work, and, unfortunately, the use of silk, the frailty of which has led to some defacement. The landscape backgrounds are a naturalistic modification of the Kose, as found in their Japanese altar-pieces : green and blue mountains in free running strata—as may be photographed to-day in Kioto suburbs—and fine curving trees of purely Japanese varieties. In this respect of landscape, also, Takanobu is the forerunner of Tosa.

But perhaps Takanobu's greatest contemporary fame was found in his portraiture. With a few telling lines he could bring before us the very individuality of the passing notables. A group of such portraits on silk, large seated figures, is still kept at the temple Jingoji in Takawo, one of Kobo Daishi's erections. Of these the most important, historically and æsthetically, is the only great authoritative portrait of Minamoto Yoritomo, the son of that Yoshitomo defeated by Kiyomori in 1160, and whose unique deeds in the age that immediately supervened we have now to narrate.

The Fujiwara had been overturned and the rude Taira had supplanted them. Very well, then, we are perhaps on the verge of a new and modified court age at historic Kioto. So, no doubt, thought the Taira lords who were giving themselves up to unwonted dissipation. But it was a short and vain dream. There was an eaglet abroad, two fledglings in fact, escaped from the Minamoto nest which Kiyomori had thought to annihilate. When Yoshitomo and the flower of their clan fell, his wife, the famous and beautiful Tokiwa Gozen, with her two little sons Yoritomo and Yoshitsune, fled from the environs of Kioto and tried to make their way to the fertile plains still held by her friends in the North East, and where she knew the education of those who should avenge their father would be in safe hands. Kiyomori had already issued an edict of proscription for the sons, whose family valour he knew he would some day have reason to fear. Spies were hounding them past Lake Biwa and through the central mountains.

Then it was that the devoted mother made that supremely romantic sacrifice of Japanese history: of diverting Kiyomori's attention from her fleeing boys by offering herself as a mistress to her husband's slayer. The ruse succeeded, and Yoritomo, with his younger brother, spent the twenty years of Taira domination in their family fastness of the far North, nerving to extraordinary deeds their young arms and souls and consolidating and replenishing the scattered wealth and power of their once conquering clan. There were Tairas who foresaw what was coming and tried to prepare for it. But the majority of them were given over to the luxuries of the day and minimized the danger of attack from so remote and barbarous a region.

There is no space for me here more than to hint at the amazing series of terrible events which convulsed now not only Kioto but the whole of Japan, between 1180 and 1192. The Hogen Heiji war had been child's play to it. It was now civil war on a national scale, waged in unheard-of bitterness, and for enormous stakes that were now fairly estimated by both contestants. It was playing not only for the wealth and power of the hopelessly lost Fujiwara, but for a new Imperial organization ; a contrast between the ancient West and the newly arisen East : between Chinese city institutions and the purely Japanese feudal life of the camps ; between prescribed ceremony and priestly formula and the rude individuality of the sword-wielders ; between town and village ; between the reign of law and the reign of life. Yoritomo founded his new capital of the North East at Kamakura, on Suruga Bay, not far from the base of Fujiyama, from which he could direct naval operations, as well as the Hakone military road it commanded. His brilliant brother Yoshitsune and his uncle executed a rapid series of campaigns which eventually gave them Kioto. The Tairas retired in hasty caparison to their great sea-stronghold near the present Kobe—where a great naval action was fought between thousands of warships. The Tairas fled farther South toward Shimonoseki, taking with them their boy Emperor, the grandson of Kiyomori. In 1184 the Minamoto put up their faction Emperor, Gotoba, at Kioto ; and following the enemy defeated them in a second Japanese Actium in the Straits of Shimonoseki. It is all a stupendous tragedy of most picturesque setting and chivalrous incident, an epic indeed of richer scope and significance than Agamemnon at Ilium, and which has also yielded rich story for native prose, verse and drama. Then came Yoritomo's

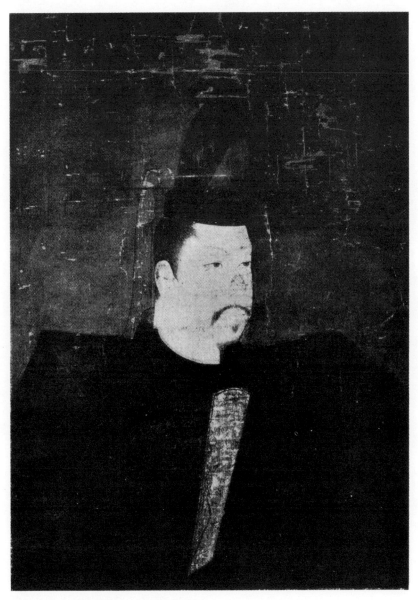

PORTRAIT OF YORITOMO. By Takanobu.

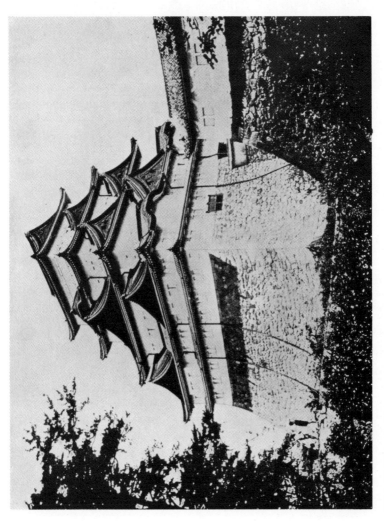

The Castle of Kumamoto.

unfortunate jealousy of his young brother Yoshitsune—idol of the Minamoto-ed nation—his murder in 1189; Yoritomo's crafty scheme of reorganization on the basis of a Minamoto adherent as local lord in every prominent capital, surrounded with a camp of Minamoto soldiers, 1175; the supplanting of Kioto as administrative capital by Kamakura; the investiture of Yoritomo by the Emperor with the title "Seitai Shogun," 1192—a thing that meant perhaps little to the Emperor, but everything to Yoritomo and his successors for seven hundred years. For though military and provincial in form, it now meant, if not source of authority, totality of executive power in fact. The poor old Emperor signed away with that name, if not his birth-right, at least the whole revenue and prestige of his court. The palace became a barren prison, where Imperial relatives and decayed Fujiwaras still received pretentious Chinese credentials of ministry, but quite devoid of function. It is to these shorn courts, rather than to Yoritomo's new one, that the artists of the Tosa school became attached as underfed court painters. Kamakura was never a seat of high culture, producing but few noted authors or artists, though it often availed itself of Kioto talent. The real power in the state, nevertheless, was feudal; and it is this innovation of a full-fledged feudal system, the work of Yoritomo, that from now on conditions life in Japan, even the life and motives and names of the Tosa artists at the Mikado's court.

It is worth while here to stop and describe at length some of the characteristics of this first form of the feudal system, because they so strongly reflect themselves in contemporary art. In the first place it must be remembered that Japan had been practically cut off from China since the fall of Northern Sung to the Tartar Kins in 1127. Its relations with Sung had never been as close as with Tang. But with Tartars in the North, and the Southern Sung hardly able to hold their own against both Kin and Mongols, the Chinese were as little likely to renew the intercourse as were the Japanese. The feudal system was to be a purely insular institution, owing nothing to continental inspiration. And after 1280, when the Southern Sung also fell before the Mongols and China became ruled by a Tartar Emperor, indifference was succeeded by open hostility. Thus Japan was left to reorganize herself as best she might with native material. Yoritomo had begun the parcelling out of the North as military fiefs to his captains as early as 1175; this he now extended to the whole

country. Castled towns arose in a hundred central districts. All men with hopes and ambitions wished to range themselves under some local leader. The peasants tilled the land on rental ; all trace of the Taihoric laws had vanished. Society tended to disperse to the provinces, or to Kamakura, leaving Kioto half deserted.

Here came in a reaction in architecture. Citadels arose with bases of faced stones and towered superstructures of heavy beams and plaster. Within the large enclosures stood residences for the daimyo families and storehouses for munitions of war. This feudal architecture of the castles is partly based upon the style of circumvallation of Chinese cities, and is not unlike the famous Thibetan Potala of Lhassa.

For private law society fell back upon the unwritten rules of the primitive village organisation, with its head-man, and its germ of a town council, and the rough recognition of ordinary human justice. It was this preservation of waning forms that the modern codifiers of 1890 seized upon in order to make an important factor of purely native institutions.

A profound reaction took place upon Japanese character also. The formal, courtly manner, the deference to rank and precedent, the welcomed yokes of intellectual and of priestly sanction, were suddenly replaced by the bare physical and mental efficiency of a man. He who could think quickly, and plan resourcefully, and act firmly—any such might rise from the ranks to castle power. For these unstable social units were pitted against each other in constant local strife, which a somewhat loose allegiance to Kamakura could not wholly check. It was a day when all pretences and conventions blew thin, and man's worth for man—individuality, that is—came out into relief. Then, indeed, was laid that foundation of Japanese quickness and adaptability which has amazed the world in their recent struggle with Russia. It is just because China has been slowly throttled in the silken meshes of her own culture, which Japan has for seven hundred years been cutting her way through to freedom, that the two races to-day invite such strange contrast.

It is this flashing of vivid personality lighting up the Kamakura annals that makes this disintegrating epoch so absorbing in interest. European writers in general have spoken of it as a sad age of anarchy, superstition, cruelty and ignorance. And indeed, it has many points of analogy with the German feudal system into which Europe broke up with the decay of the Carolingian Empire. Yet it was out of the manhood vigour of both, rather than from a bare

Imperial renaissance, that the hope of the future was to spring. For literature itself now becomes romantic. Fairy tales, and ogres, and gallant or desperate adventures, sometimes even to free oppressed ladies, enter into their crude novels. There is almost no scholarship except at the Kioto court, and nobody cares for any. It is a striking confirmation of the dominance of this new state of individuality that just here, in the early part of the thirteenth century, begins to arise a native and secular drama—and that, too, a comedy (Kiogen)— out of the buffoonery of farmers at village festivals. This was taken up by the new nobility, and even by the priests of the Shinto temples, and erected into organizations of professionals who acted on permanent stages. For in all forms of literature, as in life, it was now life itself—man himself—who became of interest to all classes of man. The subjects of romances were no longer the languorous ecstacies of silken lords and ladies, as in the Fujiwara " Monogatari," but often the triviality and even the ribaldry of common life. This is the real root of what has persisted till to-day of essential democracy in the Japanese. Even the recent Tokugawa formalism of two hundred years has passed over like a shadow, leaving the coolie as good a citizen, and a citizen as interesting to all classes, as he was in Kamakura days.

It was natural that religion also should feel the same levelling personal impulse. Just as the palace labyrinths and perfumed embroidery had been relegated to ash-heaps and junk-shops, so the mystic ritualism and the papal insolence of the Tendai *régime* had to yield to the new demand of a simple faith for simple folk. The Shingon discipline of self-purification was too high, too long, and too inconsequent for men whose time was chiefly occupied in carving up their enemies. Like the fierce Spanish conquistadors, the Japanese knights of helmet and mail wished to kneel with tears to a faith that did not require them to think deeply. So it was now that three or four great priests arose—contemporary with St. Francis of Assisi in Italy, and with the Gothic churches, who went about preaching simple faith to the masses—Saigyō, and Shinran, and Nichirin. (Saigyō died 1190—Shinran, 1263—Nichirin, 1282.) Then it was that the only purely Japanese sects of Buddhism arose by a protestant simplifying of Tendai, Shingon and Jodo philosophy and ritual. All you have to do is to believe in Amida—said these newer creeds,

and he will save you. Belief itself — mere personal surrender — is the primary thing. Great masses, and complicated genuflections, and altars hidden from the people — all these have not half as much efficacy as good hortatory sermons. On this account temple architecture became changed. In old days services had gone on in the small encrusted sanctuary whether a congregation participated or not. The Pantheon of gods needed constant pampering ; the people did not so much matter. But now that all gods but Amida were thrown out—Amida who would take his faithful to live for ever in his own golden Paradise—and that service was directed to the people rather than to Heaven, the size of the building had to be vastly enlarged and the furnishing simplified in order to accommodate the congregation. Hence the great open, matted, many-pillared front spaces of the Honganji temples as we study them to-day. Monastic orders, too, of itinerant monks arose simultaneously in Japan and Europe— mendicant orders, who passed in chanting files from castle to castle, collecting rice in their black wooden alms-bowls and carrying the news of the day and their oral traditions of learning from house to house.

In such a new world as this it was inevitable that the profoundest sort of reaction would seize upon visual art also. Individuality would necessarily be its key-note ; thus democracy in subject, dramatic grouping and the motions of violent action. Already the germs of all these things had been given form in the early paintings of Fujiwara Takanobu and of Toba Sojo, who had introduced the "makimono," or library panorama. Here was room for continuous crowded scenes of street pageantry, of fairs and temple courts, horse-races and cock-fights, the servants sweating and joking in the kitchen, councils of grey-robed monks, humorously travestied, and every possible stage of camp-life and active war. Art was a kind of journal, unprinted, that circulated about in the Imperial Court and sometimes found its way into the scattered courts of the daimyos. For the Emperor and his portfolioless ministers seem to have found a sort of desperate pleasure in watching the saturnalia of a life about them in which they could play no part. Rolls were multiplied of illustrated biographies, often becoming the treasures of temples whose priestly founders they celebrated. The incipient prose epics that were slowly maturing from the mists of myth that hovered around great deeds needed colour illumination. In short, the Tosa makimono becomes a sort of Bayeux tapestry, with a meagre interlude

of verbal explanation. Yes, what Sesostris sculptured on the rock tents of Egypt, and Nebuchadnezzar spread in glowing tiles upon the walls of Khosabad, such immortalizing of local heroism did Keion and Mitsunaga perpetrate upon frail sheets of parchment paper.

The drawing of the art is minute and vivid. The swing of action is a primary requisite, then the sweeping of the lines of many actions into great general line-currents that give motion to the crowded compositions, so unlike European Renaissance battle-pieces — Jules Romano's for instance, whose horses and men squirm in all directions, with no unified transference of masses. This the West finds only in Greek art (the Battle of Darius), and recent French cavalry charges (Aimé Morot). But in Japan it forms the backbone of the picture. Colour, too, realistic but not too gorgeous, adds vividness, and its spotting of light and dark passages lends savour and accent even to the motion. It is an art not at all unlike primitive Greek painting, especially as shown in the figures of horses and men in simple colour and spotting upon Greek vases. We may assume that such mosaics as the "Darius" had finer antecedents in mural pageants. The colour is probably richer and more varied in the Japanese. In form, too, we might perhaps say that the rushing personages look as if bombs had been exploded under the feet of figures on the Greek vases. Another analogue is the contemporary early Italian Gothic frescoing of the Giottoesque school. In those squares, crowded with mounted officers and spectators of crucifixions, which fill the plastered arches of Assisi and Padua, we see something like Tosa richness of grouping, even if without Tosa vividness of motion. If we could have an art that would combine modern French scientific drawing of motion with the picturesque crowds of *Cavalcatori*, we should strike somewhere near the battle-pieces of Keion and the street scenes of Mitsunaga.

Perhaps the very richest period was that which followed Yoritomo's triumph, Kenkiu, which lasted about ten years after 1190. Then probably Takanobu still lived, and his great son Fujiwara Nobuzane was rising into notice. Then, too, the sons of Kasuga—Takachika, Mitsunaga and Keion—were coming to ripe age. These three may be said to form the second and greatest generation of the Tosa artists. I use the word Tosa here only in an inaccurate generic sense, because the name was not actually given to the school until somewhat later, with the son of Mitsunaga, Tsunetaka. The Kasuga family then

became the Tosa family without discontinuity. I ought to say that in these relationships I follow mainly the recension of genealogies which has passed current in the Sumiyoshi branch of the modern Tosa. Some of the younger Japanese scholars are disposed to throw all such traditions to the winds : to declare that we do not know whether Nobuzane ever lived or was a painter, or whether Mitsunaga had anything to do with Takachika, or was the brother of Keion. But all such disputations must be at this stage of the game rather of an academic interest to a few Japanese scholars than of service to the world. For, after all, whether their names were Nobuzane or Mitsunaga, or Henrique or Brooks, *their works remain*—to study, and delight in, and classify, and use as the mirror of a rapidly gliding history. Until the extreme school can give us something more positive than denials, it will be the safest guardedly to follow the Tokugawa scholarship of the Sumiyoshis who prepared these lists for the use of the Shogun's court. Especially is it well to follow their canons of criticism and ascriptions of remaining examples, since it is these which have practically determined the labelling of all the modern re-collections of Japan. Most pieces have changed hands, from house to house and from temple to house, since 1868 ; and since Sumiyoshi Hirokata's death these have been mostly identified, according to his traditions, by his fellow-pupil with myself, Yamana Kwangi. It is Yamana's certificates that are found to-day with Buddhist and Tosa pieces in all Japanese collections, and attached to much that has recently come in to Europe and America. It is proper to say that my own expert attribution of pieces, whether of those in the Boston collections, or in the hands of Mr. Freer and others, has been made along identical lines with Yamana's, and that most of the pieces in the Fenollosa collection at Boston passed under Hirokata's own criticism before 1885. There may exist other schools of Tosa criticism, but none, I think, with such claim to authority.

Of the three greatest men I shall take Nobuzane first, though perhaps the youngest, because his style is most individual. In his makimonos, kept at Kozanji, and representing the transmission of the Kegon doctrine from China through Corea to Japan, he comes nearest to the style of Toba Sojo. The design is solely in black-and-white, and relies chiefly on a light, nervous, flowing line. A great storm-dragon pursues the ship of the commissioner. The waves are beaten flat, and lightning shoots in key-like forms. The type of the dragon remains essentially Tang, in spite of the

DETAIL OF THE HELL PANORAMA. By Nobuzanè.

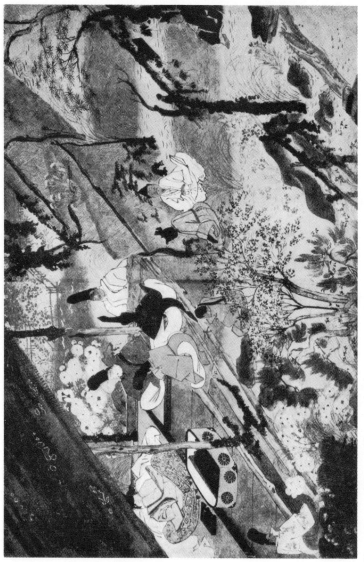

DETAIL FROM KITANO TENJIN ENGI.
By Nobuzané.

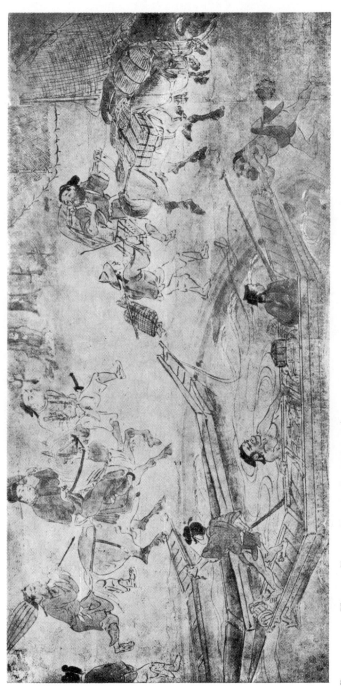

DETAIL FROM KITANO TENJIN ENGI. By Nobuzanè.

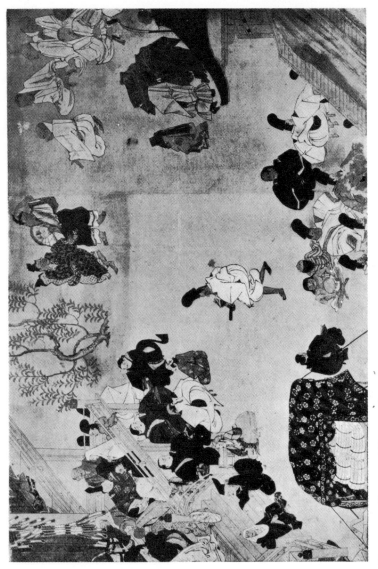

DETAIL OF SCENE AT TEMPLE STEPS.
Nobuzané.

Japanese brushwork. One of the finest passages is a scene in China where boatmen land on a shore, and porters, themselves laden, drive on over-laden bulls and horses. There is nothing so pathetically real in rustic art, except Millet's peasants. Here, however, is also a touch of humour, which Millet always lacks.

Another of Nobuzane's greatest sources of fame was his portraits. A Fujiwara by birth, he knew all the members of the fallen generation, and has left us most interesting sketches of their individual faces. He also has left the best ideal portraits of the thirty-six chief poets of the vanished age. That he made light of his own misfortunes is seen in his humorous painting of a social gathering in an old battered hut, where he, as host, with companions dressed in homespun, drink and dance away their sorrows. A servant bearing a jug of wine breaks through the rotting floor.

But the greatest work of Nobuzane in makimono form, if not the greatest of the whole Tosa school, is his long panoramic account, in nine wide scrolls, of the life of Michizane, the learned anti-Fujiwara minister of Engi. These are worked out in a kind of demonaic line, so powerful and individual that the drawing at times seems childishly distorted, as in Whistler's roughest work. Yet the effect is most intense ; I have sat before these stupendous rolls again and again, with the flesh of my back creeping as during a Wagner opera and tears standing in my eyes. The physical and spiritual excitement of it is greater than of any work I know. Yet much of this supreme effect is lost in the photographs, since it is also the unique colouring that helps to produce the charm. It may be said that the tones, though ranging through all shades of dull pinks, mauves and olives, are in the main a terrific contrast of luminous oranges against blues so dark that they seem actually blacker than black. This depth is got by scumbling powdered ultramarine over glossy inks. Of all impressionistic work in the line of story-telling this is the world's greatest.

And it tells a story, indeed, which realizes Fujiwara tragedy with an intensity wholly Kamakuran. Michizane was born and brought up to archery and letters and music, like any proud child ; we are shown it all in the first roll. Then comes a long procession of nobles in litters or on horseback passing to a temple to celebrate his coming of manhood. Nobuzane takes this occasion to make his horses leap and prance as no European but Rubens has ever conceived. The finest prancing horse is spotted in chocolate and cream, with scarlet trappings. In the

monastery yard we are treated to a genre scene which recalls the money-changers and hucksters in Solomon's temple. It is true that at the far end, on the broad verandah, sit a fine group of lacquer-hatted gentlemen and veiled ladies in every tone of soft garment, from creamed grape-juice to amethyst, who decorously listen to the old priest droning away at his beads under the latticed awning. Every figure is indivi-dualized in pose and turn of head. But down below, in the yard, we have a motley group of servants, small boys, acolytes and nuns, who are eyeing the crowd or joking with each other. The small boy leaning on a pile of hats is a strong bit of drawing. Bales of cotton under a gorgeous tarpaulin typify offerings. The singular hooded priests from Hiyei-zan stand back in a group. Behind all is a richly comic passage where the younger priests, kneeling in white robes, expostulate with shocked gestures to three drunken samurai in loose undress of delicious pattern who are desecrating the sanctuary with their ribaldry. One tucks up his spotted skirt as if to fight the acolytes, but a companion grasps him about the waist. Clearly Nobuzane has here given us not at all a picture of the sedate days of Sugawara, but a contemporary sketch pulsing with precious details of a devil-may-care life.

In a second roll follow the long scenes of conflict between Michizane and his enemies, the blindness of the Emperor, who is warned by a magnificent thunder-storm with sulphurous fumes and gold lightning that shivers the palace and bowls over the crimson lacqueys like so many leaded dolls. The Hiyei-zan pope, too, crosses the Southern Kamo by a Red Sea miracle of rolling back its waters, while his bull-chariot dashes through the bed with wheels whose spokes are a blur. Naught avails, however, and Michizane is banished to a desolate Southern island. Groups of curious peasants follow his chariot through the mountains. Motley crowds rush to the shore to see him washed to land from a shipwreck. It is all pure provocative for Nobuzane's exuberance of genre ; yet the dramatic sting is never lacking. There in his island he occupies for some years a rotten hut. Friends visit him surreptitiously, but he refuses to return against his Emperor's order. Rank unhealthy vines keep damp the leaking roof, the garden is an impressionistic tangle of wild shrubs in orange and green. At length the premonitory old man climbs a peak and protests his innocence to the god of storms, who snatches a last written message to the Emperor in order to convey

it miraculously to the Kioto palace even while he smites the petitioner with death.

Michizane's body is being slowly carried back to Kioto in a cart when the belaboured bull which draws it sinks and dies. On the very spot the attendants dig his grave with the butt-ends of their spears. A dog scratches his chin with his hind leg. Michizane is soon declared to be the god Tenjin, and the Shinto shrine of Kitano is erected to his memory on the Northern outskirts of Kioto; for which shrine these very precious rolls were painted, and where they are still kept. The marble bull which fell is here and in other Tenjin shrines, as Kameido in Tokio, visible as a sacred symbol.

You might think this to be a fair end for the legend; not so Nobuzane. His blood is just up, his opportunity is just coming, he has half his work yet to create. For should not the wicked enemy of Michizane who procured his banishment be punished both on earth and in Hell? On earth he is affected with a distress that causes snakes to creep from his ears. But Hell! ah, what could be a more deliciously opportune morsel for a painter's imagination? He gets at it by degrees. We see Fujiwara Tokihira's spirit carried toward Hell by devils. We see great scarlet flames escaping through the gates. Then come four long splendid horrible rolls of torture. If Nobuzane were Okio, as in the latter's Miidera tortures, we could not bear him. But the horror is magnificently offset both by the humour and by the colour—something as an infusion of soda keeps tomato acid from curdling milk. It is useless to describe it. Orcagna at Santa Maria Novella is a fool to it. Nobuzane could give him a hundred years handicap and win. Flames of crimson, scarlet and orange shoot all over the place in interlaced and forked serpent-tongues. Jolly, barbarous devils with cat faces pursue their nefarious calling of dragging wicked ladies by the hair; roasting a bishop or two half strangled in a Chinese cangue; sawing slabs of flesh with rusty blades from men who have been marked with a taut, inked carpenter's string; pouring red hot lead down their wretched throats; nailing their distended tongues to the floor and forcing poisonous insects to crawl upon them; or stirring gallons of human broth in copper cauldrons. One delightful green fiend, front face on, possessing a single cream coloured horn, holds a human victim head down in his two hands, and gradually tears the body apart. This might do for

a starter, but Nobuzane has far deeper game in view, no less a scheme than to picture all the various worlds of suffering and passion, cognate with Hell, through which souls, even those of deva, must learn to pass. But he never finished the stupendous work. His brush fell in death as he sketched an outline passage whose inhibited colour no human soul can ever conceive.

The second of our Yoritomo geniuses is Kasuga Mitsunaga, the reputed son (but possibly grandson) of that same Takachika who drew faineant courtiers with line so fine that it simply vanished without your knowing where. But Mitsunaga, like a true founder of the new art, thickened his passionate line nearly to the quality of Toba Sojo's, and then filled its gaps with colour on a scale as different from Nobuzane's as Venus from Mars. His line riots in massed street fights, and runaway chariots, and conflagrations that hurl brands over crazy crowds. The paper seems about to tear itself to pieces with the opposed lines of surging. His colour scheme is passages of lemon yellow shading into orange, spotted with patterns of light blue and deep pink and thrown against darks of mixed olives and crimsons. This is the real Tosa scale of early Kamakura, and it is unlike any other colour passages of the world's art with which I am acquainted; Fortuny and Monticelli at their gayest giving just a hint of it.

Mitsunaga's greatest work was the "Nenchiu Giogi," a sort of pictorial diary in sixty rolls that narrated all the striking scenes of Kioto life from January to December. Some twenty rolls of this remained in the Imperial Treasury, and were brought to Tokio in 1868; but were burned in a palace fire a few years later. The Sumiyoshi had carefully coloured copies of some of these. I succeeded in obtaining for my collection, now in Boston, a set of outline copies made from them more than two hundred years ago by Sumiyoshi Jokei, the founder of the branch line that located with the Shogun at Yedo. The runaway chariot is found from these, also the guards waving torches at night while the fat gentlemen sup under a shed, also the great cock-fight where men throw up their hats and knock small boys down in their excitement. Of the minor works of Mitsunaga, we have a fragment of Hell, and two rolls of the visit of Abe no Nakamaro to China. This latter makes a humorous contrast of Japanese and Chinese customs. There are some genre scenes, of which one of the best is a contemporary

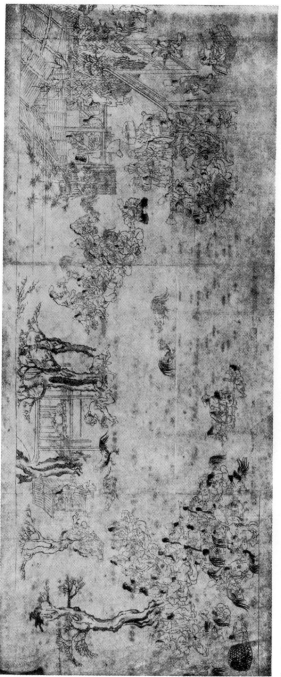

THE COCK FIGHT. By Mitsunaga.

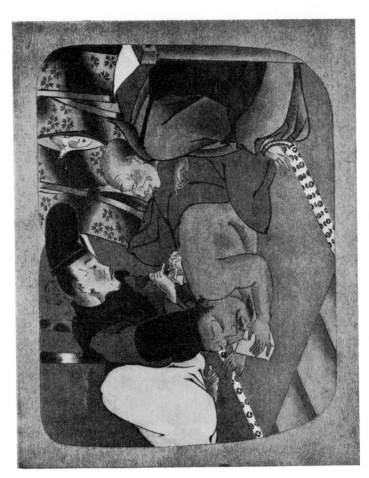

"A Surgical Operation." From one of the rolls of the "Nenchiu Giogi." By Mitsunaga. Fenollosa-Weld Collection, Boston.

surgical operation, where a squatting gentleman doctor calmly punctures, while a priest sits by and watches with eager horror.

But perhaps the finest coloured rolls of which the original remains are the scenes of "The Burning of the Gate." The people in the street stop, drop their loads and begin to run as they hear the fire-bells. Mounted policemen waving metal sticks dash up from behind. The flames drive back the yellow, green and milk-blue crowds who save the singeing of their brows with uplifted sleeves. Then comes a humorous procession of mounted knights in armour and holding folded banners, which out-does Doré's Don Quixote. Their ill-fed, knock-kneed horses are veritable Rosinantes, and the affected gallantry with which the horsemen rival each other in holding their banners is wit straight from Cervantes.

We come now to Mitsunaga's younger brother, who took the priestly name Sumiyoshi Keion. In some respects he was the greatest of the three, the greatest draughtsman certainly. He had little of the humour of Toba Sojo and the others, and his colour is more commonplace, relying more on good straightforward reds and blues and greens. But his notan, that is his dark and light "spotting," is even more effective than theirs. He is no such impressionist as Nobuzane; he is more sane and business-like. But in his stupendous massing of crowded line into totality of motion there is no one who approaches him. His subjects, too, lend themselves to such treatment. For, above all others, he is the greatest painter of battle-pieces—the central deeds of violence in all Japan's military history, the mighty struggle out of whose tearing asunder his own and his contemporaries' individuality arose on light wing. Probably he saw in his youth the Hogen Heiji horror; knew Yoshitsune by sight, and witnessed Kiyomori's triumph; watched Yoritomo grow to manhood, and may have been in Yoshitsune's train when the fortress at Dan-no-ura went up in flames. At any rate the grim, determined spirit of the day is his—not so much its roystering fun, but its keenness, cruelty and impersonality. Photographs of the Russo-Japanese war give no such vivid idea as he does of the Japanese military soul. If we compare his charges and ambuscades and cautious marches of crowded men and horses with the battle-pieces of European masters, it is only the ancient Greek and the most recent French who can approach him in reality of motion.

Keion has left us an interesting makimono of a religious subject treated with secular frankness. It is all part of a human story, in which Amida himself and his music-loving Bhodisattwa sweep through a regular Tosa landscape to their act of blessing. They are no longer the hieratic figures of altar-pieces, not shining in unhuman gold but drifting over the water like graceful floating clouds. Single figure pieces, as of a mounted warrior in full armour turning in his saddle and looking backward—seen in fact from behind so that the head of his rearing horse is hidden behind his body—are found in either originals or copies. One of the most splendid small groups is copied upon a fan by no less an artist of later date than Honnami Koyetsu. We shall speak of this again in Chapter XIV. There is no record as to whether it really is a copy, or an original composition in the style of Keion. If the latter it is a most astounding revival, for no such drawing of soldiers exists in the four hundred years between Keion and Koyetsu. Koyetsu studied the great Tosa masters, especially Nobuzane and Keion, with great care, and I am inclined to believe this at least a free transcript from some lost Keion. It represents the capture of an armoured courier by five foot soldiers of his enemy—a sort of Major André scene, in which the dismounted suspect seems to be trying to swallow his dispatches. The splendidly drawn horse is being held down by three of the soldiers, who, with their strong contrasts of white and black, make an unusually close and unconventional composition. The lines and mass of the horse and the three men are all tangled together. The brutal excitement of the faces is powerfully rendered.

The greatest remaining secular work of Keion is his panorama in three long rolls of scenes in the Hogen Heiji war. These three have been held in separate possession since early Tokugawa days. The two that are still in Japan in private hands are very interesting. In one there are vast stretches of mountain and forest, through which wander figures in small groups. In one place they fall upon the corpse of a warrior, who is lying, feet toward the bottom of the picture, with his throat cut. This is well-nigh the only striking piece of fore-shortened drawing in all Chinese and Japanese art. This would have delighted the late Dr. Anderson, of London, who seems to have thought that Tosa drawing is too childish to merit the name of art. In the second roll we see a squadron of cavalry advancing

slowly between two lines of bull-chariots. The action of the leader on the black horse, with proud, arching neck, is very fine.

But it is the third roll which reaches the full height of Keion's powers in military delineation. This was formerly in the possession of the Honda family, and I had the privilege of studying it and photographing it more than once on the occasions of the loan collections of daimyos' treasures held by the Art Club annually since 1882. I hardly thought then that some day this supreme work would fall into my own possession. The overcoming of the difficulties in its acquirement would form a romance in itself. It is undoubtedly the greatest treasure of the thousand or more pictorial masterpieces which, under the name of the "Fenollosa Collection," I contributed, through Dr. Weld, to the Boston Art Museum in 1886. It was carefully photographed several times during my administration as curator of the museum (1890-1896), and had recently been photographed again, very beautifully, for the museum.

The roll opens (from the right, of course) with the terrified flight of a court party, few of whom have had time to don their armour. Gentlemen on horseback are racing for dear life, trampling down citizens and grooms. In front of them whirls a group of chariots drawn by bullocks. The wheels whizz like electric fans. One of the chariots, surrounded by archers in lacquered caps, has its course blocked. In the confusion one of the bulls has turned upon the struggling mass and his rocking chariot crashes over prostrate crowds. In this part of the continuous composition the prevailing horizontal lines of the general rush are broken chiefly by the angular course of this runaway. Every attitude of horse and man, every clearly drawn face, is tense with fear and wild energy. Here we see such individual types as are familiar to-day on the streets of Tokio. I could almost venture to assign some of the family names. The composition is so close that one can scarcely catch a glimpse of the ground through the swarming bodies. There is no scenic display as in the Morot accessories at Versailles. It is rather like the Alexander mosaic at Naples, in which the prevailing lines of the moving figures tell the whole pictorial story. Caps and heads and chariot roofs appear over the lower edge of the picture, a vivid arrangement under a down-looking perspective, incomprehensible to ancients and Italians, and seen only in modern French impressionism, such as Degas' jockeys. A moment more and the mad mass turns a

corner, dashing down almost front on to the spectator, as we see reality in modern moving pictures. This powerful transition of angles is aided by the long dark shafts of the chariots and the tilt of chariot awnings. The variety of line and *notan* passage is here infinite, crammed at every part with startling new feeling and beauty, a torrent of torrents, a spotted mosaic whose apparent confusion is subordinate to clear keys.

The device of a garden wall divides this passage of the flight from a scene where an ancient palace is burning. The flames—of orange, yellow and red—play up in splendid writhing curves into clouds of brown and blue smoke. How unlike are these rounded tongues to the forked scarlet sword-blades of Nobuzane's fires ! It is as if we had here an instantaneous " snap-shot " at a conflagration. Soldiers in armour with gloved hands are butchering the fugitives and peering to discover some who may have hidden under the already smoking verandahs. There in the court-yard a shouting, twisting guard of mounted knights darts back and forth, finely displaying the action of their little stocky short-necked horses—for all the world like the prancing steeds of Phidias' Pan-Athenaic frieze.

After this the warriors, crazed with blood and fire, pass off to fresh exploits : hideous armoured footmen with faces stained like berserkers, bearing a coronet of dissevered heads upon their pikes. The muscles of their naked legs stand out in knots.

Lastly we have a mixed group of Fujiwara unarmed courtiers and their convoying squadrons of troops. A chariot, presumably of their own Emperor, is borne in their midst. The splendid mosaic of more than a hundred figures moves with a slow, restrained march, the grooms tugging at the heads of impatient horses. The bow-men are all now in front, some with arrows fixed on the strings. There is evidently nervous suspicion of an ambush. The front of this fine procession tapers off like a cadence in music. A general holds in a prancing white horse with taut rein ; then come two staccato notes of foot-soldiers walking abreast ; then an isolated captain far in advance, upon a fine black charger which rears in fright, as if he sensed an enemy hidden in the grass beyond ; then one last short note of a single archer ahead, who peers into space with arrow set on his half-drawn string.

The pawing action of the white horse is fine enough ; but what shall we say of the sudden leap of the black, which centres the whole

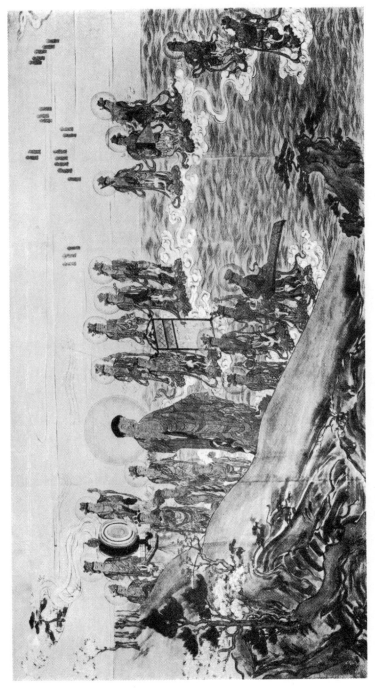

BUDDHA DESCENDING THROUGH CLOUDS.
From the Taima Mandara, Keion.

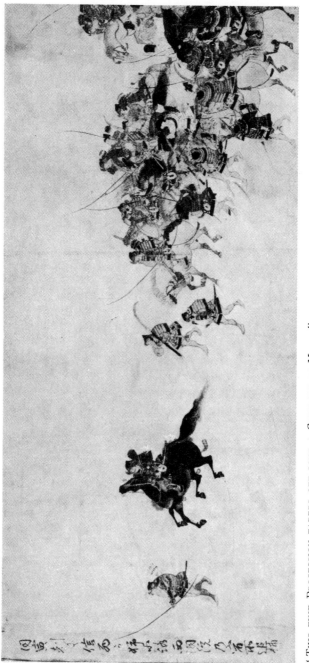

"This fine Procession tapers off like a Cadence in Music."
From the Keion Roll. Fenollosa-Weld Collection, Boston.

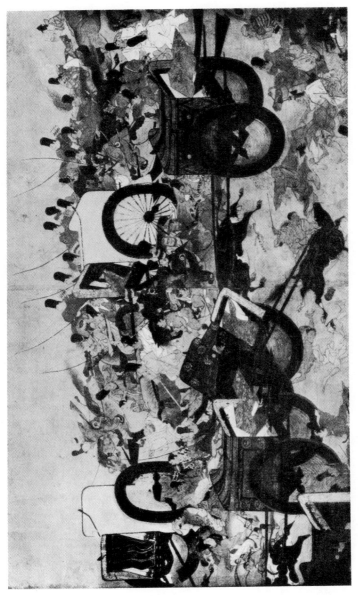

"Flight Turning a Corner."
From Keion's Panorama Roll of the Hogen Heiji War.
Fenollosa-Weld Collection. Boston.

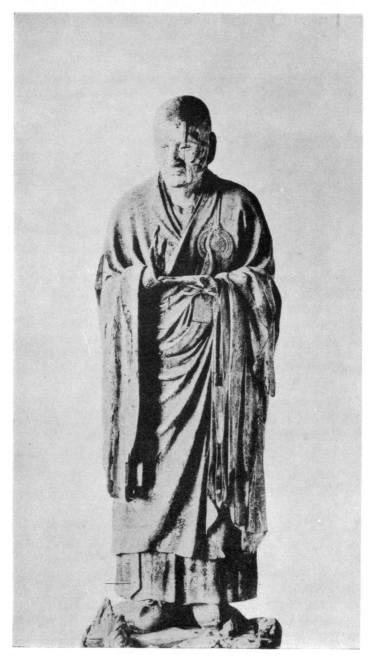

PORTRAIT STATUE OF ASAMGHA.
At Tofukuji, Nara.

van to the eye? All four feet have left the ground at once. The
nostril of the raised head is high in air. The rider tries to pull it
down by a vertical rein. Though fault might possibly be found with
some of the anatomical details of the steed, particularly if enlarged in
photography, yet on the actual scale of only a few inches it is hardly
possible to conceive of a more vitally rendered action, or of a greater
beauty of gleaming curves. If this one makimono had been destroyed,
as forty-nine fiftieths of the old Tosa works have been destroyed, our
conception of the range of Asiatic art—and even of the world's art—
would have suffered capital loss.

In the years shortly following Yoritomo's death, his dynasty of
Shoguns underwent, at Kamakura, the same sort of eclipse which the
early Kioto Emperors had been dealt at the hands of the Fujiwaras.
It was now their Hojo ministers who set up puppet chiefs and did the
actual ruling. It was a cruel, crafty and able race, this Hojo family
who could hold in check a hostile nation for well-nigh one hundred
and fifty years. The tyranny, revolts, and feudal hardening of these
days is well shown in many of the No dramas of the fifteenth century.
They had reigned hardly more than fifty years when a supreme test of
their strength came in resisting the threatened invasion of the Mongols,
who by 1269 had conquered all Asia and half of Europe and were
preparing an immense armada in China to gobble up the outlying islands.
Hojo Tokimune, the reigning Shikken or Shogun-guardian, defied the
great Kublai Khan by twice beheading his commissioners. When the
crash of invasion came in the South West, Tokimune's army drove
the landing fighters into the sea, and his navy achieved a brilliant victory
over the crowded Chinese junks on the exact spot in the " Sea of Japan "
where, six hundred years later, Admiral Togo was destined to destroy
a second Tartar flotilla—of Russia. It is said that Togo chose the site
partly for this reason, not from vain sentiment either, but in firm belief
that the souls of those defenders who died in the earlier campaign
would be able effectually to assist the living in the latter. It was in
the year after the Mongol invasion that Nichiren, the founder of the
Hokkei sect, died and was buried at Ikegami, near the present Tokio.
In 1316 a library of books, now also becoming rare, was founded at
Kanazawa on the West coast. These are the principal events that
happened before the advent of Godaigo Tenno and the prolonged
wars for the Imperial restoration.

The art of this intermediate day falls lower than the brilliant achievements of Kenkiu. In the middle of the thirteenth century the great painters of the main line, now named Tosa, were Tsunetaka, the son of Mitsunaga, and Yoshinobu, the son of Tsunetaka. Tsunetaka's line is of wonderful delicacy and crispness, without at all reverting to the imbecility of his grandfather Takachika. He did not mass his figures like Keion. He sometimes worked in black and white. It is in landscape and his wonderfully crisp drawing of trees that we see the full-fledged beauty of the Tosa background. His boatman poling through the rapids, copied by Koyetsu, is a vigorous figure.

Yoshimitsu essays a form which somewhat recalls Nobuzane. He has given us many crowded scenes, not so closely built as Keion's, but pulsing with a vigorous coarse life. Especially fine are his forty-eight rolls of the life of Honen Shonin, owned by the Imperial household of Japan. A group of women descending the palace steps is typical of his drawing. His landscape, throwing dark blue and green trees against chocolate coloured hills, is wonderfully free and impressionistic. This Tosa school of landscape is especially notable, since it so absolutely contrasts as a purely Japanese feature with the splendid Chinese school of Zen landscape that came in a century later. Yet this Japanese landscape is itself remotely descended from an earlier pre-Tang Chinese style of the sixth century. Into it, however, has been infused the characteristic drawing of pines and cherries and cedars whose waving plumes crest the dear familiar hills that surround Kioto. As we traverse the wild valleys about Kozanji, we exclaim again and again of the scenery : " How exactly like a Tosa landscape ! "— and that, too, down to the minutest tawny colour. Such mountain passages as shown in Yoshimitsu landscape with wild cherry are the most beautiful landscape illumination in existence. This was a feature which the earlier Tosa masters deigned only to suggest. We see again in the Tosa gardens the little rounded hillocks and the small curving Japanese red-stemmed pines, the "female" pine, so different from the dark towering conifers of China and of the Tokugawa temples. Such little Tosa gardens might have been seen lingering among the monasteries of Nikko some thirty years ago. En-i Hogen, the painter of the fine makimonos at Shodaiji Nara, has left us some grand Tosa landscape effects in storm and snow.

In illuminated Buddhist scripture rolls, too, we find some charming examples of pure Tosa decoration, nearly contemporary with Giottoesque

Gothic manuscripts. In one, a Fujiwara daimyo and his court ladies gaze out through an atmosphere flecked with many-sized gold flakes upon a lotos garden. The colour is richer than the best modern lacquer. In another the whole decorative band is filled with coloured lotos flowers and leaves. It should be noted too that as early as 1229 Toshiro founded at Seto, in Owari, the first kiln for making artistic pottery. His dark brown glazes had something of Sung type in them. The lacquer work of the day either had Tosa landscape executed in dull gold or black, or quite Tosa-ish patterns of flower forms and birds inlaid in pearl upon a powdered gold ground. The patterns are far less stiff and conventional than the corresponding decoration of utensils in Fujiwara days. It was such impressions of garden scenes, scenes that might have been copied from Yoshimitsu's makimonos, that Koyetsu and Korin took for models in their great lacquer renaissance of the seventeenth century.

The third and fourth generations of Tosa, Yukimitsu and Yukihiro, show still more of a fall. At the beginning of the fourteenth century Yukimitsu is more like Keion. Yukihiro is still more like him, only reducing Keion's myriad types to two or three and loosening the composition into scattered masses. It is clear that a Tosa formalism is eating away strength.

It must now be mentioned that, parallel to the family schools of Fujiwara and Tosa, a set of descendants of both the Kose and Takuma painters still flourished, and these by the fourteenth century began to do secular work on makimonos, in addition to their traditional manufacture of altar-pieces. It was one of these Koses, Nazataka—his full name and title being "Echizen no kami Nazataka"—who has left us a contemporary panorama of Tokimune's destruction of the Mongol fleet. Kose Korehisa has left some fine large groups of warriors in colour. The Kose line continued to be a little harder and more wiry than the Tosa. By the middle of the fourteenth century these parallel and friendly schools began to have an influence upon each other, approximating more and more to a common type, so that it becomes difficult to tell apart, say, Tosa Yukihida, Kose Ariiyé and Takuma Rioson.

The last stages of the first Shogunate, that is, the Kamakura domination, began with a new series of civil wars opening with the attempted freeing of the Emperor Godaigo Tenno in 1331. The Hojo tyrants had become most unpopular. Story and song had aroused

pity with tales of threadbare Emperors. Godaigo himself had the desire to assert an independence which no Emperor had enjoyed since the year 900, and which no one should again enjoy until the accession of the present Mutsuhito in 1868. Godaigo authorized the great Kusunoki Masashige and Nitta Yoshisada to fight for him against the Kamakura usurpers. With the Imperial army was, at first, a crafty general, Ashikaga Takauji, who afterward became jealous of his fellow-conquerors of Kamakura, revolted against Kusunoki and the Emperor, and proclaimed himself Shogun under a Northern Emperor of his own choosing (1337). After three years of independence Godaigo is utterly defeated by Takauji, and the despairing Kusunoki, courting death, is killed. It was the remembered tragedy of these moving days that steeled the arms of Satsuma and Choshu in their war for Imperial restoration in 1868. Saigo Takamori was hailed as a second Kusunoki; loyalty to the Emperor and hatred to the Shogun became a passion. Down to the Russian war Kusunoki has always been celebrated as the ideal samurai, and Japan's greatest hero. How far Togo and Nogi have now supplanted him in national affection remains to be seen.

The followers of Kusunoki, however, would not give up the unequal fight, and maintained a guerilla civil warfare against Takauji and his successors for years, also maintaining a separate Southern Emperor in their fortresses about Yoshino. It was not until as late as 1392 that the Southern Emperor finally gave up to his successful rival at Kioto, thus legitimizing to all eyes the power of Ashikaga. It is hard to say quite when the first feudal period falls and the second begins. Kamakura and the Hojo fell in 1333. Ashikaga was proclaimed Kioto Shogun in 1337; but he merely kept up the traditions of the Kamakura court in another place. Takauji was, it is true, temporarily beaten by the Southern party and driven from Kioto in 1351, and he died in 1358 without really knowing whether or not he had left a successful and permanent dynasty. On the other hand it is not necessary for *us* to wait for the final collapse of the Southern party in 1392 in order to recognize that a permanent change has come. The third Ashikaga became Kioto Shogun in 1368— Ashikaga Yoshimitsu, a powerful man with a deliberately new policy, who practically ruled all but a small portion of Japan. This, too, is the exact date of the advent of the native Chinese Ming dynasty which had first overthrown the Mongols. We shall adopt this date,

therefore, as not only a convenient but a real demarcation between the civilization and art of the Kamakura period and the Ashikaga period.

It was in these last days of civil war that the Tosa art became weakest. As an example of fairly good work, we may cite a copy of the equestrian portrait of Ashikaga Takauji, by perhaps Tosa Awadaguchi Takanitsu. The family had now divided into many branches ; a new school of artists had come forward, the Shiba, whose style seems to be a real but weak mixture of Kose, Tosa, and Takuma. The descendants of the Tosa, Hirochika, and Mitsunobu lapsed over into solid Ashikaga days, and will be spoken of under Chapter XIV.

Yet I have now, before quite closing this chapter, to speak of several phases of Kamakura art which went on parallel to the main stream of secular makimono painting which I have already described. I preferred to treat makimono painting first as a whole, because it is the most typical and striking innovation of this purely Japanese school. We have already seen that beside the makimono, the greatest artists of this school were celebrated for their portraits. It is natural that portraiture should have become a marked feature of a day which adored individuality. The finest painted portraits were those done by Takanobu and Nobuzane. Takanobu's great portrait of Yoritomo we have already mentioned. Nobuzane's famous portraits of the thirty-six poets are the most original things of their kind in Japan. His Ono no Komachi and his Hitomaro are the most celebrated. His large portrait of the seated Hitomaro, owned by Mr. Kawasaki, of Kobe, is finer than all. The individual portrait of a fat Fujiwara noble has been immortalized by Koyetsu's copy. His portrait of Ono no Tofu practising calligraphy is another fine piece of humour. Still other painted portraits, mostly by artists of the Takuma school, are representations of priests. The finest of these has been lately acquired by the Louvre Museum at Paris, where it is reckoned one of the supreme Oriental treasures. Its pure delineation suggests perfect modelling ; indeed it suggests the strength of a Holbein.

But what I have in mind is that the Kenkiu people soon saw that sculpture might be a more effective medium for portraiture than painting. Sculpture had been used sparingly as a subordinate art all through Fujiwara days ; the revival of Jocho in the eleventh century being the only notable one after the introduction of mystic Buddhist painting.

Before that, of course, Nara had made sculpture the chief medium of her whole culture, and with this she had executed some fine portraiture. But never before had sculptured portraits been made an important part of professional work. Of course the new sculpture that came in with Yoritomo was not entirely confined to portraiture, as we shall see in a moment. Two great men, Wunkei and Tankei, whose names are as familiar to every modern Japanese as Donatello and Michael Angelo to us, inaugurated a new school of sculpture in these violent days of Yoritomo; and, since individuality was becoming the key-note of the new life, they naturally gave great prominence to portraiture. In this they were followed by several generations of sculptors who applied their methods, but with weakening skill—just as the Makimono painters became degenerate imitators of Keion—down to the end of the Kamakura period. We may thus make the interesting generalization that what is new in the art of this third period of Japanese life can be summed up in historical painting and portrait sculpture.

First among the many such statues that have come down to us—portraits of priests, artists, Shoguns, guardians and temple-donors—are the effigies of Wunkei and Tankei themselves, self-carved. Their medium is now entirely wood, practically ignoring the bronze, clay and lacquer compositions of the Yamato Era. We see Wunkei in the form of a somewhat round-shouldered bald-pated priest, telling his beads. Another portrait of a famous old priest, with a long, hard monkey face, is of their school.* Perhaps the finest of all in this line are the six seated portraits of priests that occupy the front of the new tiled altar of the Chukondo at Tofukuji in Nara. It was indeed at Nara, and as Nara sculptors, that Wunkei and Tankei did a great deal of their work, and an important branch of their disciples located at Nara; so that Nara, through the Tosa age, became, with its corps of sculptors and its dramatic troupes—all acting in the service of the temples, chiefly the Shinto-Buddhist construction of Kasuga-Tofukuji—an even greater centre of culture than the stricken Kioto. Even such painters as Keion, too, went down from the capital to work for Nara.

The six sculptured priests have not only great strength of drapery line but absolutely individualised heads, and faces working

* This monkey-faced priest is now said by Japanese critics to be Wunkei, by himself.

in the expression of deep personal emotion. The finest, perhaps, is the somewhat thin individual with the broken right ear whose photograph we reproduce. It must be remembered that the discoloration of the flesh tones is due to the disintegration of the pigment with age ; but it does not hide the perfect finish of muscle, and tendon, and wrinkle, nor the minute veining of the hands. The neck, seen through the open collar of his keisa, is a specially fine piece of work. The earnestness of the prayer has clenched the hands almost to the point of swelling. There is not the slightest attempt at æsthetic pose. The man has fallen to his knees in absorbed devotion—an ecstasy of mortal fear and longing—and his collar has become disarranged in the long heat of his effort. It is indeed analogous to the realism of Spanish Renaissance portraits of monks, also done in painted wood. Compared to such Japanese portraits, the most famous work of early Egyptian or later Assyrian artists, though in itself admirable enough, becomes utterly outclassed for a perfect primitive realism. It is interesting to note that these statues appear on the same altar with the imported Nara statues of the Indian sculpture, and with the two colossal Tang portraits of Asämgha and Vasabandhu, from whose style and power it is probably true that Wunkei derived a good part of his inspiration. Indeed, so alike are the two styles that some Japanese archæologists are inclined to include the larger works also among the products of Wunkei's time.

Another fine line of portraits are of leading Kamakura lords and generals, in their characteristic costume of tall, pointed lacquer hat and enormous baggy trousers that half conceal the feet. That which we reproduce is a portrait of Hojo Tokiyori, the fifth of the line of Kamakura guardians, who administered from 1246 to 1261. It is interesting to note that he sits, not upon his knees as modern Japanese, nor cross-legged " as a Tartar," but with his raised knees as far apart as possible consistently with the bringing the soles of his feet together in front of him. It is here that we must call attention to the sacred sculpture, much of it extraordinarily fine, which Wunkei and Tankei inaugurated at the outset of the Kamakura era. I have not before in this chapter dwelt upon religious art, because I wished especially to focus attention upon the remarkable and quite new secular art, whose very human qualities effect the chief innovation

in that Buddhist art which would otherwise have remained traditional and dead. Of course even the old forms of it did not altogether cease. Horiuji still preserves the sect even of Suiko Tenno ; Yakushiji and Todaiji bring Nara worship down to our own day ; Shingon is still a powerful influence in Japan ; and Enriakuji of Hiyei-zan still boasts the succession of its Tendai popes, the last of whom, formerly priest of Nanshoin, was one of my Buddhist teachers. The demand for the old altar-pieces therefore did not altogether die away, and there were simpler forms demanded for the new democratic sects.

The best known works of Wunkei and Tankei, on these lines, are perhaps Buddhist " Gate Guardians (Ni-o) and Altar Guardians (Shi-tenno)." Of the former class the largest examples are the colossal statues in the great gateway of Todaiji at Nara. The most violent and complete in muscular and vein development are the two, life size, which occupy the front corners of the Chukondo altar at Kofukuji. Dr. Anderson of England has gone into panegyrics over these as the finest statues in Japan. But to our mind they are too mannered and distorted in their pose, and their overdone violence is even repulsive. Yet in knowledge of muscle, in swing of drapery from the waist and in force of motion, they evidently form part of the same epoch with Nobuzane's courtiers and Keion's soldiers. It may be noted that from this era onward the eyes are generally set with carved crystal, instead of remaining part of the basic wood. In Nara days the pupils of the eye only had been sometimes inlaid with a cylinder of dark mineral. But now white was inserted under the crystal to show the whole cornea.

Of Wunkei's Shi-tenno there are many fine examples ; typical are those of Toindo at Yakushiji, and Seigwanji of Kioto. The whole group of Bodhisattwa, saints and deva, upon the central altar of Sanji sanji san gendo at Kioto are very fine works of a generation or two later. Buddhas and Amidas we have in hundreds ; some of the most delicate, carved of plain wood and gilded, dating from the later thirteenth century. But of Buddhas we must, of course, give the palm to the colossal bronze Buddha of Kamakura, so well known to modern travellers. This was erected by the efforts of a priest whose name is not known. It has been described by many foreign writers in terms of great praise ; and it has entered into English literature, both

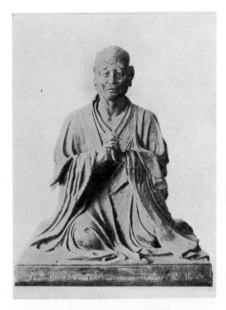

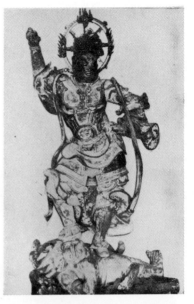

PORTRAIT STATUE OF A PRIEST.

NIO. By Wunkei.

PORTRAIT STATUE OF WUNKEI.

PORTRAIT STATUE OF HOJO,
THE FIFTH OF THE
KAMAKURA GUARDIANS.

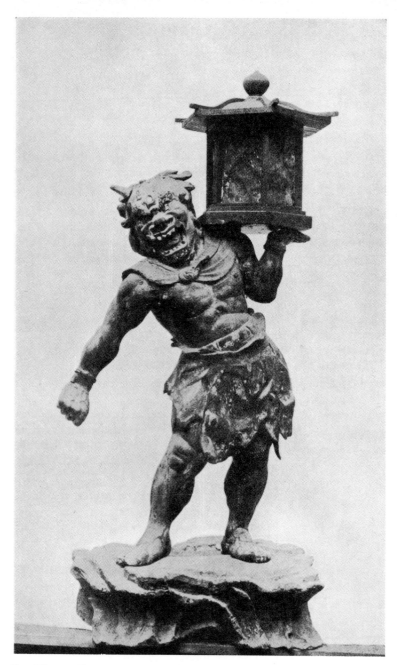

THE KASUGA LANTERN-BEARER. By Kobun
Kasuga Temple, Nara.

in verse and fiction. The important thing to say about it, next to its size and its great feeling of calm (which belongs to all good Buddhas), is that its æsthetic quality is that of the type that follows in the next generation after Wunkei. Compared with painters, it makes me think of Tosa Yoshimitsu, rather than of Keion and Mitsunaga. As contrasted with the Nara colossus, it is far finer ; not because the art of the day is more enlightened than Yamato art had been ; but because while the Nara Buddha is the clumsy work of a decadent age the Kamakura bronze comes just after the culmination of its day. The former's place is far down a descending curve ; the latter's on the descent indeed, but still near the top. Very beautiful and graceful works of the same day are the six large Kwannons carved out of unpainted wood in the Roku Kwando of Northern Kioto.

Fourteenth century sculptures of the Wunkei school are common, but weaker. In grotesques much charm remains, specially in the Kasuga lantern bearer by Kobun. Here we have a Buddhist imp, by no means a bad sort of fellow, in the painful muscular effort of holding up a heavy weight. A late fourteenth-century stage of the art, still admirable, is shown in the Shingon bronze group of the early mystic pilgrim, Enno Gioji, and his two familiar mountain spirits. Here, the weakened proportions and the unquiet surfaces, not clearly bounded in line feeling, show, in sculpture, the same poverty of styles which we find in contemporary pictorial work with the Shiba school. From that day on Buddhist sculpture fell into a kind of manufacture, like Italian mosaicing, without reference to name or fame. The last professional Butsshi * was a young man whose workshop, stocked with ancient and modern portraits, Buddhas and carved works, I visited in 1882 in Tera machi (" temple-street ") of Kioto. He died a few years later, and the tradition was lost, except in sporadic amateur work among a few Shingon and Tendai priests.

Before closing I ought surely to refer to the parallel Buddhist work that was done in painting, mostly by the self-same Tosa, Kose, Takuma and Shiba artists who won their most original fame upon the secular makimono. All these artists worked at times upon hieratic altarpieces. With the painters that had come down from Fujiwara days—Kasuga, Kose and Takuma—such work was, of course, traditional. But it had fallen into extreme weakness and effeminacy before the days of

* Or Butsuzo maker.

Yoritomo ; and if it had not been for the new life-blood infused by secular work it would hardly be worth serious mention as a phase of Kamakura art. There is, of course, in the latter, plenty of formal weakness—mere artisan persistence in the manufacture of gilt Amidas and flying Bodhisattwa. But besides this the age and the artists put new wine into the old bottles, making more human, more dramatic, more filled with motion, the hierarchical compositions demanded for the accepted sects. In short, the Tosa makimono drawing was used for it.

Chief of this semi-new school of sacred painting were the Tosas themselves. Keion has left us charming—often very minute—views of the grounds and buildings of Kasuga temple at Nara, arranged as a Tosa landscape background, against which gilded and coloured gods descend, the Buddhist analogues of Shinto deities. Tsunetaka is noted for his whirls of the star-gods, beautiful Buddhist figures, the spirits of the planets, sweeping on clouds through the sky, as orbs about the central pole. One of the finest examples is the star-mandara of Boston, which I bought as a sacred treasure from Sumiyoshi Hirokata on his death-bed, along with the Takanobu Shotoku series. Another example is in Mr. Freer's collection. Yoshimitsu is specially noted for his Shingon pieces, of which sect there was a notable revival in the thirteenth century, Dai-nichis, Fudos, and Aizens. The finest pieces of this Tosa Mandara work are in Daigoji of Yamashino. We reproduce here the Yoshimitsu Dai-nichi of Boston.

Next to the Tosa come in importance a whole new generation of Kose artists, probably blood descendants of Kanawoka and Hirotaka. Beginning with Kose Genkei in the days of Kiyomori and Yoritomo, they also introduced into their altar-pieces, even before they essayed makimono, the freer drawing and the more personal spirit that the age demanded. A splendid example is Genkei's Jizo Mandara in Mr. Freer's collection ; of which the composition is not unlike that which Raphael often borrowed from the Umbrian school, a gentle Jizo, of mixed gold and colours, seated on high on a circular halo, while below, relieved against a mountain background cleft with a stream, stand right and left in two crowds, realistic figures of devas, saints and kings, and a spirit, kneeling before the cleft, and in front of the two groups, reads from a large white scroll, thus completing the central axis of a magnificent composition. Fourteenth century Kose altar-pieces become again suave and hieratic, more like the graceful Amidas, and

Kwannons of lacquered sculpture. A Kwannon from a Yeishin-like trinity, with the traditional gold diaper pattern, by Kose Arishige, is in Detroit. The Shiba school, as of Rinken, exemplified in Boston, shows a late scrolly stage of prettiness, approaching the Byzantine formula of Mount Athos.

A final word must now be said covering the family and school of the Takumas, also descended from Fujiwara days. Their history, though interconnected with the others, is slightly different. While they sometimes painted to Shingon order, their special work seems to have been to minister to the pictorial needs of the new Zen sect of Buddhism which was slowly finding its way into Japan from the Sung of China. It is in the next chapter that I am to speak chiefly of Zen, which already in Northern Sung had influenced to some extent even Ririomin. It is enough to say that the style of Ririomin, as the Sung continuer of the Godoshi movement, began to pass over into Japan with the immigrants who founded the Zen temples. This early patronage of Zen was rather specially a matter of the Hojo at Kamakura, who were glad to accept any spiritual makeweight against the prestige of the older Kioto sects. Thus the Zen temple of Kenchoji in Kamakura, still standing, was built by the Shikken Tokiyori, the same Hojo whose portrait statue we have already seen in 1253. Other great Kamakura Zen erections followed soon after. The great Kioto Zen temples came mostly after, as we shall see in Chapter XII.

The Takuma style of this third period may be described as a mixture of the leaden lines and nobler proportions of Ririomin with the liveness and soft nervous brushwork of the Tosa. In making the combination they learned to spread the hairs of their soft brush to far wider strokes than the Tosas, in drawing the accented portions of lines. Takuma Shoga was one of the great masters of this sort of work. He lived in the mountains of Takawo to the north-west of Kioto, not far from Kozanji, where his great set of the twelve Ten Bapteri Bodhisattwa are still kept. One of these, the Kwaten, or God of Fire, shows a fine old fellow, the hairs of whose gray head are swept out into the draught which the flame of his halo creates. Another, the moon Goddess, is of a young graceful figure seen in profile, holding up in a golden dish a crescent moon with a rabbit in it. The force of the former suggests something of a Dürer drawing; the charm of the latter, with its sweeping drapery lines, is like a Botticelli. The

great Louvre portrait of a priest, probably Zen, already noted, is probably by Shoga. His followers, Yenichibo, Rioga, Rioson, Choga and Yeiga continued the style, at times falling closely under Kose and Tosa influence; but in the main it can be said, that with the clues furnished by Ririomin and the first Zen apostles, Takuma art is really the only one of Kamakura which forms a sort of transition to the wave of Sung influence which in the next period overflowed the art of Ashikaga.

END OF VOL I.